THE WAVE

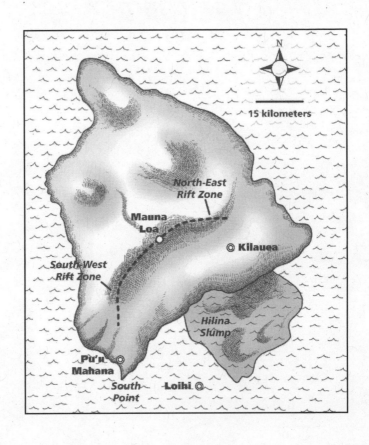

THE WAVE

A Novel by Tom Miller

SHERMAN ASHER PUBLISHING Santa Fe

ISBN 13: 978-1-890932-38-1
Library of Congress Control Number: 2009943896
Cover illustration by Janna Block
Edited by Cinny Green
Text design by Jim Mafchir

The Joint is Jumpin' Words by Andy Razaf and J.C. Johnson
Used by Permission of Alfred Publishing

Sherman Asher Publishing
P.O. Box 31752
Santa Fe, NM 87594-1725

www.shermanasher.com westernedge@santa-fe.net

Printed in Canada

To Lisa
For making every day a little brighter

ACKNOWLEDGMENTS

I'd like to thank Jim Mafchir at Sherman Asher Publishing for taking a chance with me. His gentle prodding, along with a healthy dose of encouragement, was greatly appreciated.

Cinny Green with THEMA has been far more than just an editor. She not only helped me through every step of the publishing process but was also an extraordinary teacher and mentor.

My mother-in-law, Dr. Betty Rosenstein, spent many a late night reading The Wave. Thank you Mom for the advice and support.

Sometimes all it takes are a couple of brilliant suggestions to bring out the best in a book.

Without the help of my good friend, Jim Cathcart, The Wave might have only been a ripple.

When it came to anything that had to do with airplanes I turned to Captain Jeffrey Schyman for his technical expertise. Any errors that may have found their way into The Wave were strictly my doing.

Thanks to Maureen Burdock of THEMA for her excellent map, and to Janna Bock for the strong cover illustration.

Everyone needs a head noisemaker. Thank you, Ginger Goodman, for faithfully fulfilling this important role.

PREFACE

On July 9, 1958, a magnitude 8.3 earthquake struck Lituya Bay, Alaska, dislodging approximately 40 million cubic yards of rock from the surrounding mountainsides.[1] This landslide generated the largest wave ever recorded in human history. The mega-tsunami that decimated Lituya Bay up-rooted trees over 1,700 feet above sea level. Because of its remoteness only two lives were lost.

The Big Island of Hawaii is surrounded by under-sea landslides of colossal size. Many of these slides displaced thousands of cubic kilometers of water, generating mega-tsunamis of unimaginable dimensions. Scientists have recently identified tsunami deposits left by these incredible waves over 1,150 feet above the ancient sea level.[2] While the most recent mega-tsunami to strike the Hawaiian Islands happened approximately 100,000 years ago, that doesn't mean another one couldn't happen tomorrow. When it does, there may not be any warning.

Geologists are also concerned that the western flank of Cumbre Vieja Volcano on the island of La Palma in the Canary Islands could catastrophically collapse during a future eruption. If this were to happen anywhere from 150 to 500 cubic kilometers of rock would plummet into the sea. The resulting mega-tsunami could be as much as 50 meters (165 feet) high when it strikes the East Coast of North America.[3] Of course, this devastating tsunami would pale in comparison to The Wave.

[1] http://worldnature.wordpress.com/2008/05/01/dryangs-tsunami-report-part-ii
[2] http://records.viu.ca/~earles/kohala-tsunami-sep04.htm
[3] http://www.iberianature.com/material/megatsunami.html

PART 1

And the waters prevailed exceedingly upon the earth; and all the high hills,
that were under the whole heaven, were covered.
—Genesis 7:19

ONE

AFTER A LONG NIGHT ON DUTY, Dr. Walter Grissom turned to his intern and said, "Imagine, a billion people depend on me to keep them safe, and they don't even know I exist." The director of the Pacific Tsunami Warning Center rubbed his pale cheeks as he headed for the front door. "Chip, I'm going for coffee. Can I get you anything?"

Chip McCleary had worked at the Center for less than a month. A graduate student in geophysics from the University of Hawaii, the internship had been a perfect fit, allowing the young man to earn a few dollars while working on his dissertation. He was an attentive scientist, but now his thin shoulders under a wrinkled t-shirt were hunched over his desk as he leaned his head into his hands. The young intern grimaced. "No thanks. I'm not feeling so hot, a few too many holiday parties. Thought I might cut out early."

"That'll be fine. Can you hold off till I get back? Shouldn't be more than twenty or thirty minutes."

"Sure, go ahead."

"If anything happens give me a call."

The director wasn't particularly worried as he left the building. The intern would be alone and in charge of the Center for less than an hour. He had his cell phone and if called could be back in less than ten minutes.

The tropical sun had been up slightly over an hour and the sky was a bright topaz blue as Dr. Grissom squinted into the December morning. He walked across the gravel parking lot with the salty smell of the ocean two blocks away wafting through the air. Before getting into his tan Ford Explorer, he took a deep breath then scanned the clouds hanging over the mountains that pamper Honolulu with their fragrant blossoms. The combination of verdant green slopes and puffy white clouds seemed more vibrant than usual. Standing there for a brief moment, the director mused over the twenty-seven years he'd spent working in paradise. The sign on the entrance to the minor one-story structure read Pacific Tsunami Warning Center (PTWC), but the dedicated employees that worked there called it the dungeon. The building, over fifty years

old, was surrounded by mosquito-infested mangroves, and had just two small windows. This miniscule government facility located ten miles west of Honolulu existed solely for the purpose of warning countries throughout the Pacific Basin of any tsunami activity. Grissom chuckled. Even after a long dull night in the dungeon, he couldn't complain. He was doing the work he loved.

The weary director drove down the long drive that ended at Fort Weaver Road and made a sharp right. A new Bad Ass Coffee Shop had just opened in the center of Ewa Beach less than ten minutes away. He stepped through the front door of the shop and a renewed sense of being alive filled his lungs as he breathed in the rich smell of the freshly brewed Kona Coffee. Grissom checked his watch. It was 7:18 a.m.

At 7:26 a.m., four small chimes began to ring. The Pacific Tsunami Warning Center's seismometers came alive. They frantically began to scratch out a telltale line across their slowly turning drums as the earth's crust slipped under the islands. But the fan in the men's room droned on, drowning out any sounds from outside the small cubicle. With his stomach tied in knots, Chip McCleary hugged the toilet while still trying to hold his gut. He had already spent a quarter of an hour with his head bowed, praying to the god of the water closet. Now he knew for certain those holiday parties had not been worth it. He got up slowly, washed his hands, and took a large gulp of water from the faucet. He stumbled out of the bathroom back to his desk.

As soon as he sat down, a look of confusion spread across the intern's face. What was that incessant ringing? Chip's eyes, now merely slits, roamed around his desk, then the rest of the room. "Shit!" he blurted out. "The seismometers." He ran over to the four drums. "Shit!" he blurted out once again when he realized that the alarms had been going off for a precious ten minutes. The earthquake was already over. As he stared at the lines crisscrossing the four paper-covered drums, he could tell the event had been a significant one. He just didn't know how significant. All he could think was "Please don't let this be the big one." It took him another ten minutes to determine the preliminary magnitude of the tremor that had taken place just off the southern coast of the Big Island. Chip breathed a sigh of relief when his calculations showed that the earthquake only measured 6.8, typically not large enough to produce a destructive tsunami.

Nonetheless, he had lost valuable time; had the earthquake been any larger that time could have translated into the loss of hundreds of lives. His stomach muscles went into a spasm. Chip bent over and wiped his

brow, realizing how close he had come to losing his job. Still, there were things he had to do. He ran through the Center's protocol in his head. With a magnitude of 6.8, a Tsunami Information Bulletin had to be issued. Had the earthquake been over 7.5 then the Center would send out a Tsunami Warning Bulletin. The intern had never sent out either type of notice, so he slumped in the nearest chair, picked up the phone, and called his boss.

"Dr. Grissom, we just had an event off the Kalapana Coast."

"Damn. How big?"

"6.8"

"That's major, but I doubt if it's a problem. Shouldn't be large enough to cause a dangerous wave. There's a sample template for an Information Bulletin along with transmit instructions posted on the board outside my office."

"I know where it is."

"Good. Start filling in the blanks. I'll be there before you're done."

Chip ran to the bulletin board. Pushpins went flying as he yanked off the template and instructions. He took it back to his cubicle and set it down on the desk. The words danced before him as he tried to read the instructions and find the template on his computer. The phone rang.

"Tsunami Warning Center."

"Hey. What the hell is going on there?"

"Excuse me?"

"Listen, pal, this is Captain Harry Mahana from the Hilo Police Station." He continued sarcastically, "That's on the Big Island. We just got hit by a fifteen-foot Tsunami."

"What do you mean?"

"You heard me. I thought you guys were supposed to give us some kind of warning."

"That's not possible. The earthquake wasn't that large."

Captain Mahana paused for a moment, breathing hard. Chip could feel his anger exhale through the phone. Then in a calm, almost reverent voice, the captain said, "Funny you should say that. Ya know, I was standing on our second story balcony watching the harbor being destroyed when my feet started to get wet, and that's exactly what I said... Then I thought, well maybe someone forgot to turn off the water in the bathtub...but then I remembered." The captain paused for another split second and then bellowed into the receiver, "WE-DON'T-HAVE-A-FUCKING-BATHTUB!" and slammed the phone down.

Chip McCleary could not believe what he had just heard. Had he made a mistake? It wasn't possible. How could a 6.8 earthquake cause a

fifteen-foot tsunami? The quake must have been much larger, or maybe it was some kind of prank call. He immediately pulled up the tide gauge readings for the Hawaiian Islands on his computer. It wasn't a prank. All of the readings on the Big Island had gone off scale and even the ones on Maui at Kahului and Lahaina were pegged. The panicked intern grabbed the phone.

"Dr. Grissom. There's been a tsunami." The young intern began to hyperventilate. He could barely speak. "Fifteen feet."

"Slow down, Chip. Where was the tsunami and how did you find out?"

"I got a call. The Hilo police told me."

"How long ago?"

"Just a couple of minutes. I checked the tide gauges. It has already reached Maui."

"Maui. Son-of-a-bitch. You've got to issue a warning. Shit, it's probably too late."

Dr Grissom hung up without giving any further instructions. Scrolling through the directory on his PDA, he found the number for the Oahu Civil Defense Agency on South King Street.

"Hawaii Department of Civil Defense, how may I direct your call?"

"Miss, this is Dr. Walter Grissom with the Pacific Tsunami Warning Center. We just detected a tsunami. I need to speak to someone. You've got to sound the sirens."

"Oh my God. Please hold." The tires on Dr. Grissom's SUV squealed in protest as he accelerated out of the coffee shop parking lot. He raced through the small middle class community of Ewa Beach just as it was starting to wake up. Only a few residents noticed the tan SUV speeding towards the Tsunami Center. Grissom looked at his watch. It was taking forever to get someone on the line. He slammed his fist into the armrest. What was taking so long? Much longer and the warning sirens would be useless. Finally, an annoyed voice answered the phone.

"Sir, I don't who this is, but if it's some kind of joke, we already have your cell phone number. Be advised there are criminal penalties for making prank calls to a government agency."

"This isn't a prank. My name is Dr. Walter Grissom, I'm the Director of the Pacific Tsunami Warning Center, and there's a tsunami heading for Honolulu. Sound the sirens now, we've only got ten minutes."

"If this is really Dr. Grissom then why are you calling me on your cell phone? You should know the protocol."

The director looked at his watch. His head throbbed as his blood pressure began to build. It had taken too long. Any warning would be almost useless. Still some warning was better than none.

"I'm in my car. I received a call from the Center. We only have an intern on duty. It was a local event. There's no time. Just sound the damn alarms."

"I'll have to run this through the governor's office. In case you hadn't noticed, it's Sunday morning. I'm not going to be responsible for scaring the entire population of Oahu half to death."

"God damn it, there's no time. Take some initiative and sound the fucking alarm. I'll take full responsibility. You know where to find me."

The stranger on the other end of the phone went silent as he weighed his options.

"This better be on the up and up, or we're going to be in big trouble."

"Damn it, this is no joke. Now sound the alarm and maybe we can save a few lives."

"Okay, I'll do it."

"Thank you. You won't regret it. I'm almost at the Center. I'll call you when this is over. Keep your fingers crossed."

"I've got more than that crossed."

Grissom drove into the parking lot, slamming on his breaks and sliding to a stop in a cloud of dust and gravel. Jumping out of his truck, he ran to the front door, forgetting he had locked it. After fumbling with the key, Walt Grissom ran to the four seismometers to verify the size and check the time of the earthquake. Chip had been right. The earthquake didn't appear to be large enough to cause a deadly tsunami. The director stopped and thought for a moment while rubbing the top of his throbbing head. The only other logical explanation was that there had been an undersea landslide. If they were lucky, maybe they'd find some other explanation. Maybe given the underwater topography in the area it was possible for a 6.8 quake to cause the wave that was about to hit the beach just two blocks away. His office would have to investigate the cause in the coming months. He closed his eyes while he reviewed the many issues that went along with a landslide-generated tsunami. Would there be another one? How much time would they have, and more important, how big would the next one be?

As Grissom was writing down the size and time of the tremor on the Center's log, Chip stepped into the main room where the seismometers were lined up on the far wall. Just as the young intern was about to speak, the sirens went off. He stopped, confusion spreading across his ashen face.

"Sir, I don't understand. I haven't issued the Warning Bulletin yet. The phones, they've been ringing off the hook…the sirens. Who issued the alarm?"

"I called it in from the car."

"Oh, thank God. We've got to get out of here right now. This whole

area is going to be underwater in a couple of minutes."

Walt Grissom paused for a moment. "No, we're staying."

"You can't be serious." Chip's voice quivered. "The wave. We'll die."

"We're in the business of saving lives and we just screwed up. There's still work to do. This place is built of reinforced concrete block. It'll hold." By now Dr. Grissom was almost running as he headed to his office with the intern in tow. "We need to get warnings off to Kauai and Niiahu, and then see what we can do to keep the water out."

"But, sir, judging by the calls I've been getting, I think the tsunami may be bigger than fifteen feet. There's an awful lot of damage on the Big Island and Maui."

"How big?"

"I'm not sure. Six maybe seven meters." Now the young intern was almost in tears. He pleaded, "Please, we have to go. It's insane to stay here."

"Damn, over twenty feet." Dr. Grissom stopped at the door to his office and contemplated the risk of staying. Once the wave hit the beach, there would be no place to run. The long driveway out to Fort Weaver Road faced directly towards the ocean, and was the only way out. Still the building had been constructed on a raised mound of earth. He figured they must be at least ten feet above sea level, probably twelve to fifteen. The director looked at the block walls then closed his eyes as he thought about the size and number of windows. So long as the windows held, and there were only two, they would be safe. "We're staying. Now follow me."

"But, Dr. Grissom…"

"Damn it. Don't argue. I don't have time for this crap."

The director stepped into his office, sat down at the desk, and brought up the template for the Tsunami Warning Bulletin. Chip stood back biting his lip as he watched his boss's fingers fly across the keyboard. In a matter of minutes, all of the blanks had been filled in. Dr. Grissom did a quick scan of the bulletin for errors. Then he downloaded the Warning Bulletin to the Center's AUTODIN GateGuard terminal where it was sent to 192 stations around the Pacific. He also faxed it to the police departments on Kauai and Niiahu. After he was sure the faxes had gone through, he also faxed the warning to the Center's counterpart in Palmer, Alaska, for good measure. For the thorough Walt Grissom, old habits die hard, even when a twenty-foot wave was headed directly towards him.

"Now follow me. We have more work to do."

"But, sir. You can't do this." Chip McCleary was now shaking and hardly able to speak.

Dr. Grissom stared at the young man and thought twice. Maybe he

should just let him go. He'd already made up his mind that the intern would be fired once the disaster was over. When Chip was needed most, he had failed. Mistakes like answering the phones rather than issuing the tsunami warning, or not checking the tide gauges immediately were unforgivable. And why had it taken so long for him to make that first call after the earthquake had been detected?

There was going to be an inquiry, and Dr. Grissom would have to take the heat for the young man's mistakes. He might even lose his job, but right now there wasn't time to examine his own actions in the middle of this crisis. That would have to wait.

Walt ran back to the storeroom closet, grabbed an armful of paper towels along with a screwdriver, and handed them to the panicked grad student.

"Here, take these to the back door. Use the screwdriver to jamb the towels under the sill and between the jambs. We have to seal the doors as best we can."

"This is crazy. You're going to kill us."

"Now you listen to me." Walt pointed a finger at the young man as if he were a child. "We're going to seal ourselves inside this building, and we're going to be fine. Just do as you're told."

Grissom motioned towards the back of the building as Chip started to say something. With the eyes of his soon to be ex-boss glaring down on him, the intern turned in silence and headed for the rear door.

Dr. Grissom ran to the front door with an armful of towels and an old hacksaw blade. He kneeled down and began stuffing paper between the bottom of the door and the threshold. He continued to use the blade, shoving the paper towels between the two jambs up to a height of six feet. Any higher and the window next to the front door would probably break and his efforts wouldn't matter. Then he ran to the back door to see how Chip was doing.

"All right, that looks good. Now let's move the computers and the rest of the equipment onto the desks. I'll go up front. You start from here and work forward."

With everything moved to the desktops, the director and his intern went back to the entry lobby so they could watch the devastation through the window next to the front door. Neither of the two windows in the building faced the ocean, so they were forced to peer through the glass at an oblique angle if they wanted to see the arrival of the first waves. Grissom believed they were relatively safe. The center's two windows were reinforced with horizontal and vertical steel mullions that divided them into twelve one-foot square panes of glass. They were as strong as

windows could get. Despite their best efforts, it was impossible to see the beach with four rows of houses between the ocean and Fort Weaver Road.

Looking down the long drive towards the first row of houses, Grissom watched as the panicked residents of Ewa Beach scrambled to save their belongings. He spotted a woman dressed in her blue nightgown with what looked like a half-dozen photo albums in her arms. Her husband wearing just his boxer shorts carried a small TV set. They had been working feverishly loading both their cars since the alarm sounded. The traffic was starting to build along the narrow two-lane road. For those residents caught in their vehicles when the tsunami hit, the chances of survival would be minimal. All the director could do was watch as the people tried to save their personal belongings. He wanted to scream, "Just get the hell out. That junk isn't worth it!"

Dr. Grissom turned to scan the small reception area to see if he had forgotten anything when Chip gasped.

"Oh God! Look." McCleary held one hand over his mouth while he pointed out the window with the other. Grissom spun on his feet, then pressed his face against the window.

His first glimpse of the tsunami was an eight-foot wall of water washing through the spaces between the many houses that lined the frontage road, thrashing them like so many twigs. "Shit!" Had he made a mistake by staying? The man in the boxer shorts managed to grab a palm tree and was holding on for dear life. The woman must have lost her footing and was somewhere in the churning wall of water rushing towards the Center. Grissom pressed his hands against a windowpane, wishing he could reach into the water and scoop her out to safety.

Cars were being picked up and rolled along the wave front. As the water continued to pound the small wood frame houses, they crumbled and broke like kindling wood, adding more debris to the rushing torrent with each passing second.

The tsunami careened down the driveway, heading directly towards the dungeon. Chip stumbled back from the window, unable to watch. He scrambled up onto a desk.

The first wave washed across the parking lot smashing into Grissom's Explorer. He watched his car get picked up and thrown into a corner of the building with a crushing collision that shook the walls. The lights inside the Center flickered twice then went dark as the truck rolled by the window.

The muddy water rushing by the entrance had already risen to the first horizontal mullion. "If it doesn't go any higher, the glass will hold," he mumbled. The view through the bottom row of panes reminded him of a fish tank that hadn't been cleaned. Dr. Grissom stepped back to

check how the front door was holding up. Water was seeping under the sill. The scientist made a quick estimation in his head: the seepage was slow. If nothing changed, the damage to the center would be minimal. He left the entry and walked quickly around the rest of the building, adrenaline rushing through his body as violently as the waves outside. He checked for any other leaks. The water coming under the back door was no worse than the front door. "Okay," Grissom reassured himself, but as he hustled down the hall, he heard the sound of gushing water in a closet next to the men's room. He opened the door and water spilled out over his shoes. There was a refrigerant line that penetrated the exterior block walls. It hadn't been sealed properly. A steady stream of brown water poured through the hole as if someone had turned on a garden hose. The director said aloud, "Bad, but not too bad," and went back to the front window to watch the carnage.

He passed Chip who was frozen on the desktop with his face in his hands. The constant battering and shaking of the walls, the remnants from the houses pounding the small concrete block building were too much for him to endure. "Stop, stop, stop…" the intern moaned over and over like a mantra.

"Find a pair of testicles, kid," Grissom ordered. Getting no response from the traumatized intern, he shook his head in disgust and returned to the front hall.

The water had already retreated to the bottom of the window. The current had reversed and was now flowing back towards the ocean. The smell of decaying leaves, like a mixture of stale tobacco and rotten eggs, permeated the room as the water from the surrounding mangroves swept past the Center. If the following waves were no larger than the first, the Center would survive virtually unscathed. "Hey, McCleary," he called back to the young man. "The first one is over." The director continued to look out the window, knowing there was more to come. The four rows of homes that once stood between the Center and the Pacific Ocean had been leveled. The palm tree was still there, but the man with the TV was gone. Grissom could only shake his head and wonder how many had been killed.

Without any houses to obstruct his view of the ocean, Grissom now had a clear view of the following wave. The Pacific waters that once reflected the sun's rays like a thousand mirrors were now a gumbo-soup of trash. The second wave came crashing down on the beach, the roiling foam a frothy brown mix of mud and trash. It rolled over what was left of the ruins of the small housing track and headed directly for the Center.

This wave was larger than the first. The water continued to rise past the bottom row of windowpanes until it completely covered the second

row. The front door bowed inward from the horrendous pressure, looking as if it might give way. Most of the paper towels had been pushed out from under the sill. Now there was a constant heavy stream of dirt-laden water filling the entry. Still it wasn't enough to be dangerous, Grissom judged, more of an annoyance. So long as the windows and doors held, both men would be safe and the costs to repair the building would be minimal.

The walls continued to shake and shudder as trees, telephone poles, and even furniture smashed into them. The constant grinding and pounding coming from the other side of the eight-inch thick protective barrier was even starting to unnerve the director. Dr. Grissom was about to ask Chip how he was doing when he noticed a large branch floating by. It seemed to be moving in slow motion as the far end caught on a gray steel handrail that led to the entry door. With one end of the branch now anchored against the rushing water, the opposite end began to twist towards the building. It shot through the front window, the trunk smashing a bottom pane of glass. The rank brown water came pouring through the one-foot square opening and knocked Grissom to the floor. Chip screamed at the sound of exploding glass. The director picked himself up, glared at the terrified intern, and then fought his way through the water back to the broken window. He grabbed the end of the branch still stuck in the frame and with all his strength pushed it back into the ragging torrent.

"Chip, get me something I can use to cover this hole," he yelled back into the office. There was no response. The director turned to see that his intern was still on top of the desk with his knees folded and arms tightly wrapped around them. He appeared to be staring off into oblivion, lower lip quivering as he slowly rocked back and forth. Grissom grumbled under his breath. "Useless prick."

The director ran through six inches of rising water back to the storage closet. He scanned the shelves looking for anything to cover the hole. All he could find was a vinyl three ring binder. It was much too flimsy. The brown soup rushing into the building was halfway up his calf. At this rate, it wouldn't be long before the water was above the top of the desks and the computers and the rest of the Center's equipment would be lost. Then he remembered his favorite wooden clipboard. He had purchased it over forty years ago for a summer mapping course he had taken as an undergraduate at The University of Southern California.

Walt splashed through the water to his desk, grabbed his old clipboard, tore the papers out, and slogged back to the front door. The water had risen above his knees. Pushing with all his strength, he pressed the flat piece of wood up against the broken window and held it there. While it wasn't a perfect fit, the director managed to stem most of the flow until the second wave subsided.

Twenty minutes later a third wave, much smaller than the first two, merely rolled across what was left of the parking lot. The building and its contents had survived. When Walt finally opened the front door, every muscle was trembling and his heart was pounding so loud he couldn't hear anything else. He was shocked at the contrast between the destruction in front of him and the gorgeous sky, the warm breeze, and the now lulling roll of the ocean. He leaned back against the building and shook his head. As his breathing and heartbeat slowly returned to normal, he began to hear the sounds of disaster: hissing power lines, collapsing beams, and sirens of EMS ambulances and fire engines. The one sound he didn't hear was human voices. They had been silenced.

The door by Grissom's left shoulder burst open. Chip McCleary raced out like a football linebacker. He ran first to his overturned VW camper, where drenched books and clothes spilled out of every orifice. Without a backward glance at the useless vehicle or the director, Chip galloped away down Fort Weaver Road.

Walt went back inside and rummaged in the desk drawers until he found a dry battery-powered radio and some AA batteries. Twisting the dial right and left, he finally found a National Public Radio station reporting the disaster. "The waves that inundated the Hawaiian Islands this Sunday morning have resulted in the deadliest natural disaster to ever strike the United States, surpassing the Galveston Hurricane of 1900 and Hurricane Katrina's devastation of the city of New Orleans in 2005. The president just spoke to reporters at the White House pledging immediate aid from the Federal Emergency Management Agency and generous funding to rebuild the great state of Hawaii."

Dr. Grissom carried the radio outside. Looking out at the flattened waterlogged neighborhood, he sighed. He knew how that would work. For a brief moment in time, the world would think about tsunamis. With the country's greater awareness, the PTWC would receive a generous boost in their operating budget along with numerous improvements to the facility, in all likelihood with materials inferior to the old dungeon's original construction. Purchases of new computers and paving the parking lot were long overdue and would make the place at least look state-of-the-art. More important, Grissom could now lobby hard for the installation of a new DART buoy 140 miles Southeast of Honolulu. The funding bill had been stalled in a congressional budget committee, but it certainly would be approved now. This deepwater monitor would issue warnings five minutes faster and save many lives—assuming that the person at the controls wasn't worshipping the god of the water closet when the graphs peaked and the sirens wailed.

Two

AS I SIT IN THIS ABANDONED MINESHAFT huddled next to a small fire, I have to wonder how many are left. First, it was that incredible tsunami that everyone just called The Wave. It destroyed everything along the coast, and now this. We haven't seen the sun in almost a year. The plant and animal life above is either dead or dying. The snowdrifts outside must be twenty feet. This is supposed to be sunny California, or what's left of it. Much has changed in a short time. So much sorrow. So much destruction. So much death. Someone has to tell the story no matter how painful that may be.

I've never been one to volunteer or take on extra responsibilities. But as I sit here listening to my little daughter whimper inside this mountain, I know I must. I was there at the beginning of the disaster. I knew more than most about what went right and where mistakes were made. Every story has its heroes and villains. I knew them all. Despite my trepidations, there are times when responsibility lands square in your lap and there's not a damn thing you can do about it. This is one of those times. I can only pray that someone's left to hear my story.

Where should I start?

Things were pretty normal until I got that call from Hawaii. It was about six months after a disastrous tsunami had struck the islands. That's as good a place as any to begin.

Up until the time I met Lauren, life had been simple. As I drove my Porsche down Pacific Coast Highway, I couldn't believe how much my world had changed—complicated and yet amazing. The highway ran through Malibu, an elite community that hugged the unbelievably stunning coastline northwest of Los Angeles. It has always been a disappointment for the tourists as they rarely got a glimpse of the ocean and pristine white beaches from the road. Wealthy land barons had erected huge walls between their multimillion-dollar beachfront homes and the ordinary people. I used to be one of the outsiders, but now I was living in Malibu Colony, the most exclusive enclave on the most exclusive beach

in the world. It was my little family along with Sting, Linda Ronstadt, and Bill Murray, to mention a few. I waved to the guard at the gatehouse. He smiled, waved back, and opened the gate. I headed up Malibu Colony Road. Maria, our housekeeper, was just leaving as I pulled up to my new digs. Imagine that, a housekeeper. Her clothes looked a bit worn. She looked tired. I remembered that, like a lot of immigrants, she had a few kids waiting for her at home. But now so did I. One sweet baby girl.

I closed the garage door, turned off the car, and stared out the windshield, thinking about my amazing change of fortune! And I do mean fortune. Until I joined the Navy I had to claw and scrape for everything I had, and then fight to keep it. The trailer park where I grew up was located in one of the rougher parts of Los Angeles. Mom and I managed to get by on her welfare checks, along with the few dollars she made running an illegal daycare center out of our broken down old trailer. For most of the kids in our neighborhood, survival usually meant joining a gang. I somehow managed to resist the temptation despite the constant enticement that came in the form of regular beatings. Mom never talked much about my father. All I know is they were never married. I suppose that makes me a bastard as well as trailer trash. I'm not proud of my past social standing, but it's behind me now. Besides there's nothing I can do about it.

Mom died two months after my high school graduation. I was devastated. In a blur of grief and fear, I walked into a Navy recruiting office. Joining up, I found an unexpected home. For the first time in my life I was making real friends, doing something I could be proud of, and discovering just how strong I was and how much my body could endure. My new best friend, Scott Richardson, was a surfer who never stopped talking about Hawaii and Malibu. He used to say the surf was better in Hawaii, but the hot women were in Malibu. After we got out, Scott moved to Hawaii and I went to Malibu. That should say something about our priorities. I made a beeline straight for the beach and got a job at Eddie's Malibu Gym as a personal trainer. It was the first step to living my dream life as a high living bachelor. I left my humble beginnings as far behind as I could.

I got out of my Porsche and made my way into the main entry hall. I didn't see anyone so I called out, "Hey, babee, I'm home," in my best impression of a hot Latin lover. It usually made my beautiful wife laugh, and seeing her smile made my day. It also helped me forget the headaches I dealt with at work. I was no longer just a lowly employee at Eddie's Malibu Gym; I owned it.

"I'm in Aubrey's room," Lauren answered from the back of the house.

Wow, imagine that, the baby's room. A year ago Chuck Palmer was a confirmed bachelor, six-feet four-inches of love machine. Now I was a thirty-eight-year-old husband and the father of the most darling three-month-old girl in the world. I wonder where it was written that I should have such good luck, possibly in the stars ... more likely tattooed on my ass? Thirty-seven years of safe sex. Okay, less—about eighteen—but I had never broken my cardinal rule: Just say condom.

My life really started to change when I left Eddie's and took a job for one year at this very special fat farm. My ex-employer, now my wife, would not be happy with me referring to the most exclusive weight loss facility in the world as a fat farm. Lauren Rose hired me as a personal trainer to work at this spa in the South Pacific. Of course she forgot to tell me that her daddy owned the place. Lauren showed up at Eddie's one summer. After a few meaningful glances over the elliptical machines and treadmills, we started dating. We enjoyed each other's company. I mean, so far as I was concerned there were sparks flying between us. I thought Lauren was a headhunter who specialized in placing people in the travel industry. I found out later that she was only helping her father. Lauren owned her own weight loss facility, the Rose Weight Loss Clinic in Venice, just south of Santa Monica. She convinced me to give up my job and sign a one-year employment contract at the Rose Luxury Spa & Resort. My salary was exorbitant, and I soon learned why. I thought I'd been hired to work at a luxury spa. Instead I was airlifted to this remote island where nobody was allowed to leave. Okay, I'll admit it was the fanciest, most glamorous damn place I'd ever seen. Still, I had assumed that this exotic resort would be filled with beautiful women. Boy, was I wrong. Not only was I not allowed to leave, but the entire island was populated with nothing but obese females. I'm talking fat broads—precisely five of them! Okay, I know I'm not being very P.C., but when you've spent your entire adult life in Malibu, what else are you going to call a bunch of oversized women? Despite my dire situation, there was some good news. Some of those big girls were rather horny, and a fat horny woman can lose a lot of weight in a year. Do you know what happens when a fat horny woman loses 125 pounds? You got it. She turns into a skinny horny woman. It was a hell of a year.

"Honey, I'm starving," I hollered. "What's for dinner?"

"Whatever you feel like making." Ouch, that didn't sound very good.

I was damn mad at Lauren the whole year I spent on that island. She hadn't been completely honest with me. But when I returned from the South Pacific, I had socked away more money than I had earned in the previous thirty-seven years. It was enough money to buy Eddie's

Gym. So I did. Now that trailer trash bastard kid wakes up with a smile every morning despite the headaches of owning a small business in one of the wealthiest places in the world.

I had not realized how much I missed Lauren while working in paradise until the day she walked back into my life. I hadn't seen her for over a year, and she was more beautiful than I remembered. At thirty-three, she was five feet ten with a body like a twenty-year-old. Her incredible brown eyes sparkled with intelligence, and her dark brown hair glowed no matter what the source of light. Quite simply, she was and is the most beautiful woman I've ever known. My friends tell me it's the newlywed thing. I think they're jealous.

It was a little awkward those first few minutes when Lauren showed up at Eddie's front counter after I returned to Malibu.

"How was your year abroad," she asked with a grin.

"Full of a lot of broad broads. How was yours here in the real world?"

"Come on. It can't have been that bad." She laughed a throaty, sexy laugh and my irritation evaporated.

"It wasn't," I admitted. "Just incredibly far away."

"I'll make it up to you. Let's have dinner."

She treated me to calamari at Duke's. Sitting at a table overlooking the water, there was that same electric attraction we'd had when we dated a year earlier. Without hesitation, we went back to my place that night. We were both so excited—like animals in heat—too frenzied to use protection. I broke my most sacred of rules and damn, wouldn't you know it. She got pregnant.

Things got a little dicey when Lauren first told me she was having my baby. I had gone from confirmed bachelor to future father in about three seconds. Frankly, I was terrified, but I loved her and couldn't suggest she "take care of it." Besides, I wasn't about to run away like my dad, so I asked her to marry me. To my utter shock, she said yes. Now I had this incredible little daughter, Aubrey, and was married to a sexy, smart, fantastic wife, who was the best thing that had ever happened to me.

When we got engaged, Lauren told me her father was the wealthy David Rose who owned the most luxurious resorts and spas in the Pacific, including the one where I had recently endured voluntary confinement for a year. I was more shocked to learn that he didn't have mere millions; he had gazillions of dollars. And my future wife was an only child who loved him dearly. I met Mr. D. a few times and discovered he was not only rich, but like his daughter, he was funny, intelligent, and warm. Unfortunately, along with contracting polio as a child, he also had serious heart problems and died before we got married. Lauren took it pretty

hard. The strange thing was, I missed the old guy, too.

After the funeral, Lauren and her father's attorneys sold off most of his resorts but kept a couple to be run by the David Rose Foundation. There was one other little thing Lauren kept: her daddy's Gulfstream jet. Imagine, my wife owned a friggin' Gulfstream, and I got to fly in it whenever I wanted. Life had offered me up some amazing twists and turns. This last one was more of a loop-de-loop with a couple of spins thrown in for good measure.

I walked into Aubrey's room where Lauren was changing the baby's diaper.

"Hey, how's my little girl? That would be the one on the table. You're my big little girl."

"Not girl. Woman. And you like it like that." Lauren turned around. The woman looked incredible, even when she was up to her elbows in baby poop. "Your little girl is doing great. Your woman, well, she's managing. How's the man with that ridiculous Latin accent?"

Lauren tried to put on her best face, but it wasn't working. Maybe she'd had a tough day with Aubrey. Lauren had been having a lot of tough days lately, and I wasn't sure what to do about it. In fact, I was really starting to worry. She'd never been moody, but a couple of weeks after the baby was born things changed. Then last week she started talking about hiring a nanny to raise our daughter. Lauren wasn't sure she could be a full time mother. She wanted to go back to work running her clinic twenty miles down the road. Or maybe even set up her own charitable foundation helping—of all things—single mothers. I wasn't happy about either idea. I liked to feel that I held my own in the family in spite of her financial independence.

"Your Latin lover is doing great. Three more sign-ups at the gym."

"That's wonderful." She lifted Aubrey's legs and slipped a fresh diaper underneath her. "You'll never guess what happened to me at the market today."

"You were accosted by three boxes of diapers and a roll of toilet paper. It's a paper products conspiracy."

"You're almost right. That's about my level of excitement these days." The look on Laurens face changed. It was nothing the average person would ever notice, but I'd become super sensitive to Lauren's moods and was wondering if something more was going on. I was convinced she had a slight case of postpartum depression. "I met this very nice lady with a five-month-old. We must have talked for a half hour. She invited me to join a Mommy and Me Group."

I leaned over the changing table and kissed my gurgling daughter. "I

think I'd prefer the paper products. What's a Mommy and Me Group?"

"It's a bunch of women with young kids who get together once a week at someone's home so they can have a little adult conversation—not just talk about babies. It'll be a chance for me to get out of the house. We mothers can go a little crazy spending all day and night with our children, you know."

I did know, and this sounded like a great idea. At one point when Lauren seemed particularly down, I suggested in the gentlest way possible that she might want to see a shrink. Bad idea. She told me in the not so gentlest of ways that all she needed was to get out of the house and do something besides caring for Aubrey. If a Mommy and Me group helped, I was all for it. Anything was better than having our daughter raised by a nanny.

"What do you mean all day and night? I'm home every night. You get to spend evenings with me." Aubrey grabbed my thumb with her fist and started sucking on it.

"Right. You forget I used to be a businesswoman with a full life," she sighed. "Men don't understand. Husbands are nothing more than big kids with overactive libidos."

"Ouch." I gave her my best impression of a knife to the heart.

She looked at me affectionately. "Just kidding. I love your company, ya big kid."

"Big kid. We'll see about that." I snuggled up behind Lauren, kissing her on the side of the neck while kneading her very firm butt.

"That feels nice. You don't have to stop."

"You know, that's the nicest tushy I've ever seen."

"Well thank you, dear."

"I wasn't referring to yours? I was talking about Aubrey's."

"Oh really." Lauren turned and attempted to grab my cheeks with her dirty diaper hands.

"Back. Back, you evil woman." I stepped away from my wife taking a defensive stance while trying to avoid getting my cheeks pinched. "Careful, woman. I must warn you these hands are lethal." I demonstrated a couple of quick karate chops to emphasize the point. Clearly Lauren wasn't impressed and positioned herself to launch an attack.

"Not as lethal as these."

"Good point." My chin dropped as I stared at my feet and lowered my hands. "All right, Aubrey, you have the second cutest tushy I've ever seen. Am I forgiven?"

"We'll see. Just remember there are only two tushies in this world you're allowed to touch. Aubrey's when she needs changing."

"That's nasty."

"And mine whenever you get the urge."

"Yes!" I pumped a fist in the air.

Lauren paused then frowned at me. "By the way, your buddy Professor Richardson from Hawaii called. He said to call him back at his office. It's important. Something about a submersible." There was definitely an edge to her voice now.

"Scott called? I wonder what's up. Are you okay?" I hoped she wasn't having more nanny thoughts.

"I'm fine." That was a big no. "I told him you'd be home around 5:30. The number is on the kitchen counter."

While Lauren was slipping pajamas on Aubrey, I went through the living room to the kitchen. I paused in the dining room and looked out the plate glass window at the endless Pacific Ocean. Living with such a spectacular view was another one of those nice little twists that life had thrown at me.

Lauren left Scott's number on a note pad with a smiling realtor's picture at the top. We got inquiries to sell our house all the time.

A secretary picked up the phone. "Biology Department. Dr. Richardson's office, how may I help you?" This was a first. Scott must have hit the big time.

"Yes. Chuck Palmer returning the professor's call."

"Please hold."

I first met Scott while training as a Navy Seal. After completing our initial BUD/s course the Navy sent us to Subic Bay in the Philippines, where we were stationed for the next two years. Scott stands about five feet eight inches and I'm six feet four, but I wouldn't want to mess with the guy. He's the toughest little bastard I've ever met. Like me, he came from a busted home with no money. We never saw any military action, but he helped me out of some tight spots, especially at the local bar in Olongopo. When Scott and I discovered that we both enjoyed fishing and scuba diving, a bond formed that's lasted for over fifteen years. While we were stationed in the Philippines, he also taught me how to surf.

After our first tour, we talked about re-upping, but both decided to take our chances in the real world. Scott went back to school in Hawaii where he got his doctorate in Marine Biology. I headed back to Malibu to train the beautiful people. Scott had always been the smart one. I was the good-looking one.

"Ho, brah. How's dat big moke?"

"Don't give me any of your Hawaiian pidgin crap. You're a haole just like me."

"Just thought I'd add a little taste of the islands. So how ya been? I spoke to that new wife of yours. She sounds nice, but says you're in love with another woman."

"I am. Can't help it. She's just over two foot and cute as they come."

"And I always thought you went for the tall girls.".

"I do. You should see her mother. What's so important? Are you expecting a big swell? Is the North Shore breaking?"

"No, better. You're not going to believe it. I got us a ride in a deep submersible. We're going down over a 1,000 meters. Do you have any idea how hard it is to get a ride in one of those?"

"Thirty-three hundred feet. Damn that's awful deep. Why the hell are we going so deep? Is it safe? What's down there, anything alive? It's too cold and dark. Wow, this is fantastic."

"There are plenty of living things down there. Yes, it's safe. But we're not going down to look for living creatures. We're looking for an under-sea landslide. They think it may have caused that tsunami six months ago."

"That was bad."

"Worse than bad. It was terrible."

"You guys still recovering? How many people did they finally figure were lost?

"Those waves maki almost 12,000 people. It was bad, but at least they've done an incredible job cleaning up. Almost all the damage in Waikiki has been fixed. You can't tell what happened. The only thing missing are the tourists. It's a problem."

"Sorry to hear that, but at least it's over."

"I only wish. The guys I'm working with say we could get hit by a much larger wave at anytime."

"Really? What are we talking about?"

"To put it in perspective, they're saying the next wave could make the 2004 Indian Ocean Tsunami look like a minor disaster."

"That's hard to believe…Wait a second. You're a marine biologist. Why the hell are they sending you down to look at a landslide?"

"It's all very hush, hush. Lots of politics. I'll explain it tomorrow when you get here. Oh, there's one more thing."

"Wait. Stop. You said tomorrow… I don't know. This is kind of short notice. It's not like the old days. I've got a wife and kid."

"Come on. I could really use your help."

"So the ride in the sub was just a teaser. What's up?"

"Okay. You got me. Here's the deal. I've been doing research off the south coast of the Big Island. My assistant's wife got pissed at him for

being away so often that he had to quit. I need someone with your expertise, someone I can trust underwater."

"What? You can't find a dive buddy in Hawaii?

Scott paused before responding. "Not anyone I trust. The dives are getting kind of deep. You and I have the same training." He was right about that. Deep diving for the Navy had taught us everything and put us through a lot of trials. Despite what they put us through, we always managed to survive by sticking together.

"How deep?"

"I'm trying to keep everything above 180 feet, but maybe as deep as 200."

"200 feet! That's extreme. I hope you're using trimix or heliox." Only professional or technical divers went that deep, and they needed special gas mixtures.

"No. That's the problem. I've only been using air."

"Are you crazy? You can't go that deep on air."

Scott chuckled. "It's not that bad. We make a quick run to the bottom. I check a couple of things, and we head back up. Sure, we push the dive tables a little, but most of the time we don't have to worry about decompression."

"Right. What does that give you, about twenty seconds on the bottom?"

"A little more, I need someone I can rely on. Someone that's going to recognize if they're getting narc'd."

Scott was referring to nitrogen narcosis, an unfortunate but relatively common ailment when making extremely deep dives. It's when divers begin to act drunk. Some have actually removed their mouthpiece and tried to breath the water as if they were a fish. Some have even tried to kiss the fish. The nitrogen in the air we breathe causes the condition. Under great pressure, as in a deep dive, it's actually poisonous to the human brain. I told Scott I would call him back to let him know if I could make it, and hung up.

Just as I was placing the phone in its cradle, Lauren tapped me on the shoulder. Damn, she surprised the hell out of me. Worse, she had that look. "I guess you heard."

"Yes, I did." Lauren's eyes had narrowed to mere slits. Not a good sign.

"He really needs my help. I can't tell you how many tight jams he got me out of in the Navy. How can I say no?"

"It's very easy. The tip of the tongue goes to the top of the palate to form the N and then you make a large O with your mouth."

"I know how to construct the word; it's the action I'm concerned about."

"But you're not concerned about leaving your wife and daughter."

"I'll be gone for a week." I couldn't believe where and how this con-

versation was going. Like most couples, Lauren and I had our disagreements, but I had never seen her this upset. "Besides you're planning a trip to New York. Why do you have to use your father's attorney to set up that foundation of yours? There have to be plenty of qualified attorneys in L.A."

"We've already discussed that. I want to create a symbiotic relationship between our two foundations, and he set up and oversees Dad's."

"Great, so now you'll be flying back and forth to New York all the time, but I can't go to Hawaii for a week."

"That's different."

"No, it's not."

"I'm setting up a foundation to help single mothers, so they won't raise juvenile delinquents. This is business. You seem to forget that I have other interests and desires in addition to being your Miss Susie homemaker. You're headed off to Hawaii to act like a juvenile delinquent."

"I'm going to Hawaii to help a friend, and I am not some juvenile delinquent."

"Right. Admit it, you're going there to play with one of your juvenile friends." Her voice was getting shrill and she began to pace back and forth in the kitchen shaking her head. "What was I thinking when I decided to get pregnant?"

It took me about a half second to process what I had just heard. I put my hand on her arm and turned her toward me. "I thought your getting pregnant was an accident."

"Yeah right… well, you never were the sharpest arrow in the quiver."

"What?" I pulled my hands away from her in shock. I couldn't believe what had just come out of my wife's mouth. This was the woman that I had planned on spending the rest of my life with. The only person I've ever been able to make a commitment to. Now I find out that I was duped and worse, she thinks I'm some kind of rube. I'm not sure what the look on my face was, but all of a sudden, Lauren's rage was instantly flushed out. Lauren put her hand over her mouth as if attempting to stop what had just spewed forth.

"Oh my God. I am so sorry. I didn't mean that."

"Mean what? That you tricked me, or that you think I'm a fool?" By now I wasn't sure what I should be feeling. I knew I was mad, but betrayed, confused, and hurt were the emotions that were boiling up inside. The person I loved more than anyone on the planet had just stuck a knife between my ribs and twisted it. No need for pantomime this time.

"Chuck, I am so sorry. Honestly, I've never thought you were stupid or anything like that. I could never be married to—much less love—a

man I didn't respect. I love you. I don't know what got into me. Please believe me."

"You lied. About something huge. How can I ever believe you?" I was done arguing. I wasn't going to be part of this conversation. Tears began to stream down Lauren's cheeks. I turned my back on her and walked down to the beach where I went for a long run. When I returned two hours later Lauren came out of the bedroom, eyes swollen, cheeks full of red splotches. She tried to apologize again.

"Please, Chuck. I didn't mean it."

"Mean what? The juvenile delinquent or the not-too-smart comment? How about my all time favorite, the one about tricking me into getting you pregnant?"

"Please, Chuck, Don't be this way." My wife looked like she was ready to go into another meltdown. We had never had an argument like this and I had never seen her so hurt. Deep inside I wanted to wrap my arms around her and forgive her, but like so many men, male pride wouldn't allow me. Especially after what she had done.

"Right now, it's the only way I know how to be. Frankly, I think we both need to take a break. I'm going to Hawaii." This time she didn't disagree.

I went to the phone and purchased a first class ticket on the earliest flight out. No more coach seats for this trailer trash. We spent the rest of the night avoiding each other. I finally went to sleep in the guest bedroom. Needless to say, I tossed and turned most of the night.

The following morning as I was getting ready to leave, Lauren came out of our bedroom looking like crap, all disheveled and puffy from lack of sleep, too. She came up to me and wrapped her arms around my waist without saying a word. I was still furious, but it felt awfully nice having the woman I loved embrace me. I gave Lauren a stiff hug back, intended to convey that I was mad, but that I still cared for her. Lauren let go and looked up at me with those incredible eyes of hers, stunning even though they were blood shot.

"Please call. I love you. We have to work this out."

"Right." I nodded once and left.

THREE

IN SPITE OF MY PREFERENCE FOR OUR PRIVATE JET, the flight wasn't bad with the footrest, back massage, and all the mimosas I could drink. With my marriage falling apart, I had hardly slept, so I attempted to get some shuteye on the flight over. Eventually I did nod off, but only after mulling over my wife's most recent disclosure a million times.

I opened the blackout screen and peeked out the window just before landing. We were directly over Pearl Harbor. As we flew over the famous waterfront, I could see it hadn't changed much in the last ten years. Sure there were some new buildings and they had built a causeway to Ford Island, but it all seemed so familiar. The large warehouses next to the docks, the runway in the middle of Ford Island, and of course, the stark white Arizona Memorial. Just past the monument, I could make out the U.S.S. Missouri tied up at her new dock. The big Mo with her massive guns was still an impressive vessel, her shape more feminine than the newer ships, almost sensual with her sleek curves.

A few minutes later, we set down on the reef runway at Honolulu International Airport. I grabbed my carry-on and jogged down a half-mile walkway breathing the fresh tropical air mixed with a hint of jet exhaust. Once in the main terminal, I took the escalator down to the baggage area and walked directly out to the street looking for Scott.

Someone called to me as soon as I got to the curb. I turned and saw Scott a hundred feet away running in my direction. He hadn't changed much over the years, with a full head of wavy blonde hair covering ears that stuck out too far. As he got a little closer, I did note that his forehead appeared to have grown slightly, probably a result of being named Chairman of the Biology Department. Scott was one of those super upbeat guys that always had a smile and a wicked twinkle in his eye. The kind of guy you'd hate if he weren't your best friend. He was wearing tan shorts, a white U of H polo shirt, and running shoes with no socks. He still had a faded tattoo of a dragon on his left forearm, a remnant of our drinking days back at Subic Bay.

"Hey, brudda, howzit? Come on; hurry up. We've got a big day

and a tight schedule."

We took off running, with Scott leading the way. My best friend doesn't know about walking. "How was your flight?" he asked over his shoulder.

"It was okay. First class, what's there to complain about?"

"What do you mean okay? You've moved way up since getting married. I remember the days when you used to talk about trying to fly as freight."

"With a rich wife and my own business I can afford it."

He slowed down and ran alongside me while giving me a light punch in the arm. "And you always said I was the smart one."

"Maybe you still are. These rich girls can be a lot of work, and you never know what they're going to hit you with next."

"Trust me, they're all like that, rich or poor. It's the nature of the beast."

I didn't feel like discussing my marital problems at the moment so I asked Scott. "What about you? How's your love life?"

"Aolani and I split six months ago."

"I knew that, but I can't imagine you being alone for very long."

Scott grinned as we jogged toward the short-term parking lot. "Sure, there's a girl. But I haven't totally given up on Aolani, yet. We have the kids so there's always hope." We came to a stop in front of a late model white Toyota Forerunner with a green University of Hawaii logo on the door. Scott's jovial attitude changed instantly, though I couldn't blame him. Our ride was sitting on its rims with four flat tires.

"Looks like you may have pissed somebody off."

"Damn it, this screws up everything." He scowled and slapped the side of the car with a loud thump. "I better call Rosy."

"Who's Rosy? Your girlfriend?"

"No, she's my secretary. The university has a contract with Hertz. She can rent us a car while we walk over there. I'll have her take care of this tire mess while I'm at it… Why does this always happen when I'm in a rush?"

"What do you mean, 'always' happens? Who do you think did it? Or is it just the friendly locals with nothing better to do?"

"No, it's nothing like that. Let me call Rosy. I'll explain everything on the way over to the Tsunami Center. She's a lifesaver. I don't know how I got along without her." We arrived at the Hertz pick-up point, and in less than ten minutes, we were heading west on the H-1 freeway in a brand new red Mustang convertible.

Scott was taking me to The Pacific Tsunami Warning Center in Ewa Beach located on the opposite side of Pearl Harbor from the airport. It

was only a couple of miles away as the crow flies but we had to drive in a huge loop around the water. It was going to take twenty minutes to get there—maybe fifteen minutes the way Scott drove. On the way over I asked about the slashed tires again.

"All right, so who'd you piss off this time?"

"Probably the governor."

"You think it was the governor...so the governor of the state of Hawaii slashed your tires? Sounds like a real take charge kind of guy. That's almost funny." Scott threw me a look. He was not amused, but that never stopped me from harassing him. "What does it take to get the governor so pissed off that he has nothing better to do than slash your tires?"

"No, you idiot, the governor didn't slash my tires. He's so well insulated from what goes on in this state he doesn't have a clue. The order probably came from his office, one of his people. They probably passed it to a union guy that works in a hotel or a restaurant, maybe a market, or it could be a cop or a fireman. Hell, it might have been one of the pimps or prostitutes down on Kalakaua Street."

"A union guy, a cop, or a pimp... great. By the way, do your pimps and prostitutes really have their own union over here?"

"If they don't, it's the only industry that doesn't have one."

"Damn, is there anyone in this state that isn't pissed off at you?"

"My girlfriend, Cherolyn. No, come to think of it she's pissed off, too. Been upset about me spending so much time on the Big Island. And that's why Aolani threw me out. She was tired of me leaving her with Simon and Katie all the time." It occurred to me that women must have some kind of internal woman-to-woman communication system. How can they all have the same complaint? "But the kids aren't pissed off. They still love their daddy."

"So the only two people on this entire island that are not pissed off at you are your ten- and fourteen-year-old kids. Way to go. I am completely lost. Please explain?"

"Sure, but it's a little complicated."

"Why am I not surprised?"

"Very funny. It all started six months ago with that tsunami."

"Really?"

"Yeah. If you remember, there was a 6.8 earthquake off the southern coast of the Big Island. It happened about a half hour before the waves hit Honolulu. That's what the news reported as causing the tsunami."

"Sure, so what's the big deal?"

"The problem is a 6.8 earthquake isn't large enough to cause the tsunami that destroyed Waikiki. In fact it takes some pretty special cir-

cumstances before a 6.8 earthquake can cause any kind of a tsunami, let alone a wave as large as the one that hit us."

"And exactly how big was it?"

"About six meters."

"A little over eighteen feet."

"Figure a twenty foot wave."

"Got ya."

"So they start running computer models until their eyes are ready to fall out. And no matter how much they tweak the data, they still can't come up with a scenario where a 6.8 earthquake produces a six meter tsunami."

"Who is they? How does this have anything to do with the head of the Biology Department getting his tires slashed by the governor?"

"Patience, little tadpole. So the Geology and Geophysics Department starts to look into what happened. The only thing they can come up with is that the earthquake set off an undersea landslide that caused the tsunami. They tell me that's bad news."

"Why's that?"

"Because if it was a landslide that caused the tsunami, it may have been the precursor to a much larger landslide."

"So that's what you were talking about yesterday when you mentioned getting nailed by another tsunami?"

"Exactly, they're saying this last one might have been caused by a minor slip-out compared to the next landslide."

"That's hard to believe."

"Believe it. So with this information they go to the State of Hawaii and ask for a grant to do some more research. That's when all hell breaks loose."

"But I don't understand. Why would the governor, the unions, and the pimps on Kalakaua Street get their undies in a wad over a couple of overeducated geeks wanting to find out what caused a tsunami? You're still not making any sense."

"If you'll let me finish, I can probably explain it—even to you. As I was saying, Governor Pratt and the unions now have some major underwear problems."

"But why?"

"Damn, you're impatient. Because the whole damn economy runs on tourism."

"Oh."

"Right after the tsunami, the tourist trade took a massive dump. It's just starting to recover, which is what everyone predicted. If there's one

thing we can rely on, it's the American public's memory lasting about as long as a Supreme Court nominee at a pro-choice rally. The problem is that the governor, the unions, and for that matter everyone else on this island don't want to rock the boat."

"You're not helping me much here."

"Patience. The last thing they want is to wake up your average Joe six o'clock newscaster. They're all worried that these geeks are going to announce that the real cause of the tsunami was a landslide. The next thing you know, your beloved investigative reporter wants to find out where it happened and when it's going to happen again."

"But it still doesn't make any sense. Why wouldn't they want to know if it's an earthquake or a landslide? And why is the head of the Biology Department doing the research?"

"It's called being at the right place at the right time. When Pratt found out that we wanted to look further into the cause of the tsunami he threatened to cut off all…"

"Shit, look out." I grabbed the armrest in a panic, every muscle in my body tensed. A black Lincoln Towncar swerved in front of our Mustang, forcing us across three lanes of traffic. Scott slammed on the breaks throwing me against the seatbelt. We crossed over the far right lane and were running on the dirt shoulder, throwing up clouds of dust before Scott got our car under control. The Towncar took off and disappeared at the next off-ramp.

"Son-of-a-bitch, did you see that bastard. He just tried to run us off the road." I was still trying to catch a breath after watching my life flash in front of me. "Please, don't tell me that was the governor."

"Naw, I think he drives a Caddy."

"Oh, well that's good news. You should have warned me about all this excitement. If I wanted to have this much fun, I could have stayed home and changed my kid's diapers."

"Stop being so negative. They're just trying to scare us a little." My friend never changed. The guy was absolutely unflappable.

"And they're doing a hell of a job."

Scott made a few comments about my manhood and then went on to explain why everyone on the island except his two kids were mad at him. Most of what he told me was more confusing than anything else. The one thing he said that made sense was when he compared the tsunami to a shark attack in the islands. The press reports all the shark attacks in Hawaii, but they're only in the news for a day, two at the most. The entire economy runs on tourism so the last thing the locals, including the press, want is a headline that will scare the tourists away.

Scott explained that people look at earthquakes as an anomaly—rare like shark attacks—but they think landslides are a common occurrence. He pointed out that the San Andreas Fault is one of the most active faults in the world, yet in California we happily build right on top of it. But it's virtually impossible to get a building permit next to an unstable mountain slope.

"If my research is correct, there's potential for a much larger slide and a huge tsunami."

That really got my attention. "How much larger?"

"Hopefully we'll find out at the Tsunami Center."

"I still don't get how the head of the Biology Department got involved in this mess."

"Before the tsunami, I was working along the southern shore of the Big Island doing research for a paper on soft coral and sponge growth in close proximity to undersea hydrothermal vents. You would not believe what it is like watching molten lava flowing onto the seafloor. They form these lumps called pillow basalts. Sometimes the water gets so hot I feel like an f-ing lobster."

"So, your life's work is nothing more than learning how to boil sea snot?" I commented, but my sarcasm flew right over my friend's head.

"Right after the tsunami, I went back to check on my sponges. The southern shore of the Big Island is probably the only place in the world where I can do my research. And with my luck it just happened to overlap the epicenter of the earthquake that allegedly caused the tsunami." Scott threw a hand in the air in amazement. "I found a three-foot wide fissure. So far, I've followed the crack along the sea floor for over ten miles. Unfortunately, the fissure has started to run off into deep water."

"Which is why you need my incredible diving skills."

He gave me that unappreciative scowl again. "Don't get too cocky. We're going down deep to survey the crack, and if we have time you may get to see some of my sea snot."

This was turning out to be one hell of a trip. First, the governor tried to kill me. Then I was going to be boiled alive with a bunch of sea snot. "But I thought the governor doesn't want to know."

Scott explained that the Geology and Geophysics Department heard about the crack and knew that his research area was right where they wanted to do their investigation. They convinced him to drop his sea snot report and instead map the crevasse he had found. They told him there was nothing the governor could do if he were already working in the area. He just had to make it look like he was continuing with his sea snot research. For the last five months, my friend had surveyed the fis-

sure and worked with the Geology and Oceanography Departments to figure out what caused the tsunami.

"I was intrigued enough to survey the fissure, but I'm not an idiot. When the Geology Department told me I should work on the landslide theory, I figured I was probably being put up as a sacrificial lamb. These guys will only stick their necks out if they have assured deniability."

"So they ask you to find the cause of the tsunami but they'll screw you if you find the cause of the tsunami?"

"Right, so I threw in some protection. Before doing any work, I insisted on the chairmanship of the department. That way when the governor gets his report, he can blow a gasket, but they can't actually fire me because I have tenure. Of course, they would make my life miserable but at least my retirement just went up 15%." Scott closed his eyes for a second and smiled.

"Hey, watch the road."

There was still one problem. Apparently the unions, the governor, and even the pimps on Kalakaua Street had already figured out what Scott was up to. Now they were trying to stop him from completing his research. I laughed. They didn't know whom they were dealing with. Scott's like a pit-bull that won't let go until he has his pound of flesh, or in this case, sea snot.

FOUR

WE PULLED UP IN FRONT of the Pacific Tsunami Warning Center and parked in a freshly paved lot next to a low concrete block building. From the outside, the place looked rather industrial with only a couple small windows for light. I was puzzled. The Center was only two blocks off the beach. How could a place just above sea level warn us when a tsunami was coming? Hell, it would be the first place to get hit. It seemed like typical bureaucratic incompetence—but maybe they planned it that way. If the Center got nailed that would prove there'd been a tsunami.

We opened a glass door and entered a reception area consisting of a counter and an unoccupied desk. The backs of half a dozen tan colored storage and filing cabinets separated the reception area from the offices. Row after row of fluorescent lights ran along the ceiling to the back of the building. The Center had the same institutional feel on the inside as the outside.

Scott didn't bother to announce our arrival as he barged past the reception counter. The back of the building was half filled with five or six small offices separated by moveable partitions. Next to the offices, there was a large bullpen with steel desks, computer screens, and other scientific equipment. I noticed in one corner four identical scientific instruments with large paper drums. Pressed against each slowly turning drum was a stylus that left a wavy line. I recognized these pieces of equipment as seismographs. We walked to the back of the building past walls covered with maps of the Pacific. Two scientists in white laboratory coats were looking so intently at monitors displaying mysterious charts they didn't even bother to look up as we passed.

Scott went directly to one of the office cubicles in the very back where we found Dr. Walter Grissom looking intently at his computer screen. Grissom didn't seem at all surprised to see us as he turned to get out of his chair. The good doctor appeared to be in excellent condition, especially for a lab rat. He stood almost six feet tall with a well-trimmed gray beard. His thinning comb-over failed to hide a sun burned pate.

The plastic plaque on the outside of his cubicle identified Dr. Grissom as the director of the center.

"Walt, howzit?"

"Okay. No one's making waves, so it's safe to say the Center's in good shape." With a shy smirk Grissom added. "A little tsunami humor."

Under my breath I mumbled, "Very little."

Scott pointed his thumb back in my direction. "Walt, I want you to meet an old friend of mine, Chuck Palmer. He's a haole, but don't hold that against him." Dr. Grissom had an unusually firm handshake, much firmer than I had expected. Scott continued, "Walt's a geologist and a seismologist, spends a lot of time banging on rocks and other useless stuff." That explained the handshake.

"I'd much rather be out in the field banging on rocks than stuck in this office doing the university's computer simulation crap."

"Hey, sorry about that. Have you got anything for me?"

"Of course. I was just looking at the final results. Here, I'll show you." Walt sat down in front of his computer while Scott and I crowded into the cubicle and peered over his shoulder. Dr. Grissom punched a couple of keys and brought up a map of the Hawaiian Islands on one of two large flat screens on his desk. He punched a couple more keys and the picture on his screen began to move. Just off the southern coast of the Big Island, the ocean began to deform. At first a shallow basin appeared on the ocean's surface, but then the center of the depression started to move away from the coast, and as it moved it got deeper and deeper. Suddenly the hole just collapsed, falling in on its self. Waves radiated out from where the giant chasm used to be. The computer simulation looked like someone had dropped a stone in the Pacific just off of the Big Island. "Basically what I had to do was reverse engineer the tsunami that hit us six months ago. As you can see from this simulation, I've been able to produce a tsunami consistent with the six-meter amplitude we recorded on the south-facing beaches of Oahu. This also shows that the waves that hit the east coast of the Big Island were just over seven meters, which corresponds very closely with our observations and the readings we got from our tide gauges."

I pointed to a spot on the large flat screen just off the southeast coast of the Big Island. We watched as the waves propagated out from this epicenter. "So that's where the landslide occurred that caused the tsunami?" I asked.

"Most likely. Here, you can see when I overlaid the epicenter of the 6.8 earthquake, the two points are only a few miles apart."

"So Dr. Grissom, how large of a landslide does it take to cause a

twenty-foot tsunami two hundred miles away in Honolulu?"

"You're making me feel like an old man. Call me Walt."

"Okay, Walt."

"Based on this simulation, our best estimate is that fifty cubic kilometers of material traveled down slope thirty to forty kilometers at up to two hundred kilometers per hour, or roughly 10 cubic miles of rock and debris traveling 22 miles down slope with a maximum speed of around 120 miles per hour. Capisce?"

"Yea, I capisce. Damn, that's a huge landslide, but that's good news. Isn't it?" Walt and Scott looked at me as if I had completely lost my mind. Scott was the first to speak up.

"Chuck, you're starting to embarrass me. What the hell are you talking about 'good' news?"

"Don't you see? That was a gigantic landslide. I mean it was so much larger than anything I've ever heard of. A landslide that huge must be incredibly rare. We shouldn't have to worry about something like that happening again for a long time, right?"

Dr. Grissom's response to my theory on massive landslides and tsunamis wasn't what I expected.

"I suppose in theory you're correct if your time frame is in terms of human history. But if we look at the geologic record, then landslides of this size and much larger are relatively common."

"That's hard to imagine...but these huge landslides still have to be incredibly rare when you examine them in human terms. Which is all I give a rat's ass about."

"I suppose so. Unfortunately your friend has discovered a potential problem." That must have been what Scott was talking about in the car. "The crevasse that he's been mapping just offshore is called a tension crack. It's caused by gravity's pull on the volcanic material built up over the last couple of hundred thousand years on the side of Kilauea and Mauna Loa. Scott's tension crack could be the precursor to an even larger landslide."

"And I assume you mean in the near future."

"Absolutely."

Scott jumped back into the conversation. "Walt, were you able to run any kind of simulation with the information I gave you?"

"Yes, but I had to take some pretty big WAGs with this one."

"WAG, what's a WAG?" I asked. With just an A.A. degree from the local community college, I was starting to feel a little self conscious around Doctors Scott and Walt. Not that being self-conscious would ever stop me. I'm the inquisitive type.

"Well, Mr. Palmer, a WAG is a scientific acronym." Walt and Scott exchanged a quick glance. "We use it to describe a complex statistical analysis applied to numerous variables that allows us to arrive at a reliable but often variable conclusion."

"What the hell does that mean?"

"WAG stands for Wild Ass Guess." I stared at them a minute certain they were pulling my leg. They weren't. "Look at this." Walt brought up on his screen an underwater topographic map. Then with his cursor he drew the portion of the tension crack that Scott had already mapped. He said, "That's reality, the part Scott has seen. The WAG comes into play when we figure out how far the crack extends. We only know it represents the top of the potential slide."

"And I haven't completed my survey, so we don't know how long it is," Scott added.

"The bottom or foot of the slide is an even bigger guess," Dr. Grissom explained. "The crack Scott found is probably just an extension of the Hilina Slump that we've been watching for years."

"What's the Hilina Slump?" I asked.

"It's actually a bit of a problem. The Hilina Slump is a 4,760-cubic-kilometer chunk of ground that's moving seaward at around 4 inches per year.[1] On November 29, 1975, a 37-mile piece broke off and dropped 11 and a half feet. It caused a 48-foot tsunami on the Big Island that killed two people. In fact, as I recall, there was even damage to some docks at Catalina Island right off your Southern California coast.[2] But here's the really interesting part. If the entire block ever breaks away, it's been estimated that it would cause a 1,000-foot tsunami."[3]

"A thousand feet? Are you insane?"

"Not that I'm aware of. In fact most people seem to think that's it's your friend," the good doctor eyed Scott, "that has the mental problems. I personally believe that the 1,000-foot estimate is over stated, but I agree with the people that think your friend is crazy."

"Well, that makes me feel better. I'm sorry I interrupted. Please continue."

"As I was saying, if the entire Hilina Slump ever broke away, the 1,000-foot estimate may be over stated...but then it may not be."

"And why is that?"

1. Lipman, P., T. Sisson, J. Kimura: Hilina Slump Area, 2001, p. 2-4, Onboard Report 2001, Kaiko/Kairei Cruise, http://pubs.usgs.gov/ds/2006/171/data/cruise-reports/2001/html/24.htm
2. San Pedro Pilot, December 1, 1975. http://www.drgeorgepc.com/Tsunami1975Hawaii.html
3. Napier, A. Kam, "Landslide" Honolulu, p. 28. February 1997. Cr. H. DeKalb. http://www.science-frontiers.com/sf115/sf115p09.htm

"The 1975 tsunami was generated by just 2.52 cubic kilometers of displaced material and we're talking about over 4,000 cubic kilometers moving possibly miles down slope for just the Hilina Slump alone. I suppose anything is possible."

Scott jumped back into our conversation. "Excuse me, gentlemen, we were talking about Walt's estimate concerning the tension crack I've been mapping. Not the 1975 tsunami."

"That's right. So as I was saying my biggest WAG has to do with the depth or thickness of this potential slide."

"What's your error factor?" asked Scott.

"I could be off by a factor of two—but I'm pretty conservative. I think my WAGs are good enough for your research. This potential landslide is similar in size to the one that created the Tuscaloosa Seamount."

"Hey, guys, you've lost me again. I thought we were talking about undersea landslides and now you're talking about a seamount. I know what a seamount is. It's just an underwater mountain. What does this Tuscaloosa Seamount have to do with our landslide problem?"

"He's very impatient, isn't he?"

"Yes, but he's damn good at carrying my luggage and you should see him make coffee."

"Once again you are partially correct Mr. Palmer. The Tuscaloosa Seamount is part of the Nuuanu Slide caused by the collapse of a volcano on the eastern shore of Oahu approximately one to one and a half million years ago. The debris field covers over 23,000 square kilometers on the bottom of the Pacific."

It was hard for me to comprehend a slide so incredibly large.

Walt continued. "The Tuscaloosa Seamount is the largest single block in that debris field. It's about 17 kilometers by 30 kilometers and 1.8 kilometers high. So you're looking at something on the order of 1000 cubic kilometers sliding down the eastern slope of Oahu almost sixty miles. Here let me show you what I'm talking about."

Walt pulled up another map on his computer screen that showed the sea floor east of Oahu. The landslide area was so obvious that even a neophyte could see what had happened over a million years ago. Directly offshore from the Kaneohe Marine Corps Base was an undersea ridge that had broken away leaving what Walt called the debris field. This field covered an area over twice as large as the Island of Oahu. Large pieces of the Koolau Volcano lay on the ocean floor in distinct ridges parallel to the eastern shore of the island. In the center of that field was a huge chunk of rock, the Tuscaloosa Seamount.

"Damn, you just said that this big chunk of rock right here," I

pointed at the huge seamount in the middle of the map, "is 1,000 cubic kilometers and the landslide that caused that tsunami six months ago was 50 kilometers. I may not be the brightest light on the porch, but a 1,000-kilometer landslide had to cause one big tsunami."

"For a twenty-watt bulb you're relatively bright. And you're also right; it was a big landslide. In fact that's why I've been working so hard on this potential slide off the Big Island." Walt went back to the map of the ocean just south of the Big Island. "Right here is the Hilina Slump. As I said, we've been watching it for years. So far, it has remained a slow moving mass. But that tension crack that Scott discovered has us concerned. If we have a catastrophic failure then we could easily be looking at a mass as large, if not larger than the Tuscaloosa Seamount."

I wasn't sure I wanted to know the answer to my next question. "And how big would the tsunami be?"

"Let me show you."

Walt tapped another key and his screen flickered for a second. Then the map on the screen started to move. I watched as a quarter of the southeast shoreline of the Big Island started to head down slope. Walt tapped the same key a second time and now we were looking at the ocean surface. Directly over the area where the slide had been moving on the previous screen, a hole started to form in the water just like it did on the first simulation he'd shown me. It continued to grow until the hole was almost as large as the entire Big Island. Finally, it just collapsed, sending huge waves up the sides of the Big Island. We continued to watch as the waves first encircled the Big Island then moved across the Alenuihaha channel to Maui, running up both sides of Maui and Lanai and completely engulfing Kahoolave. After striking Molokai, the waves finally hit the southern shore of Oahu where Pearl Harbor and Waikiki are.

"That's a pretty cool simulation, but how big are these waves?"

"Remember, my WAGs are conservative. The waves could be substantially larger than this simulation. If there is a catastrophic failure on the southeast shore of the Big Island, we could reasonably anticipate that by the time the waves reach Waikiki Beach they would be on the order of 175 to 200 meters. The run-up would be approximately double those numbers."

Scott and I each took a step back, bumping into the bookcase behind us as we tried to distance ourselves from the reality on Dr. Grissom's screen. Scott spoke first.

"Walt, what the hell can we do?"

Grissom shrugged and scowled. "I'm not sure. There's not a lot we can do except chart and watch. We need to map the extent of that ten-

sion crack you've discovered and then monitor it. Maybe the entire mass will continue to move slowly like the Hilina Slump. For now, finish your report. Then we'll give it to the state. At that point it'll be their problem."

While Walt and Scott discussed what to do about the tension crack, I tried to wrap my mind around the entire scenario. I couldn't imagine the devastation that a 200-meter wave would cause. There were a million questions running through my head.

"Walt, you're talking about a wave as high as a sixty story building."

"Not quite sixty stories, but over 600 feet high. Have you ever noticed how most of the high-rises in Waikiki are the same height?"

"Yeah, sure."

"Well that's because there's a 500-foot height limit on the buildings. So the waves that the computer predicts would strike Waikiki are about a 100 feet higher than the tallest buildings. The run up—the distance that the water would continue up the sides of the mountain—could reach an altitude of over 1000 feet."

"And how much warning would there be?"

"That's the real problem." Walt sat back in his chair linking his hands on the back of his head, as if trying to hold all this information inside his skull. "We estimate that if everything goes perfectly from the time the landslide starts to move until the first waves strike Waikiki will have no more than twenty to thirty minutes warning. Maui would only get fifteen minutes."

We all sat in silence.

"That's not much time." I noted the only obvious fact in this unimaginable scenario.

"It gets worse. We may have a problem confirming that a tsunami was even generated. Our seismometers will register the earthquake caused by the landslide, but there's no guarantee that the earthquake will be 6.5 or greater."

"Why do you need an earthquake greater than 6.5?"

"Because that's our threshold. Anything smaller and we don't even issue a Tsunami Information Bulletin. It takes an earthquake larger than 7.5 before we issue a Tsunami Warning. Even then, we're not positive that a tsunami is generated until our tide gauges or DART buoys actually measure it. That's what happened six months ago. We couldn't issue a warning until the tsunami showed up on our gauges. We were lucky— in a sense—because we got a call from an eyewitness. The intern on duty hadn't bothered to check the tide gauges."

"I remember the papers said there was no warning."

Walt's voice went up an octave. "That's not true. We're limited by our

protocols." Then his hands began to move, as if trying to chop each word in half. "We can only do so much. The public had about a five-minute notice on Oahu, but it's true that the Big Island and Maui didn't have any."

Walt had taken my comment that there was no warning as being his fault. "Sorry, Walt. I didn't mean it personally."

"I know. It's just that I had to stand in here and watch the damn wave wash away everything in sight." He sat up, regaining his professional composure. "The state is working to improve its reaction time. In reality, a best-case scenario for Oahu is going to be about fifteen minutes. Remember, just because we register an earthquake larger than 7.5, there's no guarantee that a tsunami's been generated. We still have to rely on tide gauges to issue a tsunami warning."

"Why don't you lower your threshold? That way you can issue a warning even if there is a small earthquake," asked Scott.

"That won't work. We get small earthquakes all the time, particularly around the Big Island. In fact lately it's been quite active down there. We can't start issuing mega tsunami warnings every time a small earthquake is detected."

"Better safe than sorry."

"Not really. If we did, it wouldn't be long before everyone would start to ignore us, just like the boy who cried wolf." Walt paused as he gazed at the ripples on his screen. "Then there's the question if we should even try to issue a warning."

"What do you mean?"

"As I said, the very best case scenario for Honolulu is fifteen- to twenty-minute warning, two or three on Maui. Not much time, and that's if everything goes perfectly."

Scott scoffed, "I'd be willing to make book it won't. Honolulu has a population of almost half million people during the workday."

"That's right. It's slightly larger than New Orleans. Chuck, do you remember that thirty-six hours before Hurricane Katrina struck they tried to evacuate the city? With over a day's notice they still couldn't get everybody out. We're talking less than twenty minutes. So the question is, do you cause mass panic for ten or fifteen minutes to save a few lives? Is it worth it?"

"You have to do something. You just can't let all those people die."

"I agree, but what can we do other than monitor the slide closely and try to figure out when or even if it is going to let go. Of course, there are some things that could be done, but they'll never fly. The state has already set up evacuation routes based on having a three-hour warning for a 10-meter tsunami. We could extend those evacuation routes to higher

ground. They could store food, clothing, and temporary shelters in the hills. We could run evacuation drills just like they do in our schools. That could save thousands of lives, but the state will never let it happen."

"Why not?"

"Can you imagine the six o'clock newscaster in Des Moines showing all the good folks in Waikiki making preparations for the 600-foot tsunami? You wouldn't be able to find a tourist in this state for the next ten years."

"I see your point, but you have to do something."

"I wish I had a better answer. We haven't run any simulations or tried to estimate what the loss of life would be. If I had to guess, I'd say we'd lose between eighty to ninety percent of the state's population from the first set of waves. I don't want to think about what will happen to the survivors. How does anyone deal with a natural disaster of the magnitude we're talking about?"

"So what do you plan to do?"

"It's called cut and run. I'm out of here in two weeks with a hell of a big raise to boot. I've taken a job with Global Pacific Oil and Exploration. I'll be their new vice president in charge of production and exploration. I'm headed to the South Pacific on the Glomar Explorer in just over two weeks. She's the largest deep-sea drilling rig in the world." Walt stretched back in his chair with an air of satisfaction. "That's my new home away from home."

Scott backed out of the office. "Sounds like a pretty cushy job. Good luck with that, Doc. Thanks for the update...I think."

We left the Center and headed back to the car. "I can't believe he's going to cut and run like that. He seems so dedicated."

"It's not exactly by choice. Grissom was forced to offer his resignation to a board of inquiry that looked into the December tsunami. He sort of lost it when they questioned him about endangering the life of one Chip McCleary, his lame assistant who didn't check the tide gauges."

I settled into the passenger seat intent on keeping an eye out for any black Lincoln Towncars. Walt's report had put us in a state of shock so we didn't talk much. The vision of the massive wave continued to run endlessly through my mind like a hamster on a wheel. We managed to make it back to the rental lot without any problems. Fortunately, Rosy had already taken care of the tires on Scott's Forerunner. We threw our bags in the back and drove to the other side of the airport where the university kept a couple of planes that Scott was allowed to use.

I finally asked Scott, "What do you think about this whole landslide tsunami thing? I mean your friend Dr. Grissom wasn't very encouraging.

What do you think we should do?"

"There's not much we can do. We're just small cogs in society's engine. As scientists, our job is to report the facts. Then we leave it to our brilliant politicians to determine what to do with the information we give them. Trouble is, if the politicians don't like what we give them, they go out and find or buy some other facts. It must be nice."

"That's insane. How can scientific facts be for sale?"

"Don't get me started."

"Okay, but what do you think Hawaii should do?"

"Actually this state is better prepared than most. You heard Walt talking about evacuation routes. California has done almost nothing. They've got thirty-five million people and over 80% live close to the ocean. If Hawaii loses a million people to a six hundred foot tsunami, I'll bet you that five hours later, California will lose close to twenty million even though the tsunami will be half the size."

"Wait. Are you saying that after this place gets hit by your mega 600-foot tsunami California will get nailed by a 300-foot one?"

"What did you think? Your Govern-ator is so strong that he'll hold it back? A couple of good jabs and a right cross is all it's gonna take? This isn't the movies."

"Yeah, I know, but I live on the beach. I've got a wife and kid. It hadn't even occurred to me that they were in any kind of danger. What are the odds? What do you think I should do?"

"Honestly. It's as real as it gets. I can't give you any odds, at least not yet. But once you see that tension crack that I've been mapping you'll get a better feel for the size of this potential disaster. If it were me, I'd call my wife and tell her to stay close to a radio. Either that or move to Des Moines."

"That serious?"

"You heard the good doctor."

I reached back and grabbed my cell phone out of the travel bag. I saw Scott's Ham radio setup in the backseat of the Forerunner. "What's with the radio?"

"Aolani got sick of me keeping the family up all hours of the night talking on the damn thing, so she made me get it out of the house." He laughed. "One night she got so mad she picked up this big receiver and threw it. I'm not sure what she was aiming at but my head happened to be in its path. Just missed my right ear by a quarter inch. Ah, how I miss that girl." He grinned at me. "That portable unit's been in my car ever since. Now I drive up to Mt. Kaala, the highest point on Oahu, and tune in. I can't bother anyone up there."

My cell phone battery was almost dead, so I plugged it into the lighter and then called Lauren.

"Hello." My heart rate went up a couple of dozen beats just hearing her voice.

"Hi."

"Chuck, is that you?"

"It's me."

"Please, don't be mad. I don't know what got into me."

"That could be a problem. By the way, Scott says to say hello. He's right here in the car with me."

"So you really can't talk right now?"

"Pretty much so." At that moment, I'd never tell Lauren but it was awfully nice hearing her voice.

"Well, I can talk. I've had a chance to think about what I said, particularly about you not being very bright."

"And?"

"In the one area I was referring to, I'll stand by my comment."

"And what area is that?"

"Women, this woman in particular. You've never been very good at reading us, knowing what we're thinking, what our needs are, having a sixth sense about our feelings."

"I suppose I'd have to agree with you when you put it that way, with one caveat."

"What's that?"

"I'm not sure any guy is very good at that… unless he's gay."

"You may be right. I haven't done much dating, and you're the only man I've ever loved. I'm probably expecting too much."

"I understand what you're saying. Don't worry about it, but we still need to discuss the baby."

"I know we do. Just promise me we'll work it out. I love you."

As much as I wanted to resolve what had happened when Lauren got pregnant, or at the very least talk about it some more, I didn't feel comfortable with Scott sitting next to me. All I could say was, "Love you, too." I punched Scott in the shoulder when he started with his fake coughing.

"Are you having fun with that crazy buddy of yours? Probably just lying around the beach watching all the cute girls."

With half the battle out of the way, Lauren's mood had lightened up considerably, and so had mine. I just had to resolve the pregnancy thing, if that were possible. Then my life could get back to normal. "Not exactly, but our fun meter's just about pegged."

I gave Scott the finger as he said, "Bull shit," under his breath.

"Listen, I need you to do me a favor. While I've been tagging along, Scott's been looking into this whole tsunami thing over here. I never realized how much damage one of those waves can do. I mean it's different when you actually see what happened."

"I thought they'd cleaned everything up."

"They've cleaned up a lot, but being here has really made an impression. We're about to pick up our plane so I don't have a lot of time. Have you got a paper and pencil?"

"Sure. What can I do? Before I forget, my first Mommy and Me meeting is Sunday. I might be a little late picking you up at the airport."

"Don't worry about it, I'll grab a shuttle."

"That would be great. Thanks. Oh yes, and there's one other thing. Maria is taking her three daughters to Mexico for a couple of weeks the Sunday you come home. You'll have to help me with the housework while she's gone."

"No problem, I'll try and stay out of the way." I hated doing housework. Having Maria around was a blessing. She was like this silent little gnome that went around cleaning everything and then disappeared before I got home. "Oh yes, one more thing. I'd also like you to call our insurance broker and make sure the house is covered for something like a tsunami. It's probably flood insurance. I don't think your average homeowners' policy covers that. Get as much coverage as you possibly can. Then talk to him about the gym. See how much coverage you can get. I'd like at least a million dollars for lost business, plus the cost to replace all of the equipment and tenant improvements."

"The gym. Are you crazy? That's not even close to the water. What's going on over there?"

"I'm just feeling a little paranoid after seeing what these things can do. It'll be fine. One other thing before I forget. Have a copy of all our policies sent to your attorney in New York."

"This is starting to sound awfully strange. Is everything okay?"

"We're fine, honestly we are. I just came from the Pacific Tsunami Warning Center where we spoke to the director. He has some concerns that there could be another tsunami even bigger than the last one. He said it might be a good idea to make some preparations if you live or work close to the beach, even in California. I have a new wife and daughter to look after. As the man of the house, I take this stuff seriously, even if my bulb doesn't burn very bright."

"Your bulb burns plenty bright, and I think that's sweet. I'll give Bob a call and check on the insurance."

Being the man of the house is definitely not sweet, but it's what men do, especially a former Navy Seal. I wasn't feeling particularly sweet, but hearing Lauren's voice made me realize how much I still loved her. "Thanks…one more thing."

"Yes, dear? Should I get a notebook?"

That slightly sarcastic tone didn't help when I was trying to be serious. I'd have to talk to her about that, too. "It would be a good idea if you stayed close to a radio or kept the TV on at home."

"Now you're starting to scare me."

"Despite what you may think, I take my responsibilities seriously. Trust me, I'm sure I'll get over it—the tsunami thing, that is, not my responsibilities. Why don't you keep your cell phone close by? Just in case there's a problem."

"Fine. I'll keep my cell phone close by, but I think we need to talk when you get home, maybe even take a vacation." A vacation with Lauren sounded kind of nice. "We'll go to one of those places where the patients—I mean guests—stare at the spots on the sidewalk." Not exactly what I had in mind. "Maybe leave you there for a while. Love you. Take care."

"Wait. One more thing."

"What?"

"Have you ever considered moving to a state where they grow lots of corn?"

"No. But you may be moving to a place with lots of padded rooms." It wasn't easy staying mad at my wife.

"Oh, come on, I was just kidding. Promise me you'll keep the phone close by and give my little girl a big hug and kiss. I'll see you Sunday evening."

"Okay, have fun."

As we pulled into the hangar parking lot Scott gave me kind of an odd look. That's when it occurred to me that I'd be spending the better part of a week with an alien lunatic. Okay, maybe not a lunatic, but Scott was definitely from a different planet.

FIVE

SCOTT AND I GRABBED OUR STUFF out of the back of the Fore-runner and jogged to a small office at the end of the parking lot. Did I mention that Scott never walks? He rushed over to the worn Formica front counter and filled out some forms before the receptionist would allow us to take the U of H plane. Once our flight plan had been called in, we made a quick stop in the men's room.

A six-passenger single engine Cessna 206 sat in the bright tropical sun just past the open hangar doors. Scott walked around the plane doing a pre-flight inspection as I undid the tie-downs. After our little incident with the governor, I insisted on Scott doing a very thorough check.

"Don't worry, Palmer. Post-9/11 airport security is so high not even the governor could get in here without permission."

I wasn't convinced, and Scott had a few more choice comments concerning my manhood. We threw our bags into the small luggage compartment behind the third row of seats. Scott got in the front left seat and I sat in the right.

Before starting the engine, I read back the pre-start and start checklists.

"Throttle."

"Open."

"Mixture."

"In."

"Propeller."

"Clear."

Scott turned the key and pressed the starter button. The three-bladed propeller turned over a couple of times and the big air-cooled engine came to life. The university's Cessna is nothing like my wife's Gulfstream, more Yugo than Mercedes, but I wasn't complaining. It was a hell of a lot more convenient than flying commercial.

After ten or fifteen minutes of taxiing, we finally made it to the departure end of the runway. Scott went through the run-up as I read from the checklist.

"Everything's in the green." We were ready for takeoff.

Another five minutes of delays and we received our departure clearance. Scott lined us up on the centerline of the runway and pushed the throttle all the way forward. At around seventy knots he pulled back on the wheel, the Cessna lifted off, and we began to climb. As soon as we were clear of the airport, the controller directed us to turn right forty degrees. Sand Island and Honolulu Harbor passed off to our left. Waikiki Beach was below and in front of us.

Just before we got to Diamond Head, the tower called and directed us to turn left, out of the way of faster traffic. Waikiki came into view as Scott banked the plane, and I could finally envision the most photographed beach in the world with a 600-foot wall of water washing over the high-rise hotels that line the white sand beach. The thought of all those twisted buildings filled with mangled bodies turned my gut. Hell, there wouldn't be anyone left to identify the closest of kin, let alone bury them.

By now my imagination was spinning out of control. Would there even be a search or rescue effort? Of course, the wave wouldn't stop in Hawaii. The devastation around the entire Pacific Rim would be horrendous with hundreds of thousands if not millions lost.

The people with the best chance of making it through this incredible disaster were the marijuana growers that plant their crops high up in the forests. What a dark comedy. There wouldn't be any food or shelter for the few that made it, but they'd be high as a kite.

We reached our cruising altitude, and Scott asked if I wanted to take the wheel. I had tried my hand at flying once before. It's not particularly difficult, but it does take some getting used to.

"Come on, Chuck, it's not a two by four. Hold the wheel like you hold that pretty woman of yours. Be gentle, and watch your altitude. You don't want to get me in trouble. Big Brother's watching."

"I don't give a damn about Big Brother. The only guy I care about is the one driving that big Lincoln."

We headed south towards the Big Island with the tops of Mauna Loa and Mauna Kea poking through clouds in the distance. Molokai was off to our left. I prefer not to spend a lot of time in small planes; I'm always listening for strange engine sounds like skips, hiccups, or coughs. Especially when I'm over the water. About the time I was leveling the plane at 8,000 feet, I thought I heard a little burp out of the engine. I wrote it off to leftover anxiety from the guy in the Lincoln. As time went by, I could have sworn the engine made a few more gurgles. Finally, I couldn't take it any longer.

"Hey, does the engine sound a little rough to you?"

Scott listened for a minute. "It might. Maybe I leaned the fuel out

a little to much." He pushed the mixture control in a fraction of an inch and the engine immediately smoothed out.

I breathed a silent sigh of relief. We continued on another five minutes with Scott checking his chart while I tried to fly the plane without gaining or losing altitude. I continued listening to the engine and could swear it missed a few more beats.

"Scott, is it just me or is the engine acting up again?"

"No, I've been listening. It sounds a little rough. Probably got some water in the fuel. It's a pretty common around here with the high humidity. I'll richen it up a little more. See if that helps."

Scott pushed the mixture control in another fraction of an inch and once again the engine smoothed out. But two minutes later the motor coughed, rumbled back and forth in its mounts, the RPMs slowed, and then it caught again. As the engine revved back up, so did my heart rate. Scott moved the mixture control half way in. It didn't help. The engine sounded like it had a bad case of asthma. Then he bent down and moved the fuel selector switch from the right tank to the left. That didn't help either. We started to lose altitude. Scott took the controls and called Honolulu Center. He reported that we were having engine problems. The controller asked if he wanted to declare an emergency. Scott said no.

I went from scared to pissed in half a heartbeat. "Are you crazy? We're about to lose the damn engine and you're not declaring an emergency."

"No, I'm not declaring an emergency. If I did, do you have any idea the amount of paper work they'd make me fill out? The FAA, the state, and then there's the university. I'd be filling out forms for the next three weeks." I was about to smack my best friend upside the head when all of the sudden the engine went silent. The propeller was still spinning, but we had lost all power. Scott tried to restart the engine, but it just coughed, sputtered, and then died. Fortunately, the little Cessna didn't drop like a stone. In fact our descent seemed almost normal. I never knew how well these small planes glide. Even so, losing all power had my backside puckering.

"Damn it. Now can we declare an emergency? We've got ourselves a real T.A.R.F.U. here." TARFU was an acronym similar to WAG. It was navy-speak for Things Are Really Fucked Up, and as far as I was concerned, that said it all.

"Hey, what is it with you and all these emergencies? We have a perfectly good life raft in the back. And guess what?" My old buddy had that look on his face. "I just put a new bottle of soy sauce and some fresh wasabi in my night bag. We'll have sushi tonight on the high seas. The stars will be out. Warm tropical breeze, you'll love it." Even for a Martian,

Scott had gone over the top.

"You son-of-a-bitch. Let me have that god damn radio mike. I'm declaring an emergency."

"Talk about a wuss. All worried about getting your feet wet." Scott still took great pleasure in driving me nuts. I was about to take the microphone cord and wrap it around his annoying little neck. "Besides, look right there." He pointed at an airport just in front of us. "It's Lanai. I know the airport manager. He's cool. Won't cause any problems."

I squinted in disbelief at our deliverance. "Can we make it?"

"Easy. I could dead stick it in from here with one hand behind my back. I'll call Lanai Airport and tell them to have a tractor out on the runway to pull us back to the terminal. If we can't fix the plane tonight I can get us a couple of rooms at the Lodge. I know the manager. It's first class, Four Seasons. Nothing but the finest for my old buddy." Scott winked at me.

I wanted to slug him. And what was with that wink? Who does he think he is, Sarah Palin? "Just get this damn plane down in one piece and I'll kiss the ground and sleep under the wing."

Scott contacted Lanai Airport and told them we needed a straight-in approach and a tow to the terminal.

The tower operator asked. "Are you declaring an emergency?"

Scott answered with a laugh, "No emergency; only a minor nuisance. But you better keep the landing pattern clear."

Scott is unbelievable. I don't know how he does it. Cool as can be, he glided our plane in for a perfect dead stick landing. We coasted to a stop half way down the runway.

Two minutes later, a guy in an orange jump suit pulled up in one of those little airport tractors and backed it up to the front of the plane. Once we were hooked up, he towed us over to a small administration building just west of the main terminal.

Scott had me place a set of rubber chocks under the front tire while he went back to the luggage compartment to find some tools. After pulling out our two bags and placing them on the ground, he removed a small red toolbox from the back of the compartment.

We had the engine cowling off within five minutes and were looking for the problem. It didn't take long to find it. All we had to do was follow the gas dripping from the fuel pump. Fortunately, once the engine had quit Scott turned the fuel selector switch to the off position. The few drops still leaking out of the pump were all that remained in the fuel line.

"Hey, will you look at this? Someone cut the seizing wire and then loosened the nut on the fuel line going into the suction side of the fuel

pump." Aircraft manufacturers build their engines differently than automotive engines. Every nut and bolt has a small hole drilled through it. A piece of stainless wire is run through the hole, twisted, and then tied off to the next bolt or to a special bracket. This way it's impossible—as long as no one cuts the wire—for any bolts to come loose. Scott tightened the bolt then ran a piece of seizing wire through its head to lock it down. "There, now it's as good as new. Let's get the cowling buttoned up so we can get out of here."

I planted both feet firmly on the ground and gave him my most determined look I could muster. "I'm not getting back in that friggin' plane."

"What do ya mean?" Scott raised his voice clearly irritated with me.

"Not until you've checked every nut and bolt or anything else that can go wrong with it." Actually I was about ready to jump on the next flight back to L.A., move my family to the mountains, and tell the rest of the world to go F themselves.

The level of frustration in Scott's voice went up another level. "You must be kidding. I just fixed it. You saw what the problem was. Someone loosened up the fuel line."

"I know what happened. I also know what you said about airport security. Remember? Not even Governor Pratt could get in without permission. Well, apparently he got permission, so how do you know he didn't mess with anything else?"

"Hey, if the governor or his buddies wanted to kill us, they would have loosened up the fuel line on the pressure side of the pump instead of the suction side. That way when it came loose the pump would have sprayed gasoline all over the engine compartment. Then we would have had a real emergency, like a fire." I couldn't believe what I was hearing. How could he stand there and act like this was no big deal? He continued as if instructing a child. "When they loosened up the suction side, it just caused the pump to start sucking air. Eventually there was so much air in the fuel lines the engine was starved of fuel and quit. They're just trying to scare us. What's the matter? Is Chucky afraid?"

"Insult me all you want. I'm not getting back in that plane until you go over it with a fine-tooth comb. I'm a proud member of the Live Cowards Club. I'll leave the dead hero stuff to guys like you."

"Oh, come on. It'll take over an hour to check it out. We're on a tight schedule."

"Frankly, dear, I...don't...give...a...damn. I'm not moving until you check every inch of this plane."

"Damn. I'm not sure about you and this whole married with kid thing." I just shook my head, crossed my arms, and leaned against the

wing-strut. Scott scowled but recognized an immovable object when he saw one. "All right."

For once my friend was wrong. It took us over two hours before we had inspected everything and put the plane back together.

When I was satisfied and Scott had stopped complaining, we got back into the little Cessna and fired up the engine. Scott flew the entire trip. I never took my eyes off the gauges. The engine ran smooth as silk for the rest of the flight.

We parked the plane at the Kona Airport Civil Aviation Terminal just south of the main terminal.

"Leave your valuables and cell phone in the plane." Scott ordered, still annoyed with his cowardly companion.

"How come?"

"It's just better that way. Besides, there's no cell reception down at South Point. Nobody lives there. The only thing that works is a satellite phone, and the university doesn't let me use it for personal calls. The place is incredibly remote."

"Damn. I guess I won't be calling Lauren while we're on the boat."

"She'll survive. We should leave our wallets. The only people you ever see are fishermen, and they can be a bit of a pain in the ass. Captain Sammy knows most of them. We give them a couple of beers and most of the time they're happy. When they're unhappy…well, our valuables will be safer in the plane."

"I'd really prefer to take my wallet. I can always hide it some place on the boat."

"Your decision."

I scrounged around in my overnight bag and found my wallet in a side pocket but no cell phone. That's when I remembered it was still plugged into Scott's truck. Was that a conscious error? I couldn't stop thinking about what Lauren had said. She must have planned everything. She was the one that picked the day, just over a year ago, when we got back together. She would have known when she was ovulating. She set the tone for that night. It wasn't just two people that let their passion get away from them. My head started to pound thinking about what Lauren had done. Worse, the pain made me realize how much I still loved her.

The sun was just setting off to the west as we grabbed our bags out of the baggage compartment. Scott had already rescheduled the helicopter to pick us up tomorrow morning in the marina parking lot for our ride to the Volcano Observatory. We trotted over to the small private ter-

minal where Scott called Captain Sammy to come and get us.

While waiting for our ride, Scott warned me about our captain. "Sammy Ohana claims he's pure native Hawaiian. I have my doubts. There are so few true native Hawaiians left. Nonetheless, Sammy is deep into Hawaiian mythology and folklore, so watch what you say about the goddess Pele. We need to respect their beliefs."

"Oh, please. A God that lives in a volcano?"

"A goddess that lives in a volcano. Every culture has its own creation story. Why is theirs any less believable than a guy that lives 900 years, builds an ark, and crams twenty million species into it while God kills every living soul on earth?"

"Okay, I see your point. But what about the Menehunes," I asked. "You know, the little guys that come out at night and work like crazy building rock walls, ponds, and stuff like that. And just before sunrise, they go back into hiding? I've always liked those little buggers."

"Sounds like you've met a few."

"Only after a late night out with you, professor."

Captain Sammy showed up ten minutes later in another white Toyota Forerunner with the university logo proudly displayed on its side.

"Sammy, this is my Navy buddy, Chuck. He's a Menehune lover."

Sammy shook my hand and smiled. I guessed he was in his mid forties, very Polynesian. Stocky fellow, maybe five-foot-six with a full head of black hair. He wore dirty cutoff pants, a stained white t-shirt, and rubber flip-flops. On the way back to the marina, Scott and Sammy went over tomorrow's schedule. They both agreed that we needed to get down to South Point with plenty of light. Scott made sure that Sammy had brought along lots of Primo Beer.

We left Sammy in the dimly lit parking lot then drove to the town of Kailua-Kona for dinner. Scott found a small restaurant where we could watch the water. We ordered a couple of Primos and a bowl of nachos with a side order of guacamole. After fighting with my wife, the five-hour flight to Honolulu, getting run off the road by the governor, and then the little incident on the way to Kona, I was exhausted. Though I had not eaten anything the entire day, my appetite was weak. After sitting back and downing a couple of Primos, making small talk with our waitress Susie, a little blonde with a pageboy haircut, I finally started to revive. Scott ordered the Opakapaka. I had the ahi tuna and a large Caesar salad. We both had mud pie for dessert.

Scott wanted to go to a little bar up the hill after dinner, but I insisted we head back to the boat. We had an early call the next morning, and after the day's excitement, I was beat. We drove back to the boat in

a food-induced coma and left the truck in the parking lot.

While walking along the edge of the marina, I realized that Honokohou Harbor must have been a bitch to build. The basin looked more like an oversized swimming pool than a marina, as if it were chipped out of the rock with a hammer and chisel. The tsunami had devastated the tiny yacht harbor. Through the glare of nightlights, I could make out a small repair yard piled with punctured and battered boats. Only a few remaining slips and even fewer boats floated in the water below me. We stepped on board the Maka Hou, a 35-foot sport-fisher.

Scott called out. "Sammy, you here?"

Our captain was up on the flying bridge. He stuck his head up to peer over the helm seat. "Right here, boss. What's up?"

"You get the rest of that beer?"

"Eree-ding in da ice chest."

As I looked around the miniscule marina, it occurred to me that the Maka Hou shouldn't be here. The only boats floating in the few slips left were small boats that would fit on a trailer.

"Sammy, how come the Maka Hou didn't get damaged by the tsunami."

"Oh man, dat be da worst."

I turned to Scott. "What is that supposed to mean?" He motioned in my direction as he looked up at the captain.

"Sammy, stick to English. Chuck's a dumb Haole."

"Okay, boss."

"So tell him what happened."

"Dat big wave come on da Sunday. We was supposed to have a big Luau with all our friends and family. So I decide to go fishing when da sun first come up, maybe catch some Mahi Mahi or maybe some Ono. I caught me one, two, den tree nice Mahi Mahi, so it time to go home. That's when I saw all da kine."

I looked at Scott. "What was that?"

"Da kine. You know, stuff."

"Oh sure."

"Yeah, da kine. Like da stuff to build da house and all da marina tings. I never felt da wave or noth'n. But when I drive da boat back to da marina and I see all da kine, I know what happen. Den I saw dis big moke. He floatin face in da wahta, no question da bugga be maki die dead."

"Damn, that must have been pretty bad. Was your family safe?"

"Yeah, de be mo bettah. We livin up on da side of da mountin."

When Sammy was done telling his story, Scott gave me a quick tour

of the Maka Hou. He took the forward stateroom that included its own head and a large V-berth. Just aft of Scott's stateroom on the starboard side of the boat was a small galley with a gas stove, sink, and refrigerator. Opposite the galley was another head. The main salon was three steps up and included a queen-sized foldout sofa bed. This would be my bunk. Scott said Sammy preferred to sleep under the stars up in the flying bridge.

A sliding glass door with blackout curtains separated the main salon from the large fishing cockpit. Scott explained that a sport-fisher was basically useless for most marine research, but because he only did underwater surveys using scuba equipment, it was perfect. The boat had been donated to the Biology Department by a wealthy alumnus who no doubt took a nice tax write-off in the process. Stepping into the cockpit, I noticed a half dozen dive tanks sitting in their own racks resting against the transom. I assumed there must be a compressor to fill the tanks somewhere deep in the hidden recesses of the boat.

Scott opened a cooler and popped another beer. "Want a Primo?"

"No thanks. I'm taking a shower then hitting the sack. We've got an early call tomorrow morning."

"Navy showers only. Sleep tight."

After a quick cold one, I climbed into my bunk and closed my eyes, but my mind refused to shut down despite my state of exhaustion. The day's events continued to roll through my head. But it was Lauren I thought about the most, especially that part about tricking me. Who was this person I had married? I still couldn't believe she was capable of tricking me into getting her pregnant? Was she really that conniving, duplicitous? Lauren was a successful businesswoman that had learned the ropes from her incredibly wealthy father. Getting what you wanted in business is one thing, but taking those same values into a marriage? What was I dealing with? Thinking about Lauren was like driving a spike into my forehead. The pain was becoming unbearable. I decided to push her as best I could out of my mind. It helped, but I still couldn't fall asleep. Then there were those little incessant sounds permeating the Maka Hou: the whirring of the refrigerator fan, the cycling of the bilge pumps, and the constant clicks and scrapes of the sea shrimp on the hull. Scott once told me the clicks were sea shrimp mating calls. I wanted to bang on the hull and yell. "Get a room!" Better yet. "Run."

I have no idea what time I finally fell asleep.

Six

I WOKE UP TO THE LOUD CLATTER of a helicopter overhead and Scott's nagging voice. "Come on, get up. We overslept. He's already here."

"Is that them. God, I'm exhausted. At this rate, you'll turn me into an old man."

"You're already an old man, now get your ass out of bed. We gotta go. Don't forget to bring a jacket. It gets cold at the observatory."

I threw on a pair of fresh underwear, sweatpants, and a t-shirt. Fortunately, Sammy had packed us breakfast. I grabbed a roll and took a bite.

"That'll have to wait. You can eat in the chopper."

We ran up the gangway to our helicopter waiting for us in the middle of the empty parking lot, its rotors slowly turning. The pilot stood next to the black Hughes 500 with the words Kona Kopters painted in an arching rainbow of colors across the side. As we jogged toward the little helicopter, I saw that we were entrusting our lives to a very young Asian man. In fact, I was pretty sure his parents hadn't incurred the expense of purchasing a razor for him just yet. I elbowed Scott and in a low tone asked, "Hey, does he have to get his mommy's permission before he takes the helicopter?"

"No, actually he has to get daddy's permission. His father owns the company. Icky's been flying since he was sixteen. He's twenty-four and their best pilot. Any other questions?"

"Just one."

"What's that?"

"What kind of name is Icky?"

"It's short for Ichabod, as in Ichabod Ishikawa. We call him Icky or sometimes just Ick."

"Who the hell names their kid Ichabod?"

"How would I know? Maybe his parents had a thing for Washington Irving."

"Maybe they didn't want kids."

Scott introduced me to Icky, a skinny kid with bad spiked hair, sunken cheeks, and a pair of dark aviator sunglasses. I climbed into the

front passenger seat while Scott got into the back. Icky made us put on headphones so we could talk. As soon as he spooled up the gas turbine engine, I remembered why we needed them. The whine from the engine and the racket from the rotors were deafening.

Once Icky had the engine running, he went through his checklist while I looked out the window. Out of the corner of my eye, I had noticed a stranger observing us. The man in his mid-thirties stood next to a dark blue van with a cracked windshield. He was taking in our every move. He didn't approach us or make any threatening moves, but he didn't go about his business either. Then again, maybe we were his business?

"Hey, Scott, did you see that guy in the parking lot?" I asked as we lifted off.

"What guy?"

"Look out your window. He's still there."

Scott looked out the right side of the helicopter and said with disinterest, "Oh, that guy. So what?"

Icky turned south and began to accelerate while gaining altitude. Most of the engine gauges for the gas turbine were foreign to me, but I did recognize the altimeter and the airspeed indicator. We leveled off at 1500 feet, making 135 knots. This little chopper was fast. Icky kept us close to the shoreline as we continued south towards the end of the island. Flying this low allowed me to check out the beaches and any possible dive spots along the coast.

It didn't take us long until the southern-most portion of the United States, South Point, came into view. From the air, South Point looks like a mile-long horn jutting out into the Pacific. Just north of where the horn attaches to the Big Island, there's a miniature volcano. It sits on the beach right at the water's edge. The side of the volcano facing the Pacific is missing, as if the waves had washed it away. But the strangest thing about this mini-volcano is the sand that makes up the beach in the center of the half cone. It's bright green.

Pointing at the little beach, I tapped Icky on the shoulder and asked, "Hey Icky, what's with that green sand?"

"That's Puu Mahana, and the green sand comes from the mineral olivine. It's the only green sand beach in Hawaii. Maybe the only one in the world. I've never heard of any others."

Just as Icky answered my question, he put the helicopter into a steep dive and started circling to the right. My stomach went straight to my throat as I grabbed the handhold by my ear. Son-of-a-bitch, the little bastard was laughing at me.

"Hey, I thought you wanted to look at the green sand."

"Thanks. I wanted to look at the green sand. I didn't want to become the green sand."

Icky just smiled as he hovered the helicopter over the beach for a few moments so that I could catch my breath and look at the bright green beach. As soon as the color in my cheeks no longer matched the color of the sand, Icky pushed the nose of the helicopter down and we continued heading south. This time he only climbed the helicopter up a few hundred feet as we passed over South Point. Once over the water, Icky put the chopper in another steep dive and brought us right down to the top of the waves. Twenty feet above the ocean, we skimmed across the surface at 135 knots, but it felt like 500. The sensation of speed was unbelievable. We rapidly came up on another point populated by a thick grove of palm trees. I like palm trees as much as the next guy, but not when they're screaming towards me at 135 knots. I was convinced we were going to become part of the local scenery, and just as we were about to smash into the vertical rock cliff, Icky pulled back on the cyclic stick. The helicopter shot straight up; my stomach headed straight down, and it didn't stop until it got to my feet. As soon as we passed over the point, Icky took the cyclic control and shoved it forward. This little action put the helicopter into another steep dive. This time my stomach shot from my feet back to my throat ignoring the middle ground. I was glad I hadn't eaten breakfast.

Icky pulled the same maneuver a couple of more times as we went flying over the numerous promontories along the Kalapana Coast. I was about to strangle the little bastard when we came up on these gnarled black cliffs. Streams of bright orange lava gushed out of the blackened burnt rock along a one-mile front. The incandescent liquid rock spewed forth into the surf below generating billowing clouds of white steam that were blown back over the barren landscape. I couldn't help but wonder how many barrels of oil we could save by harnessing all that energy.

Scott explained, "The entire coast along this side of the island is part of my research area, and I've made hundreds of dives close to the underwater vents. If we don't have any more delays, we might have time to make a dive along this part of the shore."

I couldn't imagine red-hot lava flowing underwater. How was it even possible? Wouldn't the water cool the lava so fast that it turned to solid stone before it had a chance to flow onto the bottom?

We watched as the lava erupted from the side of the cliff for another few minutes and then headed up the face of the mountain to the observatory.

"Hey, Ick, how's the helicopter business?" Scott asked.

"Not good but we're staying above water." Terrible pun, but after

seeing what had happened to the island I decided to keep my mouth shut. "That tsunami was bad. It killed the tourist trade. If it weren't for the contracts we have with UH and the USGS, we'd be in the same position as our competitors: bankrupt."

Now I understood the reason for the scenic route. Icky was padding the hours so he could bill the university for more time. I couldn't blame him. I'd do the same thing. Besides, we were getting a great tour of the island.

The Hawaii Volcano Observatory sits about 4,000 feet above sea level on the rim of the Kilauea Calder. As we worked our way up the side of the massive volcano, Icky gave us a running commentary on the recent eruptions that had occurred. Before we got to our final destination, Icky had something special he wanted to show us. Pu'u O'o is a vent on the side of Kilauea that has been erupting continuously since January of 1983. Icky said that Pu'u O'o had produced over 2.7 cubic kilometers of lava that had covered over 100 square kilometers of the island, besides adding around 230 hectares to the Kalapana Coast. I was too embarrassed to ask how large a hectare was. I assumed it must be about the size of a normal acre. I found out later it was closer to three acres or 10,000 square meters.

As we flew over the black lava fields, a cone shape hill with half a side missing came into view. Icky piloted our helicopter to the center of the cone where he stopped and hovered directly over the open vent of the world's most active volcano. The hole beneath us could have easily swallowed the little Hughes 500. Looking down, there was no way to tell how deep the gaping maw directly below us was. The fiery orange lava in the bottom came up the sides of the vent and eliminated all points of reference. From our rather precarious vantage point, the only thing that came to mind was the fiery gates of hell. It occurred to me that our half-crazed pilot might be the devil's delivery boy.

I glanced over at the engine gauges. The little black arrows on the gauges labeled Torque, Turbine Temperature, and Turbine RPM were in the yellow and not the green, something didn't seem right. The arrows hadn't reached the red portion of the gauge, but what if there were a problem? What if we got a little air in the fuel line? Or what if the big gas turbine sitting behind Scott gave a hiccup? Instead of Chuck Palmer, I'd be chuck roast.

That's when portions of my past, particularly the more pleasant ones where I had sinned the most, began to flash in front of me. When I turned to look at Icky I could have sworn that our smart-ass pilot had grown a set of horns. I poked him in the shoulder to get his attention. Icky glanced over at me as I pointed at the offending gauges. All he did

was smile and shrug his shoulders.

The noisy helicopter continued to climb up the side of the volcano until we arrived at a 400-foot deep hole that was over two and half miles in diameter. The giant Kilauea Caldera was impressive. We flew directly over the immense hole to the northwest rim where Icky gently set the helicopter down on a small pad of asphalt next to the volcano observatory parking lot.

Scott and I got out with the rotors still turning and the engine running. "I need to run back to base to re-fuel." Yelled Icky.

"We only need to be here an hour," Scott hollered back.

"Not a problem. I'll be back in plenty of time."

The Hawaiian Volcano Observatory, or HVO, is a long low building that shares its main structure with the Jagger Museum.

I was amazed at how close the museum was to the rim of the volcano, and asked Scott. "What were they thinking, maybe cook a few tourists?"

"Naw, we like our tourists raw. Kind of like sushi, but without the rice."

"Sashimi tourists. Never had it."

We walked around the back of the building to a single green metal door. Scott rang the doorbell and a few seconds later a voice came over the little speaker next to the door advising us that we were being buzzed in.

Scott and I walked into a large brightly lit room with a spectacular view of the caldera. Beyond the giant hole lay miles of barren lava fields extending down to the Pacific. I was surprised to hear John Coltrane's soulful rendition of "My Favorite Things" reverberating through the rafters. James Jordan walked over to greet us wearing a white lab coat and Reebock running shoes. He was my height with an athletic build, close-cropped hair, engaging smile, and classic African American good looks. He couldn't have been more than thirty years old, which surprised me even more given his taste in music.

"So you like Coltrane?" I asked.

"He's the man. A lot of great musicians out there, guys like Miles, Lionel, or Charlie Parker, but does anyone have a better sound than Coltrane?"

"You have a point."

"Jimmy, I'd like you to meet my friend Chuck Palmer. He's going to help me survey that new tension crack I've been mapping."

"Good to meet you. Sorry to hear you got stuck helping this guy." I was starting to get a message. Was one automatically cursed when working along side Scott Richardson? "Be careful," Jordan added, "He could

get you killed. The man's half crazy."

"Tell me about it."

"So, Jimmy, what's going on with our girls? Have they been behaving themselves?"

"To tell ya the truth they've been a little restless lately. Could be a bad case of gas."

What were these guys talking about? What girls? What gas? "Ah, excuse me guys. Do you mind filling me in? I thought I was putting my life in the hands of that insane helicopter pilot and this crazy professor so I could learn about volcanoes and tsunamis. Are you now telling me I'll be working alongside some girls with a bad case of gas?"

Jimmy proceeded to tell me about his girls. "We're talking about volcanoes, Mauna Loa and Kilauea. Those are my girls and lately they've been rocking."

"You see, Chuck, Jimmy here is a doctoral candidate. His thesis is based on this wild ass theory that the magma chambers for Mauna Loa, Kilauea, and Loihi are all interconnected."

"Loihi. What's a Loihi?"

Scott turned to Jimmy. "You'll have to excuse my friend, he's a little slow." Then he turned back to me. "You don't know about Loihi? Loihi is the next Hawaiian Island. It's about fifty miles due south of here." I knew that the Big Island was the last island in the Hawaii chain. There wasn't any island fifty miles south of here. What the hell was Scott talking about? "The top is about 3,200 feet under the Pacific. Jimmy tells me that in another 200,000 years or so it'll break the surface and become the next Hawaiian Island. Can I interest you in some ocean front property?"

"I'll pass." Just as I was going to ask Jimmy about his job at the observatory, the floor began to shudder, as if a large truck had driven by. Then things really started to shake. Instinctively I widened my stance and bent my knees. Dust began to fall from the light fixtures swinging back and forth over our heads. The bookshelves swayed as the computers bounced around the desks. Scott just stood there as if nothing were going on, but Jimmy began to thrust his pelvis forward while jerking his bent elbows and clenched fists back and forth. "Come on, baby, give it to me. Give it to me, baby. Come on, baby. Rock that mother."

The earthquake couldn't have lasted more than fifteen seconds. When things finally settled down, I asked Scott, "Hey, what's with your strange friend?"

"Oh, don't worry about Jimmy. He gets that way whenever there's an earthquake." Jimmy was all smiles, half exhausted from his carnal escapade. "You see he's got his ladies completely wrapped up in geophone

arrays, seismometers, and tilt meters."

"Okay, so he's a little kinky and likes to tie up his girls. What's he do in his spare time, and what's a geophone?"

"Jimmy, you wanna take over from here?"

"Sure, and I'm not that kinky. Besides my girls like being tied up." Jimmy continued to smile. "Think of a geophone as a microphone that listens for seismic waves in the earth. The geologists and geophysicists here at the observatory laid out strings of them over the surface of the volcano. Each string was then connected to a recording device. Normally we create our own seismic waves by shooting off explosive charges, but we're not allowed to around here."

"Why's that?"

"Because the native Hawaiians are very sensitive about disturbing their goddess Pele."

"You should hear Sammy." Scott interrupted. "The guy doesn't even want me diving around her thermal vents. I can't imagine what he'd do if he found out our friend here has the old girl tied up in geophone arrays."

"As I said, with the restriction on generating our own seismic waves, the only thing left to do is wait for an earthquake to make the waves for us."

"Okay, but what do you do with the seismic waves once you have an earthquake?"

"We measure the differences in times it takes them to travel through the various layers of the volcano. That allows me to determine the underlying structure."

"Got ya. So you can't complete your work without the earthquakes?"

"Exactly. But just a couple more good shakes and I'll have all my data."

"And you like tying up your girls?"

"Now we're talking."

Jimmy stepped over to his desk to show us his work. A partial cross section of the Big Island was displayed on his computer. It ran from the top of Mauna Loa to Kilauea to the offshore seamount of Loihi. Jimmy had drawn a number of lines through the cross section that indicated interfaces between solid rock and liquid lava. None of it made sense to me but it did look interesting. At least I understood why all the excitement when the earthquake hit.

Besides the long strings of geophones, Jimmy also showed us where the U.S. Geological Survey had placed seismographs, tilt meters, and GPS survey points all over the southern portion of the Big Island. Manua Loa and Kilauea must be the most wired volcanoes in the world.

"You guys won't believe what's been happening around here. I mean

'This Joint is Jumpin'.' I loved the reference to the classic Fats Waller piece. "We've had literally thousands of micro earthquakes in the last few weeks. The tilt meters above the ten thousand foot level and along the sides of Manua Loa are showing expansion at a rate never seen before. In just the last week the top portion of Mauna Loa has bulged another half meter." Jimmy looked at us with a glint in his eyes. "I'm thinking that my big girl may be getting ready for another eruption, something that hasn't happened since '84."

Jimmy showed us where he thought magma was rising along a 30-mile front in both the northeast and southwest rift zones. He also said that the magma production from Pu'u O'o had increased significantly in the last week from 250,000 cubic meters per day to over a million.

"I'm telling you, something big is about to happen. I've never seen it this active."

Scott wasn't nearly as excited about Jimmy's girls. "That's great, but I didn't fly all the way down here to get the latest gossip on your girls. We've got a problem. That crack I've been mapping is starting to head off into deep water. I can't get down to it safely using tanks. We need to find a place where I can dive on it in shallower water."

Jimmy pulled up the same map that Walt had shown us back on Oahu. A heavy black line delineated the ten-mile long gash that Scott had already mapped.

"If you're going to find that fissure in shallow water it will have to be off of one of these points." Jimmy pointed to a couple of the promontories Icky had flown us over. The same places where I almost tossed my cookies. "I think your best chances are right here at Pu'ulou and the next point west at Kalaepa'akai." Scott took out a small note pad and wrote down the information.

"Any idea how deep? We're using air, no mixed gas. We're pretty limited."

"I'm hoping no more than a hundred and fifty feet. Maybe a little more."

"That's not so bad, I was thinking as deep as 200 feet. Let's give Walt a call. See if he can live with it."

Jimmy sat down at his computer, "We'll use the video conference line." Then he typed in Walt's number. Thirty seconds later we were talking to Scott's friend through the monitor as if he were right there in the room with us.

"Jimmy, how's it going down there? We just picked up a nice little tremor. We're calling it a 6.2 for now."

"Hey, that's great. We've been having nothing but fun down here."

"By the way, have you got those cameras set up along the upper rift zones yet?"

"They should be online by tomorrow. I've got Sheila and Cammie working on it. As soon as they're up and running, I'll stream you some video."

"Great. The stuff we've been getting from Pu'u O'o and down by the water looks fantastic."

"I've got a couple of your castoffs here. You know these guys?"

"Sure. The tall one's okay, but I'd throw the short one in the volcano. He's nothing but trouble, make a great sacrifice."

"Sorry, I can't help you. Pele only accepts virgins. She's very picky. Probably just toss him back. Listen, I need you to pull up your map of the Kalapana Coast. Scott here has a problem."

We only had to wait a few moments. "Okay. Got it."

"His tension crack is starting to run off into deep water and he's having problems diving on it. I figure he should be able to find it in shallower water off of Pu'ulou and the next point west at Kalaepa'akai. He wants to know if that's going to work for you?"

Walt studied the map for a few moments. "That's an awful lot of uncharted water, but if that's the best he can do I'll live with it. Too bad we can't get him more bottom time in a submersible."

"That, or tie an anchor to his foot and throw him over the side."

"You know, Scott, I'm feeling an awful lot of love here. Don't you just want to wrap your arms around it and squeeze?"

"Actually I was thinking of putting my hands around a few necks and squeezing."

We left Jimmy in his office. Icky hadn't returned yet so we jogged down a path to the edge of the Kilauea caldera. The views were spectacular. Down in the very bottom of the giant hole and along the sides were numerous vents where white columns of steam escaped from the broken and burnt lava. There was even a small vent next to the path where the distinct smell of sulfur dioxide—rotten eggs—was escaping.

Native Hawaiians had placed offerings to Pele all along the path, mostly fresh fruit and incense. I thought about taking an orange. We jogged back to the parking lot when we heard Icky's helicopter approaching. The oversized black insect with the rainbow stripes on the side came swooping in from the east. Once again, I took the front passenger seat. Scott instructed Icky to take us down to the two points where Jimmy thought we might be able to find the tension crack. He wanted to check the places out from the air.

Icky headed out over the caldera to the southeast. We skimmed across the face of the volcano, with the sparkling Pacific as a background to the stark lava fields. Once we passed Pu'u O'o there were breaks and slits in the tortured black rocks where we could see orange molten lava

moving underground through a network of tubes and fissures.

From the air we checked out the two dive spots Jimmy had suggested and then headed north back to the harbor. Off to my right in the distance, I could make out the sparkling white domes of the Keck Observatory on top of Manua Kea, almost 14,000 feet high. Icky said they only allow special four-wheel drive vehicles past the visitor's center at 9,200 feet. There's not enough air that high up to cool the brakes on a normal vehicle.

It was just over a thirty-minute flight to the parking lot at Honoko-hou Marina. Fortunately, our pilot had gotten all of the aerobatics out of his system on the trip to the observatory. We jumped out of the churning helicopter and ran to the edge of the parking lot. Icky hardly waited until we were clear of the rotor before he was in the air heading off to his base.

Scott and I walked briskly along the guardrail between the parked cars and the water on our way back to the Maka Hou. As we passed the large dark blue van with the cracked windshield, we were both surprised by our unnamed admirer. I had the distinct impression the stranger had something important to say. It may have been the gun he was pointing at us that gave it away, a very large semi-automatic, most likely a 9mm. But then again, any gun pointed at me by definition was large. Our new best friend wore gray slacks and a half unbuttoned white dress shirt. With a long nose and chin, slicked back hair, and narrow eyes, he reminded me of a rat. I figured it probably wasn't a good time to bring up our friend's rodent ancestry. He stared at us through Ray-Ban sunglasses, with rings of dark sweat staining the underarms of his rumpled shirt and perspiration dripping from his forehead. Standing way too close, sweating like a stuck pig, he couldn't even control his shaky hand. The guy was an amateur.

Scott glanced at me quickly and I knew he had seen all that, too. "Hey, buddy, is there a problem here?"

"Yeah, there's a problem. I got a couple of extra slugs in this gun that are weighing it down. Maybe I need to unload them into a couple of shit-heads like you."

Oh crap, that dumb son of a bitch shouldn't say that kind of stuff. He was just gonna piss Scott off. This was not good. You got my friend mad and he could do some crazy bad stuff.

Scott turned to me. "Did you just hear what this asshole said? He called us a couple of shit-heads." I shrugged my shoulders. I'd been called a lot worse, and by guys that weren't pointing a gun at me. Scott shook his head slowly at the rat. "I've got news for you pal, the only stupid piece of crap around here is you."

Oh great. I knew what was about to happen. I started to mumble

under my breath "Come on, Scott, don't give this guy any lip. Just listen to what he has to say and he'll go away." But even if I were screaming in his ear, Scott wasn't about to take any crap from a guy standing too close with sweat dripping off his forehead and shaky hands.

I was on Scott's right side next to the guardrail, trying to figure out where I should be. My old combat training was running through my head at lightning speed. Son-of-a-bitch, I think I'm supposed to be on his left side. Was I going to be in the way? How the hell do I get over to his other side without being too obvious?

"I don't need any trouble from a couple of assholes like you. I've got a message for you from some very unhappy people. The people I work for don't like to be ignored. They get pissed off when they go out of their way to give someone a few little hints and those assholes just ignore them." I was relieved to hear we were only receiving the little hints. I would hate to see what the big ones were like. "My boss says you guys are going to put a lot of good people out of work with this investigation of yours."

While I'm trying to figure out where to stand, Scott, in a single slashing blow, strikes Rat Face's right hand, the one holding the gun. It goes off with a loud roar and the sound of breaking glass. In the same motion, my old Navy Seal buddy jabs his left hand into the rat's throat. The little prick crumbles to the ground like the sack of crap that he was, and drops the gun. Scott pounces like a cat on a mouse, or in this case a rat.

I knew that stupid son-of-a-bitch shouldn't have pissed Scott off. If there's one thing Scott couldn't stand it was incompetence. This guy didn't know his insignificant rat's ass from a hole in the ground. Didn't they teach him anything? When you're holding a gun on someone, you don't stand right in front of him; take a couple of steps back. If you don't, you're just asking to have the gun slapped out of your hand. Even if the guy were as quick as Scott, there was no way his mind was going to tell his finger to pull the trigger fast enough. At least that's true ninety percent of the time.

"Chuck, get the gun."

I ran over and picked up the gun lying between the van with the broken windshield and a white Ford Focus. "Here." I handed the 9mm Berretta to Scott, and he shoved it into the guy's left temple. It was time to have a little fun so I asked, "Are you going to shoot this, prick? Because if you are, I'm getting out of the way. Do you have any idea how big a mess you're gonna make?" It was hard to believe how much the guy was shaking. He looked like he was ready to go into cardiac arrest. "You pop this guy and there's going to be blood, brains, and bone flying all over the parking lot. Well, maybe not any brains, but whatever he keeps between

his ears is gonna make a mess. Then again… it would be interesting to find out what he keeps up there?"

"Yeah, I was thinking the same thing. Sounds like you're as curious as I am."

"Should we find out?"

I had to admit that despite having this incompetent rube point a gun at me fifteen seconds ago, I was having a hell of a lot of fun with him now. "Whatever, but we're still talking about a lot of gore. I didn't bring an extra change of clothes and I'm sure as hell not doing any laundry, especially yours. So plan on washing your own clothes. I'm on vacation."

"What if I let him get up so he can run away? I could shoot him in the back. Then we'd be okay."

"Works for me, but then we'd never know what's between his ears. Do you think you could pop him in the head when he tries to run away?"

"Hell yes. That'll be an easy shot."

"Oh crap, will you look at that? Our friend here pissed his pants. Ya know that's just not right. What, did you forget your Pampers?" I knew Scott wasn't about to shoot the fool, but Rat Face didn't know that. Of course, it didn't help that Scott had a gun shoved up against his head.

Rat Face began to sob. I was almost embarrassed for the guy. If he hadn't pointed that gun at me, I probably would have been. "They made me do it. I swear I didn't want to. Please, don't shoot. I have a wife and kids."

As much fun as we were having, Scott was still pissed. He didn't like it when people pointed guns at him. "You listen to me, you stupid fuck. I'm out there busting my ass so that jerks like you, your cute little kids, and that wife of yours with the big butt…" How did Scott know how big his wife's butt was? "…will have some warning the next time a tsunami strikes, because the next wave is going to be over 600 feet. If guys like me can't give stupid fucks like you any warning, then you and your lovely family are all gonna die. Now get out of my face and go tell your unhappy friends to stop worrying about the tourists and start worrying about their own necks."

Scott dropped the magazine out of the pistol and un-chambered the round in the muzzle. The bullet went flying through the air in a looping arch, which I caught in mid-flight. Scott handed me the magazine that I dropped along with the single round into the water. We left the guy lying on the ground sobbing and headed back to the boat. Before we got ten feet, Scott turned and yelled.

"And change your pants. A grown man… son of a bitch."

Once the fun was over, I was still pissed at my friend. With the plane almost falling out of the sky and getting run off the road, having some

joker point a gun at me was the last straw. "God damn it. This is bull-shit. You didn't say anything about getting run off the road or having some asshole point a gun at me. I'm out of here."

Scott was so mad his earlobes had turned red. "Hey, what's your problem? You heard what that guy said."

"The only thing I heard was a gun shot, and it came from a gun that was pointed at me less than a second before it went off. You don't need my help. What you need is a psychiatrist, besides you heard what Jimmy said, a hundred and fifty feet. Go find some amateur hack in Kona to help you dive on your damn crevasse."

"It was not."

"What are you talking about?"

Of course Scott was happy to explain. "The gun. He was pointing the gun at me." I threw my hands in the air and shook my head in dis-belief. "What's with you? The guy said his friends were sending us a hint."

"Right, so take the damn hint. Quit messing with these people. You're just gonna piss them off."

"They're already pissed off. Listen, you owe me."

"Oh crap. What are you talking about now?"

"What about all those times I saved your over-sized ass when we were in the Philippines? Remember the time that guy was about to slice your sorry head off in that bar next to the Shit River?" Scott was refer-ring to a minor misunderstanding I had with the proprietor of a friendly drinking and social establishment in Olongopo City. The city dumps its sewage directly into the river, hence the name.

"First of all, that guy was going to slice off something a little lower down. Second, how was I supposed to know that was his wife? And third, all you did was rap the guy over the head with a half empty bottle of Jack Daniels."

"Yeah, and you never paid me back. That guy was gonna come look-ing for us when he got out of the hospital. It was a good thing the Sore Penis pulled into Subic that night." It's actually called the John Sore Penis. Scott was referring to CVN-74, the U.S.S. John C. Stennis, one of ten Nimitz-class super-carriers. Once, when the Stennis made a port call in Australia, the crew packed the local brothels to the point it was ru-mored that some had to close temporarily to give the girls a rest. I'm sure Senator Stennis is doing somersaults in his grave.

"Fine, I'll pay for your damn bottle of J.D., if that'll make you happy."

"That's not the point." Scott looked like he was ready to rap me over the head with a bottle of J.D.

"Then what is the point?"

"We're friends, and real friends help out even when they may not like it or want too."

Son of a bitch, what could I do? Scott just pulled the old friend thing on me, but he was right. We had shared an awful lot of adventures together, and it was Scott that got us out of trouble most of the time. Of course, it was mostly Scott that got us into trouble, too. "Oh crap. Fine. I'll help you find your crack. Just look where you shove your head."

"You're probably right, but for now I'm more concerned about a different crack."

I wasn't convinced I had made the right decision, but decided I'd have to live with it for now. By the time we stepped on board the Maka Hou, Scott was back to his old self, but my nerves were shattered. I needed a stiff drink, and all we had was beer. A nice comfortable boat ride down the coast would have to do. Sammy was up on the flybridge cleaning as we jumped into the cockpit.

"Hey, I thought I heard a gun go off. Did you hear anything?"

Scott and I looked at each other and shrugged our shoulders. "No," we said.

Sammy had this puzzled look on his face. "That's strange. By the way, some guy was down here looking for you this morning. Said it was important. Did you see him?"

Scott replied. "Yeah, we met him in the parking lot."

"What he want?"

"Said he needed a bathroom."

SEVEN

SCOTT AND I UNTIED THE DOCK LINES so that Captain Sammy could maneuver the Maka Hou out of her slip. In a matter of minutes, we had powered through the tiny marina and past the breakwater. White foam curled off the bow as we headed towards South Point. With only a light breeze to disturb the Pacific swell, I looked forward to a relaxing trip. The GPS showed we were making just over 23 knots on a heading of 165 degrees. I asked Scott about fishing. He said not until we were further south.

We continued down the rugged coast past Kona-Kailua, the Kona Coast Hotel, and half a dozen small resorts. Sammy finally slowed the boat when we were off of Kealakekua Bay. From the flying bridge, we could just make out a white monolith.

"That's where native Hawaiians killed Captain Cook," Scott told me.

Sammy said, "Dat Captain Cook no naispela man."

"What did he just say?"

"He didn't think Cook was a very nice guy."

"Why not?" I asked.

Sammy looked at me with a scowl. "Damn haole all da same. I tink him kolohe."

"But didn't they eat..."

Scott jabbed me hard in the ribs and interrupted. "You know, Captain Cook was British. That piece of land where the monument sits was deeded to the Brits before Hawaii became a state." Then he muttered to me, "You dumb shit white boy. Do you want to get us killed?"

"Look who's talking? Need I remind you?"

Scott ignored me and swung down the ladder from the flying bridge into the cockpit. He went into the main salon and brought out a short but stout fishing pole. There was a large green and white feather lure attached to the heavy line rolled up on the oversized reel. Scott threw the line and lure into the water and proceeded to let it out. When the lure was skipping across the wake maybe fifty yards behind the transom he locked the reel and placed the pole in a holder. Then he climbed back up

to the flying bridge. Sammy slowed to eight knots. As the boat began to roll so did my stomach.

"Hey, this sucker's starting to get to me."

Scott saw me clutch my middle. "Hard to believe you were once in the navy." He pointed to the cockpit below. I pointed back with my middle finger. "Spare us your puking. Go down there where it doesn't roll as much." My stomach was more important than my pride so I went down the ladder and settled into a plastic chair.

We continued trolling for almost an hour without any action. Scott stayed with Sammy up in the bridge where they had a rather heated discussion. I couldn't make out what was being said, but there was a lot of hand waving. After an hour of rolling and bouncing in the Pacific swell, the pallor of my cheeks matched the blue green color of the water. Suddenly a fish hit the lure and line started to whiz out. The sound triggered a shot of adrenaline in my veins, and I forgot about being sick. The reel began to sing as our dinner raced from the boat. Scott yelled at me to grab the pole and set the hook. I jumped out of my seat, removed the stubby pole from its holder, braced it against my body, and yanked back hard on it. I'm not sure if the supposed setting of the hook does any good, but with my biceps bulging and my six-pack abs flexed, it sure made me feel manly. Sammy brought the boat to a stop while I fought the fish. Scott came down to offer encouragement.

"Come on, you big pussy. Pull the fish in, we don't have all day."

"Oh, screw you. This mother doesn't feel like cooperating." I continued to put all my weight and strength in to the fight, first raising the tip of the pole over my head and then slowly letting it back down as I reeled in the line. The fish gave up before I did, and soon it slowly swam behind the boat.

"Hey look, it's an Ono. You better not lose our dinner."

The evening's forty-pound dinner was long and silver, and the proud owner of a razor sharp set of teeth. Sammy came down from the bridge and put a glove on his right hand. When I asked if he was related to Michael Jackson, he didn't have a clue what I was talking about. Sammy picked up a club, leaned over the transom, and grabbed the line with his gloved hand. He pulled the head out of the water and whacked our dinner. He hit it a couple of more times for good measure, all the time mumbling something about haoles. When he was sure that the mouth full of teeth wasn't going to grab any of his guests, Sammy unhooked the line with a set of pliers and threw the fish into a large ice chest. With our dinner safely stowed, Sammy, Scott, and I went back up to the flying bridge.

Sammy re-started the engines, and we headed south at 23 knots. As we got closer to South Point, we saw fewer homes and no resorts along the shore. Eventually we left behind all signs of civilization. This part of the Kona Coast made me feel even more insignificant than usual, which is saying a lot. Everything seemed larger, even the ocean appeared bigger, darker, and deeper. The sides of the volcano came straight down to the water. Mauna Loa was so high that unless I made a conscious effort to look up, the blue sky was beyond my peripheral vision. As we continued down the coast, I started to wonder about the lava flows on the side of the mountain. Some of them looked like they were deposited yesterday, a lifeless black with no visible growth. Others looked like they had been there a million years, covered in a lush green carpet of vegetation. I wondered how long it takes Mother Nature to vegetate a lava flow. Was it a hundred years or ten thousand?

After two and half hours of running, we finally made it to South Point. The wind had continued to increase along with the seas. The further south we headed the more Sammy had to slow down. Fortunately, the really uncomfortable rolling only lasted a half hour. Puu Mahana was off to our left and looked much different from the boat than from Icky's helicopter. Still, the bright green beach in the center of the cinder cone was impossible to miss.

Sammy drove the Maka Hou under a long vertical cliff at least a 100 feet high. The mottled gray basalt pali, as the locals call them, was the northern boundary of the most southern point of land in the U.S. The wind whipped over the top of South Point, screaming past our heads. Then it dove straight down fifty yards from the stern of the boat, striking the water in swirls of white spray. While we cruised along the bottom of the cliff in flat calm water, the ocean a hundred yards further out was thrashed by the violent down drafts.

The shoreline along the bottom of the cliff was nothing but a pile of huge boulders, some as large as a car. When I looked down through the crystal clear water, the sea floor under the boat was covered with more large boulders. The bottom sloped steeply away from the shore. If we dropped an anchor over the side, it would surely get caught between the rocks. When it came time to leave, someone would have to dive down and pull it free.

Sammy placed the engines in neutral and Scott announced, "We're here. Feel like going over the side and tie us to the mooring?"

"What mooring?" I didn't see a buoy or anything else to tie to. What was Scott trying to pull now?

"It's right there." Scott pointed just past our bow.

"Stop yanking my leg. How are we ever going to anchor over this rocky bottom?"

"Seriously, our mooring is right there. Ok, maybe it's ten feet under water, but it's right there."

"Who puts a mooring ten feet under water? That's the dumbest thing I've ever heard."

"Wrong. This way only the locals know where it is. It's illegal to drop an anchor around here. The cops catch you and there's a big fine."

"Oh, brilliant."

"Hey, it helps keeps the tourists away. Besides you know who put all the moorings in around here?"

"Your friend the governor."

"Are you kidding? The only mooring he has is up his ass. It was Jerry Garcia."

"A pint of ice cream put in your moorings?"

"Not cherry, you idiot, I said Jerry, as in "The Grateful Dead" Jerry Garcia."

"Jerry Garcia put the mooring in? Right."

"I'm serious. Actually, it was the whole band. They're all big time divers and they donated the money to install most of the underwater moorings along this coast. Pretty cool, isn't it?"

"Yeah, I'd say that qualifies as almost amazing. So you want me to jump in the water and tie us up to a buoy that's ten feet down?"

"Yes and no. You need to jump in the water, but the buoy is just a marker. It's attached to a small line that's tied to a steel ring drilled into a large rock on the bottom. At this spot it's down about 105 feet, so you may want to use a tank."

"I'd say that calls for a tank. Let me get a bathing suit on. Do you mind getting my gear ready?"

By the time I was back on deck, Scott had a buoyancy compensator, or B.C., and regulator attached to one of the aluminum dive tanks that had been tied to the stern of the boat. I turned the valve on top of the tank and checked the pressure gauge. It was full, just over 3,100 pounds. Scott lifted the tank onto my back and handed me pliers to tighten the shackle at the end of the mooring line.

With a quick backward roll off the side of the boat, I was in the water. No matter how warm the ocean, there was always that shock of cold when I first dove in. It only took a few moments before my body acclimated to the tropical water. It sure felt great to be in the ocean after a long day, particularly a day like the one I had just had. I swam around to the front of the boat where Scott handed me the end of the mooring

line. I grabbed it, blew the water out of my regulator, and headed for the bottom.

The little orange mooring buoy was directly below me. How the hell did Sammy know where it would be? It took me less than two minutes to follow the thin buoy line to the bottom. Scott was right, my depth gauge read 106 feet, yet when I looked up at the surface it seemed like I could reach out and touch our boat. It had been a long time since I had seen water this clear, and over two years since I'd put on a tank. Comfortably floating just above the bottom, I unloosened the pin on the shackle and placed it over the steel ring that had been grouted into a large rock. Then I took the pliers out of my B.C.'s pocket and tightened the pin on the shackle. When I was done, I decided to work my way up the sloping bottom rather than back up the buoy line. That way I could spend some quality time checking out the local fish. It was getting close to sunset, my favorite time of day to be in the water. The sea life is always more active just before dinner.

I started to head up the rocky slope when a dark shadow passed over me. I looked up and saw a giant manta ray lazily swimming not ten feet above me. The damn thing looked like a B-2 bomber, slowly flapping its wings as it silently glided through the water. Mantas are fairly curious animals, and if you stay still, sometimes they'll come over to investigate the stranger blowing bubbles. This one wasn't interested as he swam off into the distance.

Floating there motionless, I inhaled the beauty of the peaceful animal and my surroundings, but all of a sudden my breath was cut short. Shit... What happened? I looked at my pressure gauge. It still read just over 3,100 psi. After giving the gauge a good shake, it read 3,400 psi. That wasn't possible. The damn thing's broken; I must be out of air. Panic immediately reared its ugly head, the one thing that needed to be controlled. I reached back and quickly grabbed my spare regulator. There should be enough air in the pressurized hose from the tank to the mouthpiece to give me one small breath. With the remaining air in my lungs, I gave a short puff into the mouthpiece, cleared the water out, and managed to take a small breath.

Normally swimming a hundred feet underwater while holding my breath would not have been all that difficult. Unfortunately not having a full breath complicated things since the air I was able to suck out of the regulator wasn't much more than what I had used to clear it. I began my ascent trying to remember what they had taught me in my Navy BUD/s class. Rule number one: don't panic. Rule number two: control your ascent and breathe out as you swim to the surface. And rule number three:

when in doubt refer back to rule number one.

If I held my breath while going from over four atmospheres of pressure to just one, my lungs would begin to expand and ultimately explode like an over-inflated balloon. Fortunately, I hadn't been down long enough to worry about getting the bends.. I increased my rate of ascent while trying to force myself to breathe out. My body was starting to tell me it needed more oxygen. Excuse me, not telling; it was yelling. I had already used up the oxygen in my lungs. My internal survival mechanisms were starting to take over, demanding "Hold your breath, hold your breath," but my training said to breathe out. I continued towards the surface with stronger and stronger kicks. I couldn't have been more than thirty feet down when my peripheral vision began to narrow. A few more seconds and I would black out. My lungs were now crying for air. Screaming at me to hold my breath. That's when I remembered to look up while my legs continued to kick hard, driving me to the surface directly under the boat. If I hit it, I would be knocked out and probably drown. Angling my ascent slightly, I came flying out of water sucking in great mouthfuls of air. I had just survived a free ascent from over a hundred feet, an ascent that would have killed most recreational divers. Scott yelled to me as I surfaced.

"Hey, are you all right?" Gasping for air, my heart pounding, I couldn't answer. I made my way slowly over to the swim step on the back of the boat, gasping for breath.

"I'm, I'm okay. I ran out of air."

"You ran out of air? How's that possible? You checked your air pressure. I watched you."

Scott pulled me up onto the back swim-step where I sat trying to catch my breath while my legs dangled in the water. Still gasping for air, I showed Scott the pressure gauge.

"Look, 3,400 psi. Now watch." I shook the gauge one more time and it read 3150 psi.

"That can't be right."

"Where's Sammy?"

"He's up on the bow. Why? You don't suspect him do you?"

"Who else has access to the equipment?"

"Mostly Sammy, although that doesn't mean someone else couldn't have tampered with the equipment while he was off the boat. Maybe it was Mr. Pampers, or one of Sammy's friends."

The effort to turn and look up at my old friend was almost more than I could muster. It had been one more close call that I didn't need. "You know this friendship thing is starting to wear a little thin on me.

I'm about this close," showing him a sixteenth inch gap between my thumb and forefinger, "to getting off this boat." I've known Scott for over fifteen years, but his response surprised even me. The son-of-a-bitch pushed me back into the water.

"Fine. Leave. Kona's that way." Pointing out to sea. "You better start swimming now if you want to make your flight on Sunday."

I held onto the back of the step looking up at an enraged Scott Richardson.

"What the hell is wrong with you?"

Scott slammed his fist down on the boat's transom with a loud reverberating thunk.

"I'll tell you what's wrong. I'm sick and tired of all this whining. I just got done listening to Sammy whine for over an hour about what we're doing to Pele and her damn house. Screw that bitch."

"Is that what you two were talking about?"

"Yeah, if you want to call it talking. And all you've done is complain since you got off the airplane. Do you have any idea how hard it was for me to get you a ride on that submersible? I worked my ass off and called in a bunch of favors, and do I even get a thank you?"

Scott had a point. The chances of the average person getting a ride in a deep submersible were about the same as hitting the lottery. I've spent a lot of time under water, but never down 3,000 feet. It was a once in a lifetime opportunity. "Okay, I'm sorry, and thank you. I forgot about that and I really do appreciate it. Forget what I just said, and help me up." I reached my hand out for Scott just as Sammy was making his way back to the cockpit along the starboard gunnels.

In a low voice, I told Scott, "Listen, we need to check this equipment thoroughly before we use it tomorrow."

Sammy jumped into the cockpit as if nothing had happened. He went over to a deck hatch, opened it, and pulled out a small gas barbeque that he mounted on a bracket over the side of the boat. Meanwhile I used the fresh water shower on the swim step to wash the salt off. After drying myself, I was ready for a Primo or two, maybe a case. Scott began to prepare the salad while Sammy cleaned the Ono. I just sat in my plastic chair at the back of the cockpit and watched the schools of fish jumping off our stern. Before I knew it, Sammy had a couple of huge fillets cooking over the red-hot grill.

The three of us sat down to a meal of Ono, salad, and fresh asparagus spears. Oh yes, we also consumed a few beers though I'm not sure how many. The moon came up over the mountain as we finished our meal. Stuffed from all the fish, we just sat there staring at the water feel-

ing the pleasant buzz. We were all alone. There wasn't another boat in sight, not a building, a car, nothing. It was like being at the end of the earth. With the cliffs guarding us from the howling wind and the water reflecting the moon's rays, it occurred to me that this was paradise, be it a very lonely paradise. Then I thought about Lauren and Aubrey. If only they were here, it would have been perfect. Damn, I missed my wife. I've always enjoyed her company. I've always looked forward to seeing her at the end of the day. Could our relationship ever be the same?

By the end of the meal, no one was feeling any pain. Eventually Scott got Captain Sammy to tell us some stories about the ancient Hawaiian Gods. He started out with a story about Pele, how she had this fiery temper and was chased to the Big Island by her older sister after getting it on with her big sister's husband. Let's face it, besides being temperamental the girl was a bit of a slut. Sammy said that Pele was getting hot under the collar because of all the construction going on around her house, and she was particularly upset about her new neighbors. I assumed he meant the Asian tourists. In the past only royalty were allowed to visit her, now every tourist that sets foot on the Big Island had to pay his respects. The park was one of the most popular tourist attractions in the islands.

The story I enjoyed the most was the one about the God, Maui, and his mother, Hina. The way Sammy told it the old girl spent a lot of time drying bark to make cloth, and like any good mother, she also spent a lot of time complaining. Maui's mother complained to him about everything, including the sun crossing the sky so fast that she didn't have time to dry her bark. Being the good son that he was, and sick and tired of listening to his mother grumble, Maui decided to climb to the top of Mt. Haleakala. He sat there hiding behind a rock until the sun began to rise. As it came up over the mountain, Maui jumped out from behind the rock and grabbed its legs. He tied them to a Wili Wili tree so that the sun couldn't move. After much discussion and debate—it was one of those I'll-have-my-people-talk-to-your-people things—the sun and Maui finally cut a deal where the sun would not cross the sky so fast if Maui would untie him. Everyone was happy. Maui's mother could now dry her bark, Maui didn't have to listen to her complain, and the sunsets were much better. Now when the sun sets, you can still see the ropes that Maui left tied to the sun's legs trailing across the sky as a reminder of his promise.

Scott nodded enthusiastically when Sammy finished his story. "Captain Sammy, you should teach a class."

"Oh yeah?"

"No doubt about it. You should contact the Kansas Board of Edu-

cation about teaching a class right along side their classes on Intelligent Design." Scott went on about there being as much scientific foundation to support his story as there was for the theory of Intelligent Design. Professor Scott was obviously not a big fan of I.D. or of mythology.

Sammy agreed, "I'll look into that." Scott's sarcasm went right over his head. Must have been the beers.

It was getting late.

"Let's call it a night," said Scott.

After cleaning up Scott went to his cabin while I pulled out the sofa bed in the main salon. Sammy climbed back up to his perch in the flying bridge. Just as I was getting into bed, exhausted from the day's excitement, Sammy turned off the generator. The little diesel stopped for the night with one last shutter. Everything went quiet, however it wasn't long before boat noises crept back into my consciousness. The waves lapping against the hull, then a school of fish jumping behind us, and the annoying whir of the refrigerator fan in the galley all conspired to keep me up. I was dog-tired, but I couldn't sleep. Two near-death experiences in one day and a wife I wasn't sure I could trust anymore had set my brain into overdrive. I finally drifted off to sleep after hours of tossing and turning.

I have no idea what time it was when the high-speed drone of spinning propellers woke me. It was still pitch black out. Sound waves travel so well under water that it's almost impossible to judge distances by them. Once the boat slowed, I could hear the rumble of its diesel engines and knew it must be close. Then the props stopped. The voices outside were speaking pidgin. I couldn't understand a word, though I swore I heard Sammy's voice. With a strange boat right next to us, my mind went back into overdrive. Here we were, moored in over a hundred feet of water with nothing around. We might as well have been a thousand miles from nowhere, completely exposed and out of contact with the rest of the world. What if Mr. Pampers and his friends had decided to pay us a visit? Was this going to be another hint, or were they tired of hints? Did Scott carry any weapons on board? Not likely.

I jumped out of bed and went to the port side of the salon to peer between the curtains. The mystery boat was right there, not ten feet off our side. It looked about the same size as the Maka Hou, and three large men stood on the rail. It was so dark I couldn't make out their faces. None of the men appeared to have Mr. Pampers' build, but maybe Rat Face was down below getting his rocket launcher ready. I abruptly closed the curtains, went forward, and knocked on the door to Scott's cabin.

"Scott, you awake?"

"I am now. What's up?"

"There's a strange boat outside with three guys on it. They're just sitting there, not moving. I think they're talking to Sammy."

"So?"

"What do you mean so? We're out in the middle of nowhere. What if it's the governor or his buddy Mr. Pampers? In case you hadn't noticed, you've made an awful lot of enemies around here."

Scott stomped out of his cabin wearing just his boxer shorts. He walked right past me into the galley, opened up the fridge and pulled out two six packs of beer without saying a word. Then he marched through the salon and out the sliding glass door to the cockpit.

Scott called to the men. "Eh brah, howzit? You lilibit long dring?" He tossed the two six packs to the guys in the back of the boat. The three men waved as their boat slowly moved back into the pitch-black night.

EIGHT

THE NEXT MORNING, I ROLLED OUT OF BED to the smell of coffee filling the cabin. While I enjoy its nutty aroma, I don't drink the stuff. Mother use to say, "It'll stunt your growth." I'm six-foot four-inches so maybe she was right. Our plan was to check Scott's fissure in the morning and then head out to the university's research vessel the Kilo Moana in the afternoon.

As soon as I finished a bowl of Raisin Bran and a mango, I stepped outside into the cockpit. It was another incredibly bright day with only a few clouds resting up against the mountains to the east. The wind hadn't picked up yet so the ride out to our first dive site would be easy. As Sammy started the engines, Scott and I tied an orange buoy to the end of the 5/8-inch nylon mooring line and threw it over the bow. When Sammy returned tonight without us, he'd only have to grab the buoy to tie off the boat.

Walking from the bow back to the cockpit, I told Scott, "After yesterday's little diving fiasco, you better be meticulous with the equipment inspection or you'll be going down without a partner."

"Get over it."

Once clear of the mooring line, Sammy put the engines in gear. I could see every rock and crevice below us as we slowly motored along the sheer cliffs waiting for the engines to warm up.

While we were still in calm water, Scott helped me pull the heavy air compressor out of its permanent storage space in the bilge. The little compressor came to life after a couple of hard pulls on the starter cord, and I began to fill the tanks. The first tank was the one I had used the day before. The pressure gauge on the compressor showed the tank was absolutely empty. The rest of the tanks had less than 500 psi instead of the 3,150 psi they were supposed to have.

Scott took our regulators and miscellaneous equipment into the main salon where he set up shop on the coffee table. He showed me where someone had tampered with my air pressure gauge and had also done same to his. "Someone knew what they were doing. I doubt it

was Captain Sammy. Hell, he has enough trouble keeping the engines running."

"Oh great. Now I get to worry about the Maka Hou as well as our dive equipment."

Once we rounded the point, Sammy headed the boat in a northeasterly direction paralleling the shore. The swell and wind chop continued to pick up, but considering that we were out in the open ocean it was still a nice day. Scott inspected our equipment and despite his dismissive attitude, he had taken yesterday's incident seriously. He did a thorough job tearing down the regulators and gauges and putting them back together. Other than the two damaged pressure gauges, he didn't find any more problems. Still, I wasn't thrilled to be entrusting my life to equipment that had been tampered with. The good news was I'd be diving with Scott, and if there were ever a problem, he'd be the guy I'd want as my dive buddy.

After we completely inspected our equipment and filled all the tanks, we went up to the flying bridge to join Sammy. Scott had already plotted our drop off points on the GPS for today's dives. It took us just over an hour after rounding South Point to reach the first site. Sammy continued to check the chart plotter to ensure we were directly over our first spot.

Before going in, we double-checked and re-checked each other's gear. I stole a quick look over the side and could just make out the bottom. I could also see that there was a pretty strong current running. I guessed around a knot and a half. Scott had explained to me the night before that we would be doing drift dives and that Sammy would follow behind us watching our bubbles. I hadn't realized how far offshore we would be.

"Scott, did you ever see that movie Open Water? You know the one about the divers that are left out at sea."

"Why? Are you worried?"

"After what happened yesterday, it occurred to me."

Scott pointed at the shore due north of our position. "It's less than half a mile. You don't think you could swim that far?"

"You have a point. So what's the dive plan?"

"As soon as we hit the water, head towards the bottom. With this current, don't bother to inflate your B.C.; we'll just get separated. We should be directly over the fissure. It's about three feet wide and ten feet deep so it shouldn't be hard to spot." Scott was in his element. "I want to stay about twenty to thirty feet off the bottom in around sixty to seventy feet of water. That way we'll be able to stay down longer than if we dive right along the edge of the crevice. We'll take it easy, and drift with the current. I've nailed some markers into the sides of the fissure. You

can't miss them. They're orange and have a small buoy floating above them."

"What do you use the markers for?"

"You'll see when we get down there."

Scott sat on the port side of the cockpit and I took the starboard. We adjusted our masks, took a couple of breaths through the regulators, and gave each other a thumbs-up. We each did a backwards roll into the water, and headed towards the bottom. Scott was off to my left. Once we were down fifty feet the water cleared up as the ocean floor spread out before us. It was a gently slopping plain of black lava rock with hardly any coral and even fewer fish. As far as interesting things to see, this wasn't going to be a great dive. Directly below us was a large canyon, maybe thirty feet wide and sixty deep. The canyon ran parallel to the shore and looked as if someone had taken a knife and cut the lava plain in half. I kept looking to either side trying to find Scott's fissure. We continued heading west at sixty-five feet, drifting with the current through the warm tropical water directly over the large chasm.

We hadn't been in the water ten minutes when Scott headed down to the edge of the canyon. I still didn't see the fissure but I followed him anyway. That's when I saw it. Directly in front of us was a plastic orange marker maybe five inches square that had been nailed into the vertical wall of the ravine. Floating five feet above the marker was a white ball, maybe seven inches in diameter. The three-foot fissure was now the thirty-foot wide canyon we had been following. Scott didn't need a tape measure to determine if there had been any movement. This had to be a problem.

It was obvious the fissure had grown into a chasm. Scott still wanted to measure exactly how much movement there had been. I held the tape against the head of the nail in the center of the orange marker while Scott swam across to the opposite side of the gully. Once he was on the other side he lined up the tape so that it was perpendicular to the vertical wall with the marker. He wrote down the measurement on a white plastic board and then reeled the tape back in. With our first measurement complete, we headed back up to our sixty-five foot depth. We continued measuring the canyon at each marker until we were both down to less than 500 psi of air. We slowly ascended making a three-minute safety stop at fifteen feet. I knew we'd been pushing the envelope. Another two minutes and we would have gone into a decompression dive.

Sammy grabbed our dive gear and placed it on the cockpit floor while Scott and I climbed out of the water onto the swim step. We sat in silence, staring at the horizon. I removed my mask and looked over at my buddy. I can't remember the last time I saw Scott looking so serious.

"So much for your three-foot fissure. How bad is it?" I asked.

"I don't know. The whole ocean floor is moving."

"So what do we do?"

"There's nothing much we can do except continue to gather data. We'll tell Walt and James this evening when we're aboard the Kilo Moana."

We made two more dives along this stretch of the canyon. Each time we descended the amount of nitrogen in our blood continued to build. To avoid the bends, our dive computers told us that each of our dives had to be shallower and shorter than the previous one. The width and depth of the fissure stayed fairly uniform along its entire length. After our last dive, Scott instructed Sammy to head for Pu'ulou Point. It was a good forty-minute run from our last dive spot.

I went up to the flying bridge to check out what the guys were doing and to get a better view. They had their eyes pinned to the depth sounder looking for the canyon. As we slowly cruised along checking the bottom, Scott pointed at the depth sounder and announced.

"That must be it."

The line showing the contour of the bottom had taken a vertical dive and then leveled off. Just a few yards further, and it began to climb as rapidly as it had descended. Sammy hit the waypoint button on the GPS to mark the spot.

In less than five minutes, we hit the water and headed for the rock-covered bottom. After three deep dives, our bottom time would only be a few minutes. Scott handed me the end of the tape measure. I headed to one side of the canyon while he took off to the opposite side. With the end of the tape measure pressed against the canyon wall, I checked the depth on my dive computer. We were at 142 feet and only had two minutes before going into decompression mode. We got our measurement and then surfaced behind the Maka Hou as it gently rocked in the Pacific swell.

Back on board, I asked Scott, "So what did you get?"

"I'm showing 9.2 meters wide. I wish we could have stayed down longer. Then I could have nailed a marker into the wall."

Sammy started the engines and we were off to make our last dive of the day. Just over a quarter mile due south of Kalaepa'akai Point, he slowed down and called out to Scott. "Eh, Professor, mo bettah you come here and see dis. Ho brah dis aznuts."

Scott went up the narrow ladder first and I followed.

Sammy was pointing at a spot about fifty yards off the bow. "Look." There was an area directly in front of us that was at least a quarter mile in diameter where the water was the color of chocolate milk. I had never seen anything like it.

"Sammy, take the boat around the murky water. We'll jump in just up current."

"Dat be mo bettah, professor."

As the Maka Hou headed into the current, we climbed down the ladder to put on our gear.

"So what do you think is causing that water to turn muddy like that?"

"I'm not sure, but I have an idea."

"Is it plankton or something like that?" Scott didn't say a word. He appeared to be lost in thought. "Are you going to let me in on the secret?"

"You'll find out soon enough."

"Great."

We did our backward roll into the water and headed for the bottom. The water off of Kalaepa'akai Point wasn't as clear as the rest of our dive sites, maybe fifty feet of visibility. As we descended, I heard some strange popping sounds all around us. Then the water started to warm up, just a stray current or two, not that unusual. Once we got down fifty or sixty feet things really started to heat up, and the deeper we went, the less visibility we had. The popping and cracking noises also started to get louder, much louder. As the ocean heated up, I started to feel like a lobster in a pot of boiling water.

Suddenly the ocean floor came into view. It was like nothing I'd ever seen. The entire bottom was moving, covered by five foot long black slugs. Each elliptical carcass was covered in huge black scales separated by the flesh of a bright orange body. The strange masses didn't move; they just sat there convulsing, enlarging, and contracting. Bubbles floated back and forth across their gelatinous bodies as if forming a protective layer. Then without warning a glowing orange slug materialized out of the canyon wall, as if being extruded by a giant sausage machine. The slug nestled between two other giant slugs and began to darken as it cooled. Except what we were looking at wasn't alive. It was molten lava being deposited at the bottom of a fifty-foot wide canyon. We were witnessing an underwater eruption. These were the pillow basalts that Scott had told me about. What an amazing sight.

I reached down, grabbed my knife, and began banging on my tank with the knife to get Scott's attention. Eventually he turned and looked at me. I motioned that we shouldn't go any further. All Scott did was give me the finger. At times he can be rather subtle. I didn't have a good feeling about this, but like an idiot, I followed him down to the rim of the canyon. When we got to the top of the rocky wall Scott pulled out one of his markers and a miniature pneumatic hammer he had brought along for the dive. He hammered the plastic marker into the side of the ravine. I checked the depth, 138 feet with almost no time left. This was

not smart, not the way we had been trained to dive. Then he tied a string to the head of the nail with a small marker buoy on the end. Like all the other measurements we had taken that morning, Scott handed me the end of his tape measure and swam off to the opposite side of the canyon. The water was so murky that all I could see was the tape going off into the abyss.

I had to hold on to a lava outcrop to get some leverage against the pull of the tape as Scott continued to swim away from me. Without warning, the rock began to shudder, just a slight vibration. Then I felt a pressure wave hit me in the back; a few seconds later a second wave hit me, much stronger than the first. I held my breath as my heart rate went wild. I swiveled my head back and forth trying to see what had happened. What was causing these pressure waves? I let go of the rock and turned just as another massive wall of water crashed into me, hurling me backwards, knocking the wind out of my chest. The violent surge ripped the regulator from my mouth and blew the mask off my face. I lay there in mid-water stunned, unable to move, my chest cinched up so tight I couldn't breath. My lungs screamed for air. I reached around, running my hand up and down the side of the tank trying to find the regulator or the hose that would lead me to it. They were gone. Impossible. That can't be. Panic ratcheted out of control. I was too deep and too tired to make another free ascent. My head started to spin as I began to repeat over and over. "Focus, concentrate; come on, Chuck, focus. Solve the puzzle." The flashes of color surging back and forth across the backs of my eyelids had turned black and white. I was on the verge of passing out when it hit me. The state of panic that had consumed my every thought, the one thing that had been drilled into me to avoid at all costs, had almost killed me. I reached into the pocket of my B.C. and pulled out my octopus, the spare regulator that every diver carries. How was it possible to become so disoriented? I hit the purge button on the front of the mouthpiece, but could only take a shallow breath. Despite my ribs feeling like they'd just gone 15 rounds with Ali, it was still the best breath I'd ever taken.

With my facemask gone, surrounded by water the consistency of dirty milk, I could hardly tell which direction was up. Slowly I began to regain my senses and started to swim towards the surface, remembering to breath as I headed up. Skipping the safety stop, I went directly to the surface surrounded by a pool of bubbles and muddy water.

"Ho brah, what da kine?" It was Sammy looking down from the flying bridge. The Maka Ho wasn't thirty feet from where I had surfaced.

"What?"

"Hey, what happened down there? You okay? Where's your mask?"

"I lost it. Can you see Scott?" Sammy scanned the area around the

boat looking for my insane dive buddy. It seemed like an eternity, yet it was probably no more than two minutes until he found him.

"There he is. He just came up. Maybe a hundred yards."

"Tap the top of your head with the palm of your hand." Sammy looked at me as if I had just asked him to drop his pants, but he followed my instructions. "Is Scott doing the same thing?"

"Yea, he be tapping his head."

"Alright, that means he's okay. Help me out of the water and then we'll get Scott."

Sammy came down from the bridge to help me into the boat. I rolled onto the cockpit floor taking in large mouthfuls of fresh air. "Go get Scott. I'll be alright." All I could do was lie there staring up at the blue sky.

Sammy pulled alongside my buddy, who was treading water in the chocolate soup. That would be the guy that had been working overtime trying to get me killed. I reached over the transom and helped Scott back into the boat. His skin was a bright red, just like mine.

"Are you alright?"

"Yeah, I'm fine." A smile spread across Scott's face. "You have to admit that was one hell of a ride."

I wasn't happy. "You stupid son-of-a-bitch. You almost got us killed. What the hell were you thinking?"

"Hey, I needed to get that measurement."

"Screw your god damn measurement. We were almost boiled alive. I've got a wife waiting for me back home. Did you ever think about that?"

"No."

"And what about my three-month-old daughter? Did you ever think about her?"

"No."

"So other than that sorry ass of yours, is there anything else you ever think about?"

"As matter of fact there is."

"I can't imagine what."

"The measurement."

"The measurement. I don't fucking believe it." I gazed out at the ocean trying to bury the rage building inside me. Okay, I knew why we were there. It was about a 600-foot tsunami, but so what. "Well, did you at least get the damn thing?"

"Yeah, 15.1 meters."

"Wonderful. So what happened down there? And by the way that was my last dive. I'm finished." I stated this simply, with no histrionics or as Scott would put it, whining. Tsunami or no tsunami, I'd had it.

"Not a problem, I've got everything I need. That was just a minor

eruption. I think our big girl had a little gas."

"Well, I hope she's feeling better." I dropped Scott's tank on the deck with a thud.

"We'll tell James and Walt about it later."

"James never said anything about molten lava way out here. What do you think it means?"

"I'm not sure, but I'd say our little problem just got bigger.

"You're just a bundle of good news."

Sammy contacted the Kilo Moana on the VHF radio. The Officer on Deck said they would send a tender to pick us up. As we slowly motored towards the point, I dried off with a towel and sat back down in my plastic chair. Maybe it was time to go home. For some unexplained reason, everything Scott touched on this trip was turning to shit, and it was getting all over me.

My old friend sat down next to me. It was time to have a serious no bullshit talk.

"Scott."

"What's up?"

"We need to talk."

"About what?"

"About me almost dying out there."

"Oh, that. Yeah, I probably should have listened to you. Hey, I'm sorry. I get so wrapped up in my research that I sometimes forget the big picture. Forgive me?" Scott grinned at me with that cherubic face, as if to say: "How can you hate someone as lovable as me?"

What could I say? "Go fuck yourself. We're going to have an understanding."

"What?"

"I want to trust your judgment—I always have—but from now on if I say it's too risky, we do as I say. Capeesch?"

Scott let his head fall back and closed his eyes. I sat there waiting for his answer as the Pacific swell rolled under the boat. I had never challenged Scott before. Not like this. When Scott opened his eyes he said, "Yeah, I capeesch, but…"

"No buts."

"Yeah, but…"

"I said no buts."

"You're worse than an old woman… Fine."

We sat back in our chairs in silence, staring at the bubbling wake churning off the transom.

NINE

THE KILO MOANA'S TENDER CAME RACING towards us off the port bow. Sammy slowed to five knots as the sleek vessel came along side. It was a big RIB, rigid inflatable boat, the ones with the fiberglass bottom and large rubber tubes around the sides. This particular RIB was completely open with just a small steering station and helm seat in the center. On the transom were mounted two huge outboard engines, 250 HP Yamaha's. I tossed the helmsman our gear then jumped in. Scott climbed aboard and stuck out his hand.

"Scott. Good to meet you." He nodded towards me. "That's Chuck."

"Welcome aboard. I'm Kimo," said the helmsman as he stowed our bags on the deck.

We waved goodbye to Sammy, telling him we would meet him at the mooring in a couple of days. I had the distinct impression he wasn't sorry to see us leave.

Kimo had on ragged blue shorts and a dirty white t-shirt. He couldn't have been more than twenty years old with a full head of wind-tossed black hair and Polynesian tattoos on his arms and neck. With a silver ring in the left ear, he looked more like a pirate than our chauffer.

"Gentlemen, I suggest you sit down and hold on tight. This baby's about to launch."

I quickly found a place on one of the big inflatable tubes and grabbed a handhold as Kimo shoved the throttles forward. The RIB literally jumped out of the water. I stuck my foot out to stop my overnight bag as it rolled along the floor towards the transom. We left the Maka Ho with engines roaring and spray flying. Kimo's big white-toothed smile continued to spread as we hurdled through the chop and over the large swells. At times we were completely airborne. I reached over and tapped Kimo on the shoulder, then yelled over the roar of the engines.

"How fast?"

"Around 50 knots. Did you want me to kick it up?"

"Only if you add wings."

Kimo headed directly for the Kilo Moana, a gray dot on the horizon maybe ten miles out. At fifty knots it wasn't going to take us very long

to reach the university's newest research vessel.

Over the roar of the twin outboards Scott yelled to me, "Ya know the Pisces doesn't normally operate off the Kilo Moana."

"What do you mean?"

"She wasn't designed to carry a submersible, so they recently upgraded the crane and added the cradle on the stern deck. You wouldn't believe what I had to go through to set this ride up."

"You mean the threat of a giant tsunami wasn't enough?"

"It's the only reason they agreed to it. Normally The Pisces V and IV are carried on an old ship called the Kok, but they were already scheduled to do some research off the north shore of Oahu."

"So you used your irresistible powers of persuasion to get them to put the sub on the Kilo Moana and run her down here?"

"No, they were already scheduled to be here. Doing some research on Loihi. It's the only way they agreed to let us use the sub for two days." As we came roaring up to the Kilo Moana, Kimo slowed the tender so Scott and I no longer had to yell over the howling engines.

"Loihi. That's where I'm supposed to buy that waterfront property."

"Right."

The Kilo Moana was the strangest looking vessel I had ever seen. She was a big catamaran with incredibly narrow hulls, hulls that couldn't possibly support the superstructure. The rest of the boat looked as if a child had planted oversized blocks facing in every direction between the two hulls. Under a large black A-frame crane on the stern deck sat the day-glow yellow Pisces V topped by an iridescent red conning tower.

As we pulled up along side the Kilo Moana, I asked Kimo, "What's the story on this ship? I've never seen anything like it."

"It's a SWATH vessel, Small Water plane and Twin Hull. Look below the waterline. See the hulls down there? They're like giant torpedoes or submarines. The hulls run under the surface in smooth water like a submarine. The rest of the ship just rests on top. It's perfect for a research vessel. It hardly moves at all in the chop."

"Got ya. You wouldn't call it beautiful."

"That depends. As far as research vessels go, she's as pretty as they come."

"Yeah, but do you ever get any hot women on board?"

With the slightest twitch of his eyebrow, our driver replied. "We get our share."

Kimo pulled the tender up to the stern of the Kilo Moana where the crew had lowered a rope ladder. Scott climbed up first. Once I was aboard, Kimo backed the big tender away from the ship and hooked up a heavy wire sling that would pull the RIB out of the water. An attractive Asian girl named Miko escorted us to the ship's second level.

"Nice shorts," whispered Scott.

"I like the halter top." Maybe that was one of the reasons Scott and I got along so well. When it came to the ladies, our preferences ran in opposite directions.

Before opening the door to the main conference room, Miko gave us a look as if we were a couple of perverts. It was a small room just forward of the weather deck on the starboard side, not much larger than a tract house bedroom with two large flat screen TV's on the port bulkhead. Captain Pixton was already sitting at a steel conference table in the middle of the room. He stood as we entered.

"Good afternoon, gentlemen. I hope you had a comfortable ride." Captain James T. Pixton stood a ramrod straight six feet tall, definitely ex-navy. He was dressed in an all white uniform, white shoes, pants, and button-down short sleeve shirt with four gold stripes on the epilates. His narrow athletic build, dark sunglasses, and perfectly groomed silver hair exuded confidence.

"Well, I wouldn't exactly call it a ride, more like a short flight, but we enjoyed it." I added.

"Good. Kimo takes great pride in transporting his charges as quickly and efficiently as possible." I wanted to ask if he were related to Ichabod the helicopter pilot.

"This is quite a vessel you've got here. I've never seen anything like her."

"The SWATH technology has been around a long time, but there are only a few vessels that utilize it, mostly specialty ships like the Moana."

Scott paced back and forth next to the windows gazing out over the Pacific. He rarely looked so serious.

"Captain, I hope you don't mind, but I need to use your video conferencing equipment to call the Volcano Observatory and the Tsunami Warning Center."

"Not a problem. Do you mind if I listen in or would you prefer I step outside."

"No, please join us. I'm sure we could use your expertise."

Scott wrote down the two phone numbers and handed them to Captain Pixton. The Captain picked up a tan phone and called his communications officer explaining that we needed to make a conference call. Then he went over to the two flat screens and turned them on, while Scott closed the blinds to cut the glare from the sun. We sat down next to each other at the conference table facing the two large TV screens. While waiting for the calls, the Captain recited a few statistics about the Kilo Moana. "She's 186 feet long, 88 feet wide and draws 25 feet. Her range is 10,000 miles and full load displacement is 2,547 tons. "

When Jimmy's face came up on the left TV screen, Scott made the

introductions.

"Jimmy, this is Captain Pixton. He's the captain of the Kilo Moana."

"It's good to meet you, Jimmy."

"Good to meet you, sir."

"Jimmy, hold tight for one minute while we get Doctor Grissom on the wire." Scott suggested. "You may want to turn down that music."

Jimmy stepped away from the camera for a second to silence his stereo. By the time he returned, Walt Grissom's face was plastered across the screen to our right

"Walt, I assume you've met Captain Pixton."

"Yes, I have. Jim, how are you doing?"

"Just fine, Walt. And you, looking forward to starting that new job?"

"I'm doing great, and if my new job gets that crazy guy sitting across the table from you out of my hair, everything will be perfect. Jimmy, how are you doing? We've been registering a lot more shaking in your neighborhood lately."

"Hey, what can I say? The 'Joint is Jumpin'." And there it was again, another reference to that Fats Waller tune. Now I'll never get it out of my head.

"I can imagine it's jumping. We just registered a 6.1 and 6.3 in the last five hours along with a couple hundred micro-quakes."

"Guys, Scott here. I don't mean to be rude, but I need to bring you up to speed on what Chuck and I found today."

"Go right ahead."

"Okay. Well, first we dove on the portion of the fissure that I've already surveyed. We measured the crack at twenty-three different spots. On average, it has widened from approximately one meter to ten meters along its entire length. Now remember, the last time I checked it was less than a month ago."

Jimmy was the first to respond. "Damn, nine meters in less than a month."

"Walt here. And you're sure you were looking at the right fissure?"

"Hey, I'm the one that put the markers in. At first I wasn't sure, but as soon as I saw the first buoy, there was no doubt."

"Walt here. This is definitely not good. In fact I'd say we have ourselves a rather serious problem."

"Gentlemen, that's not all. Walt, Jimmy, if you could pull up your maps of the Kalapana Coast." Scott waited until both men acknowledged they had the maps on their computer screens. "If you recall, Jimmy said that if we were going to find the extension of our fissure in shallow water we should head to Pu'ulou and the next point west at Kalaepa'akai. We first dove at Pu'ulou. I was able to determine that it was an extension of the fissure we've been surveying by the age of the plant and animal

growth on the exposed walls. It was also the same approximate size. Next we headed further west to Kalaepa'akai Point. Do you see that on the map?" Both Jimmy and Walt said they did. "Before we jumped in we found a large area of discolored water. When we got to the bottom I discovered a large fissure, over 15 meters wide. Despite the amount of slippage we were looking at, the most disturbing thing was the active vent expelling molten lava. Unfortunately we couldn't spend much time observing since Chuck and I had a few problems with the turbulence caused by the off-gassing from the vent."

"Turbulence! That dumb son of a bitch almost got me killed. Someone needs to chain him to a tree and leave him there. And make sure it's a damn big tree."

"Walt here. Actually I believe his wife Aolani is working on that."

Everyone in the room laughed including Scott. Apparently Walt wasn't aware that Scott and Aolani were recently separated.

"Until Aolani chains me up, which sounds a little kinky if you ask me, I'm stuck doing your dirty work. So tell me, the venting, the slippage we observed, what do you think it means?"

"Jimmy here. I suppose we shouldn't be too surprised by the active vent. It's over thirty miles from the closest lava flow, but as I told you, I've been expecting an eruption along Mauna Loa's southwest and northeast rift zones. If you look at the map, Kalaepa'akai Point is directly down slope from the southwest rift zone. Still, I have to admit I'm a little surprised. I was expecting the first eruptions to occur somewhere between the 10,000 ft. level up to or even above the 13,000 ft. level. This is very odd. Walt, what do you think?"

"As I said, I think we have a problem. There may be some good news in all of this, but if I were a betting man, I'd say we've got bad news and more bad news."

"Oh, this is just great. Chuck here. So what's the good news?"

"Well, the good news is that we've had over nine meters of slippage in the last month and we didn't have a catastrophic failure. The slide is merely creeping at the moment."

"Sounds like pretty fast creeping."

"It is, but if we're lucky it will continue to do so and we could dodge a bullet, or in this case it would be more like an atomic bomb."

"Well gee, Walt, you're just full of merriment and good cheer. Chuck here again, but I gather from the tone of your voice you don't expect this giant slide to spend the rest of its life creeping along the ocean bottom?"

"No, I don't. The more movement there is the less stable the slide becomes. Eventually there will be a catastrophic failure and the whole thing will let loose."

"And when do you think that's going to happen?"

"Good question. It could be years or it could be weeks or months, maybe even days or maybe never."

"Well, that certainly narrows it down. How about you take one of your infamous WAGs at it? You know, those very scientific statistical analyses of all the variables."

"If you're going to try and nail me down, my best guess would be months, maybe up to a couple of years."

"Walt, Jimmy here. You mentioned that you had some bad news and some more bad news. I assume some of the bad news you referred to was that we don't have much time with this slide. Would you care to fill us in on the rest?"

I wanted to leave the room. What could be worse than the news we just received?

"The rest of the bad news is that I just ran another computer model, trying to determine the size of the tsunami the slide could potentially generate. At the time I ran my first analysis, I didn't know exactly how large the area was. I had to make a few estimates. Based on the information that Scott has just provided, the dimensions of this slide are far greater than what I originally estimated."

"And I assume the larger the slide, the larger the tsunami?"

"That's correct."

"So how large a tsunami do you think we are looking at given this latest information?"

"I would prefer to run it through my software, but if I had to guess, I'd say along the southern shore of Oahu," he paused as if he couldn't bring himself to say it, "seven hundred fifty feet, maybe higher."

"Walt, Jimmy here. Is that really possible? It would kill almost every person in the state. The destruction would be…would be unimaginable."

"Unfortunately it is possible. As I'm sure you know there's substantial geologic evidence that it has happened in the past, and there is no reason to think that it won't happen in the future. The only question is, how far in the future?"

I couldn't believe my own ears. Walt's mega tsunami had just grown.

"We've run some scenarios for a six hundred foot wave. The best case for the entire state was an 85% mortality rate if we got hit in the early evening. Worst case was over 95% if it happened during working hours."

"Walt, it's hard to even imagine a catastrophe of this magnitude. I'm not sure what to say? I'm stunned." It takes a lot to shake my friend Scott, but he was definitely shaken by this latest news.

"There's nothing to say. The only thing we can hope for is that we have time to prepare, and that we can figure out a way to give our citi-

zens as much warning as possible."

"Walt, Jimmy here again. But there must be something we can do?"

"Not unless you evacuate the entire state, and that's never going to happen."

"I just can't believe there's absolutely nothing we can do."

"I'm sorry Jimmy. I've racked my brain over this one, and haven't come up with a thing." Dr. Grissom's voice was as somber as it could possibly be. "The best we can do is attempt to come up with a more accurate date as to when the slide will let go. If we could get the funds to drill a hole into the slip zone that would tell us a great deal."

Walt and Jimmy discussed where they could get the funds to drill Walt's hole for a few minutes and then we said our goodbyes. Captain Pixton turned off the flat screens and Scott opened the blinds.

The Captain called Miko to escort us to our cabin, the Principal Investigator stateroom. I was impressed. Our room was located at the forward port corner of the ship on level two. We had a couple of large windows on two walls that provided spectacular views and plenty of light. This wasn't how I remembered the Navy. I let Scott take the first shower while I rested. Dinner was at 18:30 hours.

The mess room was on the lower deck at the front of the ship. The room was filled with mostly young people, kids in there twenties. I recognized our chauffer Kimo sitting with Miko. I waved to both. We joined Captain Pixton and his first mate Karl Klessig at a booth. Karl was going to be driving the Pisces tomorrow. When he found out that I would be joining him, the first thing out of his mouth was "How the hell are we ever going to stuff you through the hatch?"

It's not like I'm over weight. I've been exercising six days a week for the last twenty years. At six four, I'm just a big guy. Klessig made it sound like I was a porker.

Karl said, "Eat a light meal and even lighter breakfast, big guy. Oh, and the toilet facilities are a couple of piss bottles so slow down on the fluids after midnight."

Dinner was served buffet style. I had a good size salad, roasted chicken, green beans, and some rice. While I had been warned to go easy, I couldn't resist the blueberry crumble for dessert with a small dollop of vanilla ice cream. Our meal was filled with plenty of conversation mostly about the research the Kilo Moana had done over the last few years. For a single guy, traveling around the Pacific might be pretty interesting. Despite my marital problems, it wasn't for me.

We were scheduled to receive a short pre-brief on our dive at 0700, and then board the Pisces at 0715.

Karl explained, "We'll make our initial decent to 1500 meters, almost five thousand feet."

"What's the maximum operating depth for the Pisces V?" I asked.

Captain Pixton answered, "6,280 feet, with a good safety margin."

I put my fork down, feeling a little advanced claustrophobia.

First Mate Klessig grinned at me. "Nothing to worry about. Nothing at all." He obviously hadn't spent much time with my friend Scott. "The safety record for submersibles," Karl explained, "is much better than the record for cars or planes. Also it will be a tethered dive with a communications cable attached from the Kilo Moana to the Pisces V."

"Walt will be monitoring what we are viewing through a video feed back to the Tsunami Center," said Scott.

Scott and I left the table around 8:30. After five dives and almost being boiled alive, we were exhausted. It had been a long day, and we both needed to hit the sack early. As we got up Karl reminded us, "Don't forget to dress warmly. It's cold way down there."

I wanted to stretch my legs before trying to sleep. "Captain, mind if I wander around the deck for a few minutes and check out some of the research labs"

"Fell free to go anywhere on board."

Compared to fatherhood, the last couple of days had been pretty hectic, scratch that, insane. After checking out a couple of labs on the main deck, I went up to the port bow and found a quiet place to unwind. The almost dying thing was starting to get to me.

The evening stars, the full moon, and the warm tropical breeze were just about the perfect remedy for settling my nerves. While I had only been gone two days, Lauren and little Aubrey were constantly on my mind, especially Lauren. I liked my comfortable new life back home with my girls, but what should I do about Lauren? What could I do? If I can't trust her, how could I spend my life with her? Could our relationship ever be the same? God, I wanted it to be just the way it was, but how? The thought of a marriage counselor made me cringe. It was like admitting failure or asking for driving instructions.

Despite my misgivings, just the thought of lying in bed with Lauren got Little Buddy's attention. It had only been a couple of days and he was lonely. While dreaming about my woman, I was brought back to the present by a loud whoosh directly below me followed by a series of three more. I looked down to see a couple of dolphins swimming in the bow wave. Their powerful tails thrusting them forward as they effortlessly flew through the water, banking and diving at will. After watching these incredible animals play with each other for a good ten minutes, I headed back to the room feeling even more disheartened over the situation with my wife.

PART II

TEN

THE NEXT MORNING WE MET KARL on the work deck just shy of 0700. Pisces V was already hooked up to the crane. Two members of the crew were untying her lashings while another inspected the pipes and wires under a fiberglass cowling. The Pisces looked as if someone had cut the top off a bright yellow submarine, lifted it up, and placed it on the back of an oversized praying mantis. The two large black manipulator arms were the front legs of the oversized insect, and the three glass viewing ports its eyes and nose. My stomach instantly tied itself in an uncomfortable knot just thinking about being a mile underwater inside this giant bug.

Karl had us step on a scale to get our exact weight and then the dive officer added lead ballast to the submersible based on our combined weight. We took off our shoes and climbed up the aluminum ladder in our stocking feet to the deck of the Pisces. I was surprised to discover that the bright red structure on top of the sub was nothing more than a fiberglass combing that surrounded the main hatch.

"Damn, how big is that hatch?"

"It's nineteen inches in diameter. I told you it would be a tight fit, but don't worry, Pisces comes equipped with a large jar of Vaseline."

"Everyone's a comedian."

"Scott should go first, then Chuck. I'll be the last one to enter."

Although it was tight, Scott dropped down into the sub without a problem. I didn't have any clearance problems until my ass engaged the steel lip where the hatch seals. I'd have to remember to ask Lauren if she thinks my butt is too big. With a quick twist and a little extra push, my rear end went through. Once my chest was even with the rim of the hatch, I put both arms over my head and tried to bring my shoulders together as best I could. It was a no go. The hatch was too small or I was just too big.

"You're doing it all wrong," Karl said "Put one arm down by your side. Good. Now lower your right shoulder through the hatch. Okay, same with your left." It worked and I continued down the ladder to

the floor of the Pisces.

When my eyes finally adjusted to the darkened cabin, I was struck by the number of switches, meters, and screens. The little submersible was more complicated than a jet airliner. And the interior wasn't much larger than an outhouse, though more like a large steel pipe that was maybe six feet in diameter and around 10 feet long. Scott was lying on a padded bench on the starboard side looking out the viewing window directly in front of him. The pilot's position was in the center of the sub on a raised bench with its own port. I lay on the bench on the left side with my face in front of a six-inch-diameter, three-inch-thick viewing port. The visibility was surprisingly good.

Karl climbed down the ladder and closed the hatch. He checked to make sure everything was properly sealed then re-checked. The air inside was heavy and hot, not what I expected. I was starting to feel even more claustrophobic. Beads of sweat were breaking out on my forehead. I maneuvered around to take my jacket off in the tight space.

Our captain powered up the Pisces and turned on the air scrubbing system. Fresh air blew on my face from the overhead fan alleviating my anxiety. Karl then went over the safety features and procedures with us. The thing that impressed me the most was the dead-man button. While I didn't care for the name, the designers had obviously put a lot of thought into making this amazing piece of technology safe. The pilot has to press the dead-man button every ten minutes or the sub automatically dropped its ballast and surfaced. That way if something went wrong with the air scrubbing system and the occupants passed out, the sub would automatically surface and we'd probably survive.

Our pilot read through his checklist then notified the dive officer that we were ready for launch. Through the porthole, I watched as the big crane lift us up into the air and then out over the stern of the ship. A wall of bubbles surrounded us as the crane lowered the Pisces into the clear Pacific water. Once the bubbles cleared, shafts of sunlight sliced through the crystal clear water as small fish swam around us. A safety diver maneuvered around to the front of the Pisces and gave us a thumbs up. Karl said that was to let us know the tail line attached to the stern of the Pisces had been released.

Karl went through a couple more items on his list and then requested a launch altitude and permission to dive from the ships dive officer. Our initial altitude was 1,520 meters, an incredible 5,000 feet below the surface. I was getting excited. Once we were clear of the ship, the dive officer gave us permission to dive. Karl turned a couple of knobs to flood the ballast tanks. The loud rush of air reverberated inside the steel hull for a

couple of minutes while the ballast tanks emptied. The thrusters were pointed straight up so that they would push us down. Submersibles are designed to operate with neutral buoyancy. The only way they can descend is by using their thrusters to force them down. With a soft whirring sound, the small electric motors engaged and we began our descent.

Karl took out a Yanni CD and placed it in the stereo. It wouldn't have been my first choice, but given our surroundings the music fit the mood. A large set of red L.E.D. numbers above my head advised us of our altitude as we continued to dive. We were descending at around 100 feet per minute. At only 200 feet, the sea had already turned a deep blue.

As we continued towards the bottom, the Pisces began to talk to us with a constant cacophony of groans, snaps, and creaks. "What's all the chatter?" I asked.

"It's just the seals settling in," explained Karl, "and the steel vessel surrounding us adjusting to the increasing pressure."

By 600 feet, the water was a darker cobalt blue, almost black, and by 1,000 feet we might as well have been diving in a bottle of ink. As we continued down, every once in a while a small fish zipped by a viewing port flashing us with its bioluminescence. The deeper we went, the more it looked like it was snowing outside the sub. Karl said it was just dead plankton falling to the ocean floor.

The air inside the sub continued to cool along with the water outside. Condensation started to form on the sides of the steel hull. At about 3,000, feet Karl removed the Yanni CD and inserted Pink Floyd's "Dark Side of the Moon." Now we're talking. At around 4,800 feet, we started to pick up the bottom on our depth sounder. I put my jacket back on as the temperature inside our oversized tuna can dropped to around 50 degrees.

At 1,520 meters, Karl stopped our descent and turned on the powerful external lights that illuminated the area directly in front of the sub. The bottom was desolate, like something from the moon. Probably why Karl selected Pink Floyd's classic album. Within a matter of sixty minutes, the world had gone from brilliant shades of blue to black and gray, mostly black. We stopped just above a featureless plain of volcanic rock. So much for an exciting dive to the bottom of the ocean. I had expected to see a bunch of strange stuff down at this depth, but there wasn't any sign of life. The only movement was the light snowfall of dead plankton. I was watching the scenery float past my port and enjoying a gentle trance when Walt bellowed into the speaker system.

"Turn that crap off." Karl grinned at Scott and turned the music down. "Good morning, gentlemen. I hope you're comfortable."

"Like sardines in a can," Karl responded.

"Good because we've got work to do. Scott, are you with us?"

"Right here."

"I take it you can hear me fine?"

"You're loud and clear."

"Maybe a little too loud," I muttered under my breath.

"My video monitor shows that you're on the bottom. I believe the boundary of the recent slide is still further west. As I've already mentioned, we're pretty sure that the slide that caused the December tsunami lies directly over an older slide. We need you to identify the limits of the new slide by identifying the location of the slide plane, the interface between the old and new slide." I wondered what this slide plane would look like. "Tomorrow we'll take a look at the eastern boundary. For now, I'd like you to traverse the slope you're on in a westerly direction. Karl, I'm thinking that a heading of around 220 degrees magnetic will keep you at the same altitude."

"Then we'll give that a try," our pilot replied.

Rotating the Pisces V with the two thrusters, we slowly began to move across the desolate plain.

"Not much sea life out there," I said to Scott. "Those "Discovery Channel" specials are a hell of a lot more interesting than the real thing."

"It's because we're on top of a recent slide. It's going to take nature a little time to repopulate this area. At this depth, maybe a few thousand years."

We continued heading west, hugging the bottom for another fifteen minutes when out of the left side of my viewing port, just at the edge of the area illuminated by our lights, I picked up something white.

"Hey what's that? There, just off to my left." Karl stopped our forward movement and rotated the sub to the left. "There, it's right in front of us maybe twenty feet away. Do you see it?"

"Karl, can you move closer?" Scott asked. "Okay, that's just about perfect. Stop her right there?"

The Pisces hovered directly over the remnants of what looked like part of a coral tree.

"What is it?

"It looks like the remains of some Corallium Secundum."

"So what's Corallium Secundum?"

"It's pink coral. The stuff is worth a fortune. They make jewelry out of it."

"What's it doing down here?"

"Exactly, it doesn't belong here. Pink coral is a deep-water coral but not this deep. Sometimes we find it growing in as much as a 1,000 feet of water. The only way it got this deep is by hitching a ride on a land-

slide. This tells me we're on the new slide because the coral is still alive, but it won't survive much longer."

We continued traversing the rock plain for another thirty to thirty-five minutes, spotting the occasional pieces of live coral. Abruptly the gently sloping plain ended in a steep drop-off.

Walt's voice came booming in over the loudspeaker. "All right, gentlemen, this slope directly in front of you should be the edge of the slide."

Karl replied. "Dr. Grissom, would you like us to traverse this slope or would you prefer that we head straight down it? We can descend another 1,200 feet before we reach maximum operating depth."

"I suggest that you follow the slope straight down until you get to 6,000 feet. If we don't find the slip plane at that point you can traverse the edge of the slide to the north and eventually you should come across the interface we're looking for."

We contacted the Kilo Moana and requested permission to descend to 6,000 feet. The scenery wasn't changing much only the angle of the bottom which was now almost a vertical wall. The edge of the slide was slightly rougher than the top with occasional large bolders, but the entire area was still a biologic desert. At 6,000 feet, we turned to the north, traversing the slope as Dr. Grissom requested.

Karl redirected the big lights on the front of the sub away from me to illuminate the steep slope on our right side. With the lights pointed towards the vertical rock wall, there was nothing to see out my side of the sub. I decided to close my eyes for a few minutes. We had been down for almost four hours; I was cold, tired, and frankly damn bored. While it was exciting to think I was over a mile below the surface of the Pacific, I was disappointed by how little there was to see. Other than the black rocks and a few pieces of coral that didn't belong there, the few strange crabs crawling along the bottom didn't provide for much entertainment.

"Hold it, Karl. What's that?" Scott was pointing at something in the rocks. "Can you turn the sub a little? I'd like to look inside that crevice right there."

The Pisces V rotated to the right while Karl adjusted the lights to point straight ahead. We hovered maybe ten feet from the vertical edge of the slide, and directly in front of us was a two-foot wide gash that went back maybe ten feet into the wall.

"Look in there. Do you see that?" asked Scott.

The walls of the two-foot crack were lined with spindly brownish red starfish and a few odd shaped red and brown crabs. At the far edge of our lights were a couple of eels. Ugly suckers with a head of tentacles like a mini octopus on a snake-like translucent gray body.

"Scott, what are you looking at? Those ugly eels?"

"No, those are just hagfish. Karl, can you move us in a little closer? I think I see the remnants of some old coral." He maneuvered the Pisces to within a couple feet of the lava wall placing Scott's viewing port directly in front of the fissure. We hung there motionless as Scott tried to peer down inside the narrow fissure. Unfortunately it was so tight, the rocks on either side blocked the lights from illuminating it.

"No. That's not going to work. Karl, what about using one of our manipulator arms? Did you see that jumble of material at the bottom of the fissure?"

"Yeah, it looked like a bunch of old sticks."

"Walt, are you there?"

"Right here, Scott."

"Did you see what I was looking at?"

"I'm not sure. I think I did."

"I think that may be more Corallium, but it's definitely old and deteriorated. I need to get a closer look. If I'm right then we're at the ancient slide and the more recent one should be just above us. Karl, do you think you can reach in there with a manipulator arm?"

"I'll try to get in there with the starboard arm. It's more maneuverable."

Karl backed us away from the rock wall, hit a couple of switches, and with a low chirping sound and a bump, the arm came to life. It was something right out of a sci-fi movie, maybe ten feet long, hinged where the arm connected to the sub, a single elbow in the center, and a nasty looking metal grasping claw. Karl extended the arm so that there was about a thirty-degree bend at the elbow. Then he lined up the sub so the arm would fit into the narrow crevice. Slowly he moved the Pisces forward as the manipulator arm was pushed farther and farther back into the rocky crag. The hagfish scattered, swimming directly towards us.

"Alright, I think I'm there. Let's see if I can grab one of those pieces of coral."

Just as he started to maneuver the arm, the Pisces shuddered. Sand and silt began to fall from the sides of the slope. The water turned muddy.

"Shit." It was Karl. Not a good sign.

"What's going on?" asked Scott. No response. Our pilot was too busy.

Small rocks and pebbles continued to rain down on us, bouncing off the metal hull. It was like being inside a bell. Visibility immediately went to zero. Karl threw the thrusters in reverse. The spinning blades echoed through the steel hull as we began to back away from the wall. Then, with the screeching of metal against stone, we stopped. The

thrusters were still hissing, beating the water. The little sub vibrated, but we were no longer moving.

"Shit!" It was Karl again, a very bad sign. The thrusters stopped. Everything went silent except for the dull ringing sounds of small stones striking the top of the sub. "We're stuck...Damn."

"What the hell just happened?" I asked.

"It may have been a small earthquake. I should have never stuck the arm in there."

"What's going on down there? Is everyone okay?"

"Yeah, we're fine, Dr. Grissom, but I may have gotten the arm stuck."

"Can you back it out?"

Karl threw the thruster into reverse again. Nothing happened. Then he tried alternating thrusters from side to side. The sub swayed back and forth, but the arm remained jammed in the crevice. "Shit."

"Karl, this is Captain Pixton. I understand you've got a manipulator arm stuck. Try using the other arm to push the Pisces away from the wall or to remove whatever has the arm jammed?"

"Good idea. I'll try it now."

I looked over my shoulder at Karl. Small drops of sweat dotted his furowed brow as he attempted to pry us loose while reversing the Pisces thrusters. "Captain, it's not working. I think she's really stuck."

I was about to offer up my best impression of Scotty the Engineer from Star Trek, "I'm given her all she's got, Captain." But decided to keep my mouth shut.

"Let's not panic just yet." Captain Pixton's assurances weren't helping. My chest muscles were tight enough to snap a rib and my head felt like it was about to go jihad.

"Why don't you try using alternating thrusters?" suggested Dr. Grissom. "See if you can swing the sub back and forth with the thrusters and push with the other arm."

Karl first tried moving the port and starboard throttles in opposite directions. Next he tried a little forward thruster and them went to full reverse. That didn't work either. The whole time he was playing with the throttles in his left hand, he was moving the joystick that controlled the one free manipulator arm in his right hand. Karl tried everything to pull the jammed arm out of the narrow fissure, but he couldn't get it to budge. Look out, Allah.

"Captain Pixton, nothing's working."

"Alright then, I guess we'll have to end the dive now. Go ahead and drop your ballast."

"Captain, I don't think I should do that.

"Why not?"

"If I drop ballast and the arm stays jammed, the back end of the sub will just rotate up to an almost vertical position with the manipulator arm holding the front down. This may drive the viewing ports into the rock wall directly in front of us."

"I hadn't considered that, but you're right. We'll need to think about this. Go ahead and power down the Pisces. That'll give us time to put our heads together up here and see what we can come up with."

"Roger that, Captain, I'm powering down as we speak." Karl started hitting switches and turning knobs. The lights and dials began to go dark. The Pisces was losing its lifeblood. The only sound was the constant thrum of the fans. I didn't want to bother Karl while he was so busy, but I had a million questions and no answers. Finally he stopped, pressed his face into the bench, and let out a breath of exasperation. I still needed my answers.

"Karl, why can't we just drop our ballast weights? This glass must be incredibly strong. I can't believe those rocks would break it."

"It's three and a half inches thick. Right now, there are over 2,500 pounds of pressure per square inch on that glass. At those kinds of pressures, glass becomes incredibly brittle. One small scratch can set up stress risers. The stress riser can turn into microscopic cracks. The instant you have a crack the whole thing implodes. At this point I'll only drop ballast as a last ditch effort to get us loose."

"Now I understand."

"What's our oxygen like? How long can we last down here?" asked Scott.

"For this mission, we can figure a maximum twenty-four hour duration. If we stay quiet, we can probably push it to 30. It'll be best if we get some shuteye so we'll use less oxygen."

I still had a few hundred more questions.

"Karl, a couple more things. You're saying we better be on the surface in another twenty-four hours or we're toast because we have already been down six hours?"

"Yeah, that's about right."

"Which gauges show how much air we have left to breathe?"

"The gauges you want to watch are just above your head to my left and your right. This one shows percent of oxygen. So long as we have oxygen in our tanks, the scrubbers will automatically keep the oxygen content of the air we're breathing at 21%. This gauge shows the oxygen pressure in the main tanks and this one is our emergency supply. You can see that the emergency tank is full at 3,000 psi. Our main tanks have just over 2,200 psi in them."

"And you figure that gives us another twenty-four hours?" I hoped I didn't sound like I was pleading.

Karl had this incredibly pained look on his face, as if someone had drained all the life out of him. "That's about right. Once the storage tanks run out the oxygen level will begin to decrease. When it gets down to somewhere between 8 and 10 percent, we'll lose consciousness. Between 6 and 8 percent, death occurs."

"That's pretty depressing. What do you think those guys are doing up top?"

"Probably trying to figure out how to get another vehicle down here to help us out of this bind."

"Something like a rescue sub?" Back in my Navy days, we were always getting news about improved submarine rescue systems.

"I only wish. No, there's nothing in our arsenal that can actually take us out of here. We're way too deep for that. They're probably trying to figure out how to get a remote vehicle down here to help pull the Pisces out, maybe attach a line."

"So we're not completely screwed?"

"Not by a long shot. We've still got plenty of options, so let's try to get some sleep."

I laid my head down on the padded bench. Unfortunately, my entry into dreamland was not part of the program. I wasn't going to give up hope. Not yet. In fact I'd probably never give up all hope. It was not in my nature. I just had never been in a situation where my life depended so completely on someone else's abilities to make decisions. It was that useless feeling that was so exasperating. Thinking about my family, not knowing if I would ever see then again was even more depressing. I glanced up at the depth indicator. The red LED lights stared back at me 6,012 feet, over a mile deep. What a crappy place to die.

I closed my eyes with visions of Lauren running through my head. I tried to set aside any thoughts about how I ended up with a family. It didn't seem very important at the moment. Alone with my grief, I tried to rest on that hard shelf more than a mile under the surface. I thought about the little things like the mole behind her left ear, Lauren's long slender fingers, and the smell of her hair. I thought back to our wedding day, and the tear resting on her cheek as she walked down the aisle. I reached out to take her hand and just as our fingers were about to touch, this unbelievably loud alarm went off right above my head. Instantly I was back in the miserable reality of our darkened sub. My heart felt as if it were being blasted out of my chest. Then it stopped, the alarm not my heart.

"Karl, what the hell was that?"

"It was the dead-man button. I must have dozed off. It's a warning alarm that goes off 30 seconds before the ballast system activates."

"Talk about a wakeup call." I looked at my watch and was shocked at how much time had passed. "Hey, why don't you give Captain Pixton a call? We've been down here almost ten hours. Maybe they've come up with something."

Karl agreed and called the ship. The communications officer answered. The captain had stepped away from the bridge, but would be right back. Maybe he'd gone to the head. Given the fact I'd been encased in this steel coffin for over ten hours that sounded pretty nice. I was ready to announce, "Excuse me, gentlemen. I need to take a leak. I'll just step outside for a minute."

The captain came on the line.

"Karl, this is Jim. How are you doing down there?" That was the first time he'd referred to himself as Jim. Not good.

"We're still hanging in here. Just over 1,800 psi of O-2."

"Good. Listen, we've haven't forgotten about you." That's nice. I figured they were taking a siesta or maybe having a latte. Captain Jim continued, "But we have some problems, and we're trying to figure out the best way to overcome them. As you know, the Kilo Moana's ROV is on loan to Scripps. We've contacted Ka'imikai-o-kanaloa, the university's other research vessel. The good news was they're working off the North Shore of Oahu but they just lost a main seal on their ROV. It's going to be out of commission for a couple of days. Pisces IV has just come out of a major overhaul in Honolulu, and the KOK is headed into the harbor to pick her up. In fact she may already have her."

"So do you have an E.T.A. yet?"

"That's the problem. The KOK's an old boat. She's not expected to be on station until 1300 hours tomorrow afternoon."

"Damn, that's really stretching it. I hope we're not room temperature by then."

"We're seeing what we can do to speed things up. Maybe transfer the Pisces to a faster vessel."

"Roger that. I know you'll do whatever you can. Keep us informed. We're not going anywhere."

"As soon as I have any news, I'll let you know."

I was hungry, thirsty, and had to pee. Worse, the temperature inside our miserable steel pipe continued to drop. I shoved my hands into my jacket to stay warm. At the bottom of my coat pocket was my wallet, where I had hid it while on the Maka Hou. Like any dutiful husband, I

kept a picture of my wife and child in it. I pulled out the pictures with trembling fingers. In the dim red light of the depth meter, I could barely discern the outline of Lauren's smiling face or Aubrey's blue eyes. It didn't matter. Just holding the pictures in my hand made my heart beat faster and brought a smile to my face.

"Hey, Chuck, What're ya looking at?" Scott asked.

"My wife and kid."

"Mind if I take a look?"

"No, not at all." I handed the two pictures to my old friend. The guy that always bailed me out of trouble when we were in the Navy. Well, this was almost like the Navy. Maybe he was going to bail me out of this one. Scott shined a small penlight that he kept on his key ring onto the pictures.

"Lauren's a beautiful woman. What's she doing with you?"

"I still ask myself that very question."

"And Aubrey, are you sure you're the father?"

"You know, it's funny. Sometimes I look at her and wonder, did I really make that?"

"I'm sure you're not the only one."

"Hey."

"Well, you did have help. What's that other picture in your hand?" I hadn't realized there was a third picture in my wallet.

"Hand me your flash light. Let me take a look." Scott handed me his key ring. When I shined the light on the picture, I could barely control myself. I started to laugh. I had forgotten I was still carrying that picture around.

"Hey what's so funny? Can I see?"

"Sure." I handed the picture and penlight back to Scott.

"What the hell. Who keeps a picture of a damn turtle in their wallet?"

"You don't understand. That's not just any turtle, that's Louie."

Karl chimed in. "Who the hell names their turtle Louie?"

"It's a long story."

"Well, it's not like we're going anywhere real soon."

"You have a point. Scott knows about my last job. I use to work at this exclusive resort on a remote island in the South Pacific. In fact, it was so remote the only thing on the island was the resort."

"Sounds like a nice job."

"Wait till he tells you the rest."

"Hey, it wasn't that bad. My wife's father owned the resort and the island. Lauren had hired me as a personal trainer to work there. That's how I met her."

"So you met your wife on a tropical island that her father owned? It still sounds pretty good to me."

"He's not done."

"No, Lauren was never on the island. She just did the hiring for her father. Anyway, there was this girl. Her name was Kathy Pierce and she was staying at the resort, actually it was a health spa."

"Health spa, my ass. It was a fat farm." Sometimes Scott has been known to throw political correctness to the wind.

"It was still a health spa even though all the clients were obese women."

"Right. It was Chuck Palmer and a bunch of fat broads. The whole place was filled with nothing but fat broads, fat broads for as far as the eye could see." So much for P.C.

"Listen, my politically incorrect friend, my ladies may have been overweight, but you know what happens to a fat woman if you keep her on a diet long enough? My ladies lost a whole lot of weight and turned into total babes."

"I'm still not sure I believe you."

"Believe me."

"Okay, but who was this Kathy Pierce?" asked Karl.

"Kathy was one of my clients."

"Right. Tell Karl what she tipped the scale at."

"Kathy was a big girl."

"That's an understatement."

"As I recall when she first came to the island she weighed in at around 260."

I can't say that I blamed Karl for looking so surprised. "That's a lot of woman. But what has this got to do with that picture in your wallet?"

"Louie was Kathy's best friend. Talk about a piece of work. She kept this ninety-nine cent turtle in one of those little tanks with the green plastic palm tree in the center."

"I didn't even know they still made those. I had one as a kid."

"I think we all did. Kathy was crazy about this damn turtle. She said he brought her luck. Funny, I can still remember how she used to put Louie on the table, make a leash out of a piece of string, and place the loop in front of Louie. Eventually he'd crawl through it. Then she'd pull the loop taut around this poor turtle and take him for a walk. It was the funniest thing watching Kathy dragging this stupid turtle around on a leash, talking to it as if it were some kind of poodle dog."

"Talk about a psycho. Girl sounds like she could use a lot of help."

"Actually she was kind of a kick to be around."

"Okay, but why the picture?"

"When Kathy gave me the picture, she said it would bring me good luck. When she first handed it to me I just laughed, but she insisted it would bring me good luck. It wasn't a month later that I returned to California and hooked back up with Lauren. We fell in love, got married, and four months later Aubrey was born. I assume I don't have to explain. Do I?"

"No."

"Good. Right after the wedding I bought the gym where I used to work. I've kept that picture of Louie with me ever since."

"So how long did you work at the resort?"

"I was there for a year."

"And it was just you and a bunch of fat women on a deserted island for a whole year. Sounds like you should write a book."

"I've thought about it, just can't write worth a crap."

It seemed like everyone felt a little better after hearing about Louie. The air in our miserable tin can wasn't so depressing. So, in a sense, maybe Louie had brought us a little luck. I put my head back down on the bench. With the constant whirring of the fans I started to think back to all the good times I had on the island. I couldn't get that picture of Louie looking up at me out of my mind. Then it hit me. The Pisces V was just like Louie. All we had to do was put a noose in front of it.

"Hey, Scott. Remember when we were stationed in the Philippines and we'd borrow a patrol boat to take on a training mission?"

"Sure, how could I forget? Remember the time we took those four strippers with us."

"Yeah, I sure do, and how the C.O. almost caught us. I never told Lauren about that little adventure."

"It's probably best, but you have to admit we had a hell of a good time."

"You guys stole a patrol boat and took four strippers with you? Now that's a training mission."

"It was one of many adventures. But that's not what I was getting at. Scott, remember when we would take the patrol boats and go surfing? Sometimes the anchor would get caught, and do you recall how we use to get it back?"

"Sure. I'd dive down and pull it out from underneath a coral head."

"Right, but do you recall that time when we anchored the boat in over a hundred feet of water and got the anchor stuck."

"Yeah, I remember that. I still say I could have dove down and got us unstuck."

"But you didn't have to. I showed you how to get the anchor out

without having to dive."

"Oh, shit. You're right. That just might work."

"Excuse me, gentlemen. What the hell are you talking about?"

"When Scott and I got the anchor stuck off this really great point-break twenty miles outside of Subic, I was pretty concerned. You see Scott here and the commanding officer weren't exactly on the best of terms."

"Hey, the guy was a prick."

"He was, but he was also your commanding officer. Anyway, I was scared that if we had to cut the anchor line and leave the anchor, the C.O. might find out and we would have been in big trouble. Those anchors aren't cheap."

"So what did you do?"

"That's what I'm getting at. We took a piece of chain and made a loop around the anchor line. Then we shackled the loop to a spare anchor line and let it drop down over the anchor. After the loop was around the anchor, we let go of the original anchor line, backed the boat up, and took up on the new anchor line. Putting the loop around the anchor allowed us to pull it out in the opposite direction it went in. Worked slick as grass through a goose."

"Ya know, that might work. We could use the communications cable to slide the loop down to us. I'll call the ship."

Bill picked up the radio and called Captain Pixton. He liked my idea and had the crew attach a large chain loop to a 6,000-foot Kevlar line. It took them about an hour and a half to get everything rigged and the loop down to us. When the chain finally made contact with the top of our stranded submersible, it was like taking a 6,000-foot column of water off our backs.

*　　*　　*

The phone rang at the observatory. Jimmy Jordan picked up on the second ring. "Hello."

"Jimmy, this is Walt Grissom. How's it going down there?"

"We're busier than puppies in a playpen. I just got off the phone with the Superintendent. They're going to evacuate the entire park. Only critical personnel will be allowed to stay. This morning at about six fifteen, the East Rift Zone opened up along a two-kilometer fissure and started to fountain and Pu'u O'o is really pumping."

"You've been busy."

"My biggest concern is Mauna Loa. I'm currently looking at over 1.5 meters of expansion along the entire south flank. I went back over our records. We've never seen anything like it. I'm telling you something big is about to happen."

"Jim, that's not what I called about. I figured things were starting to heat up in your neck of the woods. We've been picking up hundreds of tremors over the last few hours, and a couple of pretty good shakes."

"Yeah, we had one about twenty minutes ago. So what's up?"

Walt cleared his throat and then cleared it again before he spoke. "Did you hear about Dr. Richardson and Mr. Palmer?"

"No, are they alright?"

"Not really. They're down 6,000 feet in the university's deep submersible."

"They're still down there?"

"They're in big trouble."

"What's going on?"

"While they were checking out that submarine slide that caused the December tsunami, Dr. Richardson wanted to collect a sample of coral down in a fissure. When they reached in with the manipulator arm, there was a small earthquake and the arm got stuck. They can't get off the bottom."

"Damn. What now?"

"For the last ten hours they've been trying to get a chain loop around the front of the sub. They were hoping to pull the sub off the bottom that way. They couldn't get the loop to cooperate so they grabbed it with the other manipulator arm. When they went to pull, the arm wasn't strong enough. The chain popped out of the claw and broke the communications cable. They've given up trying to pull the sub out."

"So you lost communications with them?"

"No. We still have the hydrophone but it's not looking good."

"Isn't there anything else they can do?"

"We've got the university's other submersible on the way. I just got off the phone with the captain. He doesn't think it will be there in time to save them."

Both men went silent for the next few moments. "I liked Dr. Richardson, he wasn't your typical professor type, and Palmer seemed like a good guy."

Grissom let out a long breath. "I've gotten to know Scott Richardson pretty well. I was the one that asked him to check out that slide."

"I understand, Dr. Grissom, but you shouldn't blame yourself. Dr. Richardson wanted to work on this as much as anyone else."

"I know, but it still doesn't make me feel any better."

"I feel bad about those guys, but we may have even bigger problems. I don't know how much longer this big girl is going to hold together."

"You think she could let go any time now?"

"Honestly, I'm not sure. I've never seen her this active, but that does-

n't mean she's ready to collapse."

"Keep me informed. We need to give the politicos as much notice as possible, but we don't want to give them a false warning."

"I'll do my best. Walt, one more thing"

"Yeah?"

"Keep me posted about Dr. Richardson, too."

"I will, but I'm afraid it won't be good news."

* * *

We almost had it a couple of times, but the manipulator arm wasn't strong enough to grip the chain. Now the communications cable was gone. Our only hope was that the Pisces IV would get down before we suffocated or suffered permanent brain damage. I lay on my bench trying to decide which would be better. I was leaning towards suffocation.

"Captain Pixton, here." His voice sounded all choked up, and it wasn't just the weird acoustics of the hydrophone. "Would you three like us to patch you through to your families?"

He was trying to help, but I was having a tough enough time holding it together as it was. I looked over at Scott and Karl. The tight quarters made our situation that much more difficult. We were almost lying on top of one another, yet each of us had gone into our own mental corner. You could almost feel the despair permeating throughout our little submersible. From their glassy-eyed stares, I could see that my shipmates were in bad shape. No one took up the captain on his offer.

The dead man alarm went off again. Karl was too distracted to remember to hit the button every ten minutes. Each time he forgot, Scott yelled, "Turn the fucking thing off Karl. If you let it ring one more time I swear I'll…" Scott usually had amazing composure under stress. I suspected his irritation was a symptom of our decreasing oxygen. Pretty soon we'd all suffer the full affects of hypoxia: mood changes, headaches, and slurred speech. I checked the oxygen. The main and emergency tanks were empty. We had less than 15% oxygen in the air we were breathing.

I'd been trying to think about Lauren and Aubrey, but my brain couldn't hold the thought, another sign of hypoxia. I also gave up trying to think of some way to save us. Sometimes all I could see was that stupid turtle's face staring back at me. What happened, Louie? You were supposed to bring me good luck.

I closed my eyes and tried to rest for a while. Eventually the constant whir of the fans put me to sleep, or it was the lack of oxygen?

The dead man alarm went off one more time. My heart beat so fast I thought I was going into cardiac arrest. I looked at the oxygen meter. It read somewhere between eight and ten percent. My vision was too

blurry to read the small numbers on the dial. It was like looking through a long pipe.

In a very slow and deliberate tone of voice, Karl said, "Scott, Chuck, I don't know how you guys are doing but I can't keep my eyes open much longer. I've lost most of the coordination in my hands. If we're going to dump, the ballast it had better be now. What do you say?"

Scott answered first with a slightly stronger voice. "If our choice is to sit around waiting for the other submersible, only to end up with the mental capacity of a rutabaga, then I vote for dumping the ballast. I'd rather end it all in a flash of vaporized water than spend the rest of my life as a drooling idiot."

"Hey, buddy, that might be an improvement."

"You're probably right."

"Karl, I'm with Scott. I don't want my wife to spend the rest of her life taking care of vegetable matter. And I sure as hell don't want my daughter bringing her friends over to see Daddy in his diaper. I say we dump the ballast and take our chances."

I watched as Karl picked up the hydrophone mic and tried to key the transmitter. His fingers could barely hold the instrument. I'm not sure anyone heard him. He didn't even ask to speak to Captain Pixton.

"Kilo Moana, this is Pisces V. We are releasing ballast. Gentlemen, hold on tight this could hurt."

Karl tried to grab the release lever but hit the outside light switch by accident. The rock wall lit up as if it were daylight. He reached over and this time was able to grab the proper lever, but he wasn't strong enough to pull it back. I reached back, placed my hand over his, and we pulled together.

With a loud metallic clang, the lead ballast dropped out from under the submersible and hit the slope bellow. Instantly the back end of the sub shot straight up as Karl had predicted. The bench went vertical, and I started to slide face first toward the viewing port. I gripped the bench with useless hands as my face smashed into the port. Searing pain shot through my jaw. There was an instantaneous flash of light, and for a moment, my vision cleared. I stared at the rock wall rushing towards me. The roar of breaking glass shattered the monotonous silence in the little sub, and then everything went black.

Eleven

"ROGER THAT. I'LL PASS IT ON TO THE PISCES." Captain James T. Pixton placed the microphone back in its cradle and paced nervously back and forth on the bridge of the Kilo Moana. His perfectly groomed hair tousled, his starched shirt and pressed pants wrinkled. Captain Pixton had been up for over thirty hours. The exhaustion and fatigue was starting to show. He no longer stood erect. Slumping forward, the captain's usual brisk walk had deteriorated to little more than a shuffle.

"Communications, this is the captain."

"Communications here. Yes sir."

"Paul, please pass on to the Pisces that I just spoke to the KOK. We have them in close visual range. They will be on station in less than fifteen minutes. The Pisces IV is hooked up to the crane, ready to launch. We anticipate they will be in the water in fifteen to twenty minutes and on the bottom in just over an hour. Please tell them to hold tight."

"Yes, sir."

Captain Pixton stepped over to the helm chair and sat down. He rubbed his eyes not believing the events that had taken place over the last twenty-four hours. With over twenty-seven years of command, Pixton had only lost one other crewmember. It happened when he was in command of the Foss Epic, a 160-foot ocean-going tug. Halfway across the North Pacific in rough seas, a young sailor made the critical error of going down to the towing deck for a cigarette. He was instantly killed, almost cut in half, when the towing hawser snapped and hit him in the chest.

"Captain, we've lost contact with the Pisces."

"Paul, what do you mean we've lost contact? Try them again."

"Sir, I've tried three times."

"I don't care. Keep trying."

Captain Pixton slammed the handset down and jumped out of his seat. He began to pace, then turned on his heels and marched out to the starboard wing deck. The KOK was less than a mile away. The Captain could see the crew working on the deck of the 223-foot vessel. He leaned against the protective railing and stared at the churning water almost

four stories below. Captain Pixton had known Karl Klessig for over twenty years. He was as close a friend as he allowed himself to have while at sea. When Pixton was hired to command the Kilo Moana, he insisted that the university also hire his friend. The captain had even made the arrangements for his friend to get a submersible pilot certification. The thought kept running through his mind, "Why Karl? Why Karl?"

One of his junior officers peeked his head through the door. "Captain Pixton, communications is on the horn. They need to speak to you."

"I'm coming." The captain picked up his pace as he stepped over the bulwarks at the base of the pilothouse door. The young officer handed the captain the black handset.

"Yes, Paul. What have you got?"

"Captain, the hydrophone operator just reported hearing what sounded like breaking glass and implosion sounds. He said it was pretty ugly."

"Son-of-a-bitch." Captain Pixton slammed his fist down onto the large radar screen in front of him then instantly straightened and composed himself. "I'll contact the KOK and let them know that they don't have to hurry. It sounds like this will be a recovery rather than a rescue mission."

"I'm very sorry, sir. I know how much you liked Mr. Klessig."

"Thank you, Paul. Keep me informed."

"Yes, sir."

Captain Pixton went back to his helm seat and buried his head in his hands. He took in several deep breaths and then sat up straight. There would be plenty of time to mourn his loss. For now, his duties as captain came first. "Transmit the news to the KOK, Smith. We'll call the university after the Pisces V is on board."

"There will be an inquiry, sir."

"No doubt. We'll deal with that later. You just call the KOK."

Close to retirement, the captain wondered if this accident would be his legacy? Pixton began to make mental notes on how he wanted the three bodies and any evidence handled. As the captain of the Kilo Moana, it would fall on him to notify the closest of kin, a duty he dreaded more than anything else. The handset next to the helm seat rang.

"Yes, Paul."

"Captain, sonar is picking up the Pisces. She's coming up fast."

Pixton straightened abruptly. He ran his fingers through his hair. The color started to flow back into his cheeks. He jumped out of his seat and began to pace, thinking hard. He stopped and turned as the spiral cord connected to the handset straightened to its full length.

"I need to know where she's going to surface."

"Hold, sir. I'll be right back." Captain Pixton began to pace even faster, taking short truncated steps as the adrenaline began to course through his body. "Sir, she's coming up a quarter mile off the port stern."

"Thank you, Paul. Continue trying to contact them."

"Yes, sir." Captain Pixton turned to the young deck officer.

"I want three rescue divers and a line handler along with the helmsman in the RIB. Get the medic back to the work deck, along with two crewmembers with current CPR tickets. Make sure they have three oxygen tanks with them. I'll be at the aft end of the port weather deck. Let Paul know. Call me when the RIB hits the water."

"Yes, sir."

Captain Pixton stepped out of the pilothouse and went down the outside stairs to the second level weather deck where he called his communications officer.

"Paul, how long till they hit the surface?"

"Hold, sir." With the tropical sun blazing down from above, the captain began to pace again, gently tapping the handset against the side of his head. He stared at the horizon wondering what they would find when the Pisces surfaced.

"Captain."

"Yes, Paul."

"Sonar is saying less than five minutes. It's still a quarter mile off the port stern."

"Thank you. If you have any more news I'm on the second level weather deck."

"I know, sir."

Captain Pixton hung up and called the bridge. "Where's that damn RIB?"

"Sir, it just hit the water. I was picking up the phone to call you."

"Is everyone aboard?"

"Yes, sir."

"Tell the helmsman to tune to channel 72 now, I'll be giving him instructions." Captain Pixton keyed the radio transmitter and called the RIB. "Kimo, do you read?"

"Yes, sir. Loud and clear."

"Kimo, the Pisces is supposed to come up a quarter mile off our port stern. You can start heading out in that direction but take it easy. I don't want the sub coming up underneath you. As soon as she surfaces, if you can't find her I'll give you heading instructions from up here. I've got a much better vantage point."

"Rodger that, captain, we're just pulling away. You should be able to see us in a second."

"When you get to the Pisces I want two safety divers in the water. The third remains on the boat. Do you read me?"

"Affirmative. Two divers in the water; the third stays onboard."

"Okay. One of the divers is to take the towline with him when he jumps in. I want that sub under tow as quickly as possible. We need to get it hooked up to our crane and out of the water ASAP."

"I'll tow her as fast as I can."

"Just don't break the towline and be careful. We'll be backing down on you to close the distance."

Captain Pixton scanned the choppy water in the area where the Pisces would break the surface. The tropical trades had been blowing all day with the swell and wind chop building. The conditions were still well within the limits of the crew's ability to retrieve the Pisces, but it wouldn't be easy.

"Captain, there she is." One of the crew on the working deck two levels below the captain had spotted the Pisces red conning tower. As instructed, his arm was outstretched to keep track of the sub's position. The captain immediately sighted the sub as it barely floated above the confused surface, dropping in and out of view between each swell.

"Kimo, do you read me?"

"Yes, sir."

"Come twenty degrees to starboard and that should place her right on your bow. Do you see her yet?"

"Still looking, captain... Got her!" Captain Pixton watched as the RIB bolted out of the water and covered the 200 yards to the sub in a matter of seconds. He grabbed a pair of binoculars and watched as the first safety diver jumped in with the towline in hand. The second diver followed, hitting the water just off the bow of the sub. His job was to inspect the hull and look inside through the viewing ports. Pixton paced anxiously back and forth waiting for the report, repeating to himself a mantra of "Please let them be safe, please..."

"Captain."

"Yes, Kimo."

"The safety diver says the pressure hull is intact. The only damage he was able to find were a couple of broken exterior lights and some scratches on one of the manipulator arms." Captain Pixton breathed an audible sigh of relief. The broken lights explained the implosion the hydrophone operator reported.

"Any word on the condition of the crew?"

"He just went back down to check." The captain crossed his fingers, something he hadn't done since childhood. He added a small prayer

under his breath as he continued to repeat the mantra. "Please, let them be safe."

"Captain, my diver says there are two occupants with their faces pressed against the viewing ports. Their lips are blue and they do not appear to be breathing. He said he was looking for any sign of fogging on the glass. He couldn't detect any even though their mouths and noses were right next to it. He said they could still be alive but they're not in good shape."

With this latest report the weight of command had just become too much. Captain James T. Pixton set the handheld VHF radio down and covered his eyes as tears began to flow. He turned away from the crew on the lower deck and faced out to sea. All he could do was repeat the simple question, "Why?"

"Captain…Captain, are you there?" For a moment, Captain Pixton was lost in his own despondency, forgetting that he was still in charge of a 2,000-ton vessel. James Pixton gathered himself and grabbed the radio. "Yes, Kimo."

"Captain we are hooked up and about to take the Pisces under tow. The safety diver wants to open the hatch so he can begin administering first aid. Does he have permission to open the hatch?"

"Negative. Do you read me sailor? He is not to open that hatch." Captain Pixton had just lost three crewmembers. He was not about to risk losing a fourth. With the size of the swells and wind chop, if the crewman opened the Pisces hatch she would instantly flood and sink to the bottom. "He is not to open that hatch under any circumstances. Do you understand?"

"Yes, sir. I will advise the diver not to open the hatch. Repeat, we will not open the hatch."

* * *

Kimo Wilson turned to his friend and yelled across the twenty feet of water that separated them. "Grego, Captain says we can't open the hatch. He's worried about the Pisces sinking."

"Bullshit, if we don't get down to those guys right now any chance we have of saving them is history."

"What do you want me to do? The captain gave an order."

"It's going to take another twenty minutes before we can get the sub hooked up to the crane. If they're still alive, they'll be dead by the time we get them on deck. Tell the captain…. Forget it. Have you got an oxygen bottle in your first aid kit."

"Sure."

"Get it and tie a ten or fifteen foot line to it. Then toss it over.

Come on, move."

"Here, catch." Kimo had maneuvered the big RIB alongside the sub so that he only had to toss the oxygen tank a few feet. "Open that hatch and you're going to get your ass fired. Maybe worse."

"I know."

In the rough seas, water rushed in and out of the freeing ports, small drain slots along the bottom of the conning tower. Greg Sachs grabbed the ten-inch diameter wheel on top of the hatch and turned. At first it would barely move. Once the seal was broken, he spun the wheel all the way to the stops. He opened the valve on the oxygen bottle. At 3,000 psi, the escaping gas hissed at him like an angry cat. Greg quickly lowered the screaming oxygen bottle to the floor of the sub and then slammed the hatch shut. Only a few gallons of water entered the sub while the hatch was open, not enough to endanger the occupants or the sub. Greg gave Kimo a thumbs-up.

* * *

From the second level weather deck, Captain Pixton watched the Pisces bobbing up and down on the swell. What was the problem? Kimo just said they were hooked up and ready to start the tow.

"Kimo, What the hell's taking so long? Get that submarine back here. Do you hear me?"

"Roger that, captain. We had a minor hang-up. It's taken care of and we're beginning to tow. We should be there in about ten minutes."

Captain Pixton and the entire recovery crew anxiously waited at the stern of the Kilo Moana as the RIB maneuvered the red and yellow Pisces into place for recovery.

* * *

I didn't recognize the blurry face undulating back and forth in front of me. Hazy vision and the thrashing pain in my forehead didn't help. I blinked a few times attempting to focus. The young girl staring at me through wire-rim glasses and compassionate eyes smiled. She was saying something. At least her mouth was moving. Who was this strange person and why was she looking at me that way? My aching head, the bright lights shinning down, and the constant whirring sound in my ears, combined to fashion a state of confusion I had never experienced before. I squeezed my eyes shut. My mind demanded an answer to the simple question, "Where am I?" Yet there was no response, certainly not from the usual sensory systems.

"Mr. Palmer, can you hear me?"

I opened my eyes again. Maybe she wasn't that young. What did she say? Then I recognized Captain Pixton's voice, distant as if transmitted

through a speaker.

"Medic, how is he doing? Are there any signs of brain damage?"

I tried to reply. "No more than usual, sir." No one heard me. The young woman had placed a mask over my nose and mouth.

"It's too early to say, but he seems to be waking up. We need to get him in the chamber right away, but I think he's going to be fine."

"Thank God. Please hurry."

"Sir, we've already started to remove Dr. Richardson from the Pisces. We have a problem however."

"What's that?"

"Mr. Palmer is much larger. We're not sure how we're going to get him through the hatch."

"He got in there some how; I'm sure you can figure a way to get him out."

"Yes, sir. Mr. Palmer, can you hear me?" A hand removed the mask.

I tried to respond. My mouth felt like sawdust. The words came out as more of a croak than a sentence. "Have you got anything for a headache? And how about some water? Make that a beer?"

The pretty young face smiled. "Welcome back. We were worried about you." The girl grabbed a plastic bottle and dripped water into my mouth.

"So was I. By the way, if you happen to see a guy with wavy blond hair and bright blue eyes…shoot the bastard."

"Oh, you must mean Dr. Richardson. He's already on his way to the hyperbaric chamber. We're going to be placing you in there with him."

"Good. Then I can do it myself."

The young Asian woman smiled again. She thought I was joking.

As my brain moved in and out of its semi-conscious state hands without arms or bodies were everywhere as they undressed me down to my skivvies. Strapped tightly to a stretcher, I was taken into a large laboratory lined with bottles of preserved sea life. It occurred to me that I had been transported to some ghoulish alien ship where I was about to be shoved into a bottle of formaldehyde. Instead, the crew of the Kilo Moana rolled me into a large steel pipe.

The next time I opened my eyes it was to the sound of a heavy steel hatch sliding closed just beyond my feet. The mask over my nose and mouth had been removed, but trying to focus was useless. Every time I opened and closed my eyes, the only thing I could see was white. In my semi-conscious state, I wasn't able to detect any shapes or textures within my narrow field of vision. There was nothing but white. It was as if I'd gone blind and my mind had somehow substituted the black associated with blindness with pure white. Then I heard a voice. The voice seemed

distant, disconnected, and almost mechanical. Surrounded by a palate of white nothingness, the first thing that came to mind was, "Is this God speaking to me?" When I realized it was a female's voice, I thought. "No way! Is God a chick?"

"Mr. Palmer, can you hear me?" I couldn't even understand the croak that came out of me, so I gave the disconnected voice a thumbs-up, and it seemed to work. "Very good, and Dr. Richardson are you still with us?"

"Right here." If Scott was with me, this definitely wasn't heaven.

"All right, gentlemen," said the female voice. "I'm Sharon, and I'm going to place you in an oxygen-enriched atmosphere and take you down two atmospheres. You'll have to equalize."

Two atmospheres? I'm going down 66 feet, why? My muddled brain wasn't computing, but then somewhere in the furthest recesses of what little gray matter I had left, I remembered someone saying something about a hyperbaric chamber, a decompression chamber. Why was I in a decompression chamber? I hadn't been diving. The angry hiss of oxygen filled my senses as the pressure inside the chamber began to increase. I immediately squeezed my nostrils shut and began exhaling against them to equalize the pressure in my inner ear.

"Why?" I whispered.

Sharon answered, "When the body senses a lack of oxygen, it begins to shut down various organs as a defense mechanism. That way it can concentrate what little oxygen there is on the essential organs like the brain and heart. By placing you in a highly enriched atmosphere under pressure, it will literally force oxygen back into your organs. That way the liver, kidneys, pancreas, and all those other yucky things will come back on line much faster."

"Yucky. Is that a medical term?"

"Oh yes, doctors use it all the time," she reassured me and then added with a grin. "I can see you are going to be just fine."

She was right. As the life giving oxygen began to inundate my liver and kidneys along with all those other yucky organs, I began to feel much better. More important, my headache miraculously disappeared and my brain seemed to be in a semi-functioning state. I slowly rotated my head to the right and a small viewing port filled with Sharon's smiling face came into view. I smiled back. I continued to turn my head to get a look at Scott. With the entire inside of the decompression chamber painted white, I hadn't realized how small the damn thing was. We were literally lying right next to each other with our bare shoulders and arms touching.

For a second our eyes met. "Howzit?"

"Fine, I think." Talk about being pissed off, and that was with

half a brain.

"Hey, I'm really sorry. We almost died. I had no idea. I never meant it to be this way." Scott was completely subdued, almost as if he were in shock. "You've got to forgive me." I had never seen him like this. Not even after hearing the news from Dr. Grissom. Despite my ever-increasing level of rage, I thought it best to go easy on him given his current condition.

"Hell no, you son of a bitch. Ya damn right you almost got us killed.

"What can I say? I'm just really sorry."

"Sorry isn't going to cut it. You're going to owe me big time for the rest of your life. From here on out I'm the alpha dog in this pack, and we do things my way."

"Woof."

"You can say that again." I was about to continue ripping into Scott when it occurred to me that Karl Klessig wasn't in the chamber with us. It was a two-person chamber, and damn tight at that, so maybe they decided that Scott and I needed the oxygen more than he did. "Sharon, are you there?" We had to wait a few moments before she responded.

"I'm right here. I was just doing some paperwork."

"We were wondering how Mr. Klessig is doing. He's all right isn't he?" There was long pause before she responded.

"I'm sorry to have to tell you this, but Mr. Klessig didn't make it. He wasn't breathing when we finally got to him. We tried everything, but we were too late. I'm so sorry."

"Shit," was my only response. Nothing deep or introspective, not even a kind word. I wasn't feeling particularly kind at the moment, and besides that one simple word summed up everything I was feeling. All the emotions inside my miserable head, attached to my miserable body that was stuck inside that miserable pipe, had just been spelled out. Nothing more needed to be said.

"Mr. Klessig wasn't in the kind of physical condition that you two are in," Sharon explained gently. "He had recently quit smoking so his cardiovascular system wasn't very efficient. His body couldn't utilize what little oxygen was left in the Pisces as well as yours did." I'd always thought that smokers were some of the most disgusting people in the world, and they deserve everything they get—except this time it just didn't seem right. Even though I had only known Karl Klessig for a couple of days, we'd shared an awful lot. He was someone I wouldn't forget, one of the good guys. One of the good guys that deserved better.

I laid my head back down on the hard shelf. With palms pressed into my eyes, I attempted to avoid the world around me. I had survived. I was going to see my daughter smile. I was going to share another

bottle of wine with Lauren while sitting on our patio watching the sun drop into the blue green waters of the Pacific. I'd even share a few more beers with the guy lying next to me. I had survived. I still had my whole life ahead of me. Even though my current surroundings sucked, I had a future. Just the thought helped to cheer me up. With visions of my little family bouncing around in my head, ricocheting off the sides of my cranium, a guilty smile spread across my lips.

"Hey, Chuck, you okay? You still talking to me?"

"Yeah, I'm fine. I hate to say it, but I couldn't be better. I'm f-ing alive, and right now that's all that matters. And yes, I'm still talking to you."

"Good. It is nice to be alive. Karl not making it really blows."

"You're right about that, but I'll deal with it later. For now I'm just happy to be breathing."

"I know the feeling."

The two of us lay there quietly, listening to the hissing machine. Finally Scott spoke up.

"I've been thinking."

"Well, that needs to stop."

"Okay, but I was just thinking about my family. You know, what I should do about Aolani and Cherolyn."

"Hey, you're not going to get all soft and squishy on me?"

"No way… Okay, maybe a little. It's just that almost dying has been a bit of an epiphany for me. I mean the sex and everything with Cherolyn is great. It's exciting."

"Do I really want to hear this? Oh hell, what are friends for?"

"Exactly. Anyway, my relationship with Aolani is different. It's comfortable. It feels right. Lying in bed, hearing her breath, knowing she's next to me. That's what I miss. Sometimes when Aolani was asleep I'd gently rest my hand against the small of her back just to feel her warm skin. Things like seeing the kids and Aolani laugh at the dinner table. That's what I miss the most. All Aolani wanted was to have me around so I could watch Simon and Katie grow up. She just wanted to spend a little time with me. That's not so bad, is it?"

"No, I suppose not. Ya know I've been doing some thinking about Lauren."

"Now who's getting soft and squishy?"

"If you don't want to hear, then I'll shut up."

"It's okay. What are friends for?"

"Exactly. Lauren let something slip the last time we spoke."

"What's that?"

"She said she tricked me into getting her pregnant, and now we're

married. I've been trying to remember exactly what happened. I've always been religious about safe sex. I could swear she said don't worry, or something like that."

"And you fell for it?"

"It was one of those crazy nights. We'd had a fair amount to drink, at least I did. And things started to move so fast."

"Hardly an excuse."

"I know, but what do I do now. I have a daughter I love, and I don't know what to think about my wife. I'm not sure I can ever look at her the same way. Trust is the foundation of every relationship, especially a marriage. I'm not sure who she really is, or if I'll ever be able to trust her again."

"Hey, I don't see what the problem is. You've got a daughter you love and a beautiful rich wife. Keep your mouth shut and don't mess it up."

"Come on, I'm not screwing around. I've got a real problem that's driving me crazy."

"Go easy on her. Lauren probably feels worse than you do about what she did. You don't understand, when a woman decides she wants a kid, she can't help herself. Their space-time continuum changes, they enter a new dimension. It's called the female dimension."

"Really, what's it like?"

"Very scary. It's a place devoid of all reason and logic, a place where no man has ever been. She didn't know what she was saying."

"The female dimension. I've known a few women that have spent most of their life there. Maybe you're right."

Sharon kept us in the hyperbaric chamber for another hour and a half. By the time we got out, other than feeling a little wobbly on my feet, I felt fine. Scott was obviously feeling fine; he couldn't wait to get off the Kilo Moana.

"How about we go back to the Maka Hou? We'll finish up the rest of that Ono for dinner and slam back a few dozen beers. Trust me, from now on it's nothing but warm tropical breezes and beautiful women. Look at Sharon, isn't she beautiful?"

The attractive Asian woman smiled as she turned to Scott. "The female dimension. That was rather interesting."

"Ah, I forgot you could hear everything we said in there. Sorry about that."

"No, that's okay. It happens all the time. Though I'll admit this time was particularly entertaining. I just wanted to know if there was also a male dimension?"

"Sure."

"And what's that like?"

"It's filled with nothing but beer, sports and young girls dressed in thongs."

"Figures."

Scott quickly changed the subject. "How soon can we get a ride back to the Maka Hou?"

"Slow down, Dr. Richardson. You may be fit, but you have had some serious stress to your system. You ought to spend the night so we can observe you."

"Not an option. Where's Captain Pixton?"

"He's retired to his cabin." She paused. "Karl Klessig was a good friend of his."

"Oh, right. I forgot how close they were. Next in line is the First Officer. Let's ask him." I insisted. I didn't want to stay in Hawaii an extra minute longer than necessary.

Scott asked, "What's his name, Sharon?"

"Officer Hearn. He's probably on the bridge."

We hurried to the bridge as fast as our wobbly legs would carry us. The First Officer reluctantly agreed to let us go back to the Maka Hou if we promised not to dive until a doctor checked us over.

Scott and I collected our belongings. Thirty minutes later, we said goodbye to the crew and told First Officer Hearn to offer our condolences to the captain. Kimo pulled the big RIB around to the stern of the Kilo where we climbed down the same ladder that we boarded. Remembering our ride out to the Kilo Moana, I asked Kimo to take it easy.

After we were clear of the Kilo Moana, Kimo waved us over to him. "You know, Dr. Richardson, Mr. Palmer, you should probably send a thank you note to one of our crew members. If it wasn't for him you might not be here today."

"What do you mean, Kimo?" asked Scott. "Who saved us? What did he do?"

"It was my friend Greg Sachs. If it weren't for Grego, I'm sure you guys would have been maki."

"What did your friend Grego do?"

"The captain had given the order not to open the hatch until the Pisces was hooked up to the crane and coming out of the water. That's standard procedure. Grego disregarded a direct order. If he hadn't opened that hatch and thrown the oxygen bottle down into the sub, it would have been a good twenty minutes before we got any oxygen to you. He risked his job for you guys. He still may get fired."

Scott said, "Please let your friend Grego know how much we appreciate the risk he took. If he needs a job have him call me at the university."

"Thanks, I'll let him know."

The ride back to the Maka Hou was just slightly more sedate than the ride out, like a jet rather than a rocket flying over the waves. We roared up to the Maka Hou in a flurry of foam and spray, our wake rocking the little sport-fisher tied to the mooring beneath the hundred-foot cliffs of South Point. Sammy already had the barbeque out and was in the process of preparing dinner. We waved goodbye to Kimo and promised we would send Grego a thank you note.

TWELVE

SAMMY SEEMED ALMOST HAPPY TO SEE US and more relaxed than when we had left. His good mood didn't last for long when we told him about following the ever-widening crevice and getting stuck in the sub.

"Pele was giving you a warning," Sammy said. "You better not screw with her anymore. She wants to be alone."

As soon as he said it, a picture of the old girl draped across an over-stuffed sofa with her wrist gently resting on her forehead popped into my mind. I almost blurted out *I vont to be alone.* Instead I grabbed a beer, sat back in my plastic chair, and listened while Scott and Sammy went at it.

"Ya darn right it's dangerous, but this has nothing to do with ancient lore. It's geology, science pure and simple."

Sammy shook his head while waving a finger at both Scott and me. "Pele is angry. She will get her revenge. You'll see." His voice trembled. You'd have to be deaf and blind not to notice how agitated Sammy got when it came to the goddess Pele. He really believed this stuff.

"Fine," said Scott. "I'm too tired to deal with this."

Sammy scowled and stomped off to the galley to start dinner.

"Damn it, Scott, try to be a little more understanding with this guy."

"I suppose you're right. I'll try to be more careful."

We sat there in gloomy silence. Scott finally said, "Chuck, why don't you take the first shower."

I wasn't going to argue, and I quickly downed my beer. After bathing and changing into clean clothes, I went back to the cockpit. Scott had already gone back to his cabin to freshen up. Sammy was in the process of throwing the rest of the Ono on the barbeque alongside some foil wrapped potatoes. I offered to make the salad, but Sammy said it was already taken care of. Just as my backside settled comfortably into my chair, Sammy reached into the ice chest, grabbed a Primo and tossed it to me. It was the second best gift I'd received all day. I sat back and proceeded to down my first beer of the evening. No, it was the second. Sammy made a bowl of pokie, the Hawaiian equivalent of ceviche, and placed it

on the table in front of me along with some crackers.

Scott came out dressed in a clean Hawaiian shirt and blue shorts. Sitting next to me, he asked. "What happened to all the pokie?"

I hadn't realized I'd already eaten half the bowl along with downing three beers. I licked my fingers. "I guess I liked it."

Scott went and grabbed his own Primo, sat down, and surveyed our surroundings. "Nice spot isn't it? Not very many people have been here."

"I can imagine. Especially with the mooring ten feet underwater."

"Maybe that's what makes it so special. You have to admit it's a treat."

"It's almost as big a treat as being alive."

"You have a point."

I still hadn't gotten over the number of close calls we'd had on this little trip, and I was more determined than ever to make sure we didn't have any more. "Scott, I know you promised that we're done with all of the excitement. But I just want to make sure you understand how serious this is for me. Honestly, no more of this crap. From here on out, we're taking it slow and easy. We're doing it my way." I know I was sounding a little whiney. It didn't matter.

"Hey, it's not a problem. We'll get up tomorrow morning just before 0600 and pick up the mooring. By this time tomorrow, you'll be fully reclined in your first class seat dreaming about that sexy wife of yours."

"What about your plane? Maybe I should fly back commercial?"

"It's up to you, but the airlines have cut their schedules so much you'll never get back in time to make your flight."

"So we'll inspect the entire plane like we did back on Lanai?"

"Don't need to. I've got it under control." Why was I still worried? Then I remembered: if Scott has anything to do with it, we're screwed? Given our recent experiences, one couldn't possibly be too cautious.

"What do you mean, you have it under control?" Before my friend had a chance to reply, Sammy began to serve dinner. On the table, he laid out plates of barbequed fish with potatoes, snap peas sprinkled with ground macadamia nuts, and a of salad. Then he grabbed three more beers from the ice chest. We were starved, having been down in the sub for over thirty hours with only a couple of peanut butter and jelly sandwiches. Scott and I piled heaping mounds of food onto our plates, and when we were finished, we went back for more. Sammy commented that he wasn't sure he'd made enough. It was a good thing he had baked two mango pineapple torts sprinkled with crushed macadamia nuts.

When I had eaten all I could eat, I sat back and stretched out my legs. I felt nice and relaxed but I wasn't about to let my friend off the hook. "Scott, you never answered me about the plane."

"Oh, sorry. First, pass me some of that pie. Don't you remember what I did after closing up each inspection hatch? I went back and touched up the screws with white paint? If anyone tries to open a hatch, they'll scratch the paint with their screwdriver and we'll be able to tell. See it's all under control."

"I still want a thorough preflight inspection, with me looking over your shoulder every minute."

"Damn. If I didn't know any better I'd say you don't trust me anymore."

I pointed a finger at my chest. "Moi? Au contraire. I've never trusted you."

"I love you, too. Now pass me some of that mango pineapple dessert. Sammy, do you have some vanilla ice cream I could put on top of this?"

"Le'me check da freezer."

As Sammy got up to go to the galley, he turned and said: "Hey, brah, eriding pretty good. You brok' da mout?"

"What the hell did he just say?"

"He said, 'Hey, brother, everything was pretty good. You brok' da mout'? means Did it taste delicious?"

"Sammy, you brok'da mout."

He smiled and gave me a thumbs-up.

Sammy came back through the sliding glass door holding a carton of vanilla ice cream. At first I thought the low rumbling sounds I heard was the door sliding on its rollers. Sammy stepped into the cockpit, closed the door, and the noise didn't stop. In fact it grew louder. Without warning, the peaceful anchorage was shattered by the crash of falling rocks smashing into the pile of rubble at the base of the Pali. The vertical cliff seemed to be crumbling before our very eyes less than a 100 feet from where we were moored. The three of us ran to the side of the boat. All along the entire length of the cliff, portions of rock wall were breaking off and tumbling down onto the pile of boulders at the base. Some of the larger pieces rolled into the water throwing up huge sheets of spray.

"What the hell's going on?"

"It must be an earthquake," Scott casually mentioned, as he grabbed another beer.

"It must be a damn big one." I wasn't about to wait and find out what was going to happen next. "We need to get the hell out of here. I'll untie the mooring line. Sammy, you get the engines started. Scott... I don't know. Call Walt, see if we need to worry about a tsunami."

Sammy climbed up the ladder to the flying bridge while I shimmied forward along the narrow walkway past the cabin. Scott ran inside to get the satellite phone. I made it to the bow of the Maka Hou just as the first engine rumbled to life. I quickly untied the line from the bow cleat and

let it run out. I looked out towards the end of the point as Sammy started the second engine, and then I yelled, "Shit, what the hell is that?"

"What da kine, we go'n get some dirty lick'ns."

I had no idea what Sammy had said. It didn't matter. The sun was just beginning to set. Orange and yellow bands of color reflected off the back of the strange wave coming at us. The wall of water racing towards the Maka Hou was moving at an incredible rate. As the wave broke along the rocky shore, the spray shooting up from the shoreline looked like the rooster tail from some monster race boat. I looked down to make sure the mooring line had not snagged on a cleat. To my horror, someone had shackled the end of the rope to a pad eye at the bottom of the anchor locker. "Son of a bitch!" We weren't going anywhere until I cut the line, and I didn't have a knife. Oh crap. I yelled to Sammy, "Damn it, I need pliers or a knife." He just shrugged and pointed at the approaching wave. I looked up, frozen with fear, convinced we were about to die.

The wave was no more than a hundred yards away, screaming towards us at a phenomenal speed. The spray was flying into the air over thirty feet. It was only when the tsunami passed just off our stern that I realized it was only six to eight feet high. Before I had a chance to say a word, the wave passed under us, barely rocking the Maka Hou as we floated peacefully in over a hundred feet of water. I stood there not knowing what to think. Then Scott yelled up to me.

"Walt says they have a preliminary reading of 7.2. They're in the process of issuing an advisory, a tsunami watch."

"Tell him they don't have to watch for a tsunami; we just got hit by one. It was only six to eight feet." I yelled back.

A couple of minutes later Scott poked his head around the cabin, "He said we better sit tight and make sure a second tsunami doesn't hit us. It could be much larger."

"I'll stay up here. Get me a knife or pliers so I can cut this mooring line."

"I'll toss one up to Sammy; he can hand it to you."

A minute later Sammy motioned for me to take the knife. I grabbed it and went back to scanning the horizon. Waiting there, I repeated to myself as if I were some kind of a mental case, "What a mess. Why me? What a mess." Not sure which direction to anticipate the much larger tsunami that would come crashing down on us at any moment. While waiting for the elusive wave, pieces of the cliff continued to break off sending thundering claps through the peaceful anchorage. My mind started to wander. Maybe it was the pressure I'd been under, a way for me to escape to a more pleasant reality. It was the funniest thing but that damn Fats Waller song popped into my head. "The joint is jumpin, it's

really jumpin." I started to think about everything that had happened the last few days. 'Come in cats and check your hats, I mean this joint is jumpin'. I thought about Scott and me almost dying in the submersible, the dead-stick landing we made on Lanai and Mr. Pampers threatening to kill us. Then there was that all too real threat of some impossibly large tsunami destroying everything. With all these thoughts bouncing around inside my head, I started to get dizzy and almost lost my balance on the rolling bow of the Maka Hou. I grabbed the rail to steady myself.

I sat down and started to think about Lauren, my beautiful wife, my beautiful sexy wife with great legs and a tight ass. A wife that I couldn't wait to see, to hold, to hug, to feel her warm soft skin against mine. Oh, screw that, I was horny. What I really wanted to do was to get down and dirty, make some nasty love to my sexy girl. That's what was really running through my head. Sitting there dreaming about Lauren, I hadn't noticed but my Little Buddy had also been dreaming about her. Little Buddy and I are real close, though I'd swear he has a mind of his own. I scolded him. He'd have to wait until tomorrow night. I tried to explain that there were more important things for us to worry about, like a giant tsunami, but it didn't help. As usual, Little Buddy wasn't listening. He gets that way sometimes. I sat there another fifteen minutes waiting for the end of our world as I hummed that incessant tune. I finally gave up and yelled to my old friend. That would be Scott and not Little Buddy.

"I think we're fine. I'm done up here. I hope the ice cream hasn't melted."

"Naw, it's fine. I put it back in the freezer." I shimmied past the cabin and jumped down into the cockpit where Scott was sitting with another beer in hand. Sammy was still up in the flying bridge. I went into the galley to get the ice cream. When I came out Sammy and Scott were going at it again. I excused myself, saying I needed to go back up to the bow and straighten out the mooring line.

I sat down to eat with my legs hanging over the side of the boat. The sun had already set. Long tendrils of faded orange and yellow ropes left by Hina's son Maui, draped across the horizon. Except for the yelling going on in the cockpit, our mooring under the cliffs of South Point was an idyllic spot. Sammy and Scott, but mostly Sammy, continued to yell for the next fifteen minutes. Then without warning it stopped. I was done with my dessert and had coiled the slack mooring line. Now that things had quieted down in the cockpit, I figured it was safe to go back there. I found Scott sitting by himself with a beer in his hand looking at the water.

"Here, I'll help you clear the table." Scott picked up most of the

dishes and silverware. I grabbed what was left of the food. We went inside and Scott closed the sliding glass door behind us. "So what was that all about?"

"He quit. Said he couldn't work for someone that refused to leave Pele alone."

"That's ridiculous. Did you explain why we're doing this? That it's to save his family and all his native Hawaiian friends."

"I tried to explain. Trouble was, he didn't seem to be in a listening mood. In case you hadn't noticed. He just went on and on about dumb Haole's not understanding the Hawaiian ways."

"So what do we do now?"

"Sammy's refusing to help so I guess I'll run the boat back to the Marina tomorrow morning. You can sleep in."

"What about the mooring line? Who's going to jump in the water at six in the morning?"

"Do you mind? I've got to run the boat."

What could I say? "I'll shower after I deal with the mooring line. Then I'll go back to sleep."

Scott and I did the dishes, put the food away, and then went back to the cockpit. We each had one last beer and called it quits for the night. I can't remember the last time I ever felt so tired. It must have been the lingering effects of the hypoxia, though the dozen or so beers might have helped. As soon as my head hit the pillow, my eyes closed and I was off dreaming about Lauren. Fortunately Little Buddy also went to sleep early that night.

THIRTEEN

"**PALMER, GET UP, MOVE IT...NOW.**" My arm felt like it was being yanked out of its socket. What the hell was going on? I had been fast asleep. Confused, I took a swing at my attacker.

"Whoa, boy. It's me, Scott. We gotta go. Gas."

"What?"

"I smell gas. The boats' gonna blow." Shit. Scott tightened his hold on my wrist and began to pull me out of bed. The little bastard has a grip like an iron vise. Just as I was about to be dragged onto the floor I gained my footing, reached over and grabbed my wallet along with the gold Rolex that Lauren had given me. Scott pulled me to my feet while opening the sliding glass door to the cockpit. Two steps across the water-stained deck, right foot up onto the transom. We launched ourselves into the air, making an arching dive. I was fully expecting the Maka Hou to explode at the apex of our leap, just like you see in the movies, but nothing happened. We hit the water with a half dive, half belly flop. Good thing no one was around to see us. The initial shock was like a sucker punch to the gut. I gave two strong frog kicks underwater and came to the surface. Scott popped up next to me.

"You crazy bastard. Is this your idea of funny, you stupid shit?"

Scott put both hands in the air as if to say uncle. "No. I swear to god. I smelled gas. Didn't you?"

"No... The only thing I smell is a rat."

"I swear." Scott smiled at me with those perfectly white teeth of his. I was ready to knock a couple out. "But you have to admit it is kind of funny."

"No, it's not funny, god damn it. I'm tired of your bullshit." I wasn't ready to give in just yet, even if it was kind of funny. There we were, two nut cases treading water, arguing over whether our boat was about to blow-up as the rays of the sun were just beginning to outline the summit of Mauna Loa in the distance.

"Chuck, I swear. I'm not screwing with you. Didn't you smell gas?" In the early morning light, Scott looked like he was almost pleading with

me. He was either a hell of an actor or he really believed he smelled gas.

"No, I didn't smell any gas."

"Are you sure?"

"I'm sure. Come on let's dry off."

Scott and I turned to swim back to the boat as Sammy stuck his head up from behind the flying bridge settee. He yelled something just as the entire sky lit up. We were struck in the face by a massive blast. Orange jets of flame erupted in every direction as the boat exploded. The cabin and deck of the Maka Hou shot ten feet straight up, the sides of the hull shattered into a million pieces. As we dove underwater, a rancid mixture of unburned diesel fuel, fiberglass, and wood skimmed across the surface. I opened my eyes underwater and looked up. The surface of the ocean was on fire as odd flaming figures danced above our heads. With little air in my lungs and still clutching my wallet and watch, I began to swim with strong frog kicks and powerful breaststrokes. I probably covered twenty-five yards underwater. I looked up once more but the only thing above me was the gray sky of morning so I kicked up and resurfaced gulping for air. Scott came up behind me sputtering, too.

I turned to make sure my crazy friend was okay. "I don't think Sammy made it."

"No way. He's gone."

"What do you think happened?" I asked. "You think our friend Rat Face might have crawled aboard last night and sabotaged us?"

"I doubt it. Someone would have heard him." Scott was gazing off into the distance with a blank stare, grinding his teeth. It was like he was beating himself up inside as he held a hand to his forehead. "I'm sure I know what happened. Damn, how many times did I tell him?"

"Tell him what?"

"To turn off the gas when he was done using the BBQ. Sammy was constantly forgetting and I was so tired last night I forgot to check."

The loss of Sammy was more than I cared to deal with. It wasn't that I couldn't; it was just depressing as hell. All I could do was close my eyes to try and shut out the miserable reality that had surrounded me. "I can't believe he's gone. I liked him."

"Yeah, Sammy could be a pain in the ass, but I still enjoyed having him around. And now he's gone." Scott turned away and began to smash the water with his fists. Throwing up sheets of water. Cursing. After a few minutes of fury, he calmed down, turned to me, and said. "I told you I smelled gas. Now do you believe me?"

"No... I don't believe you. I don't want to believe any of this. What is it with you? You must have really pissed off the wrong person, because

that's one nasty curse you've got."

Scott paused a minute. "Let's look at the good news. Now you don't have to dive on the mooring." And there it was, that cherubic face of Scott's smiling at me once again. All I could do was smack the water with all my strength and send a sheet of spray in Scott's direction.

"Gee, thanks. What about Sammy? What do we do?"

"There's nothing we can do."

"Shouldn't we at least look for him? Maybe he survived."

"No way. If you like we can search the area for a while. I doubt we'll find all of him. There's a small launching ramp out by the point, about a half-mile from here. There should be a pay phone around there. We've got to call the cops."

The half-mile swim took less than twenty minutes. The sun had already started to turn the sky from dull morning gray to sparkling blue

As we continued swimming towards shore, Scott warned me to stay away from the edge of the launch ramp. The rocks were slippery and there were some nasty holes where I could break a leg.

We swam to the base of the ramp and I tried to crawl up. It was covered in green moss, making it almost impossible. Eventually I made it out of the water, only falling three or four times. After skinning both knees, I looked down and realized that all I had on were my boxer shorts. The rest of my clothes were vaporized in the explosion. At least I wasn't alone. Scott was wearing the same attire. Despite the seventy-degree water and the air, the trade winds were whipping across the point raising an impressive cluster of goose bumps on every exposed inch of skin. I looked around for shelter. Just past the boat-ramp there was a small concrete block building in the center of a gravel parking lot. It looked like it might be a shower room and toilet facility.

Scott stopped by the payphone outside the building. "Hey, have you got any change?" I checked in my sopping wet wallet and found a few loose quarters. He dried his hands then picked up the phone and dialed a number.

I could hear a voice answer, "Kona Kopters. How can I help you?"

"Icky, is that you?"

"Yeah, Dr. Richardson?"

"Boy, am I glad you're open."

"You almost missed me. We're helping the rangers evacuate the entire park. There are still a few hikers missing. I was just about to go looking for them. What's up?"

"We lost the boat. Palmer and I need a ride back to the airport. Can you help us?"

"You lost the boat? How do you lose a thirty-five foot sportfisher?"

"It's not like that. I'll explain when you pick us up. You know where the launching ramp is out on the end of South Point?"

"Sure."

"We're in the parking lot. How quick can you get us?" There was a brief pause before Icky came back on the line.

"I can be there in about fifteen minutes. The university pays better than the park service so I guess the hikers will have to wait." I poked Scott in the shoulder and pointed at our boxer shorts.

"Icky, can you bring us some dry clothes? Ours were on the boat."

"I've probably got something that will fit you, but I don't know about that big moke Palmer. I'll see what I can dig up."

"Palmer says don't worry, anything will do." Scott hung up.

"I never said that."

"What? Now you're getting picky."

"I see your point."

Scott and I walked around to the other side of the bathroom facility where there were two outdoor showers. We washed off the saltwater and dried ourselves as best we could. While waiting around for Icky, we didn't have much to say, lost in our thoughts over the death of Captain Sammy. I kept on checking my watch. About the time I was going to tell Scott to call again, Icky and his oversized gnat came into view. A few more seconds and the black chopper with the bright rainbow splashed across the side hovered over the parking lot throwing clouds of dust and sand into the air.

Icky shut the engine down as the choppers blades slowed. He jumped out and went around to the back of the helicopter out of view. Our friendly pilot came jogging over to where we were standing next to the showers with two grocery bags in hand.

"Sorry it took me so long, but I had a tough time finding clothes for Mr. Palmer." That's when Icky took a second look at us and realized that we were in our underwear. "What the hell happened to you guys?"

Scott said. "There was a gas leak on the boat. We just barely got out before it blew up. The captain didn't make it."

"Damn. I'm sorry to hear that."

"You'll need to call the cops, after we get in the air. Tell them you picked up a couple of survivors from a boating accident while searching for those hikers. Tell them one of the crew didn't make it and they need to check it out."

Icky just looked at us, not saying a word, and handed Scott and me the grocery bags. Scott pulled out a pair of blue jeans, underwear, a red

and white Hawaiian shirt, and some leather sandals. I reached into my bag. There was a pair of black work shoes, white socks, jockey shorts, and a pair of orange coveralls. I unfolded the coveralls and began to unbutton them.

"You must be kidding? Is this the only thing you could find?" Icky smiled. I'd swear those horns started to re-appear.

"Hey, what's the problem?"

I handed the coveralls to him. "Look at this."

When Scott saw what I was going to be wearing back to L.A., he bent over laughing so hard he grabbed his gut.

"It's not funny you, S.O.B. I've got to wear these in public."

"Well, look at it this way, at least you're management."

"I own a gym. I'm already management."

"Ok, so now you manage two enterprises, that makes you an entrepreneur."

I grabbed the coveralls out of Scott's hand and stared at the royal blue embroidery over the breast pockets. On one side it said Manny, on the other:

Manny's Mobil Thrones
Where Royalty Takes Care of Business

For some reason Icky seemed a little put out.

"Hey, that's the best I could do. It's not easy to find clothes for someone your size on such short notice. Besides everything is washed. Well, everything except the shoes."

"That's nasty."

"If you don't like them I can always return them. You can wear your boxer shorts on the plane."

"That's okay. Tell Manny thanks. I'll send his clothes back as soon as I can."

Scott and I tried on our new clothes. Scott's fit reasonably well. I don't know who this Manny was, but the guy must have been a giant. The length of the coveralls was fine. The width was another issue. I'd swear they could've put three of me in them, and the shoes were at least two sizes too big.

"Icky, how big is this Manny?"

"Manny. Oh, he's about your height, probably weighs around three fifty, a big Tongan guy."

"What'd ya mean big? He's a giant."

"Those clothes do look a little big on you. Sorry, as I said, it's the best I could do."

"I guess I'll have to deal with it." I cinched up the waistband as tight as it would go, and got into the helicopter. Once again Scott let me sit in front. We put our headphones on as Icky spooled up the big turbine engine. Within minutes we were airborne hugging the coastline, flying almost due east along the northern section of South Point. The hundred foot cliffs that protected the Maka Hou's mooring from the trade winds were now speeding past my window. We flew back over the spot where our boat had been moored. All that remained was a rainbow colored diesel slick and a few pieces of debris. We continued heading towards the green sand beach by Puu Mahana. As I was staring at the unusual beach, I noticed something.

"Hey, Icky, is that steam coming out of Puu Mahana?" Icky dipped the rotor to take a better look.

"I think it is."

"Is it supposed to do that?" By now Scott was pressed up against the right side window directly behind me.

"I don't know? I've never seen steam coming out of there before. Let's check it out."

Icky turned the chopper slightly so that we were heading directly for the steaming vent. As we got closer, more and more steam began to erupt out of a gaping hole that had formed in the crook of the eroded half cone. Icky circled the helicopter over the red and green volcanic hill. I had to look over his shoulder to see.

"Scott, Icky, is that molten lava down inside there? Look, you can see it just as we come around to the beach side of the cone."

Scott was the first to confirm that not only was Puu Mahana spewing forth tons of hot steam, this ancient vent on the side of the largest volcano in the world had turned active. There was visible molten lava churning inside its rocky innards. As Icky continued to circle the helicopter to the left, I glanced out the window to my right, gazing up slope. About a mile further up the side of the mountain, I spotted another cone-shaped hill that appeared to be venting steam.

"Look at that." I pointed out my window towards the smoking red rock cone. Scott moved back over to my side of the chopper.

Scott noted, "That one's also steaming. Look up there. And there's another one, and I think I can see one even further up the mountain. Up there in the VOG it's hard to make out." I motioned to Icky to circle in the opposite direction so that Scott and I would have a better view.

"What's VOG?"

"It's smog. Sort of like what you have in L.A., except in Hawaii we get ours from the volcano."

"Oh. Hey, look at that. Puu Mahana and the other three cones line up perfectly? I wonder if that means anything?"

"We'll ask Walt when we get back."

Icky commented. "Man, this baby is really starting to pump. You should see what's going on over by the Northeast Rift Zone. Flying over here, I saw lava fountains along a two-mile fissure. Now, way over here we're also seeing lava. That's awesome."

Awesome wasn't the first word that came to mind as I stared out the helicopter's windshield at the four cones belching out clouds of steam. It was more like time, as in do we have enough before this whole thing blows?

Icky said he wished he could check out the other vents on the university's nickel but he had to get back and search for the missing hikers. While we were heading up the Kona Coast, Icky called the sheriff and told him about the accident. The dispatcher didn't sound too happy when he found out we had left the accident scene. When Icky told him we were pretty beat up and may need medical assistance, he backed off. The sheriff also said it would be a while before they could pick up the body. Things had gotten pretty hectic since the park service decided to evacuate the park. All of their personnel were out helping the rangers set up roadblocks and directing tourists away from the southern half of the island.

It took only twenty minutes from the time Icky picked us up at the launching ramp to when he dropped us off at the Kona-Kailua Airport. We thanked him for the clothes and ride. Scott's thank you was substantially more enthusiastic than mine.

"CHUCK, I NEED TO FILE A FLIGHT PLAN. Mind untying the plane?"

"Not a problem. I'll also check the screws to see if anyone has messed with our ride?"

"Good, I'll be about fifteen minutes."

Scott headed for the small green and white clapboard building at the edge of the parking apron while I walked out to the white Cessna. It was impossible not to feel self-conscious looking like a clown in my over-sized jump suit with size 15 shoes flopping around on my feet. Starting at the tail, I checked every inspection hatch, looking at each screw slot to see if the paint had been chipped. There were probably twenty of the little plates to go over with a minimum of four screws in each. Everything looked clean. I still wasn't completely satisfied, and was intent on making sure that Scott did a through inspection of everything inside the engine compartment.

Once my inspection was complete, I walked over to the little office to find Scott. He was in the corner at a desk talking on the phone. He must have spent a good half hour talking before he came over to get me.

"Damn, I almost thought they weren't going to let us go. That was the sheriff. He wasn't too pleased about us leaving that accident scene."

"So how long did he expect us to tread water?"

"That's what I said. It took a lot of talking, but he's going to fax an accident report to my office. We're supposed to fill it out and get it back to him within twenty-four hours. They're so busy with the park that he's not going to have time to interview us for a couple of days."

"That's perfect. You didn't happen to mention I'd be on a one o'clock flight to the mainland today?"

"Oh, shoot. I forgot. I'll call him back right now." Scott was all smiles.

"How about we let it slide?"

As Scott and I stepped out of the administration building into the morning sun, our old friend Rat Face popped out from behind a small storage shed. Scott saw him first. "Hey, Chuck, will you look at that? It's

Pampers Boy come to visit." Oh crap. Why does he have to antagonize this guy every time we see him? "Don't tell me, it's casual Sunday." Rat Face was dressed in kaki shorts, a white and blue Hawaiian shirt, and running shoes with no socks. He was still wearing his Rayban's. "Or you haven't had a chance to get your pants cleaned?"

"Fuck you, assholes." Well at least it was going to be a friendly exchange.

"Hey, I didn't say a word."

"Fuck you anyway. I quit after thinking about what you said."

How did Rat Face even know how to find us? Apparently Scott was thinking the same thing.

"So what. How the hell did you even know we were here?"

"Hey, jerk off, I have friends in the sheriff's office too." I noticed that this time Rat Face kept his distance from Scott. I guess he did learn one thing.

"So why come all the way over here just to tell us you're unemployed? Looking for a job? Given your excellent people skills, I'd suggest sanitation or janitorial."

"No, you dumb fuck." As Rat Face checked out my formal wear. "Besides, it looks like you already have the outhouse concession wrapped up."

"You don't have to get personal."

"Fine. I came here to warn you. The people I used to work for are still pissed at you guys."

"Well, you can tell the people you used to work for to go fuck themselves."

"That's fine with me. Then you probably don't care about a couple of bad boys waiting for you at the Honolulu airport."

"Why should we?"

"Because they won't make the same mistake I made. They'll just shoot your ass. Have a nice flight."

"How do they even know we're flying back?"

"Because we know the same people." Rat Face turned and disappeared around the corner of the building.

"God damn it, Scott. Why do you have to insult that guy every time we see him?"

"Because he's a punk, and he pisses me off."

"Still he may have just saved our lives. So what do you plan on doing now?"

"I'll kick their asses just like I kicked Pampers Boy."

"No, you won't. At least not with me in the plane." I stopped and stood my ground.

"Oh crap, not again. So what do you want me to do now?"

"I don't know, but I'm sick and tired of almost dying. It's not good

for our health. There are all kinds of studies that show stress is unhealthy, and almost dying causes stress. Trust me, I know."

"You are such a baby." I couldn't believe I was having this conversation again. "Okay, I'll tell you what. If we can't come up with a plan that you like by the time we get to Lanai, we'll land there and you can fly to Honolulu commercial. Is that fair?"

"Fine, I'd rather be a live pussy than a dead asshole."

"To each his own."

"What about the plane? Do you think it's safe?"

"I'm sure it's fine. Why would Pampers Boy warn us about a couple of bad ass guys in Honolulu if he were going to mess with our plane?"

"Good point, but we still check it."

"Yes, dear."

"That's more like it, sweetheart."

Scott and I removed the cowlings and went through the entire engine compartment. Scott flew the entire trip while I kept my eyes and ears open staring at the engine gauges. By the time we were over Lanai, Scott had cobbled together a plan that could work. First, he called the office where the university kept its planes.

"Manu, is that you?"

"Please hold. I'll be with you in one moment, sir." I could hear the person on the other end of the line say he had to get some information in his office. Manu came back on the line.

"Dr. Richardson, is that you?"

"Yeah. What the hell is going on there?"

"You got some major problem, brudda. There are two big Samoan guys out at the front desk. They's looking for you and your friend Mr. Palmer. Been here all morning. Even been listening to the tower on a radio. The dude knows the "N" number of your plane. Boy, you must have really pissed somebody off this time."

As soon as I heard what was going on I started to tell Scott we were going to land now. Scott managed to convince me that he knew how to avoid the two Samoans.

"Manu, do you have a line boy that can drive my truck over to the inter-island terminal. We'll be there in about 45 minutes?"

"No problem, boss. What about the keys?"

"There's a spare set under the left rear bumper."

"Got ya."

"Okay, so what do we do now? Those guys are just going to meet us at the other terminal when we land. You heard him say that they have a radio. They'll know exactly where we're going."

"No, they won't. Just watch."

"Honolulu Center, this is Cessna 8950 tango."

"50 Tango, this is Center. Go ahead."

"Center, we'd like to cancel our flight plan at this time. We'll be landing on Maui at Kapalua."

"Roger that, 50 tango, your flight plan is cancelled. Have a good day."

"So now what?"

"We drop below radar level. Fly to the Makaha side of Oahu and call the tower with a different "N" number. Honolulu Airport is so big they never check the planes' numbers."

"Then what happens once we land?"

"I've got a friend who's the operations manager over at the inter-island terminal. He'll let us park there for a couple of hours. All we do is walk out to the front, pick up my truck, and give the line boy a couple of bucks to take a taxi back to the other side of the airport."

"Hey, that's not a bad plan."

We dropped down and leveled off at 200 feet. The short trip across the Molokai Channel took less than twenty minutes. Once we were over Makaha, Scott called the tower.

"Honolulu approach, this is Cessna 44 Fox Mike. We're Makaha with the numbers for landing." Scott told me it was a friend's plane that looked almost like ours.

"44 Fox Mike, Honolulu Approach. You're cleared for runway four right. Report the outer marker."

Then Scott got on the radio and called his friend at Hawaiian Airlines. He told us we could park next to the last gate until he got off work at five. As we flew over Pearl Harbor, I looked down to see the white sweeping arch of the Arizona Memorial.

Scott set the little Cessna down smoothly and taxied over to the inter-island terminal. We parked next to a Hawaiian Airlines DC-9. There were no facilities for tying the plane down so we locked it and walked to the terminal. A young woman held a door open for us. She handed Scott a pink pass saying he would need it to get through Security when it was time to move his plane. The terminal was half empty. The people standing around looked like kamaaina, locals rather than tourists. We walked out to the curb, and immediately spotted the truck. Scott waved and a very attractive young woman drove up to meet us. She jumped out of the driver's side wearing very short shorts, white tennis shoes, and a pink and white blouse. Not a single strand of her long blonde hair was out of place. She had a perfect smile spread across her face and the embroidery on her blouse advised us that Vicky worked

for Mahalo Aviation.

"You must be Dr. Richardson. Did you have a safe trip?" Vicky continued to smile as she spoke to Scott. When he introduced me, her smile turned to indifference. I needed to make a note: Outhouse uniforms do not impress the ladies. Scott reached into his pocket looking for something. Then he turned to me.

"Chuck, loan me a twenty so Vicky can catch a taxi back to the other side of the airport." I groped around patting the many pockets of my latest ensemble. Eventually I pulled out a soggy twenty from my wallet and handed it to Scott.

"Here, thanks for dropping off the truck. Sorry it's a little moist."

"That's okay. Thanks." Vicky waved and took off running towards the taxi stand.

I turned to Scott. "That's a line, boy. What an ass on her."

We jumped into the white Forerunner and headed for the main terminal. My cell phone was still plugged into the lighter. "You've got a few hours until your plane leaves. You want to go with me to the Tsunami Center? I can get you a ride back."

I looked at my watch. "Shoot, I've got over three hours. Sure, I'll join you."

We continued past the main terminal heading out of the airport. That's when I remembered to call Lauren. She answered on the second ring.

"Hey, how are my girls?"

"Chuck, we missed you. I thought you were going to call."

"Sorry. We were down at the Southern end of the Big Island. I never realized how desolate it is. There's no cell phone reception. I literally just got back to Honolulu.

"I was worried about you, but you're forgiven. So how was your trip?"

"It was interesting. I'll have to tell you about it when I get home."

"You don't sound very excited."

"No, excitement wasn't the problem. You've never met Scott. He's a little different than your average professor." I looked over to see Scott frowning. "Never a dull moment. He wore me out. I'm ready for a retirement home."

"But you had a good time?"

"You could say that. Hey, listen. You know how I worry about my girls?"

"Maybe a little too much."

"There's a lot going on over here. You wouldn't believe what I've seen. I'll tell you about it when I get home, but I'm even more convinced that we may get hit by a major tsunami in the near future."

"I've been staying close to a radio like you said."

"That's great. What would you say if we moved up to the mountains or at least away from the coast until this thing settles down? I know we could rent out the beach house for a small fortune. It might be a nice change of scenery."

"And what would you do with the gym?"

"I hadn't thought about that. I know I could work something out. I'm more worried about my girls. I wish I could talk you into going up to Arrowhead or Big Bear tonight. We could turn it into a little vacation. Besides after a week with Scott, I could use the rest."

Showing no sympathy, Scott pretended to play the violin. I think it was Verdi's Requiem.

"I've got my first Mommy and Me meeting tonight. It's potluck. When you get back, we'll talk. It's too bad your timing isn't better."

"Why's that?"

"Because Maria and her three daughters are being dropped off at the airport by her brother later today. They're going to visit her parents in Mexico. He could have given you a ride home."

"Don't worry about it. I'll catch a van. Promise me you'll stay close to a radio."

"I promise. Nothing is going to happen between now and when you get home."

"Okay, but stay close to a radio like you said."

"Yes, dear."

"No really, I mean it. You wouldn't believe what's happened over here."

"Okay, I believe you. Have a nice flight and I'll see you tonight."

"Wait, one more thing."

"What?"

"Give Aubrey a big hug for me."

"Big hug. Love you."

"Love you, too."

Scott turned to me, "Ah, the joys of being a newlywed. As I said, give it a few years."

FIFTEEN

THE DRIVE TO THE TSUNAMI WARNING CENTER was uneventful. No pimps, ho's, or governors trying to run us off the road. Admittedly, few people are able to discern the minor differences between a governor and a ho. At the back of the unremarkable concrete block building Walt and a few of his employees were squeezed into his office staring at a computer screen. The minute Walt saw us, his eyes lit up. He jumped out of his chair came over and wrapped one arm around Scott, and he gave me a strong pat on the back.

"Scott, Chuck, what a surprise, our very own celebrities. We weren't expecting you."

"Chuck here had a few hours to waste before his flight. We thought we'd stop by."

"Scott and I are celebrities? What are you talking about?"

"Your names have been all over the local news. Islanders were glued to their radios and TV's while you were sleeping in that sub."

I'm sure that Scott felt the same as I did. We could have cared less. "Gosh, do you think we'll be on Oprah? Wouldn't that be swell?" I waved a limp wrist in Scott's direction.

"You are so gay."

Walt grinned. "Did something go on in that submersible that we don't know about? It can get pretty cramped down there."

"The only thing that happened was I almost strangled Scott for getting me mixed up in this mess. What's going on?"

"You just missed all the excitement."

"Thank God," I mumbled under my breath.

"Maybe not as much as you two had, but sphincters were starting to tighten up around here."

"Is that a gay reference?"

Walt turned to his employees. "Hey guys, why don't you go back to your desks now? If Jimmy gives me another call I'll let you know." After the four assistants in their white lab coats filed out of the office Walt turned his attention back to us. "So how does it feel to be famous?"

"Wonderful, just what we needed," said Scott. "I'm more interested in what's happening on the Big Island?" Since we stepped into his office, Walt had been eyeing me kind of funny. I assumed it was my attire.

"Before I go into that, I've just got to ask."

I interrupted Walt before he had the chance. "You're wondering about our clothes?"

"Not Scott's so much. Why the Royal Business get-up? And you might want to try a different tailor."

"Thanks for the fashion advice. It's nothing like that. You didn't hear?"

"No."

"Sammy, our captain, was killed in the explosion."

"Killed?" Walt scratched his head while starring at Scott and me with a perplexed look on his face. "What explosion?"

"The boat blew up. Can you believe it? We lost everything including our clothes. This was the only thing Icky could find to fit me. It's the latest in outhouse attire."

Walt eyed my new traveling ensemble. "It's definitely you. Damn, it's hard to believe the boat just blew up, and your captain was killed in the explosion? Do you know what happened?"

Scott said, "All I know is I woke up in the middle of the night and smelled gas. I figured Sammy must have forgotten to turn off the gas tank to the barbeque. On the way out the back of the cabin, I noticed Chuck sleeping. Initially I figured I'd just leave him, but then I changed my mind and decided to take him with me. He complained, of course. You know he does that a lot, said he was tired, and tried to go back to sleep. I would have left him if he didn't have a new wife and kid."

"The only thing I ever complained about was the Richardson curse, and I'm still complaining."

Listening to Scott and me argue, Walt could only shake his head. "I'm sorry to hear about your captain and I don't mean to interrupt your little spat, but we've also had a fair amount of excitement around here. Let me show you."

Walt went back to his computer to bring us up to date on the recent events. The first images he brought up were of the Northeast Rift Zone taken three hours ago. The camera scanned from east to west. The sky was unusually hazy so the brilliant blue of the Pacific Ocean had been turned to a muted gray in the background. Across the center of the screen was an undulating band of bright orange lava. As the camera continued its scan, fountains of molten lava would appear. Based on the few trees in the picture I estimated they were anywhere from a hundred to two hundred feet high. Eventually the camera stopped scanning, but the

bright orange ribbon of lava continued past the limits of the camera's view.

"Of the two major rift zones on Mauna Loa, historically the Northeast Rift Zone has been the most active. The interesting thing about these pictures is that this morning a three-kilometer fissure opened up just east of what we refer to as the traditional Northeast Rift Zone. So on this part of the mountain we're looking at over seven kilometers of active fissure."

The next set of pictures was of Pu'u O'o. Walt said the lava was shooting up almost 500 meters, 1,600 feet. This was without a doubt the most spectacular display of Mother Nature I'd ever seen. It was like a fireworks show a thousand times over.

The next pictures were from the top of Mauna Loa at 13,679 feet. Walt said there was a small cabin up there with a camera mounted on the roof. The first shots were of the Moku'aweoweo Caldera. Except now the depression was a two-mile long lake, filled with molten lava. To the west of the lake were two volcanic cones spewing out lava that hadn't erupted in the last fifty years.

As the camera continued to scan, the Southwest Rift Zone came into view. Walt said the active fissure on this part of the mountain was over five kilometers long.

"Is this the most amazing thing you've ever seen?" Despite looking exhausted, Walt was gushing with enthusiasm, his animated hands fanning the air. "This was the largest Hawaiian eruption in modern times. Fortunately they evacuated everyone from the park except for Jimmy."

"What do you mean?"

"The eruptions along the Northeast and Southwest Rift Zones cut off all the exits from the park."

This didn't sound like a very good excuse. "So why not fly a chopper in to snatch him?"

"We couldn't, there was so much VOG and ash in the air it wasn't safe. Then all of the power in the park was knocked out. Jimmy had to switch over to a back-up generator. With the ash in the air, the communications went dicey and visibility got down to almost zero."

"Sounds like Jimmy's situation started to snow ball," said Scott.

"You can say that again. With almost no visibility, we lost track of a couple of lava flows that were headed straight for the Observatory."

"So what happened?"

"It just stopped. It was like someone hit the breaks. Everything went back to normal. I shouldn't say normal, but starting with the Northeast Rift Zone, each part of the mountain began to calm down moving from east to west. Within sixty minutes, the fountain at Pu'u O'o stopped and the rift zones settled into a lazy series of on and off eruptions."

155

"How did you get Jimmy out?"

"We didn't. He said he was fine and insisted on staying. It was just too exciting to miss."

"So he's still there?"

"You got it. He said that he and the mountain have an understanding."

"I can imagine what that understanding is," added Scott. "How do you like your grad student, over easy or parboiled? By the way, any more earthquakes or underwater eruptions?"

"Since last night when the 7.2 quake hit us, we've had three more over the 6.5 threshold. The Center has issued three tsunami bulletins and one warning in the last twenty-four hours." Walt had been up all night. "The tilt meters on Mauna Loa are showing almost two meters of expansion. The most ever recorded."

Walt said they didn't have any way to monitor the seabed, and therefore didn't know about any underwater eruptions. He was very encouraged because there hadn't been any more tsunami activity. It confirmed that the sides of the mountain were far more stable than he had originally believed. Walt really wanted to drill those sampling holes so he could check the slip zone and run some stability tests. "With our limited budget and what you tell me about the native population it'll never happen. "

Then I remembered Puu Mahana and the other volcanic cones we saw. "Walt, do you guys know about Puu Mahana?"

Walt snapped at me. "No, I can't keep track of all the vents on that mountain."

"Thought I'd ask."

"Sorry," Walt paused and took a deep breath, "as I said things have been a little tense. We just dodged a giant cannon ball. So where is Puu Mahana?"

"If you'll bring up a map of the entire south end of the Big Island? I'll show you."

Walt punched a few keys on his computer to bring up the map I had requested. In the lower left corner, South Point jutted out into the Pacific. I pointed at the crook formed by the horn-shaped point and the west facing Kona Coast of the big Island.

"There, right where South Point joins the coast. It's where the green sand beach is."

"Green sand beach?" Walt sat and rubbed his beard. "Must be Olivine."

"How'd you know?"

"I am a geologist."

"Oh, yeah. So we flew over Puu Mahana and noticed that there was steam coming out. When we checked down inside the vent we

saw molten lava."

"Maybe I should get Jimmy back on the video phone. He's the one that knows everything about that area." Walt dialed Jimmy directly through his computer. In less than a minute, Jimmy's smiling but slightly fatigued face was looking at us from the computer screen.

"Jimmy, look what I found." Scott and I smiled at the camera on top of Walt's monitor. The other monitor still had the map of the Big Island displayed.

"That will teach you to leave the doors unlocked. It's good to see you guys. We were worried about you."

"So were we," said Scott. "I guess you've had your own share of excitement lately."

"I'm sure it wasn't as bad as Walt made it out to be. Every once in a while this big girl gets a bellyache and has to let off a little gas. She's doing fine now."

"That's what we hear."

"Jimmy, Scott and Chuck wanted to show you something you may find interesting."

"Chuck here. Walt has a picture of the entire south end of the Big Island on his computer. Can you pull up the same thing?"

"Sure, give me a sec." We waited while Jimmy brought up the picture I asked for. "Okay, I've got it."

"Jimmy, are you familiar with Puu Mahana?"

"It's one of my favorite hikes. The cinder cone with the Olivine beach."

"Right. We flew over it this morning. Did you know there's molten lava down in the bottom?"

"Whoa, Puu Mahana has gone active? Then again, maybe I shouldn't be surprised. It's part of the Southwest Rift Zone."

"That's not all. When we looked up the mountain we saw three more volcanic cones either erupting or venting steam. They were in a perfectly straight line starting with Puu Mahana. We were wondering if that's significant?"

Walt broke into the conversation. "Chuck, whenever we see a straight line in a geologic structure it's significant… Jimmy, what do you think?"

"I'm blown away, pardon the pun. Let me show you why on your computer screen." Walt tapped a couple of keys and the picture on the left hand screen changed. Now it showed the same picture that Jimmy had been looking at. We still had the southern half of the Big Island on our screen, but now our map also included all of the volcanic features. Jimmy must have been using a cursor as red dots and lines began to show

up on the computer screen. "Look at this. We had a seven-kilometer fissure along the Northeast Rift Zone open up. And now you're telling me that Puu Mahana, all the way over here, part of the Southwest Rift Zone was active this morning. We don't have any monitors on that part of the mountain because there hasn't been any activity in modern times." Jimmy placed a red dot over Puu Mahana. "You also saw active volcanism along a line going up the side of Mauna Loa right about here. Is that correct?"

"Yeah, that looks about right."

Jimmy then took his cursor and measured the distance from the Northeast Rift Zone to a point past Puu Mahana out into the Pacific beyond South Point. "Walt, will you look at that. I can't believe it. This last event was roughly 127 kilometers wide. I've never heard of anything that large." Jimmy stared into the monitor. His eyes were pasted wide open and his brow arched like he'd just seen a monster.

I continued to look at the map. Something didn't seem right. I couldn't put my finger on it. "Obviously I don't know squat about volcanoes, landslides, and all this other stuff, but as a kid I use to play connect the dots. If I were to play connect the dots on this map, your little drawing would give me an almost perfect semi-circle."

"Son-of-a-bitch." It was Walt. "Jimmy, are you seeing what I see?"

"Yeah, I think so."

"We've got a much bigger problem." Walt took his cursor and scribed the semi-circle that I had suggested. When he was done, it looked as if a giant shark had taken a bite out of the Big Island. Walt stared at the map then rubbed his eyes in disbelief, his nose almost pressed against the screen. "I don't believe it."

"What? What's the problem?

"Gentlemen, what I have just drawn is the top of a potential landslide larger than any known to man. The fissure you and Scott were mapping was nothing more than a small tension crack within a much larger slide."

"So how much larger is it?" I asked.

"Based on a maximum width of 127 kilometers and I'll just throw a number of, oh say, 150 kilometers from the head to toe."

"That's like 2,000 square kilometers, twice the size of the Tuscaloosa Seamount."

Walt turned to me furrowing his brow while waving a finger. "Chuck, you may have extraordinary skills when it comes to connecting the dots, now you need to work on your math. Not 2,000 square kilometers, this potential slide is almost 20,000 square kilometers."

"20,000. What does that mean?"

"It means we have one hell of a big problem."

"No shit. How big?"

"First of all you need to get your units straight. Tuscaloosa is approximately 1,000 cubic kilometers. This slide is approximately 20,000 square kilometers and I'd guess at least three kilometers deep, maybe four. By the way, that's a WAG. In either case we're talking about a slide that's around 60,000 to 80,000 cubic kilometers."

"60,000… I hope you're not talking about a wave 60 times as large as you originally calculated?"

"No, I'm not. And that may be the only good news in all of this, though I don't even want to guess how large a wave this slide could generate." The lack of sleep and the pressure was obviously getting to Walt. Small beads of sweat began to form on his brow, and his right eye had adopted a noticeable twitch.

" Can you come up with some kind of estimate?"

"I will, once I run the numbers." Walt was rubbing his hands, kneading them as if trying to dispense with his shaking limbs.

"So take a WAG, you're pretty good at it."

Walt snapped at me again. The guy was strung tight as a bow "No… I don't give a damn about the size of the wave anymore, besides there's no accurate way to estimate it. Once a volcano starts to collapse, the motion disturbs trapped water in the rocks. That water rapidly migrates down to the molten lava generating incredible amounts of steam. Mauna Loa will turn into a giant boiler. Pressure will build so fast that within a few minutes the whole thing will go off like a million atomic bombs. We'll have 60,000 cubic kilometers of rock not only sliding into the ocean, it will literally be driven by the explosion."

This is crazy. Are the lunatics running the asylum? "Stop… I may be a little rusty with my math, but I'm not completely stupid. I know we're talking about a wave that's huge, a monster, yet you're saying that doesn't bother you. What the hell is going on here?"

"We've got much bigger problems. Jimmy, I can't think straight right now. Do you mind spelling out what's going on?"

Jimmy had been working on something at his desk when he looked up at the camera. I still had no idea what these guys were talking about, and Scott had been surprisingly quiet, just sitting back and listening.

"How about letting us in on the big secret?" I finally demanded.

Jimmy responded. "Sure. Not only is Walt concerned about the catastrophic collapse of Mauna Loa, but if that were to happen we would have an eruption larger than any ever witnessed by modern man."

"And what does that mean?"

Walt cut Jimmy off before he could respond. "We're screwed, probably dead. Are you familiar with Krakatoa or Santorini?"

"Sure, big volcanoes, big eruptions."

"No, average volcanoes, big eruptions. Mauna Loa is a giant volcano. I hate to think how large the eruption could be, especially if there were a catastrophic collapse. In fact if Jimmy's research is correct, we may have a super volcano, similar to the volcano that formed the Yellowstone Caldera or the Long Valley Caldera near Mammoth Lakes, California. What do you think, Jimmy?"

"I hate to think that's what we're dealing with, but you may be right."

I still wasn't sure what Jimmy and Walt were so concerned about. "How can a huge volcano on a sparsely populated island do any more damage than a wave that's going to destroy all of Hawaii and a good portion of the Pacific Rim? It doesn't make sense."

"Then I guess I'll have to explain." Walt looked like he could barely contain himself.

I didn't care. "Please do."

"Everyone has heard about the eruption of Krakatoa in 1883." I had, so he was probably right. "The ensuing tsunami killed over 30,000 people. Had it happened today, 3,000,000 would have been killed."

"My point exactly. The tsunami is worse than the eruption."

"Wrong. What you don't hear about is the 535 AD eruption of Krakatoa. Most historians place the beginning of the Dark Ages right around that date. We now believe that the 535 eruption of Krakatoa ejected so much material into the atmosphere, it blocked out the sun for almost a year.[9] It was the Byzantine historian Procopius that said, "during this year a most dreaded portent took place. For the sun gave forth its light without brightness." Crops failed, people starved, world wide temperatures dropped and disease set in. All major economies were destroyed. It took another 500 years for the world to recover. Walt went on to tell us about the eruption of Santorini that destroyed the Minoan civilization in 1650 B.C. He said it probably rated a VEI of 6, Volcanic Explosivity Index, one of the largest eruptions in the last ten thousand years."

"What you're saying is that if Mauna Loa collapses we're faced with an eruption equivalent to the 535 eruption?"

"No. Just let me finish. The eruption that formed Yellowstone Park two million years ago was most likely a VEI 8, the highest the scale goes.[10] It was at least a hundred times as large as Santorini or Krakatoa, a thou-

[9] Wholetz, Ken. "The Dark Ages May Have Really Been Dimmer," Science Daily, Jan. 4, 2001. http://www.sciencedaily.com/releases/2001/01/010102061812.htm

sand times larger than Mt. St. Helens."

"And if Mauna Loa blows how large will that be?"

"Jimmy, would I be exaggerating if I said a VEI 8?"

"That would be my best guess. Still we shouldn't jump to conclusions. The activity on the mountain is continuing to subside. Our gas readings are almost back to normal. We may not have to worry about it for years."

Time? I hadn't realized how late it was when I looked at my watch, less than an hour to catch my flight.

"Excuse me, one last question and then I need a ride to the airport." I'm sure everyone in the room rolled their eyes. "I thought the volcanoes in Hawaii were the kind that don't explode. They just have lots of smaller eruptions instead of one massive one."

"You know, Scott, this buddy of yours may know how to read."

"Ya think so?"

"I do because he's right." Even though Walt was making fun of me, I was still glad I had asked the question. "Mauna Loa is a shield volcano built up over thousands of years by many smaller events."

"That's what I thought. Lots of little eruptions, so why are we so worried about this huge eruption?"

"Because, Mr. Palmer, volcanoes can change. Santorini was a shield volcano prior to the 1650 BC eruption.[11] Does that answer your question?"

"Unfortunately it does…I guess I'll need a ride now."

Scott asked. "Chuck, do you mind if I stay here with Walt? I know he's concerned about how and to whom we break this most recent news. We need to put our heads together on it. I'm sure Walt can get you a ride."

"That would be great. I have just one more question." There was an audible groan. "Let's say this whole thing blows up. How much warning will the West Coast get, specifically Malibu?"

Walt went back to his desk and sat down. He pulled up a picture of the entire Pacific Basin on his computer screen.

"We're not prepared to deal with anything this size. If Mauna Loa catastrophically self destructs, we're going to lose power and communications on the entire Big Island."

"Excuse me, Walt," Jimmy interrupted, "if we're talking about a super volcano then it won't be just power and communications that will be lost. The pyroclastic flows will destroy all signs of life on the Big Island within a matter of minutes."

Once again, Walt and Jimmy were speaking a foreign language.

[10] USGS VHP Photo Glossary: http://volcanoes.usgs.gov/images/pglossary/vei.php

[11] Pfeiffer, Tom. "Geology of Santorini". http://www.decadevolcano.net/santorini/santorini_volcanism.htm

"What's a pyroclastic flow?"

Walt looked so frustrated from my constant barrage of questions I was concerned he might erupt. Jimmy answered, "As the volcano begins to collapse, it forces out immense clouds of incredibly hot ejecta. This material is half way between liquid lava and lightweight ash. Typically it's around 600 to 700 degrees Celsius, around 1,200 degrees Fahrenheit. It can travel down the sides of the mountain at speeds up to 400 kilometers per hour. Over 250 mph."

"Jimmy's right, so the next place the tsunami will hit is Maui," continued Walt. "Hopefully we'll see the tide gauges peg and then go dead. That will tell us the tsunami is on its way."

"So you're saying that Honolulu won't have much warning, but what about Malibu?"

"If we can't be sure a tsunami was generated until it hits Maui, the Center will only have ten to twelve minutes before it's destroyed. That's not much time. If we have time to issue a warning, then figure five hours until the tsunami hits Malibu. Just remember, if our communication system goes down or there's some kind of snafu, we're really going to have problems. As I said, there are no DART buoys between here and the mainland. If there were then our counterpart, the Alaska Tsunami Warning Center in Palmer, would have time to issue a warning."

"So unless you guys can get a warning off, the entire West Coast of North America is screwed."

"That's about right. No matter what happens, we'll probably only have time to send off a single notice to our counterpart in Palmer."

"I am definitely moving to Kansas."

"I suppose that's as good a place as any to starve to death."

"What's that supposed to mean?"

"Jimmy, why don't you explain while I go find our inquisitive friend a ride?"

"Sure. If we have an event the size of the Yellowstone or Long Valley eruptions as we've already said the world will be covered in ash and we'll be looking at a winter that could last a number of years. The other problem we'll be faced with is SO2, sulfur-dioxide, the rotten eggs gas."

"Do I even want to hear this?"

"You're the inquisitive one."

"So I'll change."

"During an eruption a super volcano blasts into the atmosphere not only millions, make that billions of tons of ash. It also spews out CO2 and SO2. Besides smelling so bad SO2 can be a very nasty gas when it combines with water."

"Why's that?"

"Because it turns into H_2SO_4, sulfuric acid. I'm sure you can figure out that sulfuric acid raining down on the world's crops might have a detrimental effect."

"That much I can figure out."

"Of course there's the problem with the ozone layer and global freezing. Most likely we would be looking at a mass extinction event. Something along the lines of what happened at the K-T boundary when the dinosaurs were killed. Understand, this is all speculation, I'm sure the odds of an event occurring that would trigger a mass extinction like what happened at the K-T boundary are quite small."

"Good, because I can't deal with this right now. Can someone get me a ride?"

I said goodbye to Walt and Jimmy, and gripped Scott on the shoulder for a minute.

"Thanks for a pleasant and relaxing trip."

"Anytime, brudda."

"If you ever invite me back. I will bring a gun and shoot you. Please give my best to Aolàni and the kids."

On my way out, slipping past Scott in Walt's miniscule cubicle, I said in a voice that only he could hear, "You made the right decision to try to work it out with Aolani, and thanks for the advice. The female dimension?"

SIXTEEN

BRIAN CHANG DROVE ME TO THE AIRPORT. His silver Honda Civic appeared to have left the show room about the same time Brian exited his mother's womb, over twenty years ago. Rusted rear quarter panels, missing hubcaps, and a shattered right window completed the ensemble. Before I was able to sit in the passenger seat, Brian first removed an assortment of old wrappers, cups, and miscellaneous detritus. Based on the age and condition of the car, I was a little concerned about Brian's driving. Was this going to be a case of DWO, Driving While Oriental? I was wrong. Brian's driving proved to be more than satisfactory—so much for stereotypes.

On the way to the airport we discussed Brian's work at the Center. Like so many students at UH's Earth Sciences Department, his field of interest was volcanoes. As a graduate student working on his Masters in Vulcanology, his job at the Tsunami Center helped pay the bills. Before driving more than a couple of minutes, I was on the phone calling Lauren. Her message center answered. I left a message pleading that she take our daughter to the mountains.

Even though we made it to the airport in fine time, it was going to be tight catching my plane. I thanked Brian for the ride and ran into the large open air terminal. The board on the far wall said my flight was on time, less than twenty minutes to departure. Fortunately, the First Class passenger's counter was clear. A young woman wearing a pink and white flower dress greeted me. Her unusually white teeth only enhanced the smile that greeted me. The nametag said Maureen, although the expression on her face said, "Wrong line." I reached around in my coveralls looking for my still moist wallet.

"Good afternoon. How can I help you today?"

"I'm on your flight 103 back to L.A."

"Oh my, you're going to have to run to make that flight. Your name please." She didn't wait for my response as she began typing on her keyboard.

"Chuck Palmer." I handed the now grimacing Maureen my wet driver's license. She looked at it, then her screen, then me, then back to my

license, and then back to the embroidered nametag identifying me as Manny the proprietor of a Mobile Throne Company. Confusion took over where the remnants of a smile had been. "Oh, you're probably wondering about these," pointing at the latest fashion in outhouse attire. "I lost my clothes and this was all we could find that fit me."

"Oh, I see, luggage stolen out of your rental car? We get that all the time." I didn't bother to explain. "There you are, and you're flying first class with us today." Maureen's smile had magically reappeared. She hit some more keys and a boarding pass popped out of a slot in her counter. Within a few seconds, I was headed for the gate. Maureen was kind enough to remind me to hurry and that she would call ahead to let them know I was on the way.

Despite Manny's oversized work shoes flopping around on my feet, I took off running.

I made it to gate 11 with only a few minutes to spare. Another smiling young woman took my boarding pass and handed me the stub with my seat assignment. She also thanked me for hurrying. I could feel her eyes checking out my jumpsuit as I entered the gateway. The flight attendant, Simone, made the mistake of directing me to the back of the plane before checking my seat. She blushed red when she realized her mistake, and then escorted me to my first-class seat in the front of the plane.

Flight 103 was a continuation flight out of Narita, Japan. Most of the passengers in the forward cabin of the Boeing 747 were Japanese businessmen dressed in suits. While the Japanese are way too polite to voice a complaint, I had the distinct impression that my fellow passengers weren't exactly thrilled with my sense of style.

Simone was a tall mousy blond with green eyes, a pinched nose, and a few too many freckles. Before leaving, she asked if I'd like a mimosa or some champagne. I opted for the champagne, and thought about complimenting her on the excellent selection and how much I enjoyed its hint of apricot, peach, and natty finish. Then it occurred to me that might sound a bit precocious coming from an outhouse attendant that doesn't know squat about champagne.

Exhausted from trying to stay alive the last six days, I was actually looking forward to the five-hour flight home. I glanced out the window as the last of the baggage was being loaded. Then pulled the shade down, and closed my eyes.

* * *

Governor Nelson Pratt's office with rich Koa wood paneling, large plate glass windows, and overstuffed furniture was unusually busy for a Sunday afternoon. The governor and three assistants were gathered

around his desk for a special meeting. His office on the fifth floor of the Hawaii State Capital Building faced a brilliant Pacific Ocean with Diamond Head in the background. Joining Governor Pratt were Chief of Staff and long time friend Stan Akai, Senior Advisor Paula Steele, and Press Secretary Willy Watai. The lieutenant governor was on Maui dedicating a new senior care facility.

In the past twenty-four hours there had been three tsunami bulletins advising of a potential tsunami and one tsunami warning. Fortunately, the one wave was small and didn't compare in size to the twenty-foot monster that killed over 12,000 six months ago. There had only been two deaths, a couple of drunks sleeping it off while lying on the rocks of the Ala Wai breakwater.

The governor had called the Sunday meeting because of the complaints from emergency departments and personnel throughout the islands. With each tsunami bulletin, it was becoming increasingly difficult to evacuate the low-lying areas. It was truly a case of the "boy who cried wolf" syndrome. Governor Pratt convened the special meeting to see how best to coordinate the state's emergency response. The most pressing question was how should the various government agencies respond to a Tsunami Bulletin? With his constituency becoming more and more reluctant to leave their homes or places of work with just a notice of potential flooding, the answer seemed obvious to the governor.

"Listen, we can't force the people to leave their houses every time we get one of these bulletins. We've had three false alarms in the last twenty-four hours. There's going to come a time when we need to get them to high ground in a hurry and they're going to refuse."

"But Mr. Governor, there's so little time, we just don't get enough warning," the governor's press secretary complained.

"How much time are we actually losing if we ignore the initial bulletin and wait for the confirmed notice?" asked Senior Advisor Paula Steele.

Stan Akai responded, "It normally takes five to ten minutes to issue a tsunami bulletin. As we all know, it's merely a notice that the potential for a tsunami exists. Once the warning bulletin has been issued it can take another five to ten minutes to confirm and issue a tsunami warning."

"That's my point," agreed Ms. Steele. "If we ignore the initial bulletin we could be losing as much as twenty minutes. We've only got around thirty minutes from the time the tsunami is generated off the southern shores of the Big Island until it strikes Oahu."

The governor rubbed his cheek before responding. "So we're talking about ten minutes' warning verses twenty. The reality is with so little time there's almost nothing the police and fire departments can do."

"So what are you suggesting, Mr. Governor?"

"I'm saying we deal with the local tsunami threat the same way we would deal with a tsunami threat if it came from Alaska or Japan. We notify emergency response that we've received a bulletin advising us that the potential for flooding exists. But we don't instigate our emergency response until we get the confirmed tsunami warning."

"Unfortunately, Mr. Governor, by then there's nothing our people can do."

"Paula, I understand your concern, however the reality is that with a maximum of twenty minutes warning, there's virtually nothing we can do anyways. Our contingency plans are based on receiving at least three hours notice. That's the minimum amount of time we should have if a tsunami is generated in Alaska or Japan. For something that happens in or own backyard, I'm sorry to say there's absolutely nothing we can do."

"I can't believe you're saying we just let our people fend for themselves?"

"No, I'm saying let's be prepared for the tsunami we can do something about. People are tired of getting up at all hours of the night. Hawaii is the best tsunami-prepared state in the country. Yet with all of these false alarms, we're destroying that level of preparedness."

Ms. Steele was about to make a suggestion when she was interrupted by a faint knock on the heavy wood doors to the governor's office.

"Come in."

A short, overweight Marjorie Nonaka entered the high-ceilinged office with blushing cheeks and eyes fixated on her feet.

"I'm sorry to disturb you, Mr. Governor. We just received this. I thought you would want to see it." Still afraid to look at her boss, Ms. Nonaka shuffled over to his desk and handed him a single piece of paper. Then she made a hasty retreat to the door. Governor Pratt read the short message. His face muscles tightened. Then he reread it, and the blood vessel under his right temple began to pulse.

"Stan, Paula, Willy, we're going to have to table this discussion for now. The note I was just handed came from our airline liaison. Apparently a Hawaiian Airlines pilot landing at Maui just observed a major eruption on the Big Island. He believes it was sufficiently large to cause major damage and loss of life."

"Mr. Governor, you have two offices on the Big Island. We should have heard from them by now," Akai blurted out.

"It's Sunday, Stan. Both offices are closed and I assume our people are with their families. I'm sure we'll hear more in the next few minutes."

"Governor, what about emergency services, police, and fire? They're twenty-four seven, somebody should have reported back to you."

"Stan, for now I'll assume they have their hands full. They've probably got better things to worry about than contacting our office." Pratt hit the call button on his phone.

"Yes, Mr. Governor."

"Marjorie, would you please get me John Viola from from our Hilo office on the phone? Try the cell phone first, then his home."

"Yes, sir. One minute." The governor and three staff members waited in silence until the secretary came back on the intercom. "Mr. Governor, I tried both his home and cell phone numbers. They were dead."

"You mean he didn't answer either one?"

"No, they were dead. The phones don't seem to be working."

"Get me the Hilo Police Department. Someone better be home."

"Yes, sir."

The governor turned to his staff with an expectant look. "I don't know what the hell is going on down there. But I can assure you, we'll get to the bottom of it."

"Excuse me, Mr. Governor." It was Ms. Nonaka on the intercom. "I tried the numbers that I have for both the Hilo and Kona stations and they were both dead."

The governor slammed his fist down on the solid wood desk, closed his eyes, and tilted his head back. Communication with his staff on the Big Island was critical at a time like this. The people and the press would want to know what the state was doing about this emergency.

Nelson Pratt turned to his three advisors and demanded, "What the hell is going on down there?"

No one responded.

<p style="text-align:center">*　　*　　*</p>

The captain's booming voice shattered my first few moments of divine slumber.

"Good afternoon, ladies and gentlemen. This is Captain Steve Hornbeck. Joining me on the flight deck this afternoon is first officer Michelle Spencer. We've just been cleared for taxi to our assigned runway. For most of our flight, the air should be smooth, although there is a large depression in the Gulf of Alaska pushing some weather south across our planned route. We're expecting some light to moderate turbulence about an hour out of Los Angeles. Of course we'll do everything we can to make your flight as pleasant as possible. We've been cleared to Eight Right, the reef runway. Unfortunately, this is the furthest runway from the terminal, and it will take us another fifteen or twenty minutes to get there. So please, sit back and make yourselves comfortable. Once we're at our cruising altitude, I'll get back to you with more information about

our flight."

I fluffed up my pillow then buried my head under it while one of the flight attendants repeated the captain's announcement in Japanese. Just as I started to doze off, my cell phone began to vibrate. It took me a few moments of searching to find it.

"Hello?"

"Chuck, where the hell are you?" It was Scott. The connection wasn't the best, but I could swear that there were sirens blaring in the background. My old friend's speech patterns also seemed slurred, as if he were drunk or injured.

"What do you mean where the hell am I? I'm on the damn plane. Where the hell are you? You sound like shit."

"Are you in the air?"

"Of course not, my phone would be off. Are those sirens I hear? What's wrong?"

"I got shot."

"You got shot? Who shot you? Are you all right?"

"No, I'm not all right. They hit me in the shoulder. It hurts like a son-of-a-bitch."

"Do you know who did it?"

"Yea. It was those two big Samoans that we dodged at the airport."

"You called me from the ambulance to tell me you've been shot. Are you crazy?"

"What ambulance? There's no ambulance around here."

"What are those sirens?"

"They're police sirens."

"You're in a police car? You're going to the hospital, right?"

"No, I'm not in a police car. They're chasing me. And I'm sure as hell not going to the hospital."

"They're chasing you. Why are they chasing you?"

"Because cops get pissed off around here when you're going over 100 miles per hour and don't pull over. Hey, I don't have time for this."

"You're a mad man. Get your ass to the hospital. I can't believe I'm having this conversation."

"Deal with it. Listen, we lost Jimmy."

"What do you mean you lost Jimmy? Where'd he go?"

"We didn't lose him, he's dead. We were video conferencing on one screen and looking at the top of the mountain on the other screen. All of a sudden both pictures start to shake. Jimmy dives for cover, and the next thing we know the Observatory is coming down around him. Then the entire mountain starts to slide into the sea." Scott paused and sucked

in a deep breath. "That's when the whole thing blew up, and the cameras went dead."

"The Observatory blew up?"

"No... the whole god damn mountain exploded. It was a good thing we saw it happen. That gave us a few extra minutes. Walt stayed back to issue the tsunami warnings." I couldn't believe the news I had just received. Two minutes ago, I was resting comfortably and now God only knows what will happen. "He probably won't make it. The whole mountain just blew straight up." Scott paused again as the sirens in the background continued to blare. "Son-of-a-bitch this thing hurts. Anyway, I volunteered to help but he said there was nothing for me to do. Everyone else took off."

"Where are you headed? How much time do we have?"

"I figure max, twenty minutes. I'm on my way to the Air Force radar station on top of Mount Kaala. I'm not sure I'll make it in time."

"What about Aolani and the kids?"

"I already called. They're on their way. They should be fine. Listen, you need to get that plane in the air."

"How the hell am I going to do that?"

"I don't know, but you'd better figure out a way or that new wife of yours is going to be a widow."

"Did Walt ever give you an estimate on the size of the tsunami?"

"Yeah, he said over 2,000 feet here in the islands, over a thousand feet on the West Coast. Hey, I gotta go. Man, this shoulder is really messed up" I could almost see Scott wincing. "Good luck, Buddy."

"Good luck to you... Hey, Scott."

"Yeah?"

"Next time, you come to Malibu."

"Deal." Scott hung up.

I immediately started to dial Lauren, then hesitated. Simone was standing directly over me with hands on hips and a not too friendly look on her face.

"Mr. Palmer, I'm sorry, you'll have to turn off your cell phone and put it away right now."

"Just one second." I finished dialing and put my hand out as if to fend off any advances from Simone. All I could do was cringe as I thought to myself, "Not again." It was my voice telling the caller to leave a message. I left another urgent plea telling Lauren she had to leave right now. I told her to go to the mountains. The tsunami was on the way.

SEVENTEEN

"DISPATCH, THIS IS 5 CHARLIE 16, we are in pursuit of a white Toyota Forerunner on H-2 northbound passing Ka Uka Blvd., failure to yield. Vehicle has U of H license plates 6 Echo 5897. Speeds are in excess of 100 miles per hour; need backup.

"Roger that, 5 Charlie 16."

"Dispatch, 5 Bravo 12, we're in Waipio. We're on our way to intercept white Forerunner on northbound H-2."

"Roger, 5 Bravo 12. 5 Bravo 11, what is your location?"

"5 Bravo 11 is just getting on the Northbound H-2 at Meheula Parkway, have white Forerunner and 5 Charlie 16 in sight."

"Roger that, 5 Bravo 11. 5 Charlie 16, we are checking with the university to see if your vehicle is reported stolen."

"Dispatch, this is 3 David 11in pursuit of blue Honda Accord, northbound on Kaukonahua Road just past Kamananui Road; failure to yield. License number Uniform Sierra Charlie 010. Driver appears to be female with three or four children passengers. Speeds approaching 90 miles per hour."

"Roger that, 3 David 11. In pursuit blue Honda Accord north on Kaukonahua Road, license Uniform Sierra Charlie 010."

"3 Charlie 12, what is your location?"

"Dispatch, 3 Charlie 12 is at Dillingham Airfield. Will head East on Farrington Highway to intercept blue Honda Accord."

Jean Chavez couldn't believe how her shift was starting off as she wiped off the few drops of sweat that had formed just above her left eye. Two high-speed pursuits, and she'd been on less than an hour.

"Roger that, 3 Charlie 12."

The blue Honda had just passed the eastbound police car on Farrington Highway. Jean Chavez let the patrol car know that they were running the plates to see if the vehicle were stolen.

"Dispatch, this is 1 Adam 13; we are in pursuit of a silver Explorer failure to yield. We just left the eastbound H-1 and are on the northbound H-2. License number is Uniform Tango Alpha 013. Driver just

about lost control on the over-pass, speeds in excess of 100 miles per hour."

Ms. Chavez confirmed that 1 Adam 11 was chasing a silver explorer, after making the mistake of calling the wrong patrol car. Things were starting to get hectic, though the twelve-year veteran was still convinced she had things under control. She wiped her brow one more time, still not believing how the day had started out.

"5 Charlie 16, the university advises that your vehicle has not been reported stolen. It is currently checked out to a Professor Scott Richardson."

Three failures to yield at the same time was a record for a single dispatcher at the Honolulu Police Dispatch Center. With so many vehicles being pursued at once, Jean knew she had to manage her available assets carefully. She called for her watch sergeant to come over.

"Jim, I could use some help over here for a sec. I think you should see this." Sergeant Jim Correa, six feet tall, slightly balding with dark eyes and ruddy complexion, walked over and stood behind Jean as she stared at her monitor. "Look, I've got three high speed pursuits going on and I'm concerned about running out of units."

Before her supervisor had a chance to respond, the patrol car chasing the white Forerunner reported that they had just gotten off the H-2 and were now heading east on Kaukonahua Road.

"Roger that, 5 Charlie 16." Jean continued to stare at her monitor not believing what she was hearing. "Look, Jim, this Forerunner is following the Accord, and I'll lay you odds that this silver Explorer is going to do the same thing."

"I don't believe it. Fred over there has got two more high speeds. What's going on, must be some kind of a bug going around? We've got ourselves an infestation of idiots."

"I don't know, but get this. I just got the report on this blue Honda." The dispatcher pointed at her screen. "It's registered to a Dr. Scott Richardson. See this white Forerunner, it's a U of H vehicle. Do you want to guess who it's checked out to?"

"Don't tell me, Dr. Scott Richardson... Hey, isn't that the guy that was caught in that sub?"

"I think it is. Boy, talk about a strange day."

"Hell of a family reunion?"

"The only thing on that part of the island is Dillingham Airfield. Think they're going for a glider ride?"

"The only ride they're going for is in the back of a patrol car."

"Bet they'd prefer the glider."

"Dispatch, this is 3 David 11. The blue Honda has just turned left onto Mount Kaala Road."

"Roger that, 3 David 11. You are now south bound on Mount Kaala Road."

"Jim, can you believe this? It's the damnedest thing I've ever seen? Why would she head up Mt. Kaala Road? There's nothing up there other than the radar installation and she can't get through the gate."

"It doesn't make sense. At least it's a dead-end road so we're not going to need any more units."

The patrol car chasing the blue Honda called back to report the woman driver had almost lost control of her vehicle on the winding mountain road. With kids in the car, the usually calm Jean Chavez had to suppress the first twinges of panic starting to envelope her chest.

"Jim, what do you think we should do?"

"Tell him to back off, we're not L.A.P.D. In fact tell all of your units to back off. Maybe we can get these people to slow down."

<p style="text-align:center">*　　*　　*</p>

"Mr. Palmer, you need to turn off your phone right this minute or I'll have to confiscate it. Did I hear you say something about a tsunami?" I gave Simone my friendliest smile and proceeded to turn off the phone as requested. I needed to invoke the Palmer charm.

"Simone, listen we have to talk. By the way is that French?" I was operating in the dark. I needed to get to the cockpit and the only way there was with Simone's help. She gave a chuckle at my suggestion that her name was French.

"Yeah, French Lick, Indiana."

I smiled and pointed at her as if knowing everything important there was to know about her hometown. But then again maybe I did. "Larry Bird."

"Our favorite son. He went to the same high school as my dad."

Inside I was ready to explode. A 2,000-foot tsunami was heading directly for us, and I'm making small talk with a sort of cute stewardess about a retired basketball player. Okay, one of the greatest basketball players. Controlling my emotions was becoming next to impossible. If I panicked, Simone was sure to have me thrown off the plane.

"Did your dad know him?"

"No. Dad graduated three years ahead. Now please promise that you won't use your phone again until we land. You wouldn't want me to have to get rough with you." Despite her mousy hair and extra freckles, Simone had a pleasant smile.

"Okay, I promise. Except please listen, I need to talk to you. It serious; we've got a big problem."

Simone looked around to make sure no one needed her assistance or more importantly was listening. She bent down to my eye level. Her

<p style="text-align:center">*173*</p>

pleasant smile had transformed into a look that said, "Don't screw with me."

"Mr. Palmer, you're not threatening this flight are you?" Now it was my turn to chuckle, though I'm not sure I was very convincing.

"No, it's nothing like that."

"Oh thank God." Simone slapped her open palm against the center of her chest. "They're having a twenty-fifth birthday party for my best friend tonight. If we had to take you off the plane, I'd never make it."

"No, we have a much bigger problem."

Simone interrupted me before I had a chance to finish. She looked around once more then whispered in my ear. "Please don't tell me you think there's a bomb on the plane or that you saw some Middle-eastern man that looks like a terrorist?"

"No, just let me explain... Wait, don't they all look like terrorists?"

"Excuse me?"

"Listen, my full name is Dr. Charles Palmer." It was time to start telling some convincing lies. "I've been working with a Dr. Richardson from the University of Hawaii on what caused last December's tsunami. Maybe you read about us in the papers." I could see the light going on in Simone's head, except when she looked at my outhouse attire it seemed to flicker then fade.

"I read about you guys. How come it says on your coveralls that you work for Manny's Mobile Thrones?"

"I don't have time to explain how I lost my clothes. Trust me, I don't work for an outhouse company." Even though we were in deep shit. "Please listen. That call I just received, it was from my friend Dr. Richardson. About ten minutes ago, there was a massive eruption on the Big Island. Except this one was much different from any that have occurred in recorded history. It's called a catastrophic collapse. The entire southern half of the island exploded and slid into the sea. We lost one of our friends in the explosion."

"That's terrible, but what has it got to do with us? We're two hundred miles away."

"The slide and explosion created a massive tsunami, and it's going to strike Oahu in less than fifteen minutes. If we're not in the air before it gets here we're all dead."

Simone's body language said, "I don't believe a word." Her facial expression screamed, "Bullshit."

"So how big is this tsunami supposed to be?"

No way was she going to believe the truth. I lied. "Two hundred feet."

"Oh, come on. Even I know tsunamis aren't that big. What's going on? Are you just trying to see the cockpit? I bet your phone wasn't even

on. Well, I'm sorry we're not allowed to let passengers up front anymore. Now please, Dr. Palmer, stay seated and we'll be off the ground in just a few minutes."

"No." I was starting to lose it, blood pressure rising, my heart racing as I tried to maintain even the slightest hint of sanity. My mantra became stay calm, stay calm. "You don't understand. An earthquake didn't cause this tsunami, so it's much larger."

"Dr. Palmer, if I let you out of your seat, I could lose my job. You don't want that to happen?"

"Simone, please I'm not some crazy and no I don't want you to lose your job. You have to believe me. If we can't convince the pilot to get this plane in the air in the next ten minutes it's not going to matter." Just as I was about to unfasten my seatbelt, the pilot came back on the speaker system.

"Ladies and gentlemen, we've just been informed by the tower that less than ten minutes ago a major eruption on the Big Island of Hawaii took place. Unfortunately the dust and ash cloud from a volcanic eruption can be very dangerous for us to fly through. Honolulu Center is currently re-routing us further north to avoid this hazard, but it's going to delay our departure another twenty or thirty minutes. We're sorry for the delay, but your safety is our most important concern. I'll be back with you as soon as we hear anything from Center."

I slammed my fist down. Simone jumped. Shit! I screwed up. Fist slamming was the wrong response. I needed to stay calm. Don't become a threat. Convince her I know what I'm talking about.

"Sorry, Simone. I didn't mean to scare you. Now do you believe me? You heard. The eruption took place after I got on the plane. The only way I could have known was that call from my friend. Please, I promise you this is real. I wouldn't jeopardize your job if it weren't. You have to trust me." I glanced out the window as the big United jet was completing a sharp left turn. Outside my window were row after row of military transport planes.

Simone slowly shook her head. "I must be crazy. How can I refuse a guy that dresses like that?" Pointing at my outhouse attire, "And flies first class? There's an Air Marshal onboard. I'll make the introductions. I hope you realize that identifying an Air Marshal to a passenger is a federal offense. If this is some kind of a prank, I'll lose my job and probably end up in jail. So if you're having any second thoughts, now's the time to speak up." Simone looked at me as if she were pleading, Don't make me do this.

"I promise, this is on the level. It's not a prank and I'm not some kind of nut case. We've got to get this plane off the ground." I could see

175

that Simone was already having second thoughts. I gave her my best out-house guy expression: concerned, worried, needy…make that pathetic.

"All right, follow me."

"Listen, if I have to take out that marshal, keep the passengers calm."

Simone stopped. She looked at me with those big blue eyes and shook her head.

"You're planning on taking out an armed federal marshal? You are crazy. By the way, our pilots are also allowed to carry guns."

"I'm not crazy. I'll do my best to reason with him, but just in case I can't, don't get between us."

Simone led me back to the stairway. Being a gentleman, I let her go up the stairs first. Simone may not have had the best face or hair, but damn, she sure had a great set of legs and a tight ass. The upper deck of the 747 was only half filled with more Japanese businessmen and a few well dressed Asian couples.

The fed stood out like a toad on a log. He was seated in the bulk-head row, right side, aisle seat. The seat next to him was empty. White flakes of dandruff highlighted his rumpled dark suit. The back of his neck showed a few too many folds, and his cheeks sagged as if waiting for someone to stuff them full of nuts. I knew the government had rushed the air marshals into service after 911, but I hadn't expected to see a guy this far out of shape.

Hopefully I wasn't going to have to subdue him, but as long as I could get close enough, my reactions were going to be quicker than his. Was this deja vu? More shades of Rat Face? Scott may be good, but I've got a few moves of my own. After twelve years of working out with Sense LeBell, you had better learn something.

At seventy, they still call Gene LeBell the toughest man in the world. Let him get close enough to touch any part of your body, and I guarantee it's going to end up hurting. I speak from experience. There's even a story running around Hollywood about Gene working on a movie set with one of the more obnoxious martial arts stars. The guy was being a dick and pissed Gene off. So seventy-year-old Gene grabbed him and took him down in a headlock. The famous star pissed his pants and Gene got fired from the set.

I continued to follow Simone down the isle. We walked up behind the fed. Simone stood at the entrance to the narrow hall that led to the cockpit. I stood in the aisle staring down at him. At first the overweight marshal just ignored us.

Simone looked scared to death. "Excuse me, sir." The fat fed imme-diately unbuckled his seat belt and stood up. "This is Professor Charles

Palmer. He needs to speak to you, and then the pilot."

"Miss, I don't know who you think you are, but identifying an air marshal to a passenger is a federal offense. I should have you removed from this flight and taken into custody right now." Damn, the guy had a real attitude. It was obvious that my good looks and charm weren't going to cut it.

"I know, sir, and I apologize. I'd never do this except that Dr. Palmer has something very important to speak to you about."

"Miss, I'll need your last name. You've just jeopardized the safety of this entire flight."

"Kaminski."

The fat fuck took out a small note pad and wrote down Simone's name. I wanted to clock him right there. Then he turned to me.

"You sure as hell don't look like much of a doctor. This had better be good."

Simone blurted out. "Oh, he can explain that. People get their luggage stolen out of their cars all the time. Those aren't his real clothes."

The fat fed turned back to Simone. "Lady, you need to stand back and keep your mouth shut."

"Sorry."

"Now, Dr. Palmer, what the hell's so important?"

"Sir, I'm sorry to bother you, but it is extremely important that I speak with the Captain... Right now."

"Well, that's not going to happen."

"No, you don't understand. Remember when he announced that there had been a major eruption on the Big Island? My associate, Dr. Richardson, and I have been studying undersea landslides. Didn't you read about us in the paper? We were caught in that deep submersible."

"No, I didn't read a thing." Maybe he didn't know how to read.

"Doesn't matter. The eruption on the Big Island caused Mauna Loa to collapse. It's called a catastrophic collapse. I just received a call from Dr. Richardson. The entire southern half of the island slid into the ocean and generated a tsunami that is over two hundred feet high."

The fat son-of-a-bitch just looked at me. "Bull shit! You go back to your seat or I'm taking you into custody."

I ignored the fat bastard and continued to explain our predicament. "Don't you understand? If I can't convince the captain to get this plane in the air in less than ten minutes, we're going to be hit by a two hundred foot wall of water. I need to speak to the captain. I have to see him." My brain felt like it was ready to detonate. It was getting more and more difficult to keep my calm

"The only thing you're seeing is the inside of a…" The fat S.O.B. went for his gun. Instantly I went for his wrist, grabbing it, hyper-extending, and twisting at the same time. I could feel the bones grinding. I wrenched the semi-automatic out of the crippled hand and let it fall to the floor. With a single continuous motion, I threw a knee into Fat Fed's flabby solar plexus and an elbow to the temple. The bastard crumpled to the floor like the pile of crap that he was.

Simone stepped out of the hallway and immediately raised both hands as she turned to the passengers. "Ladies and gentlemen, please stay calm. You've just witnessed a simulated terrorist attack. I want you to know that Mr. Palmer here has just disarmed and subdued a potential combatant. Now, didn't he do a great job? Why don't we give him a big hand?" Simone began to clap as she kicked me in the leg and whispered. "Wave to the crowd." I meekly waved, as the passengers first looked at one another and then gave me a half-hearted round of applause.

"Now please stay seated while Mr. Palmer and I report the successful completion of our test to the captain." Simone turned her back on the passengers, "Stay out of the hall," pointing to where she wanted me to stand behind the bulkhead. "There's a camera that the captain checks before he'll open the door."

While Simone headed for the cockpit door, I picked up the semiconscious Marshal and dumped him back into his seat. I felt around in his pockets and found a set of handcuffs that I placed on his right ankle and clamped onto the seat support. It took me a few minutes to find the handcuff keys in an inside jacket pocket. Then I reached down and grabbed the gun the marshal had been carrying a SIG Sauer P228, typical law enforcement.

Now it was decision time. Did I take the gun and threaten the pilots or should I just try to convince them. Unfortunately, my incredible powers of persuasion seemed to be a little rusty, but I decided that threatening people with a gun wasn't my style, even if my abilities to persuade sucked. I removed the magazine and placed it in a pocket. Then I checked the chamber. It was empty. I reached around and tried to put the gun under my belt. That wasn't going to work, so it went in my back pocket. I looked around the corner to see how Simone was doing with the cockpit door. As she started to open it, I stepped over the marshal and made my way to the front of the plane.

EIGHTEEN

GOVERNOR PRATT'S FRUSTRATION ROSE along with his blood pressure with each passing second. He looked at his three coworkers expecting some form of help from his trusted advisors. "Paula, Stan, Willy haven't you got anything?"

"How about FEMA? Maybe the Feds have something," suggested Stan Akai.

"Come on, Stan. I can get more timely information from my grandmother and she's dead."

Just then Marjorie Nonaka tapped on the door, but this time she didn't wait for the governor to invite her in. Ms. Nonaka walked briskly over to his desk. Instantly, everyone in the room knew something was up. This was not the Marjorie Nonaka they were used to dealing with.

"Governor, this just came through. You need to see it." Marjorie handed the single piece of paper to the governor, and then handed copies to his three aides. All four sat in silence as they read the notice from the Pacific Tsunami Warning Center.

TSUNAMI BULLETIN NUMBER 002
PACIFIC TSUNAMI WARNING CENTER/NOAA/NWS
ISSUED AT 2317Z 17 JUN 2006

THIS BULLETIN IS FOR ALL AREAS OF THE PACIFIC BASIN

...TSUNAMI INFORMATION BULLETIN ...

AN EARTHQUAKE HAS OCCURRED WITH THESE PRELIMINARY PARAMETERS

ORIGIN TIME - 2308Z 17 JUN 2006
COORDINATES - 19.7 NORTH 155.7 WEST
LOCATION - HAWAIIAN ISLANDS
MAGNITUDE - 8.9
MEASUREMENTS OR REPORTS OF TSUNAMI WAVE ACTIVITY

GAUGE LOCATION	LAT.	LON	TIME	AMPL	PER
HILO HAWAII	19.7N	155.0W	(OUT OF ORDER)		
KAWAIHAE HARBOR	19.9N	156.0W	(OUT OF ORDER)		

TIME - TIME OF MEASUREMENT
AMPL - AMPLITUDE IN METERS FROM MIDDLE TO CREST OR MIDDLE TO TROUGH OR HALF OF THE CREST TO TROUGH
PER - PERIOD OF TIME FROM ONE WAVE CREST TO THE NEXT

EVALUATION

SEA LEVEL READINGS ARE NOT AVAILABLE AT THIS TIME. TSUNAMI ACTIVITY MAY HAVE DESTROYED ALL SEA LEVEL EQUIPMENT. THEREFORE A TSUNAMI CANNOT BE CON-FIRMED. HOWEVER – EARTHQUAKES OF THIS SIZE SOME-TIMES GENERATE LOCAL TSUNAMIS THAT CAN BE DESTRUCTIVE ALONG COASTS LOCATED WITHIN TWO HUNDRED KILOMETERS OF THE EARTHQUAKE EPICENTER. AUTHORITIES IN THE REGION OF THE EPICENTER SHOULD BE AWARE OF THIS POSSIBILITY AND TAKE APPROPRIATE ACTION.

OF GREATER CONCERN IS THE CATOSTROPHIC COLLAPSE OF THE SOUTHERN HALF OF THE MAUNA LOA AND KILAUEA VOLCANOES THAT ACCOMPANIED THE EARTHQUAKE. VERY LITTLE DATA IS AVAILABLE TO DETERMINE WAVE SIZE OR PE-RIOD BASED ON LAND MOVEMENT OF THIS NATURE. PRE-LIMINARY CALCULATIONS INDICATE WAVE HEIGHTS IN EXCESS OF 666 METERS IN THE HAWAIIAN ISLANDS AND SOUTH PACIFIC. WAVE HEIGHTS IN EXCESS OF 333 METERS ARE PREDICTED ALONG THE WEST COAST OF NORTH AMER-ICA AND EAST COAST OF JAPAN. AUTHORITIES IN ALL RE-GIONS SHOULD TAKE APPROPRIATE ACTIONS.

THIS WILL BE THE ONLY BULLETIN ISSUED BY THE PTWC FOR THIS EVENT. THIS FACILITY IS CURRENTLY BEING EVACUATED.

THE WEST COAST/ALASKA TSUNAMI WARNING CENTER WILL ISSUE ANY FUTURE BULLETINS FOR ALASKA - BRITISH COLUMBIA - WASHINGTON - OREGON - CALIFORNIA - AND THE REST OF THE PACIFIC RIM

The governor was the first to speak. "Can anyone tell me what the

hell this is supposed to mean?" His three aides look at each other without volunteering an explanation. Finally Paula Steele spoke up.

"Nelson, I'm not sure what this means, but I know we need to find out. This bulletin, if I'm reading it right, says that we can anticipate a wave over 2,000 feet high. That's ridiculous. It's probably a typo. I'm sure we're all in agreement that we need to confirm exactly what we're faced with. I suggest someone get the Tsunami Warning Center on the phone right now."

The governor hit the intercom button. This time he asked Ms. Nonaka for the Pacific Tsunami Warning Center's phone number. Pratt adjusted the volume on the speakerphone so that his aides would hear the conversation. It did not take Ms. Nonaka long to get the governor the number he requested. He dialed and after five rings a recording announced that no one was available to answer the phone and to leave a message.

"God damn it. What the hell is going on around here?" The governor slammed his fist into the heavy wood desk again and again. His aides jumped at the unusual outburst. "How can I do my job if I can't get any answers?"

"Mr. Governor." It was Paula Steele. "If I can make a suggestion."

"You sure as hell can."

"There's no question that this bulletin contains typographical errors. If I were a betting woman I'd say the wave height was intended to be 6 meters, about twenty feet. That would make it almost exactly the same size as the December tsunami."

"I would have to agree with you. It certainly makes more sense." Willy Watai and Stan Akai both nodded in agreement.

"I suggest we contact our emergency service providers and tell them to begin implementing our evacuation plans. They can start by getting their people and equipment into position, and calling in off duty people. They know the drill. At the same time, let's continue to try and reach the Tsunami Center. The Bulletin does say that it will be the only one issued as the Center is being evacuated."

"If the tsunami is only twenty feet, then why would they evacuate?" asked the governor.

"I don't know. As I recall they had quite a bit of damage from the December tsunami. Didn't the director have to submit his resignation for endangering his own life or some interns? Maybe they're concerned that their equipment will go down so they're handing off responsibility to Palmer, Alaska. We need to send a patrol car over to see if anyone's home."

Press Secretary Willy Watai began taking notes. If there were a major disaster, it was going to fall on his shoulders to explain what the state did—or did not do—to protect its citizens.

"We can also begin calling other islands," continued Paula. "First Maui, then Lanai, and finally Molokai. If there's a tsunami, these islands will get hit first. Once we have confirmation of a destructive wave, we can implement our plan to evacuate the people."

"Thank you, Paula. That sounds like as good a plan as any." Governor Pratt turned to his other two aides. "Do either of you have anymore to add?" Akai and Watai shook their heads to indicate they had nothing else to say. "Well, that settles it. I think we have a plan. Now I would like to take care of some personal business. Each of you knows what has to be done, so let's get to work. I'd like you to get back to me in," the governor paused while he looked at his watch, "ten minutes."

The three aides filed out of the oversized office with the view of Diamond Head through the floor to ceiling window. Once everyone was gone, Pratt picked up the receiver on his phone. He made sure the speaker function was off and then dialed his house.

"Governor Pratt's residence."

"Julie, is Suzanne home?"

"Yes, sir. She just came back from shopping. I'll get her."

"Thank you." Nelson Pratt waited, nervously tapping his fingers on the desk.

"Hi there. Are you done with your meeting already?"

"Listen, dear, something has come up. We just received a bulletin from the Tsunami Warning Center."

"Not another one?"

"Yes, but this one's different. I don't want you to panic. We're pretty sure there's a typo in the message, but I don't want to take any chances. Get the kids this instant, put them in the car, and drive up to the top of the Pali Highway. You should be safe there."

"The Pali Highway? What's going on?"

"Please, Suzanne, there's no time for questions; just call me when you get there. I'll fill you in, but please hurry."

"Nelson, what about you?"

"Don't worry, I'll be fine. Call me on my private line when you get to the top. "

"Dispatch, this is 3 David 11. That crazy wahine in the blue Honda just crashed through the gate on Mount Kaala Road. She's got kids in that car."

Jean Chavez could not believe this latest report. What a nightmare this was turning out to be. She wondered why sane people risked their own lives, let alone their kids. She directed the patrolman to turn off

lights and siren hoping the driver would act more rationally.

"3 David 11 is turning off lights and siren, but I don't think it's going to help. This girl is as spooked as they come."

"3 David 11, Sergeant says to just keep her in sight and don't try to take her into custody until she stops."

"Roger that."

Just as the watch sergeant was about to direct dispatcher Jean Chavez to back off even more on her pursuits, he was handed a note.

"Ah crap, not another one." Jean Chavez momentarily looked away from her screen.

"What is it?"

"We just got another one of those damn tsunami warnings. At least this time they don't want us to start evacuating people until they can get a confirmation on the size of the wave."

"That's good, because I don't think we're going to get anyone to move anyway." Jean turned back to her monitor and announced: "All units, we have just received another tsunami warning. You are instructed to re-position yourselves to your evacuation stations. You are not to begin evacuation procedures until you receive further instructions. Repeat, do not start evacuation procedures until given further orders." Ms. Chavez turned to her Watch Sergeant and asked. "What do you want me to do with these pursuits?"

"Just leave one car in pursuit. None of these cars have been reported stolen and the registered owners don't have criminal records. I'll assume one officer can handle it."

"Units 5 Charlie 16, 3 David 11, and 1 Adam 13, stay in pursuit of your vehicles. All other units are to report to their evacuation stations."

"Dispatch, this is 5 Charlie 16. My white Forerunner has just turned left onto Mount Kaala Road. It looks like you were right. They must be planning a family reunion."

"Roger that, 5 Charlie 16. You can back off. He's not going any place."

"Dispatch, this is 1 Adam 13. My silver Explorer has just rolled over at the intersection of Kamehameha Highway and Kakonahau Road. He was attempting to avoid slower traffic. Driver was ejected from the vehicle and is D.O.A. No other vehicles involved."

"Roger that, 1 Adam 13. We'll send the coroner and accident investigation team. Did you get an I.D. on the driver?"

"Dispatch, 1 Adam 13. Driver's name is Dr. Walter P. Grissom."

NINETEEN

SIMONE ENTERED THE COCKPIT as Flight 103 was taxing up to the runway. I slid in behind her and bent down to check out the scene through the front windshield. From three stories up, the view of the Pacific with Waikiki and Diamond Head in the background was as good as any postcard. Off to our right was a ten-foot high breakwater to protect the 12,000-foot strip of concrete from storm waves. Beyond the breakwater, wavelets of metallic blue reflected the tropical sun. Everything looked normal, peaceful, and almost surreal. Would it stay that way for the next twenty minutes? Either there was still time, or Simone and I were in an awful lot of trouble. Just as the captain turned around, Simone started to say something. He interrupted her.

"Who the hell are you?" The captain glared at me, clearly not a happy camper.

"Captain, I'm sorry. I know this is against regulations, but Dr. Palmer needs to speak to you." Captain Hornbeck hadn't reached panic stage yet. Even so, it was abundantly clear that he wasn't pleased to have an intruder in his cockpit.

The captain's mood seemed to change as he checked me out starting with my black wingtip shoes and working his way up to Manny's Royal Flush Logo. All I could do was smile when he said, "What kind of doctor are you, proctologist?" The co-pilot in the right seat, a cute little brunette wearing an oversized co-pilot's hat and dark aviator glasses, turned away for a second. I knew she was snickering at the captain's comment. At least the guy had a sense of humor. "You need to go back to your seat mister. You're not allowed up here. Simone, we're going to have a little talk once we're in the air." The mousy Simone attempted to speak one more time but the pilot interrupted once again. "Wait a second, how did he get past the air marshal?"

"Captain, please. Dr. Palmer can explain everything."

Just as I was about to speak, the radio came alive.

"Qantas flight 391, turn right to a heading of eight zero and track inbound. Report outer marker."

"Tower, Qantas 391 heavy turning right to eight zero will report outer marker."

"Dr. Palmer, I can't even imagine how many laws both you and Simone have broken." The captain continued, "I should have you both removed from this flight. Where the hell is that air marshal? If you'll please go back to your seat right now, I'm willing to forget about this little incident."

"Captain, just give me a second. I promise I'll go back to my seat." The captain didn't look convinced, and I wasn't going to give him the chance to deny my request. "My associate Dr. Richardson and I were investigating an underwater landslide that caused the December tsunami. While making our investigation, we discovered a large fissure that ran for over 60 miles along the southern coast of the Big Island. This fissure was evidence of a potentially much larger landslide. The eruption that you were just informed about has caused the catastrophic collapse of Mauna Loa, the largest volcano in the world." The captain tried to speak. I put my hand out and wouldn't let him. "This collapse sent tens of thousands of cubic kilometers of rock into the Pacific causing a two hundred foot tsunami. We don't have much time."

I continued to scan the horizon. Everything seemed normal, just not as normal as usual. Something wasn't right. But I couldn't put my finger on it. There was this feeling in my gut, almost a sixth sense, as if something were rushing towards us, like thunder after a bolt of lightning. That little voice that everyone carries around inside was yelling, "Look out."

I continued to stare out the windshield. I'm not sure if it was my conscious or subconscious that was attracted to a dark line on the surface of the water. It wasn't a wave, and it sure as hell wasn't the tsunami, it was moving much to fast. The line of dark water was now clearly visible as it stretched across the horizon, accelerating towards us at incredible speed. I started to lift my hand to point just as the screaming imperfection in the ocean's surface hit the breakwater, crushed the low cut brush and grass next to the runway, then struck us. The entire plane trembled. Even inside the cockpit, with the engines running, there was still this low moaning rumble. The wings flexed, the sound of the idling jet engines momentarily changed to a high-pitched whine. Then as quickly as we were hit by the invisible pressure wave everything went back to normal. The captain and co-pilot instantly turned to look at the wingtips and engines.

"What the hell was that?" asked the captain. We'd been hit by a giant wave of compressed air. I knew what it was and was about to explain when the radio broke the silence in the cockpit.

"Tower, this is Qantas 391 heavy. We just got hit by something and went from wings level to vertical in two seconds. We just about lost it there."

"Qantas 391, we just got hit by some kind of shock wave in the tower. Just about broke the glass out."

"Tower, we may have injured passengers, requesting emergency equipment."

"Roger that, Qantas 391. You're cleared to land runway eight right. We'll have emergency equipment rolling to meet you."

"Qantas 391 heavy is cleared to land eight right, and we just passed the outer marker."

Once things had returned to normal, Captain Hornbeck and the cute co-pilot, I couldn't remember her name, turned away from the engines and towards each other as if to ask: "Do you have any idea what that was?" All they could do was shrug their shoulders and stare blankly at each other.

"That was the shock wave caused by the eruption of Mauna Loa."

"Don't be ridiculous. We're over two hundred miles from the Big Island. That's impossible," said the Captain.

"Trust me. You have no idea how big that eruption was. The guys over at the Tsunami Warning Center said that when Krakatoa erupted in 1883 the sound was heard over 2,200 miles away. The scary part is that this eruption was bigger."

"How do you know how big the eruption was when it happened after everyone had boarded?"

"Listen, we don't have much time. My associate called me on my cell phone. He just left the Tsunami Warning Center and was headed to high ground. The pressure wave from the eruption has to travel at the speed of sound. Dr. Richardson said that when the tsunami is in the open ocean it travels as fast as a jet. How fast do you guys fly compared to the speed of sound?" Both Captain Hornbeck and what's her name, turned to face me. It was the captain that spoke first, as he looked at me, obviously questioning my credentials.

"You're not really a doctor, are you?"

"You're right, I'm not. Still, everything else I've told you is true. So how fast do you guys fly? There can't be much time left."

"Figure just over eight-tenths the speed of sound, eighty percent. Which means there should be about a five-minute difference between the arrival of that pressure wave and the tsunami, assuming you're not full of crap." I was just about to protest when the captain called the tower. "Tower, this United 103. We're holding for Eight Right. That pressure wave just hit us also. Have you received any reports of a tsunami? And how is our re-routing coming? Can you give center a call?"

"United 103, we've been advised of a possible tsunami. They told us to sit tight until we get a confirmation. We'll give center another call."

"Thank you, tower. United 103 continuing to hold."

I was starting to lose it as I told the captain, "Screw the tower, we've got to get this plane in the air." I continued to scan the horizon.

"You're a regular rocket scientist. Do you have any idea how fast they'd pull my license if I just decided to take off without clearance?"

Through the windshield, I could see off in the far distance a line of fishing boats working out past Diamond Head. Closer in, passing the last entrance buoy to Honolulu Harbor, was a large container ship heading to sea. Party boats and small sailing yachts were cruising just off the coast from Waikiki. The Pacific was back to normal. There was no more high-pressure blast of air rushing towards us at the speed of sound. Maybe it was a false alarm. Maybe I had just gotten Simone fired, and I was about to be thrown in jail. Then I saw it. It wasn't a wave, more like a large swell. Probably over ten miles away, barely perceptible at such a great distance, only fifty to a hundred feet high. Still, it was definitely there, billions of tons of water coming straight at us. The fishing boats must have been in deep water as they rode up and over the gently sloping surface. The swell, a benign defect in the oceans surface, would slow and continue to build as it roared up onto the shallow bottom that surrounded the island. Eventually that rolling swell would turn into a vertical face of unbridled rage crushing everything before it. We were helpless, tied to the tracks, staring at the freight train bearing down on us. I pointed and yelled.

"There, right there. Do you see it?" The captain leaned forward as did the co-pilot.

I continued to point. "Right there. Damn it, don't you see it?" The captain turned away from the windshield and faced me.

"I don't see a god damn thing. Now, Mr. Palmer—or what ever your name is—you had better get back to your seat. Simone, where the hell is that marshal? Get me that damn marshal."

* * *

"Dispatch, this is 3 David 11. The blue Honda has stopped at the end of Mount Kaala Road. I've attempted to apprehend the female driver. Be advised that she refuses to come out of her car, and she has four young children in the vehicle with her."

Jean Chavez covered the microphone in front of her mouth. "So shoot the bitch." The watch sergeant merely smiled when he overheard the dispatcher's comment.

"3 David 11, the sergeant says to stay with the vehicle. Have you tried to speak to the lady?"

"Affirmative. She keeps saying something about a huge wave

that's going to destroy everything. Says she and the kids will get out of the car and leave with me in ten minutes."

"Roger that, 3 David 11. Just sit tight and we'll be back with you. It looks like her husband is on the way to meet her. Maybe you can get things straightened out when he arrives."

Watch Sergeant Jim Correa took the note out of his secretary's hand. After reading it, he handed it to his dispatcher Jean Chavez.

"I guess this isn't a drill. You had better put the word out to all units. I'll go give the rest of the crew the good news," he added sarcastically.

"All units, this is dispatch. We just received confirmation on the tsunami. We do not know the size of the wave. Therefore, you are directed to begin evacuation of all low lying areas."

"Dispatch, this is 4 Echo 12. We need to have some idea of how large the wave is. If we can't give these people a rough estimate we'll never get them to move."

"Roger that, 4 Echo 12. We're working on it. We'll get back with the information A.S.A.P."

Jean Chavez turned to her watch sergeant just as he completed making the announcement to the rest of the dispatchers to begin the evacuation. "Hey, Jim, we need to get an estimate on the size of the wave."

"I've got Kim working on that. She's calling the Emergency Operations Center as we speak… Kim, did you get anything from operations?"

"They said they're not sure; assume the wave will be the same size as the December tsunami and will flood the same areas."

"All right, everyone, you heard what the lady said. Tell your units to evacuate people from the same areas that were flooded in December. That'll keep it simple."

"Dispatch, this is 3 David 11. I just spoke with the lady again. She says that two of the children are hers and the other two are her neighbors. Her husband is a professor at U of H and was studying the December tsunami. He called her to say Mauna Loa erupted and caused, now get a load of this, a tsunami over two thousand feet high. She said that's why she was in such a rush to get up here."

"And that's why we shoot the crazy ones," added Ms. Chavez.

The agitated dispatcher smiled when she overheard her watch captain say, "Amen."

"Roger that, 3 David 11. Too bad I forgot my water wings. Her husband is only ten to fifteen minutes behind. When he gets there, find out what's going on and get back to us. We're still trying to confirm the size of this tsunami. We've only got an estimate."

* * *

"It's right there." I continued pointing, but the captain didn't even bother to turn his head. He no longer cared what I had to say. He wasn't buying any of it. "Look! Look at the horizon! Don't you see the faint white line... Oh shit! Oh my God!"

Finally, he turned to take another look. Instantly my stomach wrapped itself into one large knot. I tried to swallow, tried to speak. Attempting to comprehend what I was looking at was no longer a realistic goal. My brain was only capable of dealing with a reality that exists in a normal world. This wasn't normal, and it sure as hell didn't feel like it was from this world or any other I could imagine.

"What? What's going on? I don't see any white lines."

All I could do was repeat, "Oh my God!"

"What. What the hell are you looking at?"

"Look. There, off to your left. That container ship, it's not floating. It's just stopped. It's on the bottom. The water off Waikiki, Diamond Head, the Harbor, it's all gone. The boats aren't moving. They're high and dry." I turned to look directly out the front windshield, over the rock breakwater, past the exposed ocean bottom to the horizon. Now there was no denying the approaching disaster. "Oh shit... We've got a bigger problem... Look." It was impossible to gain any practical perspective, maybe a few small sailboats. The proportions were all wrong. The change was hard to comprehend. When I first spotted the wave almost ten miles off, it lifted the line of fishing boats without hardly disturbing them. It appeared harmless. Now the massive tsunami was directly off the nose of the plane. It had gone from a huge, gently rolling swell to a moving mountain of seething water. The upper third consisting of roiling white foam, the lower two-thirds building as the wave moved towards us. It had to be over a thousand feet high. I thrust my arm out between the two pilots and yelled: "Look!"

Captain Hornbeck's response was short and to the point. "Oh, shit!" He reached out and grabbed the throttles pushing them forward. Instantly the whine of the engines changed. As much as I wanted it to, the 747 didn't leap forward. It's just too damn big, but we began to move. The captain started to make a left turn to line the plane up on the center of the runway.

"What the hell are you doing?" yelled the co-pilot. Her name? What's her name? "That Qantas flight's on short final."

"Get on the radio and don't let him land. We're making an emergency departure."

"There's no such thing as an emergency departure."

"Damn it, Michelle." That's it. "There is now. Make him go around.

If he lands, we're dead and so is he."

I continued to stare at the growing tsunami. As the plane made a wide arcing turn to the left, the horizon moved to the right. I had to look over Michelle's head to see the wave, which had grown so large I couldn't see the top any longer. Even so, I knew it would continue to grow as it built to an unimaginable size.

"Qantas 391, abort your landing! Repeat, abort your landing! United 103 heavy is departing Eight Right. We're making an emergency departure on eight right." Everything was happening so fast. Captain Hornbeck continued to push the throttles forward as he turned the plane. I could feel the big jet leaning. Michelle looked out her side window towards the right wing.

"Slow your turn. You're going to hit number four."

The captain ignored her as he continued to advance the throttles. The tsunami was no longer just a wave. The proportions were out of whack, much too large, as if I were standing at the bottom of the Grand Canyon looking up at a vertical wall of water. Except this wall was moving, moving and growing, about to crush us under its incredible weight, like a giant foot about to squash an invisible bug. The radio was blasting in my ear, except the words were unintelligible. The tower and the Qantas pilot must have been stepping on each other. Finally the Aussie accent filled the cockpit.

"You crazy bugger. What the hell are you doing? I'll have your god damn license… You stupid son of a bitch." Then the voice of the controller replaced the furious pilot.

"United 103, you are not cleared for departure. Repeat, you are not cleared, hold short. You have landing traffic. Hold short!" I never did hear the rest of the tower's transmission. Michelle must have turned down the volume. Either that or the roar of the Qantas 747 engines drowned it out. The big plane flew directly over us. Our initial instinct was to duck. Then we craned our necks and watched as the white underbelly of the jumbo jet sped by. It couldn't have been a hundred feet over our heads. Flight 391 was so close streaks of black oil and dirt were clearly visible against the white underbody of the big Aussie jet.

Once Flight 391 had passed, the captain yelled to his co-pilot, "Forget the radio, we need to get off the ground."

Michelle looked out her side window. "I don't think we're going to make it."

"We'll make it." Once the pilot had lined us up on the centerline of the runway, he hit a button just above the throttles and then let them continue to automatically advance. "Call the airspeed." I had to press

forward against the constant acceleration, while still looking off to my right at the ever-advancing wall of water.

Co-pilot Michelle announced, "Air speed's alive."

As we sped down the runway, the nose of the plane seemed to bob like a metronome. It was as if we were leaping over small mounds in a rhythmic fashion while accelerating. Flight 103 felt like it was dancing to some strange beat, and that's when it struck me—that infernal song—of all the annoying things to pull out of the old memory bank. "*The joint is jumpin*."

Michelle glanced out her side window and said it again. "Captain, we're not going to make it."

"We're going to make it. Just call the air speed."

"110 knots."

And that sick twisted brain of mine began to sing, "*The joint is jumpin*."

"120 knots."

"*It's really jumpin*."

"130 knots."

"*Come in cats an' check your hats. I mean this joint is jumpin*."

"We're not going to make it"

"We'll make it," insisted the captain.

"140 knots."

"*The piano's thumpin*."

"Captain, we're not going to make it."

"*The dancers bumpin*."

At 140 knots the captain took his eyes off the runway for a split second to look out the right side of the cockpit. All he could see was water, a vertical wall of raging fury over two thousand feet high, and it was about to crash down on us. Our lives were about to be snuffed out in an instant.

Then he said the wrong thing. "Shit, we may not make it."

My heart sank as he reached over and grabbed the throttles. This time he shoved them all the way to the forward stops. The engines low-pitched moan changed to a combination high-pitched whine and roar.

Co-pilot Michelle screamed, "Captain, you'll over temp the engines," Alarms started to go off. "150 knots."

"It doesn't matter. The engines will hold."

"160 knots, V one."

And all this time, despite being half scared to death, the only thing running through my head was. "*This here spot is more than hot. In fact the joint is jumpin*."

"V - R." As soon as the co-pilot announced V – R, Captain Horn-

beck pulled back on the combination wheel control yoke, and the nose of flight 103 began to lift. Holding on to the co-pilot's seat as the angle increased, I never felt the main landing gear leave the runway. We must have lifted off about the same time the foot of the tsunami crossed over the breakwater. The same breakwater built to protect the runway from storm waves. Now it didn't even qualify as an appetizer for the giant tsunami that was swallowing up everything in its path.

The co-pilot announced, "Positive rate, gear coming up." We continued to gain altitude at a dizzying angle of ascent. It was becoming more and more obvious that there was no way of out-running the mountain of water bearing down on us.

Captain Hornbeck twisted the wheel counter-clockwise and the giant 747 banked steeply to the left. It was if we were surfing up the side of the largest wave known to man. There were so many alarms going off it must have been impossible for the crew to concentrate. The racket inside the cockpit was more like a thousand video arcades than the business end of a modern jet.

"Captain, all four engines are in the red. We need to reduce power." The incredible wall of water couldn't have been more than a 100 yards from our wingtip.

We were still climbing and turning when the Michelle announced, "Captain, we must be getting an updraft. We've pegged our vertical speed indicator."

"That's what I was hoping for. That wave is pushing a huge wall of air in front of it so that we're being lifted."

"I have to pull back the throttles?"

Captain Hornbeck continued to lean as far forward as possible and look out the front windshield up towards the lip of the tsunami.

"Not yet. Give me ten more seconds."

"Captain, please, we may not have ten seconds."

"Five seconds." For a brief moment, despite the blaring alarms, all was quiet in the cockpit. Everyone held his breath. "Okay, now. I still want full takeoff power."

Michelle reached over, wrapped her delicate hand around the four throttles, and pulled back. Instantly the loud whine of the engines changed to a low roar as we continued to climb up the face of the incredible wave. White foam rushed by the Co-pilots window. We continued our climb all the while banking away from the face of the incredible tsunami. Then suddenly, without warning, the pale green and white reflection from the massive wave changed to the bright blue of the tropical sky. We popped up and over the moving wall of water. It was like

walking out of a matinee. No, make that the worst horror movie imaginable. The bright light of the afternoon sun burst through the windshield. Our 747 continued to gain altitude, carrying us to the safety of the clear blue sky as if nothing had happened.

Captain Hornbeck turned to his co-pilot and asked, "Did you get a height on that wave?"

She either ignored or didn't hear him. Our co-pilot just sat there staring at the five large screens in front of her. "Michelle, did you get a height on that wave?"

Finally, she shook her head as if trying to dislodge the cobwebs.

"I'm sorry, Captain. What did you say?"

Hornbeck reached over and pulled the throttles back even further. With all the excitement, I hadn't noticed that the alarms were no longer blaring in our ears. The only sounds were a low groan coming from the engines, and the quiet hiss of air flowing past the windshield.

"I wanted to know if you got a height on that wave?"

"Oh, sorry. The radar altimeter read 120 feet as we passed over it. We were 2,440 feet above sea level. So that means the wave was…" Michelle paused as she ran the simple equation. "2,320 feet high."

Captain Hornbeck pushed forward on the control yoke and the nose of the 747 lowered to a more reasonable angle of climb. Spreading out before us the view from the front of the plane was right out of some incredible disaster movie, except the special effects were way too real. The monstrous wave was starting to move on shore. First it swallowed up Diamond Head as if it were a child's sand castle. Huge plumes of white spray shot straight up the face of the famous landmark only to be swallowed by the monster wave as it continued on its path of destruction. The 500-foot high-rises along Waikiki Beach looked like the Lego buildings my nephew used to build. Except these Lego buildings were filled with thousands of living souls, souls that were about to be wiped off the face of the earth. All we could do was quietly stand-by and watch as the wave ripped the heart out of the famous seaside resort.

We continued to stare out the windshield as if the scene before us wasn't real. The relief of surviving the massive wave instantly changed to a gut wrenching pain. Tens of thousands of people were dying below us. All the time, the big jet continued to quietly climb through the tranquil blue sky, effortlessly removing us from the incredible scene of suffering. I turned away. The thought of all those lives being snuffed out in a single instant was just too much to deal with. Watching the destruction of an entire city was more than I could endure.

With my head buried in my hands, I wondered how the crew of

the Enola Gay felt as they watched the first atomic bomb destroy Hiroshima. Probably different, they volunteered for their mission. No one would ever volunteer for ours.

<center>* * *</center>

Governor Nelson Pratt jotted down a few notes, more bullet points for the myriad of speeches he would make after the tsunami struck. He would tell the news agencies once again that Hawaii was the best tsunami-prepared state in the country. Still, even though this latest disaster had not occurred yet, the governor knew the death toll would once again be substantial. He could only hope that the additional preparation the state had made would reduce the body count compared to the wave six months earlier. He would attempt to explain how little his brave emergency personnel could do with just a few minutes warning. Nelson Pratt leaned into his overstuffed leather chair and began to stretch his arms when he was interrupted by the voice of his receptionist on the intercom.

"Excuse me, Mr. Governor, but your wife is calling on your private line."

"Thank you, Marjorie. I'll take it." He looked at his watch and smiled. His wife had made unusually good time to the top of the Pali Highway.

"Suzanne, are you there yet?"

"I'm just pulling into the parking lot. On the way up a cop tried to pull me over for speeding. I didn't think I should stop."

"No, you did right."

"Here he comes… Oh, he doesn't look very happy."

"I'm sure you can handle it." Pratt listened as his wife spoke to the officer. As soon as Suzanne pulled out her driver's license and explained who she was, the officer let her off with a warning.

"I'm glad that's over with. How long do we need to stay up here? The boys will be getting hungry soon?"

"It shouldn't be much longer. We still haven't gotten a confirmation on the size of this wave."

"Nelson…"

"Yes, dear."

"Nelson… Nelson. Oh god, Nelson. Look out your window." From his fifth floor office, Pratt had a beautiful view of Diamond Head and Waikiki Beach. He swiveled his chair to face the wide picture window behind his desk. The capitol building began to shake. The thought flashed through his head, "The last thing we need is an earthquake." He quickly realized it wasn't an earthquake. The two thousand-foot wall of water

<center>*194*</center>

racing towards him was less than a mile away. His face went ashen white and he gasped. "Nelson. What is it? Do you see it?"

Nelson Pratt stood, as if the monster devouring everything before him was calling. He stood there dazed, without expression, numb to his surroundings. The twelve-foot-tall picture window began to rattle in its frame from the hurricane force winds buffeting the building. His wife screamed into the phone, "Nelson. God no. Nelson, don't leave me."

The governor of our fiftieth state remained perfectly calm as he told his hysterical wife. "It's okay dear. Everything will be fine." The wave continued to grow as it raced up the streets of Honolulu. Pratt could not move a muscle as his fate unfolded before him. Then a glint of light from the shiny wing of a jet departing out of Honolulu Airport caught his attention. The plane was both climbing and turning away from the crushing face. The pilot was attempting to outrace the tsunami. Governor Pratt stood there frozen, whispering, "Please let them survive. Please let them survive," as if it were some mystical chant.

His wife continued to scream into the receiver. "No. You can't do this. Please don't leave me. Please don't."

"I love you, Suzanne."

"I love you, Nelson. I love you so much. Please don't. Please."

Pratt watched the departing jet crest the tsunami and climb into the brilliant turquoise sky. His only thought, "Thank God they made it." The governor of Hawaii craned his neck to look up at the writhing, foaming crest hundreds of stories above him. He spoke gently into the phone.

"Suzanne, please tell the boys I love them very…"

PART III

TWENTY

"UNITED 103, THIS QANTAS 391 HEAVY. Are you still with us?"

"Qantas 391, this is United 103 heavy," responded Captain Hornbeck. "Yeah, we're still here. Sorry about that departure."

"Please, United 103, don't apologize. You just saved our lives. We're still having a tough time believing what we just witnessed."

"I understand."

"If we ever have the pleasure of meeting I'd like to buy you a beer. What the hell was that? I mean I know what it was. What caused it?"

"Qantas 391, I'll take you up on that beer. We're still trying to deal with this disaster. We have a Professor Palmer on board." Not bad. I'd gone from obnoxious passenger wearing the latest in outhouse attire to a tenured professor—well, maybe not tenured. "He's the one we owe the thanks to. He convinced the crew we were in imminent danger. Professor Palmer says the tsunami was caused by a massive landslide that occurred in conjunction with the eruption of Mauna Loa."

"United 103, this is Qantas 391 heavy. Please tell the good professor that I'd like to buy him a beer as well."

"Roger that, 391. How are you looking on fuel? Have you decided what you're going to do yet?"

"That's a wee bit of a problem. We were held up in Sydney on the apron and had devilish headwinds on the way here. I estimate that we have just over an hour before we're either on the ground or in the water."

"That is a problem," replied the Captain.

A bit of a problem, how can these guys be so composed? What happened? We just watched over half a million people die and these guys have a bit of a problem? Captain Hornbeck and the Qantas pilot were now just a couple of jet jockeys coolly discussing the immanent destruction of flight 391. So add a few hundred more to the list. No problem. Where do they find guys like this? I wasn't sure what to think, what to do, even how to act. My brain had gone into overload or neutral, or just left the building. I wasn't sure, all I knew was it refused to process any more of this disaster. All those people were dead, and for now, we were

safe. All I wanted to do was go back to my seat, curl up, and hide from the world until we landed.

"I guess you don't have a lot of choices," Captain Hornbeck calmly pointed out to the Aussies.

"It doesn't look too good. We've been talking about heading up to Kauai. Our charts show the runway is 153 feet above sea level. I'm thinking that of all the runways we can reach, it will most likely to be clear of floodwaters, but the runway's not rated for us."

"Yeah, I'm looking at the charts. 6,500 feet is going to be a little short. Maybe you should burn off fuel over Honolulu, then land on runway eight, right. It will still be covered in water, but at least it should be fairly clear of debris. Besides, if there's water on it, at least you won't have to worry about fire."

"We'll have to think about that. You know, even if we make it, we won't be out of the woods."

"Qantas 391, why do you say that?"

"Because there's not going to be any food, shelter, or water down there. If I had to guess, I'd say that a couple of deserted islands in the middle of the Pacific aren't going to be very high on the priority list when it comes to rescue operations."

"Qantas 391, I hadn't thought about it, but you're probably right. Let us know what you decide. We'll stay on frequency. When we get to the mainland, we'll tell them where to find you. Unfortunately the world is going to be a different place."

"Roger that, United 103. For now we'll take a ride up to Kauai to take a look. If we don't like it, we'll have enough fuel to make it back here. Don't forget I owe you and the professor a beer."

"Qantas 391, I'll hold you to it."

I started to head back to my seat then changed my mind, or what was left of it. At least there was calm, some semblance of sanity in the cockpit. I couldn't imagine what was going on in the back of the plane. Half the passengers had just watched all of their loved ones killed. As depressing as it was in the cockpit, dealing with a planeload of crying passengers was worse.

The captain was right. The world had changed. We were comfortably flying towards the West Coast of North America at over 500 mph. Following directly below us were the remnants of the largest tsunami ever witnessed by man, a tsunami that was going to destroy every coastal city in the Pacific basin. A tsunami that just killed hundreds of thousands of people and was about to kill millions, maybe hundreds of mil-

lions. What would the rescue effort look like? Who would be left to rescue? And what about the cloud from Mauna Loa—the fallout? Walt had said the eruption of Mauna Loa would be larger than the 1883 or even the 535 A.D. Krakatoa eruption. The world was going to be clouded in ash, crops would fail, communications disrupted, transportation would grind to a stand still, and the fragile world economies would certainly fail. With so much pain and suffering was anyone going to care about rebuilding the cities that surrounded the Pacific? Certainly not Hawaii.

I asked the captain. "Where are we going to land?"

"What do you mean? LAX of course."

"The Tsunami Center said the wave would cross the Pacific and strike the West Coast in about five hours, eight hours to hit Japan."

"I hadn't considered that. Did they say how large?"

"They could only estimate. From what I can figure out, the wave will be about half the height on the West Coast as it was in the Islands."

"That's over a thousand feet. Sounds like a change of plans." God, how does he do it? There's supposed to be emotion when you're talking about a thousand-foot wave crashing into the United States. Shooting pains continued to stab my jaw. I began to massage the area under each ear. The pressure merely moved the pain up into my temples.

"Are you okay?" asked the captain.

"Yeah, I'll survive. It's just a headache." I looked up and asked, "Do we have enough fuel to get to a safe airport?"

"That's not a problem. Where would you like to go? How about Salt Lake City or Vegas, maybe Phoenix?"

"Let me see. Vegas? Salt Lake?" I turned up both palms as if I were weighing the possibilities in my hands. "Vegas, Salt Lake." The Salt Lake palm fell to the floor as if I were holding a fifty-pound weight. "Looks like Vegas."

"Sounds good to me. I'll call the head of Operations in L.A. and tell him what happened. They'll need to get our planes and people out of there. They can change our flight plan."

Then it struck me. I'd been so pre-occupied, so completely consumed by the disaster I'd just witnessed that I had completely forgotten about the most important people in my life. "My wife and kid… I've got to reach my wife. We live on the beach in Malibu."

"I was going to say it must be nice, but it sounds like your living arrangements just became temporary."

I started to panic. Lauren was with that Mommy and Me group. She promised she'd keep her cell phone close and listen to the news.

"What do I do? My wife and kid, they need to evacuate. I've got to

get them out of L.A."

"Slow down." Captain Hornbeck put his hand up as if he were trying to get a dog to sit. "Stay calm, we can help." Stay calm. I was ready to strangle the damn pilot. No way was I staying calm. "Fortunately this plane is equipped with satellite communications. Give me your wife's number and I'll dial it for you."

At least my headache was gone with the most recent surge of adrenaline. I gave the captain Lauren's cell phone number. The keypad must have been on the console to his left as he looked down. When the captain was done dialing he handed me a microphone and told me to depress the transmit button when I wanted to speak. The ringing of Lauren's cell phone was accompanied by earsplitting static coming through the cockpit radio speaker. It kept on ringing. The captain turned down the volume. Finally her message center picked up. Son-of-a-bitch, why wasn't she answering her phone? The recording was barely intelligible. I left desperate instructions telling Lauren to take Aubrey and go to the mountains. I could only hope she would understand what I said through all the static.

"What am I going to do?"

"Do you know where your wife is?"

"She took our three-month-old to a new Mommy and Me group, whatever that is. It's their first time. I have no idea where they're meeting."

Co-pilot Michelle spoke up. "We were supposed to arrive in L.A. at 9:05 p.m. which from what you tell me is about the same time the tsunami will arrive. When did your wife leave for her meeting?"

Rational thought had become impossible with my brain going in a million different directions. Everything had been so clear when I was trying to save my own skin. Now it was my wife and kid. I slapped myself on the forehead. When was the last time we spoke? It was right after we returned from the Big Island. I could only leave a message at the house when I tried calling from the plane.

"She must have left for her meeting right about the time we were pulling away from the gate, just after one o'clock, Honolulu time. She said it was a potluck."

"Okay, so they're going to eat. Trust me if you've got a three-month-old, the latest she'll be home is eight thirty, probably more like eight o'clock. You'll have at least an hour to warn her and I'm sure the tsunami will be all over the news. She'll be fine."

"God, I hope you're right. Still, she should have answered her phone."

"Maybe there's no reception," said Captain Hornbeck. "Try back in an hour or so. I'm sure you'll get her." An hour. How would I ever sur-

vive waiting that long?

Simone leaned past me and tapped the captain's shoulder. I had completely forgotten that she was still standing behind me. "Captain, the rest of our passengers will want to call their relatives to let them know they're okay. What should I do?"

"Make an announcement. Tell them we only have five satellite lines. You'll have to coordinate this."

"How will we take care of our other duties?"

"Assign one flight attendant to oversee the calls and the rest of you can take care of your normal responsibilities. You'd better apologize for all the static. It's probably from that eruption."

There was nothing more for me to do. "Captain, I'm going back to my seat now. I'll keep on trying to call. There is one more thing you could probably help me with."

The Captain didn't look too pleased. "What's that?"

"I may have a little problem with our air marshal. He's cuffed to the seat, probably not too happy with me."

"You handcuffed the air marshal to his seat? How'd you manage that?"

"Ex-Navy Seal. It wasn't that hard. Maybe you could run some interference. He may be a little pissed when I take the cuffs off."

The captain turned to his co-pilot. "Michelle, mind taking it for a couple of minutes?"

"No problem, I've got a couple of new video games I've been dying to try." Michelle turned and gave me a mischievous smile as Captain Hornbeck got out of his seat.

"What did you do with the marshal's gun?"

"Oh, I almost forgot." I reached into the back pocket of Manny's coveralls and pulled it out. "It wasn't a problem relieving him of it. These marshals could use a lot more training."

"Whoa." The captain raised both hands and tried to take a step back. "Mind if I hold that."

"No, not at all. It's not loaded. Here's the clip."

"Yeah, I'll take that, too."

I handed over the gun and loaded clip as Simone, the captain, and I squeezed out of the cockpit. Fat Air Marshal was still in his seat half dazed. I felt a little guilty over how hard I hit him. It must have been the adrenaline. I handed the handcuff keys to the captain and suggested that it might be better if he released the marshal.

* * *

The United Airlines 747 leveled off at its cruising altitude of 37,000 feet. Captain Hornbeck picked up his satellite phone and dialed. "Joe,

can you hear me? This is Steve Hornbeck, Flight 103 out of Honolulu."

Joe Salvatore, the Assistant Head of Operations for United's LAX facility, was having a tough time communicating with his flights over the Pacific. Sunday evenings were always busy. The last hour had been ridiculous. The eruption of Mauna Loa blasted millions of tons of charged particles into the upper atmosphere. Communications were becoming almost impossible as the massive cloud of ash continued to spread.

"Steve, I can barely hear you. I take it you're in the air?"

While the static was annoying, Captain Hornbeck was still able to understand his friend.

"Yeah, I'm in the air. What's going on over there?"

"Things are getting pretty crazy. I've had to cancel all our flights over the Pacific and call back or re-route them away from that damn volcano if they're in the air. You'll probably have some lengthy delays landing. I'm not even sure where we'll put you. Probably have to bus your passengers to the terminal."

"Joe, you're breaking up. Aren't you preparing to evacuate?"

"Evacuate? What the hell are you talking about? We've got so many flights coming in I don't know what we'll do with them. I'll be here all night."

"What about the tsunami?"

"Tsunami? What tsunami?"

"Come on, Joe, just over an hour ago all of Hawaii was destroyed by a tsunami. You've got maybe four hours to get the hell out of there. Haven't you been told to evacuate?"

"We haven't been told shit. What tsunami are you talking about?"

"I can't believe it. We just watched Waikiki and Honolulu being destroyed. I'm sure over 90% of the population was killed. The tsunami was over two thousand feet."

"Two thousand feet, come off it. Have you been drinking again?"

"God damn it, Joe, I'm not screwing with you. What's going on there? There must have been some kind of warnings issued?"

"I told you no one said shit. With the cancellation of all the Pacific flights this airport is going to be so overloaded I don't know where they're going to find space for all the planes."

"Listen to me, Joe, I'm not messing with you. My co-pilot measured the tsunami with our radar altimeter. It was 2,320 feet."

"Come on, Steve, quit yanking my chain. I've got a big enough headache with that volcano. How do you expect me to believe any of this?"

"I know. I didn't believe this professor onboard until I actually saw it coming towards us. He said the tsunami will be over a thousand feet when it hits the West Coast."

"A thousand feet? Steve, that's not funny."

"I'm not trying to be funny. You've got to warn all our people along the entire West Coast. Get those planes and people out of there."

"But who'll believe me?" Joe Salvatore was starting to think that maybe his old friend Steve Hornbeck wasn't messing with him. Over a thousand feet? His first thought was that at least his family back in Denver would be safe.

When Joe received his new promotion and transfer to LAX, he hadn't realized how expensive housing in Southern California was. The raise he received with his new job wouldn't cover the mortgage on a decent house. Joe decided to leave his family in Denver and commute back and forth to work. As an airline employee the cost was minimal.

"Make them believe you. If they don't then call me." Hornbeck was becoming more and more agitated. Joe Salvatore had worked with airline pilots for over twenty years. If there was one thing he had learned it was when a pilot gets agitated something serious was going on. In just the last few minutes, the static had become so loud that both Captain Hornbeck and the head of LAX operations were forced to repeat everything they said.

"You had better not be messing with my head. I'm going to lose my job over this if it's one of your little jokes."

"Trust me. And get us re-routed to McCarran."

"McCarran? This seems like an awful lot of effort just so you can go play the slots." Captain Steve Hornbeck could no longer maintain control as he barked into the microphone. "God damn it, Joe."

"Okay. I'll get you to McCarran. Do you realize what I'll have to go through?"

"Just get me to Vegas and get the hell out of there."

"Okay. I'll be back to you with a revised flight plan. Be patient, I've got an awful lot of people to call."

Just as Captain Hornbeck was signing off with the LAX Director of Operations, the radio filled the cockpit with a combination of static and the Aussie accent of the Qantas flight 391 pilot. Steve Hornbeck looked at his watch. It had been just over an hour since he last spoke to the man that owed him a beer. By now the big 747 would be low on fuel and the decision where to land would already be finalized. Captain Hornbeck figured his chances of collecting on that beer debt were extraordinarily slim.

"United 103, this Qantas 391 heavy, are you with us?"

"Go ahead, 391. You're breaking up but we can still hear you."

"United 103, we just got back from Kauai. The runway was so wonky we could hardly find it. Most of the concrete was gone, ripped up. What was left was covered in mounds of trash. We just flew over Waikiki

and Honolulu. There's nothing left. I mean bloody nothing." Despite the constant static, it wasn't hard to tell that Captain Shayne Mallard was having a tough time controlling his emotions. "Even most of the foundations were ripped out. The land's been stripped. The only thing down there is water and mud. No signs of life. Hell, there's hardly a sign there ever was any life down there. We're now on final approach to eight, right."

Captain Hornbeck and Co-pilot Michelle Spencer couldn't believe what they were hearing. How could the destruction be so complete? The pilot from Flight 391 had described a disaster so utterly devastating it sounded more like an atomic blast. All signs of plant, animal, or human life had been erased. The land had been stripped of every recognizable feature. A pall of depression hung over the cockpit of Flight 103. Everything moved at the wrong speed, even the controls to the big jet seemed sluggish.

"How does eight right look?"

"It's hard to tell. There's still heaps of water on it. Without our GPS, we'd probably never find it. At least there doesn't seem to be too much rubbish."

"Can you see the pavement?"

"We think we can. It seems like it's still there but I wouldn't give you a brass razoo for it."

The two pilots looked at each other, shrugged their shoulders, and then asked simultaneously. "What's a razoo?"

"Did you see any sign of life on the islands?"

"None. The only places there could be any left are on the tops of the higher mountains. Even the geography has changed. We're coming up on what used to be Pearl Harbor. Now the entrance is wider than the harbor and Ford Island is gone. There are no ships or buildings, just piles of rubbish. The ocean looks like one big junk heap."

"Qantas 391, we'll let the people back home know what your situation is. Give us a call when you're on the ground."

"United 103 will call if we survive this one."

"That bad?"

"I'm thinking there's about to be a bloody big prang." More Aussie slang, though there was no doubt as to what it meant. "Bugger, we just lost our number two. This ash is really starting to muck things up. I hope we make it to the end of the runway or what's left of it."

"391, we'll stand by. You've got your hands full. Let us know when you're on the ground."

"Bugger, number four just flamed out." Captain Hornbeck turned to his co-pilot.

"Two engines out. I don't think they'll make it."

TWENTY-ONE

THE TREES HUNG HEAVY as drops of water continued to fall from their limbs. It was late Sunday afternoon, and the storm had just started to break up over the small farming community of Palmer, Alaska. Small patches of blue peaked thru the thick layer of clouds as the gray overcast skies and blustery winds moved to the south. Forty-two miles northeast of Anchorage on the Matanuska River, Palmer was home to the National Oceanic and Atmospheric Administration's West Coast and Alaska Tsunami Warning Center, or the ridiculously long Government acronym WCATWC.

The late afternoon sun was still high above the surrounding mountains, the summer solstice only a few weeks away. The remains of the late spring storm cast a gray shroud over the community of 6,000. Situated a few miles just outside Palmer on a gravel road, WCATWC was housed in a large white rectangular building. Its bright blue roof a stark contrast to the gray green of the surrounding mountains and the dull white of the satellite dishes located in the field next door.

The main entrance to the facility was through a pair of large double glass doors. The high ceiling and modern workstations of this brand new structure was striking when compared to the cramped, tired quarters of the Hawaii Tsunami Warning Center. Furnished with modern black and gray modular furniture and glossy new equipment, the WCATWC was the keystone of the Pacific Tsunami Warning System. Unlike its sister station in Hawaii, Palmer was located over forty miles from the closest saltwater, no doubt a gift to the local congressman for supporting his party's numerous pork barrel subsidies.

The Center's director, Dr. Patrick Gould, stepped out of the breezy surroundings into the warmth of the brightly lit reception area and removed his jacket. At six feet three inches tall and just shy of 180 pounds, most Alaskans considered Doctor Gould lanky; his wife of twelve years called him skinny. At thirty-eight years of age, he was the youngest director to oversee the Center's operations in its 40-year history.

Doctor Gould looked past the reception area to the large bullpen

that occupied most of the building. There were only two other people in the sprawling facility: the receptionist and Doctor Gould's assistant director, Kevin Bradshaw. His assistant was seated at a brand new workstation staring intently at the twelve computer monitors stacked around its central desk. While WCATWC was manned 24/7, Sunday evenings were always the slowest time of the week. Doctor Gould had purposely scheduled the installation of the new station on a Sunday to cause as little disruption as possible.

"So Kevin, are we back online yet?" A recent graduate from the University of Washington's Geophysics Department, Kevin Bradshaw turned away from the stack of monitors to look at his boss.

"We're just coming up."

"Any more action in Hawaii?"

"Just a few minor shakes."

"That's good. We've got our Pacific Wave Exercise coming up in just over a week and we need to be ready. I'll be in my office." Dr. Gould stepped away from the new workstation and headed for his corner office.

"Pat, why don't you go home and have dinner with the family? I can handle this," suggested his assistant.

"Thanks, I just want to make sure everything's working. I'll sleep better."

As Dr. Gould stepped around a modern gray and black cubicle partition, his assistant called out again.

"Pat, you better come and take a look at this."

Dr. Gould peered around the corner. "What's up?"

"I don't know why we haven't gotten anything from Hawaii yet. It looks like they had a pretty good shake at 2308 Zulu. I've got a preliminary of 8.9." Dr. Gould looked at his watch, pressed a control button, and switched over the time to the prime meridian. "That's almost two hours old. Where the hell's the notice from Hawaii?"

"I don't know, sir. Mary was supposed to be checking the fax printer every half hour while we were down."

"Where is that girl?" Dr. Gould complained, as he picked up the phone on Kevin's desk, turned it to intercom and announced in a loud annoyed voice: "Mary White please come to station two immediately."

If Dr. Gould were considered tall and lanky, twenty-nine year old Mary White was his exact opposite. Standing barely five feet two inches with ample breasts resting on an abundant gut, her pleasant face and long straight black hair said native Alaskan. Mary came rushing around the corner out of breath just as Dr. Gould was about to key the microphone he was holding in his right hand. Mary's voice was almost

unintelligible as she spoke.

"Dr. Gould, did I do something wrong?"

"Mary, you were supposed to be checking the printer every half hour."

The expression on Mary White's face went from concerned to almost bursting into tears. "I did. With the movers going in and out, it was difficult but I still checked every half hour like I was told."

"Well, what the hell is going on here? We had an 8.9 earthquake almost two hours ago in Hawaii and I don't see any warnings."

"Sir, I don't know." Mary White looked down at her watch. Anything to avoid the frustration and anger spreading across her boss's face. "I can go check right now to see if it has come in."

"Please do that."

Mary ran to check the printer. Patrick Gould had been picked as the Director of WCATWC for many reasons, one of them because of the reliable people he surrounded himself with. This error in procedure would not help his career. Trying to control the rage building inside, Dr. Gould turned to his assistant. "I assume that 8.9 was caused by the eruption. I doubt if there was any uplift, so we're probably okay. What do you think?"

"We know there was an eruption, we just haven't gotten any word as to how large. If the movement of magma caused the earthquake, we'll be okay. If it was caused by an undersea landslide, that could be a problem."

Mary White stumbled around the corner holding a single piece of paper in her hand. Catching her balance, she took large gasps of air as she handed the document to her boss.

"Dr. Gould, you need to see this. It was under the desk next to the printer. The wind must have blown it out of the tray when the movers left the doors open. What does it mean?"

Doctor Patrick Gould read the one page Bulletin from the Pacific Tsunami Warning Center, and then he re-read it. A look of confusion replaced the anger and frustration he had shown his receptionist. He handed the note to his Assistant Director. "I'm not sure what to make of this? What do you think Kevin?"

Kevin Bradshaw also read the notice twice before responding. "I think we have a problem, but I also think there's got to be something wrong with this bulletin. It can't be right."

"Thanks, that much I figured out. Still, how big of a problem do you think we have?"

Kevin Bradshaw placed the two-hour-old bulletin on the desk so that both he and Dr. Gould could study it. "There's no question we're dealing with a major tsunami. Otherwise why would they evacuate the

Center? Obviously calling them isn't going to help. Who else can we call?"

"I suppose we could call NOAA headquarters?"

"Before we do that, let's check the other sea level tide gauges. The eruption may have destroyed the instrumentation on the Big Island, but the other gauges should be working."

Kevin swiveled his chair back to face his new console and began to type. In a matter of seconds, a map of the Hawaiian Island was displayed on the monitor directly in front of the keyboard. The other eleven monitors stacked three high around the desk remained blank. The Pacific and Alaskan Tsunami Warning Centers monitored seven tide gauges in the Hawaiian Islands. Kevin placed his cursor on each one. As he left clicked on the first icon, the screen displayed a simple but terse message: Out of Order. Dr. Gould watched in silence as the same message came up six more times. There was no question this was serious, but he wasn't about to jump to conclusions.

"This is not looking good. Lets check Johnston and Wake."

Dr. Gould's assistant hit a few more keys and the map expanded to include Johnston Island to the south and Wake Island to the Northwest. Each island supported a single tide gauge. Kevin Bradshaw moved his cursor to the icon covering Johnston Island. When he left clicked the same out-of-order message popped up.

Dr. Gould swore. "Shit. This is not good."

"Johnston's just an atoll, probably not more than ten feet above sea level. It's where the military disposes of all its chemical agents left over from the Cold War. Let me check Wake Island. It's larger and further from the epicenter." Kevin Bradshaw left clicked the icon for the Wake Island tide gage, and once again, the same message appeared.

"Damn, this is getting us nowhere. We need to make some calls. Try NOAA in Hawaii."

The Assistant Director reached over and pulled out a list of phone numbers. He quickly found the number for the Sand Island, Honolulu NOAA Base and dialed.

"It's dead. No ring, the connection doesn't go thru. What now? Do you want me to try again or call the phone company?"

"Don't bother. I think we have our answer, but how much of this notice can we rely on?"

"It's why they pay you the big bucks, Pat. Ultimately it'll be your decision. If I were you, before I did anything I'd take a closer look at that warning." Dr. Gould rolled a chair over from the adjoining workstation and sat down next to his friend and co-worker.

"So other than the fact that there's one hell of a big tsunami out

there, what else do we know?" The assistant director inquired.

"We know this warning was issued nine minutes after an 8.9 earthquake hit the Big Island and it was issued without the benefit of any sea level readings."

"Nine minutes is pretty quick, in fact, it's darn fast."

Dr. Gould explained, "I know Walt Grissom. He's methodical, doesn't jump to conclusions. About a month ago, he told me about some professor from the University of Hawaii working on a potential submarine landslide. The way he described it, it sounded like a monster."

"Where was this professor looking?"

"They had found a major crevasse that appeared to be a tension crack along the southern shore of the Big Island. Thought it could be the head of a slide, possibly as large as the one that created Tuscaloosa."

"That big?"

"Yes, they even did some preliminary work to determine potential wave size. Said it could run 50 to 200 meters."

"200 meters is one monster of a wave, but that's not 666 meters, over 2,000 feet."

Dr. Gould wiped his brow and grabbed the single sheet of paper and reread the notice for a third time. "Kevin, there's no way an 8.9 earthquake is going to cause a significant tsunami in the Hawaiian Islands unless it is accompanied by a major submarine slide. Walt must have had some kind of notice, maybe direct evidence that the slide he and this professor were studying let go. Maybe a ship offshore saw it happen."

"Could be. So let's say he knows this slide has let loose, cameras, sensors, visual confirmation from other scientists on the island, or a ship. He's probably got less than 30 minutes to get out of that Ewa Beach facility. The place is only ten feet above sea level."

"So he starts to issue the warning knowing there's this gigantic wall of water rushing towards him at jetliner speeds."

"I don't know about you, Pat, but my typing and certainly proofreading would be a little shaky under those conditions, like make the proofreading nonexistent."

"I agree. So he types out the warning without checking it, sends it off, and then gets the hell out of Dodge."

"It occurred to me that maybe he's one of those guys that uses the calculator portion of the keyboard to type numbers, and held down the keys too long. Maybe he intended the notice to read 66 and 33 meters, and didn't take his finger off the keys fast enough?"

"That would make a lot more sense than a two thousand foot tsunami," said Dr. Gould. "A two-hundred-foot tsunami would cause

enough damage to wipe out our sea level equipment and destroy all communications to the islands."

"So you think it was 66 meters in Hawaii and we issue a warning for a 33-meter tsunami along the entire West Coast?"

"I don't know. A hundred foot tsunami is huge. If I'm wrong you'll have my job."

Kevin Bradshaw smiled at his boss. "You see. It's not all bad news… just kidding." His boss was not amused.

"I don't see any other choices. We're certainly not looking at a 6-meter tsunami. We'd be getting all kinds of calls from the islands. If it's a 666-meter tsunami, it probably won't matter. Even half that height hitting the West Coast would be hard to comprehend. The panic would kill as many people as a hundred foot wave."

"I'll get the word out," replied the assistant.

"Darn right you will. And I'll be standing right over you. No more screw-ups. We've already lost almost two hours."

"You know something just occurred to me."

"What's that?"

"666, Revelations, Mark of the Beast. That whole thing, it's almost kind of creepy." Director Gould had merely maintained a blank stare while listening to his assistant. "Do you even know what I'm talking about?"

"Haven't a clue."

"Forget it."

* * *

First Officer Ian Firth read through the landing checklist as Captain Shayne Mallard made sure Qantas Fight 391 was ready for its final landing.

"Gear check."

"Handle down, three in the green."

"Speedbrake."

"Armed."

"Hydraulics."

"Checked."

The fourteen members of the 747-400 cabin crew had already been briefed and prepared the passengers for the unavoidable crash landing they were about to make. Pillows, blankets, anything soft had been passed out. The passengers were bent forward in their seats, silent in their own thoughts and prayers. Captain Mallard had already instructed the chief steward not to deploy the escape slides until he gave the order. The captain had explained that so long as there wasn't a fire, the safest place for the passengers was inside the plane.

The pressure continued to build on Captain Mallard as Flight 391

approached the remains of runway eight right. Was the concrete runway even there? The only way the crew of Flight 391 even knew where the runway was supposed to be was because of the onboard GPS navigation system. There were no recognizable landmarks to judge their approach.

Captain Mallard began to reduce throttles on the remaining two engines slowing Flight 391 to a final approach speed of 132 knots. The V-ref speed was unusually slow for the big jet. With hardly any fuel and only 186 passengers on board, the plane was extraordinarily light.

The captain knew his GPS was incredibly accurate. Still, not knowing whether they were about to land on solid runway or an undefined strip of mud was taking its toll. He threw his hat behind the seat then wiped his forehead with the embroidered handkerchief his wife made him pack.

"Ian, make sure you're buckled up tight. This could get a little rough."

"Captain, number three is starting to heat up."

"Bastard. Watch it. Just give me sixty seconds. Come on."

The 747 continued its approach. The crew maneuvered the plane down the glide slope displayed in front of them on the large flat screens of their instrument panel. The radar altimeter started to call out the altitude at fifty feet. Just as the sultry voice filled the cockpit, the number three engine overheated. Alarms blared, lights flashed.

"Captain, number three just went red. Climbing fast. Do I shut down?"

"Damn ash... Don't bother I'm reducing power to flight idle in ten seconds."

"50 feet, 40 feet, 30 feet, 20 feet, 10 feet. Captain, altimeters getting jumpy; it must be the water on the runway."

"Turn it off. Just give me touch down and brakes."

First Officer Firth turned around to look back at the right wing just as the rear wheels contacted the layer of water covering the runway. Sheets of white spray errupted from the undercarriage. "Touch down. Speed breaks deployed." As Captain Mallard began to lower the nose of the 747, the sheets of spray being thrown up by the main landing gear turned into a wall of water. Both number one and three engines flamed out. Captain Mallard wrestled with the controls trying to keep Flight 391 on the runway heading. With over two feet of water covering the 12,000-foot strip of concrete, the big jet's wheels were hydroplaning over its surface. Brakes were useless. Directional control was becoming impossible. The big plane felt like it was skating on ice. As the 747 began to slow, the controls became less and less responsive. Flight 391 started to veer right. Captain Mallard attempted to correct with left rudder. The big 747 shuddered with a heavy jolt and then a loud noise reverberated

up and down the entire length of the fuselage.

"Bugger, we just lost the main gear. Hold on, we're gonna loop."
Captain Mallard mashed down on the left rudder pedal as far as it would
go, but as the 747 settled onto its underbelly all directional control was
lost. Flight 391 began to bank to the left as it continued to turn right.
Sheets of spray covered the wings. Water blasted over the nose blocking
any forward visibility. Then a loud crack shot through the cockpit as the
left wing snapped off. The 747 spun on its axis dipping left as the right
wing went high into the air. Just as Captain Mallard was sure they were
about to flip, Flight 391 came to an abrupt stop, piling into the remains
of the protective breakwater. The right wing came crashing down, as the
plane leveled and then there was silence. Captain Mallard held the wheel
with an iron grip in his left hand, the throttles in his right. He uncurled
his fingers from the engine controls and let out the breath he'd been hold-
ing for the last two minutes.

"Ian, you alright?"

"No worries."

"Do you think me boss might get a bit shirty over bending his plane."

"Screw the bugger if he can't take a joke."

With the 747 resting on its belly, Captain Mallard and First Officer
Firth turned to look out their respective side windows to make sure there
weren't any fires. If any portion of the plane had caught fire, the water
on the runway had extinguished it. First Officer Firth immediately an-
nounced over the cabin address system that the crew should open all
emergency hatches. He also reminded them to hold off deploying the
emergency slides.

"Ian, you better go back and see if we have any injuries. I'll call
United 103 and let them know we're on the ground, as it be." First Of-
ficer Firth was starting to open the cockpit door when Captain Mallard
stopped him.

"Ian, get back here as quick as you can. I'll need you to organize a
search party."

The First Officer could only wonder what he would be searching
for as he stepped out of the cockpit into the upper Business Class section
of Flight 391. The passengers looked severely shaken but no one ap-
peared injured. Then he noticed the flight attendants crowded around an
elderly gentleman. First Officer Firth walked up to a tall young man
wearing a blue Qantas blazer with the bright red tie of a customer serv-
ice manager and asked what had happened. He was told the man may
have had a heart attack, but seemed to be doing better. Someone was al-
ready on the way with an oxygen tank.

Ian Firth made his way down the forward staircase to the main cabin. The passengers were still buckled into their seats as instructed. A few of the overhead bins had opened spilling their contents into the cabin. The First Officer noted a few passengers with scrapes and bruises, but there were no major injuries. Considering the possible consequences of the landing they had just survived, Ian was pleased with the overall outcome. The one thing he was not happy about was the mental state of at least half the passengers. They had just lived through a potentially deadly crash yet the cloud of misery and depression hanging over the cabin was undeniable.

That's when First Officer Firth remembered that at least half the passengers on the flight were returning home. It had finally sunk in that home was no more, and neither were their family and friends. The people on Flight 391 that lived in Hawaii were returning to nothing. When Ian thought about it a little more, he realized they weren't returning to nothing. Nothing would have been an improvement. These poor passengers were returning to something much worse, mangled families and friends, houses destroyed, businesses crushed. It was so much worse than nothing. It was excruciating, gut-wrenching pain.

After walking up and down both isles in the main cabin, Ian returned to the security of the cockpit. Captain Mallard had just gotten off the radio with Flight 103.

"So how did we do? Any major injuries?"

"No, everything's apples, a few minor cuts and scrapes. One old guy with a possible heart attack, we're not sure yet."

"That's good."

"Captain, one other thing."

"What?"

"You realize half the passengers used to live here. They've lost everything. Most of them seem to be in shock."

"I hadn't considered it. Those poor people." Captain Mallard sat in silence for a few moments trying to comprehend what his passengers must be going through. He thought about his wife and two kids safely back in Australia and wondered how long it would be before they were reunited again? At least they would know he was alive.

"You said before I went to check the passengers that you wanted me to organize a search party."

"That's right."

"What am I searching for? There's nothing left out there. We're not going to find any survivors. I bet there aren't a handful of people alive on this island."

"You may be right, Ian. But we can't stay here. I have a feeling that any rescue operation is going to be a long time in coming. We're going to have to survive on our own."

"Just like the TV show."

Captain Mallard grimaced at the thought. "I suppose so. Meanwhile, I want you to put together a search party. Have you got your running shoes?"

The First Officer pointed over his shoulder to the back of the cockpit. "Right here in my dilly bag."

"Well, I suggest you get them on. You're going walkabout. Find yourself three passengers, preferably runners. I want you back here by tomorrow sunset."

"What am I searching for?"

"Your first priority is shelter. We can't stay here. This alloy tube will get too hot. Our batteries are almost dead so we won't have a loo that works much longer."

"So you'll be taking care of the loo?"

"That's one of the things I'll work on while you're gone."

Ian Firth smiled at the thought that his captain was taking care of the facilities while he was out scouting around for a place to stay.

"What else do I look for?"

"Fresh water. We probably have enough on board for a couple of days, and finally food."

"That's going to be a tough order to fill. You saw what it looks like out there. We may find some bottled water and a few cans of food in some of those rubbish piles. Remember we've got almost 200 people to care for."

"You should head towards the hills. That's where you'll find what we need."

The captain had just placed more responsibility on First Officer Firth than he had ever known. The success of his search would determine the chances of the crew and passengers surviving. He looked out the windshield towards the mountains that formed the backbone of Oahu. There was nothing to see. In fact, Ian Firth couldn't see over a mile. It had started to snow. The flakes falling from the sky weren't the pristine white that the First Officer was use to seeing in the Qantas brochures. The volcanic ash raining down on the once tropical paradise was a dirty gray brown. The visibility continued to deteriorate as the two pilots sat there staring out the windscreen. The sky had turned a muddy shade of orange. Small specks of ash were settling onto the windshield and covering every surface of the plane. Even the surrounding water and rocks were covered in a thin layer of ash.

"Captain, the ash from that volcano is getting awfully thick."

"Make sure your party has towels from the galley. Wet them and wear 'em over your mouth and nose."

Ingesting millions of microscopic particles into the lungs could have serious consequences. "You don't want to breath that stuff," ordered Captain Mallard.

TWENTY-TWO

THE CROWDS IN FRONT of the Tom Bradley Terminal at Los Angeles International Airport were typically heavy for a Sunday afternoon. Maria Pedrosa smiled, glad they had arrived with plenty of extra time before their flight departed. She opened the door to her brother's SUV and stepped onto the sidewalk. Her three daughters, Emily six, Martha four, and little Maggie age two and a half, were still safely belted into the rear seat of the aging Chevy Suburban. Maria gathered up her daughters while her brother Miguel retrieved the luggage from the SUV with the oversized chrome rims. He set his sister's and three nieces' bags on the curb then gave Maria a hug and said goodbye to his nieces. Each child dragged her own brightly colored orange and yellow suitcase into the terminal. Even little Maggie towed a carry-on bag as her mother looked for the Mexicana Airlines desk inside the massive main hall.

Maria Pedrosa and her children were on their way to Guadalajara, Mexico, to visit her parents. Juan, Maria's husband, was staying home to work at the small Mexican restaurant in Burbank where he was the head chef. After ten years of marriage, both Maria and Juan still harbored dreams of owning their own restaurant someday.

Maria had always been a nervous flyer. Even though she hadn't seen her parents in over seven years, she was not looking forward to flying with her three small daughters. Little Maggie already needed changing and Martha missed her daddy. Only Emily stayed quiet as her mother searched for the sign that would direct them to the Mexicana counter. Once she located the green and white placard with the arrow pointing to the center of the room, Maria began to shepherd her three daughters through the hall, coaxing them to stay close. To the rest of the passengers in the congested terminal Maria Pedrosa thought she must look like a mother duck crowding her babies across the highway with each little girl dutifully pulling her colorful bag.

The Pedrosa family had arrived over two hours before there flight was scheduled to leave. Maria had three small children to look after and couldn't be rushed. The anxious mother somehow managed to cajole her

girls into the proper line where there was only one elderly couple ahead of them.

"How sweet. Are you taking a vacation with your mommy?" commented the gray-haired woman dressed in baby blue sweats.

Six-year-old Emily answered, "We're going to visit Grandma and Grandpa. They live in Mexico."

The old lady smiled. Maria shifted her weight back and forth as she waited her turn. The elderly couple was taking an interminable amount of time to check in. She kept looking at her watch thinking how smart she had been to arrive so early. Finally the old couple headed off in the direction of the many airline gates, but only after thanking the ticket agent, finding out how to get to their gate, then thanking the smiling agent one last time.

Maria immediately rounded up her three little ducklings and ushered them up to the check-in counter. She placed two large bags on the luggage scale and the red and blue plaid diaper bag by her feet. Fumbling through her oversized brown leather purse, she searched for the family's travel documents.

Maria handed four individual packets containing tickets and passports to the smiling agent wearing a trim navy blue uniform. Her gold nametag said Rodriguez. Maria returned the agent's smile as she watched her children out of the corner of her eye. The smiling Ms. Rodriguez opened each packet, placed the appropriate passport with the ticket, and then typed something into her computer.

"Mrs. Pedrosa, I see you and your three daughters are booked on our Flight 933 direct to Guadalajara," she said as she continued to stare at her computer screen. "The flight doesn't leave for some time. You may want to wait upstairs in the food court. Once you go through security there isn't much to do or eat near the gates." Maria Pedrosa smiled. "Oh, one last thing. I almost forgot. Do you have a letter?"

"A letter?"

"Yes, a letter from your daughters' father."

"But they never said anything about a letter."

The friendly ticket agent's smile no longer looked as sincere. "Oh, yes. Whenever one parent travels with a minor child, we must have a notarized letter from the other giving them permission. I'm sorry but we can't allow a parent to take the children out of the country without written permission."

"They never told me. I don't have a letter." The timbre of Maria's voice went up an octave as she looked down at her children and then back to the ticket agent. The friendly agent sensed that Mrs. Pedrosa was

218

becoming agitated. The last thing she needed was a hysterical mother making a scene in front of all her customers.

"Mrs. Pedrosa, why don't you come with me?" Ms. Rodriguez continued to smile as she glanced at her watch. "Fortunately you still have plenty of time. I'm sure we can work this out." The agent motioned for Maria to follow her over to an opening in the long counter. She then took the concerned mother and her girls to a back office where they were introduced to her supervisor Carolina Fox. The friendly ticket agent explained to her boss the problem then handed the tickets and passports back to Maria telling her to hold onto them. Maria was assured she could leave her check-in baggage behind the counter where it would be safe.

Michelle Rodriguez held the door open for Maria, so they could follow Ms. Fox down a long hallway to a locked door. The supervisor swiped a card through the lock and held it open. This door led to another long hall that ended in a steep set of stairs that took the five women to the ground floor. They entered a large room with row after row of fluorescent lights and tightly packed work cubicles. Maria, Emily, Martha, and Maggie followed Ms. Fox to a small room off the brightly lit room. The supervisor smiled at her customers as she opened the door.

Maria frowned. The small room looked like a police interrogation facility with a gray steel desk surrounded by six metal chairs and a tan trashcan in the corner. The marker-board on the far wall was filled with numbers neatly printed in green and red that made no sense. One entire wall of the holding room was made of frosted glass. The dancing shadows from the people running back and forth provided a bizarre backdrop for the Pedrosa family. The supervisor motioned for everyone to take a seat. Emily held little Maggie in her lap while the other three women sat down.

"Mrs. Pedrosa, as Ms. Rodriguez explained to you we have to have your children's father's written permission before we can allow them to fly out of the country."

"But he's at work."

"That shouldn't be a problem. This happens all the time. I'm sure we can contact him. What does your husband do?"

"He's a chef."

"Good. That should make it easy." Carolina Fox had been worried that Mrs. Pedrosa's husband might be a construction worker. They were always the toughest to find. "If you can just give me the number where he works, I'll call him and I'm sure we can take care of this little problem and have you on your flight with plenty of time to spare."

Maria looked at her watch and breathed a sigh of relief. She wrote

down her husband's work number and handed it to the supervisor. "Now you'll have to stay in this room until I come back. It could take some time. Does anyone have to use the bathroom?" Maria looked at her daughters. All three girls shook their heads, including little Maggie with the wet diaper. As Ms. Fox stepped out of the room she turned, smiled, and waved as if to say don't worry. Then she gently closed the door.

Once the supervisor was gone, Maria placed Maggie on the table, opened the diaper bag, and changed her. Emily and Martha quietly opened their carry-on bags and took out coloring books and crayons.

* * *

Joe Salvatore refused to give up. After a frustrating ten minutes of begging, pleading, and finally threatening the young secretary, he convinced her to give him Vince Kennard's home phone. With his boss's number in hand, he thanked the intransigent young woman, hung up, took a deep breath, and dialed. The airport Director of Operations picked up on the first ring.

"Hello."

"Vince."

"Yeah."

"Vince, this is Joe Salvatore, United Airlines. Sorry to bother you at home."

"Not a problem. Just sitting down to watch the news. What's up?"

"We've got some major problems here."

Vince Kennard's voice was filled with an extra helping of sarcasm. "What, this isn't a social call?"

"Hardly. That volcano is a disaster and I don't mean just in Hawaii."

"Tell me about it. I just got off the phone with the LAX Board of Directors. We've scheduled an emergency meeting tomorrow morning."

"Tomorrow morning?" Joe Salvatore couldn't believe what he was hearing.

"Yeah, first thing. With this eruption, they're talking about shutting down air traffic over the Pacific and North America for the next two months possibly longer. We'll be out of business."

"Are you crazy?" Joe Salvatore was immediately sorry for his poor choice of words. Even though Vince Kennard wasn't really his boss, he could still make life difficult for him. "We don't have that kind of time. You've got to give the order to evacuate the airport now."

"Evacuate the airport. What the hell are you talking about? Who's the crazy one?"

After rerouting his Pacific flights or finding places to park the dozens of cancelled flights, Joe Salvatore could barely control himself. The tem-

perature in the room seemed to be rising as he began to sweat. "Damn it, Vince, the tsunami! We've got something like two hours before it arrives. We need to get our people and equipment out of here."

"Tsunami. What tsunami? No one said anything about a tsunami. I've been sitting here watching the news. They haven't said word one about a tsunami."

"I'm telling you."

"Hold on, I hear my cell phone ringing in the other room."

Joe Salvatore could feel his blood pressure rise as the vein in his right temple began to pump. "Forget the god damn cell phone. This is too important."

"Fine. But why are you so worried about a tsunami? The airport's almost a mile from the water."

"Didn't you hear?" The United Airlines Operations Manager was dumbfounded, confused. His head felt like a hamster on an exercise wheel, running a mile a minute and going nowhere. How was it possible that only the one pilot knew about the impending disaster? "I don't understand. I got a call from our flight out of Honolulu. It was over a half hour ago. I know the captain. He's as straight as they come. The guy said if it weren't for some professor with the university over there, they would have been caught by—and get this—a two thousand foot tsunami."

"Two thousand feet. Come on. I don't have time for this"

"I made him repeat it three times. The reception wasn't great but I know what he said."

"So you're asking me to evacuate the airport because one of your fly boys saw a two-thousand-foot wave?"

"I know it sounds crazy, but you've got to believe me; I know this guy. I've known him for almost twenty years."

"Come on, Joe, if there were a two thousand foot wave on its way here don't you think that someone would have called the airport? Maybe the feds, or what about the state? How about those numbskulls over at FEMA? Don't they have some Tsunami Warning Center over there? I thought I saw something about that on the Discovery Channel."

"Vince, I don't know what's happened. I can't believe this pilot would try to start a mass panic. He's not that kind of guy. Besides he said the wave would only be a thousand feet by the time it gets to the West Coast."

"Only a thousand feet? Well, there's your answer. Next time you hear there's a tsunami on the way, don't bother me unless it's at least fifteen hundred feet."

"God damn it, Vince. I'm not joking. This is serious. If you don't be-

lieve me fine, but I need the departure slots so I can get my people and equipment out of here."

"You know I can't do that."

"Damn it, my people, the planes, they'll all be destroyed."

"Wait, the guy on the news is saying something about the governor making an emergency announcement."

Joe Salvatore paced back and forth in front of his desk. He pressed the phone to his ear trying to hear what the governor was saying.

Vince Kennard sat back in his Barco Lounger and took a long drink from the can of beer he had been holding. The governor's face appeared on the television. As soon as the head of operations saw him, it was obvious that whatever he was about to say was important. The man looked exhausted, no makeup, his hair barely combed, the jacket he wore hadn't been pressed. With the most solemn look the governor could marshal, he gazed into the camera. Not wasting a minute, he immediately announced that the recent eruption in Hawaii had caused a massive tsunami. The tsunami had just destroyed the Hawaiian Islands, killing most of the population. Then he announced that the killer wave was headed directly for the California coast. The governor first instructed all emergency personnel to report to their stations. Then he asked all residents of low-lying areas to immediately evacuate to higher ground. The governor said the tsunami bearing down on the state could be over a hundred feet high. He directed everyone close to the water to move to an area that was at least two hundred feet above sea level.

Once the real message had been given it was time for the political message. The governor went on to say that his administration would do everything possible to help the people through what will surely be the worst natural disaster in the history of mankind. His final plea was that everyone not panic and to please move swiftly. There was still plenty of time, over an hour before the tsunami would strike.

After listening to the announcement through the phone, Joe Salvatore yelled, "No, you idiot. Not a hundred feet, a thousand feet! They'll all be killed!"

"Joe, don't get crazy on me. In just over an hour the airport is going to be covered in forty feet of water. I need to coordinate the evacuation. I gotta go. If we have to, we'll use the north and south taxiways for extra runways." Vince Kennard hung up and immediately dialed his assistant at the Los Angeles World Airport's offices at One World Way.

The evacuation was to begin immediately with the airport police blocking off all entrances. The only people that would be allowed access were flight crews being called in by their airlines to move planes.

The airport director lived just one block off the beach in Playa Vista, only ten minutes from the airport. Vince Kennard called his wife and told her to stay at her sister's house. He would gather up her jewelry and the family's pictures and take them to his third floor office where they would be safe.

TWENTY-THREE

FIRST OFFICER IAN FIRTH FOUND THREE PASSENGERS in Flight 391's coach section to join him. Jeremy Horne, a 27-year-old grad student from Melbourne, 34-year-old Paul Imhoff, a nature guide from Queensland, and 29-year-old Heather Turland, an emergency room nurse from Sydney. Paul, the nature guide, had been looking forward to trekking across Kauai. He had brought along a handheld GPS and backpack for the trip. The other three managed to borrow backpacks from the passengers.

The flight attendants packed enough food so that each member of the search party would have five light meals. In addition to the food, they each took three towels to help prevent ingesting the constant rain of ash falling from the murky sky and three large bottles of water. The search team carefully-folded the towels and placed two in their backpacks. The third was soaked in a lavatory sink and tied so that it covered their nose and mouth.

The volunteers slid down the escape slide to the runway still covered in six inches of water. First Officer Firth would be the last to exit the crippled plane as he stood next to the open door with Captain Mallard by his side.

"I'll need you back here by sunset tomorrow. It's too bad you don't have a local, but then there probably aren't any landmarks left so maybe it doesn't matter."

"Captain, you know we'll do our best. I just don't think we'll find much. You saw what was left of Waikiki."

"No worries. Any form of shelter will do. A suite at the Four Seasons would be nice."

"With a view?"

"Just find us something, anything, maybe a bridge. A building would be better."

" I assume I'll find fresh water up in the mountains. When it comes to the food, I don't know where we'll find enough."

"We're going to be here for awhile. If the world hasn't forgotten

about us yet, they will in the next few hours. We have some food on the plane, but it's not going to last very long. You may want to spend some time rummaging through the piles of trash, assuming there are any. See what's there. Maybe you'll find some canned stuff."

"Ten years of flying commercial jets and I'm relegated to garbage inspector. We'll need to do better than a couple cans of tuna."

"Food's the lowest priority. Find us shelter. That's what we need and use that GPS." Captain Mallard pointed to the murky atmosphere. The caustic ash had reduced visibility to less than a mile. "Looks like it's coming down harder. Assuming you find some shelter, we'll need to find it again. With the way the visibility is dropping, unless you leave bread crumbs, the GPS is the only way we'll get back."

First Officer Firth bent to pick up his backpack. He adjusted the straps, said goodbye to his friend Captain Mallard, and jumped onto the emergency slide. The plane had settled onto its belly after the crash landing destroyed its undercarriage. The angle of the emergency slide was too shallow to allow Officer Firth to actually slide down. Ian pulled himself to the ground using his hands and feet, hardly a graceful departure.

The search party took off at a comfortable jog with the First Officer leading the way. Ian kept the small group in the middle of the runway, heading west in the opposite direction they had landed. The runway had been built with a crown in the center. By staying at the apex of the crown, the rescue party was able to stay relatively dry. They passed by the remains of a forty-foot flatbed trailer lying on its side. The crushed pile of scrap was resting about fifteen hundred feet from where Flight 391 had stopped. Ian figured this was probably what wiped out the landing gear.

It didn't take long for them to reach the end of the concrete pavement. Ian had memorized the layout of the airport after reviewing the charts stored in the 747's onboard navigation system. They turned north on to taxiway Right Bravo. His plan was to take his three companions to where the main terminal used to be. Unlike the concrete runway, the taxiway had been constructed from asphalt. The softer material was not nearly as resistant to the rushing waters. The edges were torn up and there were large holes in the center of the taxiway. Chunks of asphalt scattered across the surface made it difficult to run.

Ian, Heather, Jeremy, and Paul made excellent time, arriving in less than an hour at what appeared to be the remnants of the main terminal building. The only way they could tell that a large structure once stood in front of them was the mile-long rows of cutoff columns. Hundreds of three-foot diameter concrete pillars stood silently, jutting into the air ten feet or more. The force of the water had sheared off the massive supports

as far as the eye could see. Steel reinforcing bars sticking out the tops of the columns bent and twisted towards the now placid Pacific. Where once the impressive Honolulu International Airport Terminal stood, all that was left was a forest of fractured pillars, each supporting a wedged shape pile of trash leftover from the destruction of the once famous city. In addition to the broken concrete columns, there were lines of twisted steel I-beams, still attached to their concrete footing, bent flat against the remnants of the building slab.

Piles of refuse were all that remained of what used to be Honolulu. Ian directed each member of the search party to select a pile and rummage through it for any food or bottled water that could still be used.

First Officer Firth began to remove broken tree limbs, odd shaped pieces of metal, and assorted bits of trash. As he worked on the pile of garbage, he prayed that he wouldn't find a body. After everything he had been through, Ian Firth was not prepared to deal with a body, especially if it were a child. He kept repeating over and over, "Please, no bodies, no bodies."

Nothing in Ian's pile had retained its original shape. Even the broken tree limbs had been stripped of their bark, the ends ground to a smooth point. Pieces of sheet metal were now rolled into small cylinders. Even the broken asphalt had rounded corners from rolling and bumping up against the remains of Honolulu. The top layer of trash along with everything else that wasn't moving had been dusted with a layer of the gray toxic ash. The gritty coating looked like an early fall snow except it instantly turned to a choking sludge as it came in contact with the water that covered the ground. Ian brushed the millions of tiny beads of glass out of his hair. A dust ball of abrasive rock the size of small sand particles instantly encircled him. He closed his eyes tight.

All Ian could think about was washing off the abrasive grit covering his face—and not finding any bodies. The minute particles were making it almost impossible to see or breath. Everywhere he looked, there was water. Water drained down from the higher ground in small rivulets; puddles of water had settled into natural depressions, or those unnatural depressions where the tsunami had torn away portions of the airport's parking apron. Ian couldn't find a cup of clean water. Wherever he looked, the puddles, the small rivers, even the wet asphalt were covered in a rainbow-colored sheen of oil mixed with the toxic ash. He looked up where he thought the mountains that surrounded Honolulu should be. The visibility was now less than a half-mile. The air was slowly suffocating him and his small rescue party. Breathing was becoming more and more difficult. Without towels wrapped around their mouth and nose, they would have been gasping for air by now. Soon the minute grains of

glass would fill every void in the towels. Breathing would become impossible. Flight 391's rescue party needed to find clean water.

Ian turned back to the pile of trash and started to poke at it with a broken 2 x 4. The pile was massive yet didn't seem to contain anything of worth. Ian had been concentrating on looking for canned food but there didn't seem to be anything of value left in this enormous pile of waste. He looked around feeling more and more despair. The proverbial needle in a haystack, he thought.

His grandfather once told him while fishing on the small pond in back of the house he grew up in, "If you ever have to find a needle in a haystack, burn the haystack." At the time, Ian had only smiled and nodded to acknowledge his grandfather's sage advice. Concentrating on his fishing line and bobber was more important because, after all, he was six years old. It did puzzle him, though, that Grandpa was telling him to burn stuff. Years later he realized with a laugh that the old man was instructing him to think outside the box.

Given their current situation, thinking outside the box shouldn't have been all that difficult, except Ian wasn't sure where the box was. Who had ever dealt with circumstances like these? The remoteness, the total devastation, over two hundred souls depending on their success, and everything seemed so foreign. After a half hour of poking and prodding, Ian was ready to give up. It was time to gather his three companions and move on. He was hoping to make it to the high water mark by nightfall. He had envisioned a long mound of broken homes, buildings, trees, and cars heaped up against the hills that formed the backdrop of Honolulu. Something like the high tide mark on a beach only thousands of times larger. He figured they would have to climb to an elevation of two or three thousand feet to find this elusive smear on the sides of the surrounding hills. It was where they would have the best chance of finding some useable materials, and also the place where they would most likely find any human remains. Ian cringed at the thought. The only dead body he had ever seen up close was his grandfather's at the man's open-casket funeral. Twelve-year-old Ian Firth was the last person to leave the funeral home, the last to see his grandfather before they closed the lid. When nobody was looking, Ian walked over to the open coffin and peered inside as tears rolled down his cheeks. He whispered his last goodbye then reached into his pocket and took out a sewing needle he'd taken from one of his mothers quilting projects. Ian gently placed the silver needle inside his grandfather's breast pocket and left.

As the First Officer turned to gather up his party, out of the corner of one eye—or was it the recesses of his subconscious, Ian wasn't sure—

he thought he saw a glint of light. It was just a small sparkle from the depths of that useless pile of garbage. Ian shook his head and took another two steps and then stopped. What was that? In all this washed out, blurred landscape covered in mud and ash there was something that still glimmered. The entire sky was overcast. A choking haze of brown ash blotted out the sun. The usual white cumulous clouds on a backdrop of tropical blue were long gone.

First Officer Firth grabbed a small limb stripped of its bark and began to poke and prod at the pile of trash. He worked in the general area where he thought he saw the sparkle of light, tossing aside palm fronds denuded of greenery, tree limbs covered in mud, and mostly unidentifiable trash. Ian removed a two-foot layer of garbage and was continuing to dig deeper when he saw it.

"Shit!" Jumping two steps back, Ian stumbled over the debris left from his earlier garbage investigation. Once he regained his balance, the First Officer bent forward to take a closer look and make sure that what he thought he saw was actually there. It was. A diamond, a diamond mounted in a classic white gold Tiffany setting. It was an engagement ring, and it was still affixed to the hand of the betrothed. The rest of her body was nowhere in the pile. The contents of his stomach instantly began an upward migration. Ian bent over and grabbed his stomach. He had to gather every ounce of willpower available to avoid throwing-up the acidic bile that seared his throat. Ian turned back towards the mound of trash, but he could only stare at the lifeless appendage resting peacefully on some unidentified piece of construction debris. Most of the hand's mottled skin had been worn away and the nails broken with just a few specks of red polish remaining. The gruesome scene told Ian all he needed to know about the horrendous power of the deadly wave.

First Officer Firth slowly backed away from the pile of junk that contained the severed limb. Then something inside clicked, an ephemeral notion, a fleeting thought that changed his mind. He wasn't sure why but Ian Firth wanted to take one more look. The diamond was partially covered in mud. Stretching his arm to its limit Ian reached in between mud and dirt encrusted branches and wiped off the sparkling gem with his finger, then quickly withdrew his hand. It had to be at least two carats maybe three.

"Must be worth a small fortune," he uttered under his breath.

Ian only saw the gem, thinking of its value as he weighed the dilemma before him. If he ever got back to Sydney he could sell it and finally rebuild the engine on his 1958 MG. The revulsion of the dead hand was quickly abandoning him. Who would ever know? What were

the chances that a relative or friend would ever see the body? What were the chances that the body would ever be identified, even found? Yet if he took the ring wasn't that looting, more grave robbing than stealing? Ian backed away from the pile of trash. He began to pace back and forth. There was no one left to claim the body or the ring. Should he leave it there for an eternity or maybe for some archeologist to recover in a hundred or even a thousand years? No, taking the ring was wrong. It was stealing. Ian left the body covered in debris and went looking for the rest of his search party.

Standing next to what was left of the terminal the co-pilot asked. "Did anyone find anything we can use, food, water, anything?" The question was at best rhetorical. The small rescue party stood there silent, empty-handed. Their hair matted down, eyes red from the irritating specks of ash floating through the air. The three just looked at one another then told the First Officer almost identical stories. There was nothing of value to be found in those huge heaps of trash.

"We need to keep moving. I'd like to make it to the high water mark before it gets dark. We should find fresh water in the hills."

Less than a mile north of the airport, Ian thought he could make out the remains of the H-1 freeway, enormous concrete slabs piled on top of one another. He pointed the small group in direction of the massive mound of concrete and told them to head in that direction.

"I forgot something back there." As First Officer Firth pointed at the pile of trash he had been inspecting. "I'll catch up with you in a few minutes."

TWENTY-FOUR

MARIA PEDROSA SET DOWN HER COPY of *La Opinion*, the largest Spanish language newspaper in the country, and looked up to check on her daughters and the time. The girls were still busy working on their coloring books. Fortunately, they hadn't started to complain as Maria's mouth arched into a nervous smile. It had been almost an hour since the supervisor had left the family in the small holding room. Why was it taking so long? Was there a problem? Had the woman been able to contact her husband? While the girls were still happily occupied with their artwork, their mother became more and more anxious. She checked her watch a second time to confirm that there was still time to make the flight. Maria knew she would need a bathroom soon, and she was sure that Martha and Emily would, too.

The level of activity on the other side of the thin frosted glass wall had picked up substantially in the last fifteen minutes. It sounded as if the people in the huge fluorescent-lit room were racing back and forth. Running shadows bounced across the opaque wall while the employees on the other side talked loudly, almost yelling at each other. Maria tried to make out what they were saying. With the commotion of so many people running around, half panicked, yelling at one another it was impossible to tell. She glanced at her girls and said a small prayer. They were still happy to be coloring. How much longer would it last?

It was now almost 4:15. Their flight was leaving in forty-five minutes. She had never dreamed the nice supervisor would leave her and the girls alone for so long. Why couldn't she reach her husband? What was the problem?

The activity level began to subside outside their room. Maria didn't hear a voice, or see the silhouette of a single person run by the glass wall for fifteen minutes. What she had heard was the loud whine of jet engines starting up. They seemed to be everywhere, but suddenly even the jets were quiet.

Maria set the newspaper aside and began to pace. She couldn't stand the wait and needed to use the bathroom. The three girls, still occupied

with their coloring books, ignored their mother. Maria looked at her watch again as she continued to pace in front of the glass. The flight would be boarding any minute. Maria had always been a patient woman. She was used to waiting in long lines, especially those that had anything to do with people in official uniforms, like the ones at the free health clinic.

Maria thought back to the one line she didn't mind waiting in. It was the ticket line at the Coliseum. Mr. Alvarez, the owner of the restaurant where Juan worked, was a fanatical USC booster and on rare occasions gave them tickets to a football game. She didn't understand the game, and her husband's abbreviated explanation made no sense. It didn't matter. It was one of the few times her husband was willing to hire a babysitter and take his wife out. The excitement of the crowds, the cheers from the student body, the band playing the USC fight song had always been worth the wait. Best of all they had never attended a game where the team had lost, and winning always left her husband in the best of moods.

Today Maria wasn't waiting to see a football game. She and her daughters were locked in a holding room, and she wasn't about to wait another minute. Maria got up, went to the door, and tried opening it. It was locked. She pushed harder just to make sure.

"Mommy, why'd that lady lock the door?" asked Emily.

"I don't know."

She had never been able to hide her emotions. The girls were staring at her. The furrowed brow, the flush of her cheeks, the clenched jaw muscles told them she didn't like being locked in the room. The three sets of brown eyes never left their mother's face. Maria scanned the room for something, anything she could use to attract the attention of someone on the other side of the wall. There was nothing, no phone, no intercom; even the switches for the lights were on the other side of the door. The only thing left to do was to start pounding on the glass and call for help. It was the least desirable option, certain to scare her daughters.

"*Niñas*, does anyone have to go to the bathroom?" All three girls instantly raised their hands. Maria could only smile at little Maggie still in diapers. "Okay now, I don't want you to be scared, but mommy needs to get somebody to open the door for us. I'm going to pound on the glass and call for help. It'll be okay."

Emily said, "We're not scared mommy. We want to go see Grandma and Grandpa."

Maria began to rap lightly on the frosted glass door with her knuckles, calling out in a voice not much louder than a normal speaking tone. "Is anyone there? Hello. Is anyone there?" There was no answer, not even a stirring. Maria began to pound harder as she raised her voice. It didn't

help. Eventually she began slamming her fists into the door, shaking the glass wall, calling out "Is anybody there?" Maria's daughters gathered together, wrapping their arms around each other, closing their eyes while their mother continued to beat on the door. There was still no answer. How was it possible that nobody could hear her? How could they ignore the racket she was making? The room must be deserted. Surely someone would have come to their assistance. Panic began to set in as Maria pounded on the glass door just short of shattering it. The girls began to cry as their mother continued to scream for help.

Maria worked herself into an uncontrolled frenzy. Without thinking, she grabbed a chair, lifted it high over her head, and threw it at the door. Shards of glass flew across the hall. The little girls screamed. They had never seen their patient, compliant, loving mother act this way. Maria half stunned, eyes propped wide open, turned to her girls.

"*Niñas*, quick, grab your things. We need to go." Maria Pedrosa wasn't sure where she would take them, but it didn't matter. She just knew she had to get her family out of that room and find help.

The panicked mother rushed them into the hallway where she told Emily to look after the littler ones while she went to find help. Running up and down the narrow corridors formed by dozens of small work cubicles, Maria continued to call for help. The huge room with row after row of fluorescent lights was empty, abandoned. Why? None of this made any sense.

Maria returned to her frightened children, sweeping little Maggie up in her arms, instructing Emily and Martha to follow. She herded her brood to the opposite side of the room where there was a steel door with a sign that read "Caution Jet Blast." Maria shoved the door open with her shoulder and stepped out into the late afternoon sun just as an American Airlines Boeing 777 was taking off. The four covered their ears from the noise of the screaming engines. As soon as the wide-body jet had passed, Maria began to look for someone to help them, calling out at the top of her voice. No one responded. It was if they had been abandoned. The aircraft parking apron was empty; not a single plane remained. All of the service vehicles stood silent. She couldn't find anyone. Less than two hours ago the airport had been bustling with flights taking off and landing. Now it was deserted.

Maria stopped as she tried to gather her wits, scanning the massive concrete parking apron. None of it made any sense. What happened? Where did all the people go? What about the planes? Had there been another terrorist attack? Maybe someone had threatened to blow-up the airport? The only thing that mattered was the safety of her children. She

had to find a secure place for them. Her natural instinct was to run, anything to get far away from her current surroundings. The silence of the abandoned terminal, the missing planes and people, and the eerie lack of any movement heightened her fears. The frightened mother gathered her girls and headed south towards the runways, away from the international terminal. As soon as she was past the end of the terminal building, she turned east towards the other terminals on the south side of the airport. Maria began to walk briskly past the empty Terminal Four towards Terminal Five where there was a single Aeromexico 727 sitting on the tarmac. By the time they made it to Terminal Five, the girls were out of breath.

"Mamá, I'm tired," whined Martha.

Emily tugged on her skirt. "Please slow down, my legs hurt."

Maria stopped under the wing of the 727 and screamed as loud as she could. "Help, is anyone here?" Once again there was no answer. She spotted a door that led to the lower level of the terminal and ran towards it as best she could, dragging her two oldest while carrying her youngest. Maria opened the door. There was a short hallway that led to a stairway that she prodded her children to climb. They ran down a long corridor and finally out through another door into the abandoned Terminal Five.

The silence of the massive hall almost sent Maria into a panic. She called out again, but there was no answer. What happened? Why was the airport empty? Fear was starting to supplant her protective instincts. The half crazed look on their mother's face scared the girls. They began to cry. Maria found a glass door that lead outside. It had a warning to only open incase of an emergency. She ignored the warning and barged through the door setting off an earsplitting alarm. The girls covered their ears as their mother pulled them down the stairs to the parking ramp.

Maria continued to head east, past Terminal Six towards Terminal Seven where there was a United Boeing 757 rolling out onto the taxiway. Surely there would have to be somebody there. How else could the plane back away from the gate? Emily and Martha stumbled behind her, clutching her skirt with tight little fists. The muscles in Maria's arms burned from holding onto little Maggie and her diaper bag.

"Emily, Martha just a little further. See that building where the plane just left, we need to go there."

Martha grabbed Maria's arm and pulled on her mother with all her strength as her feet skidded across the pavement. "Mamá, please stop."

Maria frowned then knelt down by the two little girls. "Niñas, por favor. Just a little further. Do it for Mamá."

Emily and Martha scowled, crossed their arms, and stared at their feet. They were not moving another inch no matter how much their

mother pleaded. Maria gazed at her daughters then back towards Terminal Seven weighing her options. Just as she was about to set Maggie down and give them a rest, Maria Pedrosa saw a squat powerful-looking vehicle flash around the far corner of the terminal. The man driving was dressed in gray coveralls and had on a white hardhat. It was a tractor used to back the big planes away from the gates. Maria set Maggie down and started to yell and wave her hands. The chilren imitated their mother, but the noise from the departing 757 halfway down the taxiway cancelled out their screams. Just as she was about to give up, the strange vehicle swerved to the left and headed straight for the frantic Pedrosa family.

The 65,000-pound Hough TD-500 came roaring up and stopped less than ten feet in front of them. The man driving the low-slung tug with oversized tires took off his sunglasses and hardhat, and climbed out of the enclosed cab. The stranger stood a bit over five feet ten inches tall, with broad shoulders and a barrel chest. As he walked towards the family, the man reached into his back pocket and pulled out a black plastic comb. He proceeded to comb a sparsely covered head of silver hair off his ruddy face. His pleasant smile, as he looked down at the three young girls, said he was there to help. Maria breathed an audible sigh of relief as the strange man walked up to her while taking the leather glove off his right hand and thrusting it out.

"Kazimierz Jasinski, Just call me Kaz." Maria instantly grabbed the friendly hand and began to shake it.

"Thank you, thank you, *señor*, thank you so much. I didn't mean to break the glass. I promise I'll pay. The niñas were so afraid. I didn't know what to do."

"Lady, slow down. What glass? Are you okay? You shouldn't be here. It's dangerous. We need to get you to a safe place before the wave hits. Grab your kids, please hurry."

"Wave?" Maria couldn't imagine what the kind gentleman with the strange name was talking about. Was this wave the reason there was no one left at the airport? What kind of wave could it be? "I don't understand. We need to get on the plane." Maria looked at her watch. "Oh my, it leaves in less than fifteen minutes. We need to hurry."

"Lady, you're not getting on any plane. You see that 757." Kaz turned and pointed to the blue and white airliner just as it turned onto the active runway. "That's the last one. There won't be any more for a long time. This whole airport is gonna be underwater in less than an hour. We need to get you and your family to safety."

Maria couldn't believe what the nice man had just said. How was it possible that the airport was going to be underwater? Was the man sick?

He seemed so nice. How can she trust this man with the crazy ideas?

"Mr. Kaz, please excuse me. I don't understand. What happened to all the people? And what about the airplanes? Where is everybody? Why are you the only one here?"

"Lady…"

"My name is Maria Pedrosa. You may call me Maria. These are my daughters Emily, Martha, and Maggie."

"Maria, we don't have much time. I don't know what we can do, but we must find a safe place. I'll have to explain later. The wave. Well, it's huge. The airport officials said it was at least a hundred feet high. One of our pilots saw it. He said it would be over a thousand feet high by the time it got here. Please you and two of your daughters take the jump seat." Kaz pointed at the single black vinyl seat welded to the right front corner of the giant tractor. "And I can take one with me in the cab. Who would like to help me drive the big tractor?"

Maria realized she didn't have a choice. If what this man was saying was true—and why else would the airport be so empty—she had to trust him. Emily tugged at her mother's skirt. She wanted her to bend down so she could whisper something in her ear.

"It's okay, Emily, you can tell the nice man."

Emily raised her hand as if answering a question in school.

Kaz smiled again as he looked down at the little girl with the big brown eyes. She must be about the same age as my Julie before the accident, he thought.

"Yes, Emily, did you want to say something?"

"My mommy says it's okay if I ride with you."

"Good, you can help me steer, but we have to hurry."

The little girls and two adults climbed onto the tractor covered in gray diesel exhaust and drove off in the direction of Terminal Eight.

Kaz yelled over to Maria, "I think I know a place where we'll be safe."

Emily cried out for joy as she helped her new friend steer the tractor down the taxiway while waving to the departing jet.

* * *

Since returning to my seat, I had made three more calls to Lauren without any luck. Richard, the flight attendant handling the phones, had done an excellent job keeping the passengers under control. With just a limited number of outgoing lines, each rotation of passengers making their one-minute call took almost an hour. My last chance to call Lauren was coming up. Richard had just stepped into the first class cabin. I thought that by now most passengers were finished using the phones. I was wrong. Everyone was trying to warn their relatives, friends, anyone

they could think of. My palms had turned clammy. The air inside the cabin seemed to be filled with fear, remorse, or maybe guilt. Hell, I didn't know. It was just stuffy. I could barely stay seated waiting for permission to make that last call. If I didn't reach Lauren this time and had to wait through another rotation, it would be too late. The biggest problem was, I needed to calm down. I was panicked because of not reaching Lauren, and there was no good reason. By now the incredible tsunami must be all over the news. The authorities had to be evacuating the costal regions from San Diego to Seattle. That's when it hit me. The traffic might be so backed up it would be impossible for them to reach safety. There was nothing I could do.

Richard stood at the front of the first class cabin and read off five seat numbers. Seat 2A was the second seat he called. I pulled the handset out of the armrest and dialed Lauren's cell phone. The satellite connection took forever. I waited as the fingers on my right hand mechanically thrummed the leather armrest. Lauren's phone rang and rang and rang. She wasn't going to pick-up. The phone stopped ringing when Lauren's voice announced that she was not able to answer and to please leave a message at the tone. This would be my third message. I couldn't contain myself and began to stammer. My mouth went dry. The words wouldn't come out. I wanted to yell at Lauren for not answering my calls, warn her to leave. I just wanted to let her know how much I missed her. All I said was "I love you." And then hung up, knowing that she might never hear my last message.

I unfastened the seatbelt and stood up while Richard announced five more seat numbers. Pacing back and forth in the aisle while waves of nausea rolled through my gut, I had never felt so helpless. For the last thirty-eight years, I had avoided one thing like the plague, responsibility. Now I was responsible for a wife and child. They were the most important people in my life. God, what I would do to trade places with them. I began to pace faster and faster while talking to myself, trying to dispel my fears, robotic hands waving through the air uncontrollably. I'm sure I scared the hell out of the other passengers. Screw the bastards. I had to figure out how to warn my wife. I couldn't wait another hour until it was my turn to call again. Maybe I should go upstairs and beat the crap out of that fat air marshal again. Take his gun and threaten to start shooting unless I could continue to use the phone. I knelt down on my seat and peered out the window. The ocean from 37,000 feet didn't look any different, blue with a few white caps, but mostly covered by clouds. It certainly didn't look threatening.

Just as I was about to get back up and continue my pacing, Simone

tapped me on the shoulder.

"Dr. Palmer?" My nerves were shot. I jumped when Simone touched me, scaring the poor girl half to death.

"Sorry, you okay?"

"I'm really starting to lose it—jumpy as hell—crawling out of my skin. I can't reach my wife. She doesn't answer. What'll I do?"

Simone's expression instantly changed to sympathetic. Maybe it was just part of her training? They probably teach them that look to keep unruly passengers under control, and I was about to go out of control. Though maybe she actually cared. I didn't know, and for the moment, it didn't matter.

"Did you just try to call?"

"Yes. If I have to wait another hour it will be too late."

"Let me think a minute," Simone said as she gently placed her hand on my shoulder.

"You've got to help. I'm going crazy."

"Maybe I can. Follow me, Professor."

"Ah, you know I'm not really a professor."

"I know, but it sounds a lot better than 'outhouse guy'." She smiled and I felt a little better for an instant.

"I suppose you're right, but I'm feeling pretty shitty."

Simone grimaced. "Sorry, bad joke."

"Didn't even qualify for joke status."

"Right."

We headed back to the stairs that would take us to the upper deck. Once again, I followed. Simone's legs were still just as shapely and her ass just as tight except it no longer mattered. For now, the only thing that mattered was getting in touch with Lauren. That may have been the first time since puberty that I failed to appreciate a great set of legs and a tight butt on the opposite sex. Simone walked by the fat air marshal with me following close behind. He nodded, and I sheepishly smiled back. This time I didn't bother to hide from the camera next to the door. I stayed with Simone as she walked down the short hall. She knocked on the cockpit door and a few seconds later it opened. Michelle wanted to know what we needed. Simone explained my predicament. The pilot gave me a thumbs-up, and the co-pilot motioned for us to come in.

"So you still haven't been able to contact your wife," asked the pilot.

"I'm going out of my mind. What'll I do?"

"Well, don't worry. Wives will do that to you. I've been married twenty-one years. Get used to it." The pilot smiled, and our co-pilot punched him in the shoulder. I tried to smile back. "Give me that phone

number again and I'll try it for you. We'll just keep on calling until we reach her or we land."

"Hey, thanks. I can't tell you how much I appreciate it."

"Not a problem. You just saved everyone on this flight. Besides, you got me a free beer. Too bad I don't drink."

"That'll leave more for me and I could use a few about now." The pilot dialed and then handed me the microphone. Michelle reminded me to press the transmit button when I wanted to speak. "Oh crap, I gave you the house number. We should have called her cell phone first."

"Not a problem." Just as the pilot was about to re-dial, the ring of our home phone filled the cockpit. Two rings later Lauren picked up. I let out an audible sigh. "Oh thank God."

"Hello."

"Lauren."

"Hey, babe. It's good to hear your voice."

"What the hell are you doing there?"

"I was just getting ready to leave. You were right. All of Malibu is being evacuated."

"But, sweetheart, why are you still at the house? You've got to get out of there."

"Oh, I'm okay. I'm just about done packing the Hummer. I'll be ready to leave in five minutes." There was a brief pause and then Lauren was back, her voice filling the cockpit. "Hey, where are you? Did you land already? Do you want me to come get you?"

"No. I'm calling from the plane."

"From the plane. How sweet. You were worried. You missed me." Lauren paused for a moment and then my beautiful wife's voice filled the cockpit again. "But then knowing you it was probably your Little Buddy that missed me. It's been almost a week."

The pilot and co-pilot turned away doubled over with laughter. Michelle's face had turned crimson red. I felt like crawling under the carpet.

I blurted out. "It's a nickname." Then depressed the transmit button. "Uh, sweetheart, I'm calling you from the cockpit. The pilot and co-pilot, well, they're right here with me...and can hear everything we say."

There was another brief pause. I could hear Lauren laughing on the other end of the line. "Oh my. How embarrassing."

"Don't take the Hummer. Take the Harley. You've got to hurry. Get out of there now."

"Don't worry, sweetheart. I'm fine. The police said the wave wouldn't hit for another forty-five minutes to an hour. I'm almost ready. I'll take Aubrey and drive up one of the canyons. You know we're going to

lose the house. It's so sad. We'll re-build. I'm glad you made me call the insurance agent. I added as much coverage as I could, same for the gym. I can come get you if you like." None of what Lauren was saying made any sense. Taking Aubrey up one of the local canyons would be a death sentence.

"Lauren, what did the police say?"

"What do you mean? The police said the waves would start arriving in forty-five minutes to an hour. That as long as we were at least two hundred feet above sea-level we would be safe. It's kind of creepy. Some of our neighbors are going to drive up Malibu Canyon so they can see the waves roll in. They're going to sit up there and watch as their houses are being washed away. I couldn't bear to do that."

"Babe, listen to me. Something's wrong. The tsunami that hit Honolulu...it almost nailed us as we were taking off. It was over two thousand feet high. Hold on a sec." I turned to Michelle who was still smiling to confirm how high the wave was. I didn't appreciate her response.

"Well, I'm sure it was bigger than Little Buddy. The radar altimeter said 2,320 feet."

"Lauren, the co-pilot, measured the wave at 2,320 feet. Scott said over a thousand feet when it hits L.A., not a hundred feet. The whole city is going to be destroyed. The entire West Coast of North America is going to be inundated. There won't be any electricity or water. There won't be any way to get food or other essentials. Sweetheart, you've got to take our baby and get out now. We're going to land in Las Vegas. LAX will be annihilated. You have no idea how big a disaster this is going to be."

"A thousand feet? That's not possible. I don't understand. They said as long as we were at least two hundred feet..."

"No." I cut her off. "Listen to me. The wave is going to be...it's going to be over a thousand feet when it hits Malibu. Take the Harley. Just pack some food and diapers for Aubrey and get the hell out of there. Meet me in Vegas."

"Chuck, are sure? A thousand feet? I hate driving the Harley. I'm not very good and it scares me. Why can't I take the Hummer?"

"Lauren, please no arguments. I know what I'm talking about. You've got to take the Harley. Don't worry, you'll do fine. If there's traffic, you can split lanes or if there's an accident you'll be able to get around it. You have to go now."

"Ok, but how should I go?" Normally on a Sunday evening the quickest way to Vegas would be through downtown Los Angeles. Except the entire route was going to be underwater once the wave hit. She'd never make it to high ground in time. I decided it would be better if

Lauren headed over the Santa Monica Mountains into the San Fernando Valley. I needed to get her to the north end of the valley, furthest from the ocean. It occurred to me that depending on the size of the tsunami, much of the San Fernando Valley might be saved. With a little luck, the bulk of the U.S. Porn Industry was going to survive the greatest human disaster in history. I wondered what that big mouth Pat Robertson would have to say about that?

I gave Lauren the quickest route to get her to the north end of the valley. "But how will I find you?" Lauren still didn't comprehend the danger she and Aubrey were in. There was no sense putting her off. I know my wife. She doesn't give up until she has all of the answers.

I asked the pilot when we would be landing in Vegas. He said it was hard to say because of all the traffic that was being re-routed. He was sure center would put us in a holding pattern until they could get us a landing slot. Our co-pilot said with all the traffic being re-routed to Vegas there wouldn't be a gate for us either. They'd have to bus the passengers to the terminal. It could be a long time before I got off the plane.

"Don't worry. I'll wait by the curb, close to the baggage pick-up. I've got my cell phone. You've got to get out of there right now or you'll never make it. Please hurry."

"Okay. I'll see you in Vegas. Love ya." Lauren hung up before I had a chance to say goodbye. That's when this empty feeling settled into my stomach. Except it wasn't just my gut that felt empty; it was my entire being, as if my life had been put on hold. With all the adrenaline coursing through my veins gone, I slumped into the jump seat between the two pilots. My world became fuzzy, out of focus. Nothing mattered. Now there was nothing else for me to do. The rest was up to Lauren. The next five or six hours were going to be impossible, the longest of my life. Michelle turned to me. I'm not even sure what the look was she gave me, sympathetic or just pathetic.

"Hey, you all right?"

"I guess. I'm not sure. My wife and kid, they're all I have."

"It's called responsibility. Makes life interesting."

"Tell me about it. Nothing else matters, not the house, toys, my business—just my wife and our beautiful daughter."

"I don't think you have to worry. In fifteen minutes, they should be safe. You'll have a wonderful family reunion in Vegas. Then you can start over. It sounded like your wife took care of the insurance. Besides, you still have Little Buddy." She gave me one of those ear-to-ear grins and punched me in the shoulder. I couldn't help but laugh.

"Right, about that nick-name." I puffed out my chest and smiled

back. "It's merely a term of endearment. It has nothing to do with his size, which by the way doesn't matter.

Michelle rolled her eyes. "Yeah, right. That's what they all say."

The pilot, co-pilot, and I eyed each other sheepishly, embarrassed that we were making such silly jokes under the circumstances. Well, a little humor never hurts.

TWENTY-FIVE

PATRICK GOULD PACED NERVOUSLY as he watched his assistant Kevin Bradshaw work feverishly at the new twelve-monitor workstation. Bradshaw had been attempting to confirm that the AUTODIN Gate Guard Terminal had uploaded the tsunami warning for the Multilevel Messaging System (MMS). But the system wasn't working. The Gate Guard Terminal seemed to be transmitting, but the MMS maintained by the U.S. Navy in Wahiawa Hawaii wouldn't respond. The Alaska Tsunami Warning Center's attempt to utilize the MMS was merely for insurance purposes. A tsunami warning had already been transmitted over an hour ago directly through the AUTODIN Terminal to Fort Detrick, Maryland. Maryland would then disseminate the warning to the 192 Pacific Basin Commands, various police and fire agencies, Coast Guard bases, harbor masters, even select Life Guard facilities.

By trying to utilize the MMS in Wahiawa, Director Gould was attempting to ensure that there were no glitches, that every station received the tsunami warning. With 192 stations, there was plenty of room for errors, and the youngest director ever appointed to manage the Alaska Tsunami Warning Center was not taking any chances.

Mary White, the only other person on duty that Sunday evening, peeked around the corner into the small space where her boss was staring at the new console.

"Excuse me."

"Yes."

"Doctor Gould, there's a phone call for you on line one." The Native Alaskan replied in a barely audible voice as she stared at the floor.

Patrick Gould snapped back at his receptionist. "Not now, Mary. Get rid of it. I'm busy."

This time Mary White did not leave. To her boss's amazement, she stepped into the small space next to the massive console. She could not look directly at the man that had yelled at her just two hours ago, so she stared at his size thirteen work-boots. "I tried to tell him you were not taking calls, but he said it was extremely important that he speak with the

director, or whoever was in charge."

"Mary, I don't give a damn what his problem is. We've got a disaster in the making. Get rid of him and stop bothering me."

Mary knew her boss was barely maintaining his temper. She hastily removed herself and went back to her desk where she told the insistent caller he would have to try back tomorrow during business hours.

Once Director Gould was sure his secretary could no longer hear him, he turned to his assistant.

"I don't know what to do with her. I can't believe she'd disturb us at a time like this, especially after misplacing that fax from Hawaii."

"It's not like she wasn't doing her job. The fax was under a desk." Gould ignored his assistant and continued to stare at the bank of monitors.

"Damn, why won't Hawaii answer? We haven't been able to get anything out of them since the initial warning."

"Come on, Pat, a two-hundred-foot tsunami is going to do a lot of damage. Clearly they've lost all communications and power. Don't worry, we're still okay, Maryland's got our notice. They'll get it out."

"Two hundred feet, it's hard to believe."

"It's unimaginable, almost twenty stories."

"But you're right. I'm trying to envision what it must be like over there. I can't even picture what the place must look like. I wonder how long it will be until we find out the extent of the damage?"

"Probably weeks, maybe months."

"I'm sure over half the island's population is gone, and that's if they're lucky."

Just as Gould was about to try and contact Hawaii one last time, Mary White stepped back into the room, staring at the floor, knowing full well the wrath that was about to be unleashed on her.

"Doctor Gould, I'm sorry to disturb you again. The caller refuses to hang up."

Upon hearing his secretary's voice, the director became so irritated he wouldn't acknowledge his employee for fear of what he might say or do. With her boss's face burning red, the veins in his neck throbbing, Mary White took two steps back, unconsciously trying to put as much distance between her and the man who was about to explode.

"God…damn…it, Mary, I can't be disturbed. Now leave."

Almost in tears, Mary White tried to explain. "I know, sir, but the man said he was an operator. I think he said Ham Operator or something and that he had a call from somebody in Hawaii for you."

Patrick Gould and Kevin Bradshaw could not believe what their sec-

retary had just said. In unison, they turned to face Mary and replied. "Hawaii."

"That's what the man said. I thought you would want to know." Mary White continued staring at her boss's feet, her cheeks covered with salty tears. "He said it was not a very good connection, something about the volcano. He's very hard to understand, and very excited. I'm sorry, I just thought…"

"That's okay, Mary, thank you. You did the right thing. I'm sorry if I yelled at you. I've been under a lot of pressure." Mary White was finally able to look up. The red had drained from her boss's face. The veins in his neck no longer stood out. She let out a long breath.

"That's all right, Doctor. I understand. The caller is still on line one."

"Thank you." Dr. Patrick Gould turned to his assistant. "Put him on speaker." Kevin Bradshaw hit a single button on the phone suspended from the console in front of him. "Hello, this is Director Gould. I understand you have a call from Hawaii for me."

"Yes, Director, thank you for taking the call. I understand you're rather busy right now."

"That's correct, sir. We've been trying to reach Hawaii. There's been a major disaster over there. We haven't been able to contact a soul."

"That's what I heard. I'm a ham operator, and I have a patch for you from over there. You were lucky that I was even able to pick him up with all the ash in the air from that volcano. You know your receptionist? She's rather obstinate. Wasn't sure she was going to let me through." The veins in Patrick Gould's neck were starting to throb as a massive headache began to brew. Why couldn't this fool shut-up and put the damn call through? "You know that ash just plays havoc with transmission. It's the static electricity in the air."

"I see. Well, I appreciate you handling this call for me. It's very important that I speak to Hawaii."

"Okay, by the way my name is Roger Cruz. That's spelled C-R-U-Z, and I'm calling you from North Bend, near Seattle. We're having a beautiful day here. Doesn't happen very often. It's just spectacular when the weather cooperates." Pat Gould was about to explode when his assistant spoke into the speakerphone.

"Mr. Cruz, this is Kevin Bradshaw. I'm Doctor Gould's assistant. It's extremely important that you put your Hawaii call through to us right this minute. We have some very important questions that need answering."

"Oh, I can do that right now. As I said, the reception is not very good. Did I tell you that?" Now Kevin Bradshaw feigned pulling his hair out. "I think I may have told your receptionist. Anyways the man on the

line seems rather agitated. With the static, you may have problems understanding him.

"Thank you, Mr. Cruz. Now can you please put him on the line."

"Sure, no problem." Pat Gould and Kevin Bradshaw could hear their friendly ham operator in the background. "K-A-6-K-N-H go ahead, I have the Alaska Tsunami Warning Center on the line for you." The level of static faded in and out, sometimes making it almost impossible to understand the caller, while other times the call was perfectly clear.

"Thank you, Seattle…Hello, is this the Tsunami Center in Alaska? How do you read?"

"Yes, we can hear you, but you're fading in and out." The director spoke in a slow deliberate cadence as he yelled into the phone. "Can you hear us?"

"Speak in a normal voice."

"I see, thank you. This is Pat Gould, Director of the West Coast & Alaska Tsunami Warning Center. Where are you calling from?"

"I'm calling from Oahu. I'm here with a couple of families and a few cops." The man was obviously distraught and was having a difficult time speaking. "It was terrible. I think we're all that's left."

Kevin Bradshaw looked at his boss. The message didn't make sense. The man's voice was weak. It sounded like he was sobbing as he spoke. How could a few families and a couple of cops be all that was left? Who was this guy anyway?

Before the assistant director had a chance to say a word, Director Gould asked, "Sir, we understand that just you and a few other people are all that you believe are left on Oahu? Is that correct?

"Yes… The wave was horrendous. It swept over the entire island. They're all gone. There's no one left. There's nothing." Kevin Bradshaw and Pat Gould could only stare at the phone as the caller continued. "They're all dead, every last one. The ash from the volcano is choking us. We're having a tough time breathing." At that point, the man calling from Hawaii broke down and could no longer speak. All the two directors could hear was the stranger's loud sobbing.

"Sir… Please we need your help. What's your name, and where exactly are you on Oahu?"

It took a moment before the distraught man could reply. "This is Dr. Scott Richardson. I was working with Dr. Walt Grissom at the Pacific Tsunami Warning Center." When the director heard his counterpart's name he could barely contain himself. He started to interrupt the caller, "Walt…"

Kevin Bradshaw put up his hand up and mouthed, "Let him continue."

"We were trying to determine the cause of the December tsunami. We had found some active tension cracks on the southeast face of Mauna Loa. We believed they were an indication that a much larger slide was possible. We never dreamed the entire mountain would collapse."

"Doctor Richardson, is Walt with you at this time?"

"No... I repeat, no! I'm sure he didn't make it. He stayed back to send... a warning. I was calling to make sure you received... Did you get it?"

"Dr. Richardson, you're breaking up. Yes, we did get the Center's warning, but there was some confusion with the message."

"Understand, you did... message. We have very little food or... up here. We'll need help in a couple... a week at the most."

"We will contact the proper authorities and try to get you help as soon as possible. Where exactly are you located on Oahu? How many people are with you?"

"We're on top of Mount Kaala. Repeat on top of Mount Kaala. There are fourteen survivors with me."

The two directors could not believe what they just heard. How was it possible?

"Dr. Richardson, are you sure there aren't any more people? How high above sea level are you?"

"Mount Kaala is the highest point on... over four thousand feet. The run-up from the wave came... close. I'm almost positive that no-body... survived."

Through the static, the two directors could hear Dr. Richardson as he began to sob again.

"Dr. Richardson, can you hear us?"

Once again, the two men had to wait for Dr. Richardson to respond. "Yes, I'm sorry. Things are just a mess. I've been shot. My wife and kids are okay. They're with me, but all those people down there. It's terrible." Pat and Kevin could only look at each other. Dr. Richardson was becoming less coherent and the static was making him harder to understand, and why had he been shot?

"Dr. Richardson, could you see the wave from where you're at? Could you estimate how high it was?"

"Yes. Dr. Grissom estimated it would be over two tho... feet, and from what I could see, I would agree with his estimate."

Directors Gould and Bradshaw weren't sure what they had just heard. It wasn't that they weren't sure. They just couldn't believe what had come through the static-laced phone.

"Dr. Richardson, did you say two hundred feet? I repeat two hundred feet?"

There was no delay in Dr. Richardson's response. "Negative, the wave was over two thousand feet high, repeat two thousand feet. Do you read me? The run-up came most of the way up Mount Kaala. Dr. Grissom said it would be over a thousand feet when it hit the West Coast."

Pat Gould turned from the monitors that he had been staring at for the last two hours and began to pace. Half dazed, a hazy concentration spread across the director's face as he repeated over and over, "What have I done? What have I done?" Kevin Bradshaw could only bury his face in his hands. After all, he had convinced his boss that the message from Hawaii needed correcting. Thousands, possibly millions of lives were about to be wiped out because of his mistake.

"Alaska, are you still there? Can you hear me? We are going to need rescue. We have children with us. Please help."

Kevin Bradshaw responded. His boss was still pacing behind him somewhere off in his own wretched world of self-doubt. "Yes, Dr. Richardson, we did hear you, but we have to go now. We have to send out another warning. We will contact the authorities… Seattle, are you still on the line?"

"I'm right here. Sounds like you boys really needed to speak to that doctor fella."

"Thank you, Seattle. Get away from the coast and tell every one you know. You need to be 2,000 feet above sea level."

"I'll go higher into the mountains. Boy, wait until the club hears about this call."

"We may have to contact Dr. Richardson again. How can we reach you?"

"Oh, that'll be easy. Let me give you my number. I've got a mobile transmitter in my truck. And I'll tell Hawaii to stay close to their radio in case we have to call them back." The ham operator gave Director Bradshaw his number and hung up.

By now, Pat Gould was completely lost in a fog of misery. His friend and assistant had never seen his boss without a single measure of emotion; now only his blank gaze permeated the small room.

"Kevin, you'll have to issue a revised warning. Please do it immediately. I have things to take care of." Kevin Bradshaw looked at his watch. In less than thirty minutes, the California coast would be hit by the massive wave, striking Oregon and Washington only a few minutes later. Ninety percent of the industry in these three crucial states would be destroyed along with their seaports that handled over 50% of all imports and exports in the U.S. The loss of life would be unimaginable.

Kevin Bradshaw turned to his half comatose boss, "It's too late, Pat. There's just not enough time. There's nothing we can do."

"Just do it." Pat Gould turned and left.

Kevin Bradshaw began typing out the revised message that he would send to Fort Detrick, Maryland. It would say the tsunami height had now been verified at over two thousand feet in the Hawaiian Islands and was anticipated to be over one thousand feet on the West Coast of North America and throughout Asia and the South Pacific.

Director Gould continued walking. His brisk energetic steps had been reduced to a mere shuffle. He made his way through the main room of the West Coast and Alaska Tsunami Warning Center, no longer aware of his surroundings. He stepped through the pair of double glass doors into a gray and dreary evening. He didn't bother to put on the jacket tucked under his left arm as he crossed the gravel parking lot. A light drizzle had begun to fall. Walking over to his blue Ford Taurus, Pat Gould opened the passenger door and reached into the glove compartment. The youngest man ever appointed to the directorship of the West Coast and Alaska Tsunami Warning Center removed a box of ammunition and a Ruger SP101 .357 magnum. He proceeded to load a single cartridge into the weapon.

* * *

The noisy tractor rumbled past Terminal Seven as Kaz scanned the taxiway and parking apron spreading out before him. Little Emily sitting on his lap, hands clenched around the large black wheel, had kept up a constant banter. She wanted to know everything about the massive tractor she was helping to steer. "What's that dial for? What's that button do? What's that lever over there?" Kaz couldn't help but smile as he answered each question. It had been a long time since he had felt anything, let alone the pleasure of a little girl's company. He tried to remember how long it had been. When did he receive that awful call?

A police sergeant from the L.A.P.D. had phoned on a Sunday afternoon. Instantly Kaz knew there was a problem. The police don't call on a Sunday afternoon with good news. A drunk had swerved in front of an eighteen-wheeler causing it to lose control. The mammoth truck came crashing through the freeway divider directly into oncoming traffic. Kaz's wife and two children were gone in an instant. For the last three years, the widowed father had been merely going through the motions of living, marching day by day through a life shrouded in misery. Every day as he drove to work, the concrete freeway abutments whizzed by constantly beckoning him to end his wretched existence. It had not been easy.

Right after the accident, Kaz began to work much longer hours. When he wasn't working, he was in his garage lifting weights. Everything he had done for the last three years was intended to help him forget.

With each passing day, his meals were more likely to come out of a bottle. He had been living in a whirlpool, a downward spiral that sucked him deeper and deeper into a life of despair.

Emily continued to ask questions as she waved to her mother and two sisters sitting just outside the cab. Kaz glanced over at Maria, her dark brown hair blowing in the breeze as they rumbled along the taxiway towards Terminal Eight. She was younger than his wife was the day of the accident. She was also a little overweight, but that was okay. It just meant the curves were more rounded, no sharp edges. Kaz never minded seeing a few extra pounds on a woman. It made them look more feminine. Maria's face had a certain gentle quality, with creamy skin and full cheeks. Her sparkling opalescent eyes spoke of caring for and nurturing her three beautiful daughters. He relished in the knowledge that these three young girls and this lovely woman were his responsibility. They gave meaning to his barren existence. They had instantly become the sole reason for his survival. Finally, there was some purpose making its way back into his life.

When Kaz was first told about the giant wave rushing towards the coast he had told himself, "This will end my pain." Except now the pain was gone. The only thing that mattered was this family: these three young girls and their mother. Kaz kept on telling himself there had to be a way to save them. But the wave, how could it be? The pilot said it was supposed to be a thousand feet high. Who had ever heard of such a thing? With a thousand feet of water covering the airport, where would they be safe? If the wave didn't destroy everything in its path the water pressure would surely crush it. The only thing that could survive that kind of pressure was a submarine, and there weren't any subs at the airport. Kaz knew he needed a container, a very strong container. They would need a watertight container, one that was made out of steel. One that was large enough that he and the family could get inside.

As the Hough 5000 continued to roll down the taxiway, Kaz spotted what he had been looking for. Just past Terminal Eight was a construction project. The concrete parking apron was being replaced. The heavy construction equipment had been left sitting there over the weekend along with a mobile water tank. The large yellow tank was about twenty feet long and eight feet in diameter. It was supported by steel scaffolding with a set of black rubber tires at the rear. The tank rested more than ten feet above the ground, and would easily hold all five of them.

Kaz, with Emily's help, pointed the dusty white tug directly towards the yellow tank. There was an inspection hatch on top of the tank with a ladder leading up to it. At one end of the tank was a six-inch diameter spout connected to a large valve used to fill water trucks. At the other

end, a fire hose was screwed onto a fill pipe that ran to the top of the tank.

Kaz drove the tractor up to the tank and parked it just to the side of the fill spout. As he opened the door, he told Emily not to touch a thing then stepped out of the tiny cab. He quickly went around to the opposite side of the dust-covered tractor, opened up a toolbox, and removed a 20 oz. ball peen hammer. Using the hammer to strike the horns on the threaded fire hose connection, he spun it off, letting the hose fall to the ground as the residual water trickled out around his feet.

While Kaz was disconnecting the fill hose, Maria and her three daughters watched and wondered what the strange man was doing. Why was he continually checking his watch? Why would he be playing with a fire hose at a time like this? Most important, what were his plans for this water tank? When the big man climbed on top of the tractor and opened the valve that would empty the tank, the two girls sitting on Maria's lap could only scream for joy as the water poured out of the tank covering the tractor and it's passengers in a heavy mist. Emily sat perfectly dry inside the cab waving and smiling at her mother and two sisters as they tried to cover up.

The strange man jumped down off the tractor, sloshed through the expanding lake he had just created, and got back in the cab. He turned the tractor around and drove off towards terminal eight leaving the tank to flood the construction site. Kaz picked up Emily and stepped around the front of the tractor to where her mother and two sisters were still seated.

"Mrs. Pedrosa."

"Please, Mr. Kaz, call me Maria." He smiled at the lovely woman holding her children, as he thought to himself, "These are the nicest people to ever ride in that seat." He checked his watch before speaking.

"Maria, we have to hurry." Kaz nervously checked his watch again. "I need your help inside the terminal building. Can the girls stay here? Can Emily look after them? We'll only be a few minutes." Kaz gave the frightened mother his most reassuring smile.

Maria's face contorted as she became more and more concerned about the strange man's intentions. Why did she have to leave her daughters alone? Why did he need her to go inside the empty terminal building? What choices did she have?

"Mr. Kaz, why do we have to leave my daughters out here alone? Can't we take them with us?"

"Madam, please. We have to get blankets, hundreds of them. The little girls will slow us down. We don't have much time."

"But why blankets? What do we need blankets for?"

Kaz put his hand to his forehead. He felt agitated. His wife had never

questioned him. This woman was different, her will was stronger, at least when it came to protecting her daughters.

"It's okay, Mommy, you can go with Mr. Kaz. I'll watch Martha and Maggie."

Emily's smile was reassuring, still Maria didn't know what to do. Leaving her daughters alone was bad enough. Going into an empty building to get blankets was worse. It was Emily who finally convinced her mother that going with their new friend would be okay. When it came to strangers she had always had a sixth sense, and Maria couldn't remember when her oldest daughter had taken to a stranger so completely.

The worried mother instructed her girls to stay by the tractor. Kaz said they would be gone less than ten minutes as he looked at his watch one last time. He held the door open. "Thank you," Maria said as she entered the brightly lit room filled with aisle after aisle of shelves. Kaz asked Maria to take one of the laundry carts next to the door and follow him. They each pushed a cart, running down a long row of shelves filled with toilet paper, soft drinks, and paper towels. They stopped at the neatly folded blankets that had been placed in stacks of twelve. Kaz began filling his cart with them. Maria followed suit. By the time they were done, each cart was filled with hundreds of blue and gray blankets.

"Mr. Kaz, all these blankets, what are we to do with them? Are you sure we can take them?"

"Don't worry. We'll be fine." Kaz checked his watch. "But we have to hurry, there can't be much time."

"You're worried about the wave? The wave that is going to wash over the airport?"

Kaz tried to paint a picture of the disaster that was about to take place. Explaining to the frightened mother the dire situation they were faced with. He was certain Maria couldn't possibly comprehend what he was describing. He wasn't sure he understood what was about to happen.

"That's right, the wave, the giant wave. It's going to wash everything away. We have to get you and your girls in that tank. These blankets will act as padding. We have to hurry."

"But shouldn't we take your tractor and drive as far from the ocean as we can? Wouldn't that be better?"

"I don't know. The Airport Administrator said the wave would be a hundred feet high. One of our pilots saw it and said it would be over a thousand feet. A thousand feet, can you imagine anything so huge? We could never out run it. It's going to destroy everything in its path. That's why I think the tank is the safest place for us."

Maria put her hand over her mouth as she gasped. "My husband, he

works close to the Burbank Airport. Will he be safe?"

"Maria, please, we don't have much time and you're asking me questions that I don't have answers to. We'll be safe inside the steel water tank, but we need to hurry." Kaz purposely avoided answering any questions about the woman's husband. If the pilot were right, there wouldn't be a soul in the Los Angeles basin who was safe.

Maria and Kaz pushed their carts back outside and parked them next to the tractor where the girls were sitting quietly. Kaz began to throw blankets on top of the tractor and instructed Maria to do the same. As soon as they were done, he picked up Emily and climbed back into the cab while Maria and her two daughters got into the jump seat. They drove back to the flooded construction site where now just a trickle of water flowed out of the tank. Kaz parked his tractor next to the ladder leading to the inspection hatch.

"Maria, I need you and Emily to climb up this ladder. Emily will need to go inside the tank. There should be a ladder that she can climb down. I'll help."

"But Mr. Kaz, how can we put such a small girl in that tank? She'll be scared to death."

Kaz turned to Emily and started to say something, when the little girl told her mother, "It's okay, Mamá, I can do it."

"Are you sure, sweetheart? It's very dark in there."

"It'll be okay. I can be brave."

"That's a good girl," Kaz said. "It'll be like a fort or a tree house."

Kaz helped Emily up the ladder, opened the hatch, and shinned his flashlight into the depths of the tank. As he suspected, there was a ladder. Each rung covered in brown scaly rust that still dripped into the pooled water at the bottom of the tank. Maria watched as Emily, without hesitation, climbed down into the tank. Kaz handed her the flashlight. As soon as she had made her way safely to the bottom of the ladder, he motioned to Maria that it was her turn to climb to the top of the tank.

The concerned mother yelled out to her daughter, "*Chica*, are you okay down there?

"I'm fine, Mamá, but there's lots of water in here." Maria turned to Kaz as if to say what do we do now?

"Emily, I'm going to have your mother throw down some blankets. Use them to push the water towards the other end of the tank, away from the ladder. There should be a hole at that end of the tank. If you push the water into it, it will flow out. Do you understand?"

"I think so."

"Good. Just wait there." Kaz helped Maria up the ladder and ex-

plained, "I'll throw the blankets to you, and you toss them down to Emily."

Once Maria was safely sitting on top of the tank, Kaz climbed down the ladder and began to pass blankets to her. As soon as Maria dropped the first blankets into the tank, Emily began to push the remaining water away from the ladder, doing exactly as she had been instructed. As Kaz continued to pass blankets to Maria, he kept an eye on the fill spout. Soon, instead of a few intermittent drops, water began flowing out in spurts and fits as Emily pushed the residual pool towards the opposite end of the tank. Kaz smiled. He could almost see the fearless little girl bent over with neatly folded blankets in each hand pushing the water towards the spout. Kaz couldn't have been more proud of the brave little girl.

He continued to throw blankets, hundreds of them, sweat pouring off his shoulders as he labored to transfer the entire pile to the top of the tank. With most of the water gone, he instructed Maria to drop the pile of blankets into the tank. He then picked up little Maggie, and she immediately began to cry. Stretching as far as he could, Kaz handed the screaming toddler to her mother. As soon as Maggie was tightly wrapped in her mother's arms, she stopped crying. Kaz then turned to the four-year-old Martha.

"You need to go up there with your Mommy. Would you like to climb the ladder or do you want me to hand you to her?" Martha glared at the strange man with steely eyes peeking between sparse bangs as she crossed her arms and shook her head in a slow deliberate motion. Her response was an emphatic no. Kaz looked down at the little girl not knowing what to do or say. "No, you don't want me to pick you up?" Martha glared back at the big man. With a defiant stare she slowly nodded her head. Kaz could only offer his most friendly smile and ask: "Okay, so you want me to help you climb up the ladder?" Once again little Martha would only glare and shake her head. She was not about to move. Kaz threw his arms in the air and turned to Martha's mother after looking at his watch. "Maria, Martha is refusing to move. Is it okay if I just pick her up and hand her to you?"

"Martha, please I need you up here right now. Mr. Kaz will help you. He's a big strong man; it'll be all right. Can you do that for your Mamá?" Martha shook her head. She wasn't about to move and she certainly wasn't going inside the big tank no matter how much her mother pleaded. "Come on, sweetheart, I'm going to tell Mr. Kaz to pick you up now. It'll be okay." Maria nodded and Kaz bent down to grab the little girl. She let out a yell and began to hit him on the arms as he lifted her up.

"I don't want to go. You can't make me. I don't want to. I don't want to."

Kaz attempted to calm the frightened girl. "It'll be okay. Your mother's right there. We're all going to be fine." It was no use. Martha bent over and tried to remove a piece of flesh from her rescuer's arm. Fortunately, Kaz was able to pry the offending limb from the little girl's mouth before she had a chance to take a piece out of it. Martha continued to yell and scream, only stopping when she was in her mother's arms.

Once Kaz had turned Martha over to her mother, he climbed the ladder and shimmied his was way down through the small opening. When he reached the bottom rung, Kaz turned to inspect the insides of the tank. It was as bleak as he had imagined. The air heavy with the musty smell of rust, every surface dripped with moisture. The sound of his labored breathing echoed as if inside a bell. Emily was busy spreading out the blankets in layers. She had prepared what appeared to be as comfortable a mattress as could be expected given the circumstances. Even though she was only six, her domestic skills were impressive. Kaz smiled.

"Okay, Maria, hand Maggie down first." Kaz looked at his watch, but couldn't read it. It was much too dark inside the tank. Maria handed her youngest to Kaz. As soon as she let go, Maggie began to cry. Kaz bent down placing the little girl in Emily's outstretched hands. Once Emily had her arms wrapped around her sister and was softly telling her everything would be all right, she stopped crying. Maria then handed Martha to Kaz and climbed down the ladder into the musty interior of the empty tank. Emily continued to spread blankets as her mother and two sisters stared at their dismal surroundings. The light from Kaz's flashlight bounced off the concave rusted walls forming strange shadows.

Maria inspected the layer of blankets that Emily had laid down for them. While the air was thick with the moldy smell of stale water and rust, the blankets did provide an inviting, and more important, a dry place for them to sit. "It will have to do."

Martha and Maggie had both stopped crying as they lay between their mother and Emily. Sitting quietly in the bright beam of the flashlight that Emily still held, the women looked as comfortable as they were going to be.

Kaz climbed back up the ladder to make sure the hatch could be closed and latched from the inside. If it couldn't, the one place that Kaz rested his hopes on to save his new family would turn into a steel death trap. He tested the latching device twice just to make sure.

Now the only thing left to do was wait, watch and see who was right. Hopefully it was the airport director and not the pilot. The weary tractor driver stuck his head out through the hatch facing a golden horizon

where the sun had just dipped below the waters of the gentle Pacific. The airport lights were starting to switch on, casting lifeless shadows across the empty parking aprons. If the airport director were right and the wave was only a hundred feet, Kaz figured their odds of survival were pretty good. If the pilot were right, he couldn't imagine anything surviving the power of a thousand foot wave. The water pressure alone would instantly crush the tank. Their only hope was if the tank were sufficiently buoyant, it would ride up the face of the wave like a beach ball rather than being submerged under it.

Kaz had already decided that if the pilot were right he would lie to his new family. His job was to protect them, to shelter them from any possible pain. When it came to pain, dealing with its throbbing sting, its never-ending grip, he knew everything there was to know. Kaz was determined to not let his new family suffer. If death were inevitable then he wasn't about to let them know. He would tell them everything was going to be okay. Not to worry. They were all going to survive.

Kaz would wait until the last moment to close the hatch. The air inside the tank was saturated with water vapor, so thick a heavy fog permeated the dark cylinder. Closing the hatch would only make it worse. Besides there was almost a perverse desire to view the massive wave up close, to see its grandeur the power of something so incredibly violent.

Kaz didn't have any idea how long they would be inside. What if the wave deposited the tank upside down so that it was resting on the hatch? That wasn't supposed to happen. The scaffolding and tires should keep the tank upright or at least on its side. What if the tank was caught under tons of debris? The more Kaz thought about their situation, the less he liked the odds. Then again, what could anyone do against a thousand foot wall of water?

Kaz kept his head above the lip of the hatch, his eyes straining to get that first glimpse of the colossal wave. The sand dunes at the end of LAX's four parallel runways hid the ocean from his view. If the tsunami were as huge as the pilot said, it would dwarf the barrier that had protected the runways for over seventy years. If it were only a hundred feet then the water would make its way up through the canyons that cut the dunes on either side of the airport. Even though he wasn't a religious man, he said a small prayer, not for himself. He only asked that his new family be spared.

Kaz continued to glance at his watch every couple of minutes. It was twenty to nine. The wave was late. The director said the airport would be hit by eight thirty. It had been over a half hour since the sun had dropped behind the sand dune. The twilight sky was rapidly fading to

night as just the faintest splash of color could be seen far off on the horizon. To the east, the stars were beginning to sparkle as Kaz looked up. Off in the distance the wail of sirens punctuated the silence of the night as the last emergency vehicles sped away from the coast. The airport was perfectly quiet, not a plane or service vehicle moved. All of the terminals had emptied out long ago. The entire 3,425-acre facility had been left to fend for itself. Only Kaz and the Pedrosa family were left to witness the destruction of the fourth busiest airport in the world.

As Kaz continued to scan the horizon, his attention was drawn to the racket directly overhead. He looked up to see the dark outline of thousands of birds, flocks of gulls, brown pelicans, and shearwaters, their shrieks and screeches obliterating the eerie silence as their wings beat the air. The pungent smell of rotting seaweed and dead fish wafted in from the ocean as the flocks of birds continued to race inland. A light onshore breeze began to rustle the decorative flags on the terminal. Kaz had never seen so many birds. Their flight was different, not the usual lazy flapping of wings. These birds were flying as hard and as fast as they could, as if they were trying to escape some unseen predator.

Kaz turned his attention back to scanning the horizon. The stage was laid out before him, and he was prepared to view his last show, except something didn't feel right. The change was subtle but noticeable. It was the stars. A few minutes ago, they had been barely visible with the fading twilight. In less than two minutes, they had become more plentiful and amazingly bright. Kaz thought the stars no longer shimmered like normal stars, rather they shown bright. There was even a line of red ones. In fact, they weren't even acting like stars as they spread out across the vast darkened rostrum. They appeared to be distributed in an almost linear pattern, as they continued to climb higher and higher in the night sky. It was the strangest display of lights he had ever seen. Then it occurred to Kaz that these weren't stars at all; rather they were from some kind of alien craft. That's when he realized that the bright lights moving towards him weren't stars or lights from some strange alien vehicle. They were the runway lights and surrounding streetlights reflecting off a vertical curtain of water, a curtain of water that stretched for as far as he could see.

The curtain may have been drawn, yet it was still rushing towards him, climbing higher with each passing second. The onshore breeze began to pick up. The flags on top of the terminal were standing straight out snapping like angry whips in the gusts that buffeted the tank. As Kaz continued to stare, mesmerized by the immensity of the tsunami, he could just start to make out a white cornice at the top of the wave. Roil-

ing foam began to cover the crest making its way down the vertical face only to be caught by the water rushing back up. The giant tsunami didn't strike the sand dune at the end of the runway. It consumed it. The wave rolled over the two hundred foot high barrier as if it weren't there.

Kaz knew that tsunamis slowed as they moved into shallow water. He estimated that this incredible wave was still advancing at close to one hundred miles per hour. The sand dune just past the end of the runways was over a mile and a half from where he was standing. He figured they only had about a minute before the wave would crush the fragile tank and its precious cargo. How could his new family ever survive something so powerful? He thought about brave little Emily climbing down into that dark enclosed tank, and not a single complaint. Tears rolled down his cheeks at the thought of this lovely girl's life ending in less than a minute. He could almost see her bent over pushing the water towards the hole that led to the fill spout. She never said a word as she pushed the water out so her family would have a dry place to sit. He remembered opening the giant valve to drain the tank and the small lake forming when thousands of gallons of water drained onto the construction site.

All of a sudden, Kaz was gripped by a surge of panic. He had forgotten to close the valve. How could he have been so stupid? With the valve open, he might as well leave the hatch open. The tank would fill so rapidly that his new family would surely perish. Kaz pounded the metal tank with his fists. The sound echoed inside the steel vessel as Maria and the girls covered their ears.

"What's going on up there?"

"It's okay. Don't worry. I can see the wave. It's not too big. You'll be fine. Just brace yourselves. I forgot something. I have to run and take care of it." Kaz lowered his voice an octave: "I'll be back." He pulled himself through the narrow opening and was on the ground in a matter of seconds, but not before he had checked the hatch to make sure the cover was closed and secure. As Kaz climbed down the ladder, he kept on looking up to try and gauge where the killer wave was. Would he have enough time to make it back to the relative safety of the tank? He told himself, "It doesn't matter." There was no possible way anyone could survive the destructive power that was about to be unleashed. Kaz began to panic when he realized that the valve handle was too high to reach. He would have to move the tractor, except there wasn't enough time. Had his foolish mistake just become his precious little family's death sentence?

TWENTY-SIX

AS SOON AS LAUREN HUNG UP the phone, she ran to her closet. It was going to be a long ride to Las Vegas. She had no idea what the nighttime temperature would be, but a five or six-hour motorcycle ride in shorts and a cotton blouse was insane. There wasn't much time. Still, Lauren thought she could rely on the announcements the police were making over their loud speakers, letting residents know that mandatory evacuations were to be completed within fifteen minutes.

As Lauren changed, she thought about Chuck and how much she missed him. She also though about that little slip up, and how she had tricked him into getting her pregnant. Now what? What could she do? She had wanted a baby so badly. The marriage was his idea. Everything had worked out perfectly, but now Chuck might never forgive her. She had to make it right. No, they would have to work it out together. All Lauren could think about was that she loved her baby and she loved her husband. She was prepared to do whatever it took to keep her family intact.

Lauren quickly changed into leather pants, a light sweater, and her leather motorcycle jacket. Then she replaced her running shoes with a pair of black riding boots. For Aubrey she pulled out the Snugli baby carrier that she and Chuck used when the family went hiking. Lauren pulled the straps over her shoulders and cinched the waistband. Then she picked up her sleeping daughter and slid her down into the carrier. Without a sound, the baby laid her head on her mother's chest. Lauren found a small blanket and gently tucked it around Aubrey's head to protect her from the wind.

She ran to the garage and backed out the Hummer. Then she grabbed Aubrey's diaper bag and a small carrying case with her best jewelry. She opened the back hatch and took out two photo albums, one of their wedding pictures and another filled with family pictures. Lauren stuffed the diaper bag and jewelry into one of the motorcycle's fiberglass saddlebags. The two photo albums went into the other bag.

The custom Harley Davidson Roadmaster with yellow and orange flames on the side had been her wedding gift to Chuck. When he sug-

gested that she learn how to ride the big bike, too, Lauren initially refused. It took Chuck a couple of months of gentle prodding before she finally agreed to give it a try. Her first lesson was early one morning at the Zuma Beach parking lot. She had never been so afraid hoisting her leg over the saddle of the 800-pound bike and then having to start it. Coordinating the throttle and the clutch had been far more difficult than she had ever dreamed. She stalled the bike on her first two attempts. Eventually Lauren did get the hang of it, but she never got over her fear of driving the big V-twin motorcycle.

Lauren put the key in the ignition, stepped on the foot peg, and threw her leg over the brightly painted touring bike. She settled into the oversized black leather seat and hesitated a moment before starting the motorcycle's engine. Lauren was still afraid of the damn thing, and now she was about to take her three-month-old daughter on a 300-mile ride across the California desert. She began to question hers and Chuck's sanity. God, why couldn't she take the Hummer, it would be so much easier? Then Lauren thought about what Chuck had said and knew he was right. Lauren turned on the headlights and twisted the throttle. The rumble from the twin exhaust pipes reverberated through the enclosed space as she rolled out of the garage. She glanced over her shoulder and thought about putting the Hummer back in the garage. Why bother? The Hummer, garage, their house, everything was going to be destroyed in less than forty-five minutes. If their neighbors wanted to take something, they could have it.

Lauren gingerly advanced the throttle and rolled out of the driveway onto Malibu Colony Road. The neighbors, still packing their SUV, gave her a strange look as she rode by them with her baby strapped to her chest. Traffic on Pacific Coast Highway was surprisingly light, just a few cars packed to the roof with their owners' possessions. Emergency vehicles were blaring their final warning message. Lauren roared past the sprawling Pepperdine University campus where thousands of people had camped out on the manicured lawn. A party-like atmosphere had taken over as they sat on their brightly colored blankets watching, waiting with prurient desire to see one of the world's wealthiest enclaves destroyed. She was feeling almost comfortable riding on the wide-open Pacific Coast Highway. It was the twisting canyon road five miles further up that worried her. She couldn't remember the last time she'd seen the busy highway so devoid of cars or people.

With her confidence building, Lauren revved up the big V-twin road bike and roared past Dan Blocker Beach at over 80 mph. Flying through the red light at Paradise Cove, she slowed to make a right turn at Kanan

Road. Lauren blasted up Kanan Road past Chuck's gym. As she continued to climb up the canyon, the traffic in the opposite direction appeared to be getting heavier. Oddly, the lanes leading away from the beach were still empty. Past the turnout where the cop usually hid, traffic coming down the canyon had slowed to a stand still. Thousands of people were lining both sides of the road waiting for the deadly tsunami to strike. The sun was just beginning to set as Lauren sped up the canyon past family after family. What were they thinking? Didn't they know? Why hadn't the police or fire department warned them? Chuck knew. He had warned her, yet all these people were going to die because they didn't know and there was nothing she could do. Lauren pushed the bike back up to 80 mph as she flew by the doomed families. She wanted to scream at the clueless hoards, but it was useless. Lauren had to concentrate on the road as she drove the bike through the most torturous portion of the canyon.

Once on the Ventura Freeway, she breathed a sigh of relief and accelerated the Harley to over 90 mph. There was just a slight chill in the evening air as she sped through the cities of Agoura and Thousand Oaks and onto the 23 Freeway. Off to her right the lights of the Ronald Reagan Library were just coming on as the night sky enveloped the coastal valley. It was as if the entire population of California had gone into hiding, she thought. Were they all sitting in front of their televisions watching the news? But it probably wasn't just California glued to their televisions; the entire world must be holding it's collective breath as it waited for the disaster to unfold.

News vans had been dispatched to every lookout along the California, Oregon, and Washington coasts. Helicopters dotted the air from San Diego to Seattle. News stations from around the world were already recording, anticipating, and analyzing the spectacle. Every expert in the fields of geology, volcanology, seismology, and marine hydrology had been commandeered to render an opinion. Many of those news vans would record their own watery burial.

Lauren gripped the handlebars. Adrenaline coursed through her veins. She covered the entire length of the 23 Freeway in less than ten minutes—sometimes hitting almost 100 mph. Trees and signs flew past the Harley as she leaned into the gentle freeway curves. Lauren slowed for the overpass that would take her onto the 118 Freeway. She checked her watch knowing that there were still over 20 miles to go before she hit the 405, the San Diego Freeway. If she made it to the intersection of the 118 Freeway and the 405, it would be only a mile or so to the grade that would take her out of the San Fernando Valley to safety.

It was just past 9:30 when the white minivan filled with a mother,

father, and three children passed Lauren doing over 100 mph. It was the first vehicle she had seen in the last 30 miles. The top-heavy van over-loaded with family and possessions had no business driving so fast. What did this family know? Why were they in such a rush? Then another car, a dark Honda Accord with an elderly man and woman merged onto the freeway. Just as the elderly couple passed the Harley, the white van lost control. It smashed into the median barrier and began to career across the freeway. Lauren watched in horror as the van went airborne, rolling through the air, throwing bodies, glass, and debris across all four lanes. Lauren mashed down on the brake peddle with her left foot and squeezed the front brake lever with her right hand. The rear tire started to fishtail as she fought to maintain control. Lauren's heart raced as she maneu-vered the bike onto the paved portion of the median and flew past the accident scene. There was nothing she could have done for the family in the van. As she continued down the 118, more and more cars, all of them ignoring the speed limit, began to merge onto the freeway.

The authorities must have finally corrected their warnings. Now everyone was trying to make it to high ground. Lauren knew that for most people the warning would be too late, especially for those that had driven down to the ocean cliffs. They had gone to witness an incredible disaster, and now they would be part of it, each one becoming a faceless number that would be joined by millions of others.

* * *

When the giant wave hit the Southern California coast, it was over a thousand feet high. By the time Lauren passed through Simi Valley, the wave had already rolled ashore and destroyed city after city up and down the California coast. It obliterated Chuck and Lauren's house along with the rest of Malibu. The giant wave washed through the canyons, rac-ing up the sides of the coastal mountains to an altitude of over 2,000 feet. Everything in its path was destroyed, swept away, or ground up. The remnants were deposited along the steepest parts of the coastal range as a reminder of nature's power.

As the tsunami rushed through the Sepulveda Pass into the San Fer-nando Valley, Lauren was speeding down the Santa Susana Grade. By the time she rode into the San Fernando Valley, so had the wave. It was grinding up the San Diego Freeway as if on rails, headed directly for the intersection of the 118 Freeway and the 405 Freeway.

Lauren crested a rise and slowed to take in the entire scene over her right shoulder. Streetlights stretched along perpendicular roads that criss-crossed the San Fernando basin. The full moon was high in the evening sky and helped to illuminate the areas that had already lost power. Lau-

ren tried to find the wave in the distance. She knew it must have come ashore by now. How close was it? It didn't matter. She kept her eyes on the road. There was nothing she could do but push the Harley as hard and fast as possible. Lauren needed to concentrate on the road, stay in her lane, and avoid the increasing traffic. She stopped looking for the wave and twisted the throttle on the motorcycle feeling it accelerate back up to 100 mph. The speed was exhilarating but also frightening.

Lauren raced by the first sign announcing the 405 Freeway ahead, only three miles to go until she reached her turn. Traffic started to move over to the right lanes allowing her to maintain her speed. She was going to stay in the left lane for as long as possible, then dive onto the off-ramp at the last minute. Chuck was right. She never would have attempted the move in the Hummer.

In great leaps and bounds, the tsunami tore the sleepy suburban neighborhoods apart, one after another. But it was no longer just a wave of water. The killer tsunami had been transformed into a moving wall of trash. It had spent much of its energy crashing into the Santa Monica Mountains, but it was still over a hundred and fifty deadly feet high and the entire vertical face was covered with the remains of Studio City, Van Nuys, and Sepulveda. Trees, telephone poles, cars, trucks, and the homes of over 800,000 people chewed up everything in the waves path.

Quickly, Lauren looked off to her right and was shocked to finally see the wall of trash advancing in the moonlight. The immensity stunned her and made her ease off on the throttle. She felt Aubrey move against her chest, forcing her to concentrate on her mission to find safety. She looked at the deadly wall of debris one more time, trying to gage her progress against the wave. She twisted the throttle to accelerate. She hadn't been on the 118 Freeway in years. Was the off-ramp to the 405 a sweeping bridge that rode up and over the San Diego Freeway or did the 118 go under the 405 forcing her to double back as she made a 270-degree turn? Lauren prayed, "Please don't make me slow for the off-ramp. Let it be a bridge. It's got to be a bridge. Please."

The freeway lights began to flicker as she came up on the last sign announcing her off ramp. The bridge she had been praying for wasn't there. There were a couple of overpasses at the intersection of the two freeways, but they were for cars traveling in the opposite direction. Under her helmet visor, Lauren cursed and tensed every muscle. Aubrey awoke and started to cry, screaming as only a newborn can. Although Lauren wanted to pull over and comfort the child she said out loud, "Can't stop now, baby."

The flickering lights didn't help. From the corner of her eye Lauren

could see that the moving mountain was almost on top of the freeway interchange. She knew it would be close. If she had to slow for any traffic on the off-ramp, they would never make it. Her only hope would be to maneuver around vehicles impeding her progress. "Thank you, thank you, Chuck," she whispered. "I love this Harley."

Lauren dove the motorcycle across all four lanes of the freeway. Cutting in front of a silver Lexus, she climbed on the brakes to make the off-ramp to the 405 Freeway. The Harley raced towards the tight curve that would take her to safety. Lauren breathed a sigh of relief. The lanes were clear. She could push the bike through the tricky arc as hard and fast as possible. She reminded herself that if they made it to the 405 they would live.

Lauren slowed the bike as the tight bend of the off ramp raced toward her. She kept the Harley as low in the curve as possible, but when she looked up Lauren realized it was too late. The curve was sweeping her directly into a one-hundred-and-fifty-foot wall of moving debris. She berated herself. Why didn't I ride harder, not bother to pack my jewelry, or a thousand other things I could have done to save a couple of seconds? We're not going to make it. She couldn't let go of the handlebars so she tried to squeeze her upper arms against her baby instead.

The wave was like a predator threatening her child, and that made her mad. It became personal. The wave was going to take all that she valued as it crushed and pulverized everything in its path. Despite the full riding helmet, Aubrey's screaming, and the roar of the Harley, Lauren could now hear the grinding, crushing sounds of the moving wall of rubbish as it loomed over her less than a hundred feet away. The relentless mass was poised to add another mother and child to the thousands it had already consumed.

Lauren screamed a guttural bellow that erupted from deep in her diaphragm. She gunned the 800-pound Harley, dropping deeper into the curve, leaning the bike over even further as she wrestled with the handlebars. Centrifugal force pulled on the motorcycle. Lauren fought the heavy bike, trying to keep it turning, leaning it even deeper into the turn. The right foot peg rubbed on the pavement. Sparks flew off the metal strut as it raked along the asphalt. Then the chrome exhaust pipe scraped the road and the rear tire started to slide as Lauren gave the Harley even more gas. The front forks began to twist. The handlebars almost wrenched from her grip as she held on with all her might, straining every muscle in her body. With the massive wave towering above her, she fought with all her strength to save Aubrey. The inevitable was only microseconds away. She clenched her teeth and screamed, "Noooo!"

TWENTY-SEVEN

FIRST OFFICER IAN FIRTH CAUGHT UP to the search party just as they were making their way around and through the remains of the H-1 Freeway. Spread out before him were hundreds of dusty concrete columns ten-feet wide by thirty feet tall. The elevated freeway deck had been toppled from its supports. The massive ten-foot thick slabs lay tilted at odd angels, flattened like a deck of cards. Water was still seeping from every crevice. Ian looked up trying to grasp the power of the incredible wave. How could the water be powerful enough to destroy the concrete structure and spread it across the barren landscape like so much paper in the wind? The rescue party stood in the midst of the rubble staring dreary eyed, stunned at the level of destruction. If the H-1 couldn't survive the onslaught of water then there wasn't a building in Hawaii that could. It was becoming abundantly clear that their search for shelter and food was a waste of time. Their only chance was to find fresh water in the mountains. It was the sole reason to continue the search.

"Let's take a short break. The water flowing from those crevices may be clean enough for us to rinse our towels."

Heather Turland shook her head. "Mr. Firth, this sucks. We'll never find shelter. We'll never find any food. There's nothing. Everything's gone. I'm glad we can't see more than a few hundred meters. I'm not sure I ever want to see what's out there."

The falling ash had limited visibility to less than a half mile. The search party, wrapped in a protective cocoon of choking dust, stood between two huge slabs of concrete, dazed but insulated from the vast extent of destruction.

"Ms. Turland."

"Call me Heather."

"Heather. Our only hope is that as the wave climbed the sides of the mountain it would tend to lose energy. There could even be some survivors up there."

Heather Turland looked on the edge, barely controlling her emotions. Her arms began to flail at the invisible demons occupying her sub-

conscious, eyes darting to and fro uncontrollably. "Survivors, we're the only survivors. And we're worse off than a bunch of deros' on the streets of Sydney. At least they've got a box to live in."

"I'm not saying our situation doesn't look dire, but we need to get to the high water mark. That's our only hope. I'm hoping we will find enough to live on above the high water line." Ian Firth wasn't very convincing. It was the tone of his voice, his body language. Mostly he didn't believe they'd find anything useful no matter where they searched. "I figure we've covered maybe eight kilometers. We should do another fifteen or sixteen by dark."

Ian had felt a pressing urge to empty his bladder for the last half hour. "I'll be back in a minute. I've got to take a leak before we move on. I suggest you do the same." He left the three survivors to find a place to relieve himself in privacy.

Walking amid twisted masses of concrete slabs and columns, Ian found a spot to relieve himself behind one of the massive columns that use to support the freeway deck. He thought about the ominous situation. The captain was right. The world had already forgotten about them. A fleeting smile crossed his lips at the thought of the captain's desire for a suite at the Four Seasons. The only suite they were going to find would be four stumps with a sheet tied between them. Just as he was finishing, the voice of Heather Turland startled him.

"Can I help you with that?" Ian didn't know what to say. Caught off guard, it took him a few seconds to regain his composure.

"The holding's all done. Only thing left's the shaking."

"I can handle that." Ian quickly zipped his pants and turned to face the intruding Ms. Turland.

As a perplexed look spread across his face, Ian asked. "Am I getting a message here? Cause if I am, now's not the time."

Heather instantly broke down in tears. Covering her face with ash-coated hands, she began to sob uncontrollably and took a few steps forward, standing directly in front of the first officer. She looked up with tears still running down her cheeks. Her faced stained black from the grimy residue falling from the sky.

"I'm so embarrassed. I'm such a tart. It's just..." Heather continued to sob uncontrollably, hardly able to catch her breath. "It's just, I don't know. We're going to die. We're going to die and no one will ever know. They're not even going to care. We're just going to starve to death on this god forsaken island."

Ian wrapped his arms around the sobbing Ms. Turland. "Hey." Gently placing a finger under Heather's chin he lifted her head so that their

faces were only a few inches apart. With his most solemn and convincing gaze, Ian said. "Don't worry. If we can find fresh water, we'll have plenty of time to look for food." Heather wiped her right cheek with the back of a greasy hand. "They say a man can survive four minutes without air, four days without water, and four weeks without food. We need to find fresh water. That will give us time. This is the tropics. It shouldn't be that difficult." Again Heather began to sob uncontrollably, muscle spasms wracking her body. "What's the matter?" Ian had to wait while Heather gained some level of control.

Heather Turland blurted out. "We're not going to have four weeks."

"What do you mean?"

"We're runners. Look at us. We've got less than ten percent body fat. We won't last two weeks." Heather started to cry again. All Ian could do was hold her frail body while tears continued to run down her cheeks as she pressed against his chest. Finally she said, "I use to have a t-shirt. It was my favorite, not very P.C. It said: When the aliens land, they'll eat the fat ones first. We're not like the others."

"We'll figure something out. I know we'll find something or someone. It's gonna be all right." Heather stopped crying. She removed her head from Ian's chest looked up and gave him a kiss on his grimy cheek.

"About that little comment. You know, shaking your Willy." Ian nodded. "That's not like me. I'm so embarrassed. It's just that. Well, I figured we weren't going to be around much longer. I might as well go out with a bang."

"It's okay. And if you're ever in the mood again, you'll find me very accommodating."

Heather smiled for the first time since they had landed. "Besides, I think you're kind of cute."

Now Ian smiled. The two turned to head back to find Jeremy and Paul. They had already washed out their towels using the water that flowed from a crack in the broken remains of the H-1 Freeway. Heather and Ian untied the towels that covered their nose and mouth and proceeded to wash them out in the trickle of water. Once they were a musty ochre color, they retied them. Ian used the GPS and led the small group off in the direction of the coastal mountains.

As they gained altitude, visibility improved to over a mile. The landscape was tortured beyond imagination. The rushing water had stripped away the lush gardens, brightly painted homes, and even the telephone poles had been snapped off. But it had also removed all of the topsoil. The only thing that remained was mile after mile of ancient black and red lava bedrock that underlay the city of Honolulu and formed

the core of the island.

Heather pointed. "Look at those giant rocks. They look like they're about to roll down the hill." The massive boulders were spread across the exposed bedrock as if some twisted giant was preparing to play a game of marbles.

"Jesus, they're big as houses," whispered Jeremy.

Paul said. "They're called erratics. The tsunami moved them. They find them all the time in the dry riverbeds of Queensland, but I've never seen any so large."

Ian kept the search party on top of the ridges whenever he could. As they continued to climb, the small party was forced to bypass immense potholes that had been dug by the enormous boulders caught in a whirling eddy. The huge rocks had ground away at the soft igneous bedrock like a pestle grinding on a mortar.

The evening trade winds began to slacken, carrying less and less ash to the islands north of Mauna Loa. With the skies starting to clear, it became easier to breath. Ian, Heather, Jeremy, and Paul continued to clamber over the rocky surface. With each mile, the terrain got steeper. The fast moving water had piled millions of tons of rocks into enormous ridges. The ridges were actually wave ripples formed by the rushing water. The same ripples that form on sandy river bottoms only massive in size. The chevron-shaped stacks of rock and debris stood over fifty feet high and five hundred feet from ridge to ridge.

The team was exhausted after four hours of tortuous hiking, and they had not covered the distance Ian had hoped they would. He urged them on. Despite battered shins and bloody knees, they continued to scramble up the sides of the wave generated ridges, often forced to use their hands to crawl up the steep sides of each successive hill. Once the four survivors crested a ridge they would carefully make their way down to the valley that separated them from the next ridge. Rarely did anyone look up, too exhausted and fearful of falling. With each step, the group of survivors became more and more despondent. When they hit a ridge, Ian would scan the area looking for anything of value. All he ever found was the next ridge in front of them with mounds of trash buried under tons of rocks.

The sun dwindled to a dim orb as it plunged to the dust-choked horizon. The trade winds subsided. The rescue party removed their towels as the sky continued to clear. Ian climbed to the top of a ridge and checked the GPS. He looked up from the battered landscape they had been traversing. At first he thought he was looking at a bizarre shadow. A play of light caused by the cloud of ash to the south. He asked Paul for

the binoculars. Scanning the mountains in the distance, Ian saw a wide swath of garbage and debris. The line of trash, the high water mark, drew Ian's attention, a writhing coil of rubble that snaked across valleys and ridges for as far as he could see. It was less than a mile away. This endless ribbon of trash was all that remained of the tropical paradise of Honolulu.

Beyond the high water mark was the lush foliage that normally covered the coastal mountains of Oahu. Instead of a brilliant green, the plants and trees were now encrusted with a layer of brown mottled ash. Below the serpentine line of trash lay nothing but barren rock, the island had been stripped clean. Every manifestation of human endeavor was either lying in a heap along the sides of the Koolau mountains or washed out to sea.

As he continued to scan the slopes, Ian came across a large gray structure. With the dusky light rapidly fading, he could barely make out the odd shaped building. Why was so large a structure so high on the side of the mountain? Ian squinted into the glasses refocusing them to get a clearer view. That's when he recognized what he had been staring at. It wasn't an oddly shaped building at all. He was looking at the massive hull of a ship. The dark hull rested on its port bilge lying motionless against the steep slope. Ian attempted to inspect the dented hull through the binoculars. The battered plating accentuating the steel ribs that formed the inner structure, but the streaked and tattered ship appeared to be intact. Even the large derrick in the center of the deck, though bent over at an odd angle, was still standing.

Ian pointed in the direction of the huge ship. "There. Right there is our new home. Do you see it?" The three runners looked up in the direction Ian was pointing.

"I don't see a thing," exclaimed Heather. "Paul, Jeremy do you see what he's pointing at?"

"Let me 'ave a gander through the binoculars. All I see is that big gray shadow." Ian Firth handed the binoculars back to Paul. Only after Paul Imhoff had adjusted the focus could he make out the shape of the massive hull.

"Bugger. It's a ship. It's a huge ship."

"What kind of a ship? Is it a cruise ship?" asked Heather.

"No, not a cruise ship. I don't know what it is, but Ian's right, it looks intact. A ship that size will be a self-contained city. There'll be food, water, medicine, blankets, everything we'll need."

"If we're lucky they'll have a generator and communications equipment. It looks like it survived without much damage. Maybe there are survivors on board," Ian said with a smile spreading across his face. It

wasn't the Four Seasons. Still, he knew the captain would be pleased.

<center>* * *</center>

Kazimierz Jasinski looked up at the wave as it swept down the abandoned runways. The mass of air in front of the towering wall had built to a howling gale. Kaz could barely stand as the wind whipped the small pond left by the drained tank. He needed to find something to extend his reach, something that would allow him to close the six-inch valve that operated the fill spout. Dust flew everywhere in the flickering light. It was becoming almost impossible so see. Kaz could barely make out anything on the ground. He turned his back to the wind to keep the sand out of his eyes and started to shuffle his feet through the water. He was looking for a piece of wood, maybe a tool or some pipe, anything that might have been left behind by the construction workers. He needed something that would allow him to reach over his head about three feet.

The deafening roar of the wind—or was it the roiling water—was as loud as the jet engines that normally filled the tarmac. Kaz shuffled along in a low crouch, buffeted by each blast of air. As he took a step through the giant puddle below the tank, his foot caught on something, something solid and round like a pipe. He reached into the turbulent water and felt around where his foot had caught. It was a length of steel rebar used to reinforce the new concrete apron. Kaz wrapped both hands around the half-inch shaft of steel and started to pull. The steel bar gave a few inches, yet despite all his efforts he couldn't break it lose.

Kaz glanced back over his shoulder. He froze at the sight of the incredible wave careening down the runway. It was so high, so large. The perspective was all off. How could it advance so far in so short a time? It had only been a few seconds and already the wave had swallowed up the end of the runway. Now it looked like it was almost on top of him. Kaz bent over the obstinate piece of steel as if he were about to perform a dead lift. He took three quick breaths and pulled with all his might as he let out a bellow. His scream was instantly carried away by a blast of wind. The bar began to give, then something snap. Whatever had been holding the rebar gave way. Kaz almost fell backwards into the pond, just barely able to regain his footing before getting soaked. He held up the four-foot-long piece of steel to inspect it. There was a broken wooden stake attached with seizing wire to the end of the metal rod.

Kaz rushed back to the tank, battered by the wind, squinting through the blowing dust. He hammered on the offending valve handle with the steel bar. He beat on it with all his strength. And after a couple of heroic blows, the valve turned and the tank was secure. Kaz threw down the steel shaft then ran back to the ladder. He climbed up the bulky

side of the water tank as it rocked back and forth in the blinding wind. Blocked by the tank, Kaz didn't realize how little time he had left. Once on top, his legs straddling the eight-foot metal tube, riding it like a bucking bull, Kaz saw that the towering wave wasn't more than a few hundred yards away. He instantly started to undo the inspection hatch. As he began to turn the handle, he looked up.

The airport lights had gone dark. When he craned his neck, looking almost straight up, Kazimierz Jasinski could just make out the seething foam crest of the massive wave. It was almost a thousand feet directly above him. The inconceivable wave's brilliant white teeth gnashed at him as they roared down the face of a liquid wall of destruction.

The moon rising in the east illuminated the deadly crown of froth. Kaz froze. The muscle in his arms refused to cooperate with the commands issued from his brain. His world instantly narrowed to a small light at the end of a very long tunnel, that dim light shining on just one thing, the hatch cover that was his new family's only hope for survival. Kaz paused momentarily, willing his hands to turn the locking mechanism. He tightened the hatch. and with a yank, checked to make sure it would not come loose. There was no time left. All that mattered were the four people inside. Kaz closed his eyes and concentrated on the smiling face of the six-year-old girl who had helped him forget three years of pain, the persistent pain that had attached itself to him like a shadow. The same pain that in the next few seconds was going be pressed out of existence for an eternity.

The wave exploded into the tank with brutal force. The bone crushing acceleration pressed Maria and her three children against the two-foot layer of blankets. The noise inside was deafening as broken pieces of building smashed into the metal sides of the tank. The miniscule watertight vessel shot forward on the face of the wave. It began to climb, accelerating faster as if attached to some out of control elevator. By the time the little water tank had exploded past the San Diego Freeway, it was over 800 feet above sea level. The frothing crest rolling the tank like a top while the centripetal force of the spinning cylinder pinned Maria and her children against its side.

As the massive wave washed over the Los Angeles Coliseum, the same place where Maria and her husband used to wait in line for tickets to the Trojan football games, the tank began to fall off the seething crest. The family inside became weightless as the tank went into a 250-foot freefall. Blankets and bodies floated in mid air as Maria and her daughters screamed, clutching one another with adrenaline-spiked fear. Around

Figueroa, the support scaffolding, still attached to the bottom of the tank, struck the face of the wave. The girls and their mother smashed into the sides of the tank. Maria's right wrist snapped, but the blankets provided enough padding to leave only nasty bruises on the children.

The tsunami rolled through downtown Los Angeles, consuming everything in its path. It continued to pick up more and more debris from each building torn off its foundation. As the suspended load carried by the wave increased, the monster slowed. No longer was the face a vertical wall of water. As the tsunami passed the Hollywood Hills and Dodger Stadium, it began to take on the appearance of a moving garbage dump. The steel tank, still water tight after the incredible beating it had taken, was far more buoyant than the surrounding debris and it floated on top of the moving mound of trash. The remnants of the most destructive natural disaster to strike mankind finally stopped as it washed up the sides of the San Gabriel Mountains. Maria and her daughters, along with the crumbled remains of Los Angeles, were thrown onto the sides of the mountain peaks that formed the backdrop to Pasadena, the City of Roses.

The noise had all but stopped as the battered water tank came to a rest then lurched, falling backwards just a few feet. The tank stopped moving. Everything went silent. Inside the water drum, Maria grabbed her broken wrist, trying not to cry in pain. Maggie and Martha continued to hold their mother, squeezing the blood out of her good arm. Emily stayed silent, barely moving a muscle as her eyes darted around the dank insides of the tank. Only a dim light peeked from under the blankets and illuminated the metal sides. It was the flashlight she had dropped. The one Kaz had given her.

TWENTY-EIGHT

BY THE TIME WE LANDED at McCarran International Airport, Lauren should have been on the road for over three hours, halfway to Vegas. Maybe more. Lauren and Aubrey were either safely riding up the I-15 on their way to Vegas or... I couldn't bear to think about the alternative. Once we were on the ground I tried to reach Lauren on her cell phone. A disconnected mechanical voice came on advising that all lines were busy. I continued to dial with no luck. I rationalized that there was no way Lauren could have heard her phone while riding the Harley anyway. I was still convinced that she and Aubrey were safe. Maybe the wave wasn't as large as Scott had said it would be?

Scott's face popped into my head with his slightly tousled hair, perfect teeth, and those blue eyes that drove the ladies to unconscionable acts of self-indulgence. The smiling son-of-a-bitch that almost got me killed at least a half a dozen times on this trip. Had he made it, and what about his family? He said he'd been shot, but when he called, he was driving to meet his family on top of a mountain. I laid my head back and closed my eyes. White rivulets of light rolled across the backs of my eyelids as I tried to picture Scott's smiling face. The guy was more like a cat than a human. Make that ten cats. Nine lives wouldn't last him a year. He was probably fine, sitting on some mountaintop downing a couple of Primos while tossing a ball with his kids. All I could do was smile at the thought of my friend calmly walking up to death's front door and knocking. When the door finally opened, he'd just stick his hand out and give the S.O.B. the finger.

The airport was overrun with planes. Even the taxiways were filled with brightly painted jets outlined against the bright lights of the strip. The tower directed us to the far southeast corner of the airport where Captain Hornbeck parked Flight 103 and shut down the engines. He then informed us that it would be some time before we could deplane. He apologized for the delay and announced that all drinks would be free for as long as they lasted. Half the passengers cheered, the ones that didn't live or have family in Los Angeles or Hawaii. The rest just sat there miserable and depressed. With the destruction of our homes and the pos-

sible death of family and friends, the cloud of gloom inside Flight 103 thickened with every passing minute.

I checked my watch. Again, I tried to envision where Lauren would be. As long as she made it to the 405, she'd be fine. Was I being too optimistic? God, I hoped she was pushing the Harley, ignoring the speed limits. She knew how to ride when she let go of her fear.

Finally, three school busses showed up and began transporting passengers to the terminal. The place was a madhouse even though it was after 2:00 a.m. Every slot machine was occupied with tourists throwing money at the noisy contraptions as if their lives depended on keeping the insatiable boxes full. Large crowds had gathered around the few television monitors spread throughout the terminal.

I was completely baffled by the mood in the crowded building. Half the people, the ones watching the TVs, were dazed and in shock from the devastation they were witnessing. From my perspective, they were the normal ones. It was the other half that didn't make any sense. The only explanation for their behavior was that they were celebrating, celebrating their survival despite the loss of millions of innocent people. They gathered in small groups at the bar, or sat in front of slot machines feeding them quarters, but invariably talking to the person next to them. Everyone was making some kind of connection with another human being. Maybe it was their way of confirming that humanity had survived this incredible disaster. Or was it their way of avoiding it?

I started to dial Lauren's cell again and discovered my battery had died. I looked over at a row of pay phones but there were travelers lined up at each phone. I rushed down the long corridor dodging old ladies searching out empty slot machines and kids looking for their mothers. If Lauren had made it, she would be waiting for me outside.

I passed by a TV where hundreds of rigid bodies were staring at pictures from a helicopter flying over the devastation wrought by the tsunami. The news copter was over the Coachella Valley. The tsunami had washed all the way up the Gulf of California and inundated the valley that used to sit a couple hundred feet below sea level. By the time the wave struck the northern tip of the gulf, it was only two hundred feet high. The problem was that the natural land bridge that separated the gulf from the below sea level valley was only six feet high. A channel was cut right through the earthen barrier, extending the gulf over a hundred fifty miles further north. Palm Springs was now an ocean front resort. Without warning, the cities of Thermal, Indio, and Indian Wells had been drowned out of existence. The loss of life in just this one remote corner of the world was horrendous.

All flights in and out of the West Coast had been cancelled. Air traffic across the entire country was a mess. The arrival and departure board displayed nothing but cancelled flights. I've never been comfortable around crowds, but with the extra pressure of not knowing where Lauren and Aubrey were, I was on the verge of a meltdown. I kicked open the door leading out to the street, almost breaking the glass.

The sidewalks weren't much better than the terminal. The taxi lines stretched for as far as I could see. With people yelling, horns blaring, and tires screeching. The scene unfolding before me was symphonic pandemonium as the stranded travelers tried to leave the airport. Every car rental company had a sign out announcing they had run out of vehicles. How was I ever going to find Lauren in this mess?

I went to the passenger pickup area located on the second level of the parking garage. It was virtually deserted. More important, Lauren and Aubrey weren't there. I found an empty concrete bench and sat down. On the ground was a crumpled newspaper. I couldn't help reading the headline: West Coast Destroyed by The Wave. My headache, the one I'd had for the last three hours went critical. The few brain cells left were in a battle to the death as visions of Lauren racing down the 118 Freeway ricocheted off the back of my cranium. With my knees tucked tightly into my chest, I rested my head on clenched fists. The thought of losing Lauren and Aubrey kept exploding back into my consciousness. Tears started to soak my hands and cheeks. I buried my head deeper, as I curled into a tighter and tighter fetal ball.

No matter how hard I fought it, the only logical explanation for them not showing up was they hadn't made it. I kept on telling myself, bullshit, Lauren had plenty of time and she knows how to ride. There were a million possible scenarios. I just couldn't convince myself to believe any. The pain in my head continued to swell while all cognitive thought processes continued to shut down. I was drowning in my own mental abyss as the world around me evaporated.

"Excuse me? Excuse me, sir." Someone tapped my shoulder. "Excuse me."

As I raised my head a cop with a large sunburned face, stooped shoulders, and glassy eyes stared down at me. He looked as if he'd worked straight through the last three shifts. I started to apologize for putting my feet up and acting like a wuss. I had assumed the local chamber of commerce wasn't too thrilled about having an outhouse guy weeping like a child in the middle of their airport. The cop reached back and pulled a small note pad out of his pocket. He thumbed through the pad, and then looked up. "Are you Chuck Palmer?"

My heart began to pound. The cop must know something about

Lauren and Aubrey. Why else would he be looking for me? "Yes. Yes, I'm Chuck Palmer. Have you heard from my wife? Is she okay?"

"Hold on a second." The cop raised a hand as if instructing me to halt as he spoke into his radio. "Sherry, I've got Mr. Palmer by passenger pick-up. What do I do?" There was a brief pause while the person on the other end replied. "Roger that, I'll keep him here until trauma arrives."

Trauma, did he just say trauma? What the hell was going on? I started to stand only to find my legs too weak to carry me. Trauma. Why would they be sending trauma?

"Excuse me. Why are they sending someone from trauma up here? Is it about my wife and kid? What do you know? What's going on? What happened?"

"Happened? I don't know anything. They just told me to find you and keep you here."

"But why are they sending someone from trauma. It must be about my wife."

"Could be. But even if it is, it's no big deal? You're in Vegas." A smile spread across this fat bastard's face as he continued. "We've got the hottest women in the world. This is the town where everyone wants to be single." I couldn't believe what this fat S.O.B. had just said. "Hell, I've been trying to get rid of my old lady for the last fifteen years."

"Are you out of your f-ing mind? I just got married. I've got a three month old daughter."

"Hey, trust me, no matter what happens, it's not going to be as bad as you think. I'm telling you, the women in this town are hot. There's so much going on a kid will just get in the way. Don't worry, you'll be fine."

How could anyone be so cavalier, insensitive, a fucking prick? I was about ready to pummel the bastard. "What kind of a horse's ass are you? Get the hell out of here. God damn it, leave me alone." I pointed to the curb twenty feet away. "Just leave."

"Hey, don't take it so personally. I was just trying to help." The fat cop waved his fat finger around in the air and then pointed it at me. "Don't move until they get here."

As the S.O.B. turned to walk away, he seemed to be grinning. I couldn't believe the sadistic bastard. How could anyone take pleasure in… God, I didn't even want to think about it as I dropped my elbows to my knees and covered my face. With lips quivering and tears once again drenching my cheeks, I tried to blank out the world around me. Millions of people had just died; millions more were mourning their losses. I shouldn't be one of them. I'd warned Lauren, gave her plenty of time. They should have made it. Everything should have worked.

Curled up in a fetal position on the rock hard bench, I tried to erase the last few days from my memory. My stomach was wrapped so tight I could barely endure the cramps. The only sensation I felt, the only emotion I experienced was excruciating pain. My family was gone, and there was nothing more I could do about it.

<p style="text-align:center">* * *</p>

The small rescue party was exhausted as they collapsed next to the giant ship. Their hands and knees were scrapped and bruised from scrambling over the ragged remnants of Honolulu. A downcast moon was just beginning to peak through the clouds of ash announcing the end of their journey. The four passengers from flight 391 rested twenty feet below the turn of the ships bilge, despondent, lost in their own thoughts after witnessing the incredible destruction inflicted upon the once tropical paradise. They rested on the sharp rocks, breathing hard while starring straight up at the battered sides of the steel hull.

"My god, this thing is gy-normous. How will we ever get aboard?" asked Heather Turland.

Ian Firth scanned the area around the ship noting that the hull, though badly battered appeared to be in tact. "She seems to be lying on her port side a bit. We should climb around to the uphill side. Maybe we can get aboard from there."

"Do you think anyone survived? They're probably all dead," commented Heather.

The identical thought occurred to First Officer Firth as he repeated to himself, Please no more dead bodies, no dead bodies.

The four hikers labored towards the rear of the ship where the rudder and propeller should have been. Both were gone, having been torn away by the power of the wave. With the ship lying on its side, tilted into the hill, the deck was only twenty feet above where the hikers stood.

"We'll never get aboard," complained Heather. "I'm knackered. We've all been A over T a half dozen times. Look at my bloody shins. I say we call it a day? We can camp under the hull if you think it's safe?"

"Before we give up we should see if anyone is aboard." Ian Firth replied. "Did anyone get the name of this bugger?"

"I think it said Glomar Explorer on the stern, but it was awful dark," Paul Imhoff explained.

Ian asked. "Anyone heard of her?"

Jeremy spoke up first. "It was a long time ago, but I think this was the ship that, the American millionaire Howard Hughes built to recover a sunken Russian sub. They converted it to the largest deep sea drilling rig in the world."

<p style="text-align:center">276</p>

"Well maybe somebody's on board. Let's get some rocks to beat on the hull, stir up a racket. We'll give it a fair go, then call it a night," suggested Ian.

Beating on the heavy steel hull revealed a dull thud rather than the sharp clang that Ian had hoped for. Still with the four rescuers pounding away, Ian figured if anyone were still alive they would be heard. After ten minutes, Heather Turland was the first to throw in the towel.

"That's it. I'm fed up to the back teeth. We've given her a fair crack of the whip."

"I suppose you're right. We'll spend the night under the hull and tomorrow morning see if we can figure out a way to get on deck." Just as the rescue party started to head back, they heard a voice coming out of the pitch black.

"Help! Help! Is anyone there? Please help."

"We're right here. Below you," yelled Ian Firth. A bright beam of light zigzagged across the hills until it rested on the four hikers.

"Oh thank God. We need a doctor, please," begged the man with the flashlight. "Please, we need help. You have to hurry."

<p style="text-align:center">* * *</p>

Emily reached under the pile of blankets and grabbed the flashlight, shinning it on her mother. While Maria covered her face from the blinding light, Emily could see that she was in excruciating pain, the color drained from her face, eyes agonizing slits.

"Mommy, are you okay?"

"It's all right, Emily, I just hurt my wrist. Mommy will be okay."

Emily inspected her surroundings with the light. The rusted walls, no longer a smooth circle, were dented and creased from the pressure and constant pounding they had been subjected to. Maggie and Martha sat silent still clutching their mother's arm. "Mommy, where is Mr. Kaz? Is he okay?"

Maria didn't know what to say. How do you tell a six year old? The only answer was from the heart. "Mr. Kaz will be fine. He's with the angels now." The look on Emily's face broke her mother's heart as she dropped the flashlight and buried her head in a blanket. "Emily, please. We can't do anything about Mr. Kaz. He'll be okay. He was a good man. We have to get out of this place. Mommy hurt her hand. Do you think you can help?" After a few moments, Emily took a deep breath and looked up with swollen red eyes. She merely nodded. "Mommy is so proud. You're such a big girl. Now see if you can open the hatch."

"I'll try," as she wiped away the tears. With the tank lying on it's side, Emily only had to crawl a few feet. She reached up and grabbed the rusty

lever that would disengage the locking pins. Placing both hands on the rusty handle, she was surprised at how easily it moved. Emily spun the lever all the way around, first clockwise then counter clockwise. Nothing happened. The two locking pins refused to move. "Mommy, something's wrong. It won't open. What should I do?"

"What do you mean sweetheart? Why won't it open?"

"I don't know. Look." Emily shinned the flashlight on the lever and then spun it as her mother watched in horror. "See it doesn't work. We'll never get out. We'll never get out." Emily began to yell uncontrollably. "Help. Help, is anyone out there,... Help."

"Emily, stop it. Stop that right now." Emily turned to see her mother glaring at her. She couldn't remember the last time she'd been yelled at. "Screaming isn't going to help. We need to figure out what's wrong. Now shine the light on the lever again and move it." Emily did as she was told. "Okay, That's better. It looks like the handle is broken, but do you see the metal bar that the handle is connected to?" Emily nodded. "All you have to do is move the metal bar which will move the other pieces of metal and unlock the door."

"How do I do that, Mommy?"

"See if you can push on the end of the bar. Maybe it will move."

Once again Emily did as she was told. "It's not moving. It's not working. We're going to die. We're all going to die in here." Emily looked away from her mother then buried her face to hide her tears.

"Sweetheart, we're not going to die. Just listen." Emily refused to look at her mother. "Emily, you need to listen." The little girl shook her head, still refusing to show her face. Maria realized that despite her broken wrist she would have to open the hatch. She slowly moved closer to her frightened daughter, making sure not to put any pressure on her bad hand. She gently removed the flashlight from Emily's grasp and began hitting the end of the locking mechanism with it. With each strike, the locking pins moved a little more. Soon they disengaged the edge of the tank. "Emily look, it's open. We can get out. All you have to do is push on the hatch. Can you do that for Mommy?"

Emily finally looked up with red cheeks and swollen eyes. "I think." "That's my girl."

Emily reached up to open the hatch; pushing with all her strength it moved a few inches. She repositioned herself and continued to shove. The steel door opened until there was a three-inch gap between the rim of the tank and the lip of the hatch. But that was as far as she could move it.

"Mommy, it's stuck again. It won't move. I think something is blocking it."

"Are you sure?"

"I pushed with all my strength. I really did."

"Can you reach your arm out and check?"

"I'm afraid."

"Emily, you have to do this. Mommy's arm is too big. You have to move whatever is blocking the door."

"I can't."

"You have to. Now please try." Tears ran down the little girl's cheeks as she worked her arm through the narrow opening into the dark of night.

"It feels like there's a stick or a branch. It won't move. It's too big. Mommy I can't move it. I can't. What do we do? I'm scared."

"You have to baby. You have to move the branch."

"I can't. I really tried. I tired as hard as I could and it didn't move, not at all. Mommy, I'm so scared. We're going to die. We're going to die. I know we are. Mommy, please?"

<center>* * *`</center>

"There's no doctor here, but Ms. Turland is an E.R. nurse. Are you injured?" Ian Firth yelled back.

"No. I'm okay. It's my friend. He's caught. I'll throw down the pilot ladder. We need to hurry." A rope ladder was tossed over the side of ship clanging against the steel hull. Buzz Harvin introduced himself as the chief engineer on the Glomar Explorer. The man was covered in oil. The few strands of gray hair he possessed matted flat, his orange jump suit a solid dark stain.

"My god, what happened to you?" asked Ian.

"I'll explain on the way to the machine shop. We've got to help Eddie. He's caught."

The engineer lit the way with his flashlight. The four runners followed close behind as the engineer dodged around the few pieces of equipment still remaining on the deck of the giant ship. Other than the massive derrick towering high above them, the ships topsides were virtually bare. The engineer explained that he had been inside the main engine inspecting a connecting rod when all of a sudden the entire ship was picked up and rolled over. It was fortunate he had been inside the cramped space as the motion was so violent. Buzz figured he was probably knocked out, as he couldn't remember what happened after that initial jolt. When he finally woke up the engine room was dark except for the dim glow of the emergency lights. He had no idea how long he had been out. Except for a large knot on the back of his head, he appeared to be in reasonable shape.

Ian, Paul, Jeremy, and Heather followed Buzz down a steep stairway

<center>**279**</center>

into the bowels of the silent ship. The ceilings of the long hallways were a maze of broken wires and pipes. The flickering emergency lights cast eerie shadows on the walls as their batteries continued to run down. At each open door broken furniture and miscellaneous junk had poured into the darkened hall blocking the way. Ian made the mistake of peaking inside the mess hall. He counted at least five bodies lying in the shadows. Twenty feet from the machine shop, Buzz shined his light on the silken white face of a crewmember, his morbid eyes staring off into oblivion. Ian could barely control the sour bile racing up his throat. The engineer merely stepped over the motionless body.

"I didn't know him. Watch your step in the machine shop. There's oil all over the place." With most of the equipment lying at odd angles, the small shop seemed even more cramped. "Eddie, Eddie are you still with us?" Buzz bent down to check on the injured man, his legs caught under a large piece of machinery that had fallen over. "Come on, buddy, hold on there. I've got some help." The fifteen-by-twenty-foot room was a shambles. Even the ceiling was covered in a heavy film of oil. Broken boxes of nuts and bolts along with every hand tool imaginable lay on the floor. The engineer turned to Heather. "Please, you've got to help him."

"Can I borrow your torch?" asked Heather as she cleared away a small pile of nuts and bolts with her foot. The emergency room nurse shinned the flashlight in her patient's eyes. There was no pupillary reaction. "Eddie, my name is Heather. I'm a nurse. Can you hear me?" The injured man moved his lips, but nothing came out. She shined the flashlight on the sailor's legs, and saw that both femurs had been crushed. She moved to the opposite side of the machine to get a better look. That's when she spied a dark streak of blood running down the tilted floor. It stopped at a large black pool of congealed liquid next to the wall. Heather covered her mouth as she gasped. "Ian, we should talk."

"What about Eddie? He's going to be all right, isn't he?"

"Your friend has lost a lot of blood. Hurry, get me a first aid kit?" The engineer rushed out of the room.

"What was that all about?" asked Ian.

"I wanted him out of here. That first aid kit isn't going to help this man. His femoral artery is cut. He's already suffered some brain damage. The only reason he's still alive is because that heavy equipment has squeezed off most of the blood flow to his legs."

"So what do we do?"

"I'm not sure. The minute we lift it he'll bleed out. There won't be any time to put tourniquets on him."

"Then put them on before we lift the machine?"

"We can't, he's pinned to the deck. There's no way to get anything around his legs."

"Then we lift and place the tourniquets as fast as we can. We'll tell Buzz that his friend is probably not going to make it, but at least he'll know we gave it a go."

Heather looked down at the injured sailor. "I guess I'll tell him."

Buzz Harvin steeped into the machine shop carrying a large white metal box with a red cross dashed on its side. Heather proceeded to explain the situation to Buzz. He took the news much better than she had expected. Everyone stepped into the hall so that Buzz could have a moment alone with his friend.

Paul Imhoff asked. "Now what are we supposed to do?"

"Heather tells me that sailor is not going to make it. We'll give her a go, but we need to get on with our business. You and Jeremy will head back to the plane at first light. Heather and I, and hopefully that engineer can get this ship ready. There's a bloody big mess to clean up."

"Do you think they have much food on board?" asked Jeremy Horne. "We're going to have over two hundred people to feed."

"That's the first thing we're going to look into once this messy business is taken care of."

Buzz Harvin called out to Heather. "I'm not even sure Eddie heard me. Let's get this over with."

Ian, Buzz, and Jeremy rigged come-a-longs from the ceiling. The instant the half-ton lathe was lifted off Eddie's legs, he went into convulsions. The man was dead before Heather had a chance to tie off the gushing artery. All she could do was wrap her arms around the despondent engineer.

"I'm so sorry, Buzz. Your friend Eddie had lost so much blood there wasn't much we could do."

Taking in deep breaths, Buzz replied. "I know. He was my oldest friend. Spent over thirty years at sea with him."

"It must be a terrible loss, but we need your help. There are over two hundred people back on our plane and they're going to need food, water and a place to sack out."

"Water shouldn't be a problem. Our tanks are almost full. We normally carry a crew of around 125. We can figure out a place for them to bunk. We have food on board, but I don't know how long it will last with so many people. We weren't scheduled to receive our final provisioning for a couple of days."

Ian commented. "I noticed your power is out. I assume that means your frig and freezers are clapped out."

"The main generators are saltwater cooled. I can't bring them back online, but the emergency generator should still work."

"Good." Said Heather. "You need to get that generator started while we suss out the food situation?"

"The walk-ins are at the back of the galley behind the mess hall. We passed it on the way here. I may need some help with the generator."

"Take Jeremy and Paul. Heather and I can check on the food."

After placing a clean rag over his friend's face, Buzz Harvin gathered up a few tools and headed off with his two helpers. Ian and Heather went back down the hall past the rigid corpse with the pasty gray skin and lifeless eyes. As he stepped over the lifeless sailor, Ian noted that the man's front teeth had also been broken. Back lit by the flickering emergency lights, Ian and Heather had to duck under a maze of broken wires and light fixtures as they entered the mess hall. The day's lunch was spread across every surface of the dimly lit room. Mixed in with the smell of mashed potatoes and gravy was the unmistakable stench of death. The broken and twisted tables were still anchored to the floor, but the chairs were piled against the far wall, along with at least five bodies. Ian looked away from them as he and Heather carefully made their way to the galley.

The couple stood at the door to the ten-by-twelve walk-in refrigerator shining their flashlights into the darkened room. A mound of fruits, fresh vegetables, and various cuts of meat occupied the floor. The broken shelves along the walls, and the pile of useless food were covered in an assortment of gravies and dressings. "My God," exclaimed Heather. "Where do we start? This place is ready for the garbo."

"Let's check the freezer. That shouldn't be so bad." Ian went over to the heavy door and checked the outside thermometer. He smiled at the little bit of good news. The temperature inside was still bellow freezing. When he opened the door, his smiled instantly disappeared. While the contents inside the freezer were still frozen, the few cuts of meat along with some frozen cheese and butter would barely feed the passengers of flight 391 a couple of days.

"Heather, you need to see this."

The nurse came out of the refrigerator room shaking some unidentifiable slime off her hands. She shinned the flashlight on the metal floor of the freezer. "Bugger, I guess I had expected a lot more. What do we do now?"

"We'll clean it up later. I'd like to get the dead off the ship. It's too creepy sleeping on board with all those bodies. We can go about burying them tomorrow. Just the thought makes my stomach go round."

Heather Turland was deep in thought, nervously pulling on a strand

of hair when she finally looked up. "I don't think we should bury them."

"Why? They'll be nasty in a day or two."

Heather continued to play with the strand of hair as if it were connected to her deepest thoughts. "We need to place them in the freezer."

"Why would we do that? The thought of having a bunch of dead bodies in the same reefer as my dinner makes me want to chuck up."

"Me too, but I still think we should do it."

"But why?"

Heather continued playing with her hair while rubbing her cheek. "Protein. That's why."

"Protein? Have you gone completely bonkers? You're not suggesting..."

Heather interrupted the stunned co-pilot. "That's exactly what I'm suggesting. There's barely three days worth of food in there. You're the one that said we'd be here a long time, maybe even months before we're rescued. There's nothing on this island to eat, save a few wild pigs in the mountains."

"But you're talking about... cannibalism."

"I'm talking about survival."

<p style="text-align:center">* * *</p>

"We're going to be okay, Emily. We've just got to figure out a way to open that hatch."

"But I can't. It's stuck."

"Maybe if I help push, we can both open it?"

The two leaned and shoved with as much strength as a six year old and a woman with a broken wrist could muster, but the hatch was completely jammed.

"See, I told you it's really stuck. We're never going to get out of here."

"Emily, we're going to be okay. You just have to have faith. I think it will be easier in the morning when there's some light."

"Mommy, I don't want to spend all night here. I hate this place. I hate it."

"I know, sweetheart. But there's nothing we can do."

"Maybe there's somebody outside. We should yell for help, maybe they'll hear us."

Maria never believed for a second that anyone could have possibly survived the terrible wave. Still, she allowed here oldest daughter to call for help, but just for a little while. Her sisters needed to go to sleep. Emily gave up after screaming at the top of her lungs for over an hour. The girls and their mother wrapped themselves in blankets to ward off the damp chill inside the dark tank.

Emily closed her eyes and dreamed of playing with her best friend and neighbor Olivia in their backyard playhouse. She dreamed of how they would sneak into her mother's bathroom and put lipstick on. Then they would go out to the plastic playhouse and pretend they were having a formal tea. As the sun began to set, her mother would call. She and Olivia would have to quickly wipe the lipstick off their faces as they continued to laugh and chatter. Except this dream was different. It wasn't her mother calling but a strange voice. Emily opened her eyes but it was pitch black inside the steel tank. She had never been in a place so dark and thought she was still asleep, except the woman's voice kept calling.

"Hello, is anyone out there? Hello, hello."

Emily rubbed her eyes. It didn't help her see, but now she knew the voice wasn't a dream. She felt around for the flashlight.

"Mommy, someone is out there calling. I can hear them." Emily shined the light in her mother's eyes. Maria covered her face as she pushed the light to the side.

"Sweetheart, you were just dreaming. Go back to sleep."

"I know I heard a voice. They're right outside. I can yell to them."

"Sweetheart, please."

Emily ignored her mother and crawled over to the partly opened hatch. "Hello, hello. Is anyone out there?" She stopped to listen, but there was no response. "Hello. Help. Help."

"Please, Emily, go back to sleep. You're scaring your sisters."

The six-year-old girl continued to ignore her mother. "Help. Help. Help."

"Emily, stop that right now."

"Mother."

Maria screamed at her daughter. "Emily." That was all the little girl had to hear. She turned to crawl back to her spot at the bottom of the tank when she heard the voice again.

"Hello. Is someone out there?"

Emily's heart skipped a beat. "Mommy, did you hear her? There's a woman outside."

"No, dear, I didn't hear a thing. Now go to sleep. We'll figure out something in the morning."

And again Emily ignored her mother "We're in the big tank. Help...Help."

"What tank? I don't see any tanks."

"Mommy, did you hear that? I told you someone would hear me. You have to put your ear next to the crack so you can hear."

"Little girl, where are you? What color is the tank?"

Maria could not believe what she was hearing. How was it possible?

"Emily, quick hand me the flashlight." Maria pointed the beam of light through the three-inch crack and attempted to aim it up into the sky. "Do you see the light? We're in the big yellow water tank."

"My god, I see it. I see it. How many of you are there?"

"Four. Please help. Please." Maria was almost in tears as she called out. "I have three young girls." She continued to wave the beam of light, and it wasn't long before she could hear the breaking of twigs and branches as the stranger pushed aside the debris blocking their exit. As the hatch slowly opened, Maria silently crossed herself and said a small prayer. Her family would survive.

"How did you ever get inside there? Are you okay?" The woman looked to be in her forties as she reached a hand out to help Maria. She was dressed in blue jeans and a white cotton blouse covered in mud.

"My hand... my wrist is broken. Oh, thank God. Where are we?"

"The hills of Pasadena." The woman held her hand over her mouth in disbelief. "Where did you come from?"

"The airport."

"Burbank?"

"No, Los Angeles."

"That's impossible. It's over forty miles from here." The woman's smile continued to grow as she watched Emily help Maggie crawl out of the tank. "I can't believe anyone survived that terrible wave."

"It was Mr. Kaz that saved us, but how did you survive?"

"My partner and I live in the foothills. By the way, my name is Edith. What's yours?"

"Maria." Smiling, she pointed at her three girls. "And this is Emily, Maggie, and Martha."

"We were sitting in our living room watching the news. Just before the wave struck, the governor came back on the television. He looked awful." She attempted to mimic the governor's expression in the din of her flashlight. The girls laughed at the face Edith made. "He told us that there had been a terrible mistake. The wave was going to be over a thousand feet high, not a hundred feet. When we heard what happened we instantly ran out of the house, jumped in our car, and drove to the end of the street. As we scampered up the fire road, we could see the lights going out down below." Maria looked off in the direction Edith was pointing. The area was pitch black, not a single light shown. Even stranger was how quiet it was, not a siren, none of the usual city sounds only a light ruffling from the breeze. "It was like the wave was eating the city. By the time it got to Pasadena, it was just a pile of moving garbage."

Maria couldn't help but sniff the strange combination of salt and the

sour leftovers of a ruined city. "After the water receded, my partner and I decided to split up to see if we could find any survivors. She took off in that direction," pointing to the west. "You're the only ones I've found in two hours of searching."

Maria pointed her flashlight back at the tank that had saved her family's life. There wasn't an inch of the original steel surface that wasn't bent or scratched. Huge scalloped dents covered one entire side. She couldn't imagine the beating the immensely strong vessel had taken. The water tank had come to rest next to the remnants of a small house. The five survivors were standing on the slightly tilted wooden roof stripped of its shingles. A piece of broken telephone pole protruded thru one corner of the structure. Opposite the telephone pole was a tree trunk denuded of its leaves. The remains of a child's tricycle, with its pink tassels still attached to the handlebars, hung from a limb. Maria turned her beam of light on the base of the tree. She gasped, holding her hand over her mouth. In the center of the yellow halo formed by her light was a small shoe caught in the roots. Its owner couldn't have been more than six months old.

While Maria had been examining their dreadful surroundings, Emily had been pulling on her mother's dress. "Yes, chica, what is it?"

The little girl looked up with sad eyes. "Mommy, you said that Mr. Kaz was with the angels. What about Poppa? Is he with the angels, too?"

* * *

Somewhere in the darkest recesses of my misery, I heard a voice, a voice that couldn't have been real. The one voice I needed to hear more than anything else. It had to be my overloaded brain playing tricks on me. Synapses gone haywire, firing uncontrollably, all for the sole purpose of imitating the one set of harmonics that could make the agony go away. Then I heard it again, that same voice pierced the barbed wire barrier gripping my head, louder this time.

"Chuck, is that you?"

My stomach did a back flip. I wiped my cheeks with the back of my hand, and turned to face what I was sure must be a phantom. My world had lost focus. Everything around me was a blur. Everything that is except the one incredible image I had been praying for. Lauren's essence wavered before me. Was this one more trick of an over stressed mind? I looked at the fat cop. His palms were pointed skyward with a large grin encircling his sunburned face. As the world around me began to spin faster, he said, "I was just yanking your chain…I lied. Times like these, you gotta keep a sense of humor."

He lied? What did he lie about? None of this made any sense.

"What do you mean?"

"What I want to know is how does an outhouse guy like you get a hot babe like that?" He pointed at the wavering image of Lauren. "Come on. Move. Go to her."

Motioning again towards the vision that was Lauren. I turned once again to face her, as she stood smiling, one hand on her hip the other holding her helmet. Lauren had on her matching black leather riding pants, jacket, and black boots. Her long brown hair glistened in the glare of the surrounding lights. Fragile legs transported me to the specter standing before me, never sure if it was real.

"Are you okay?" With those three words, my legs began to fail. As I headed for the pavement, Lauren reached out and caught me. I wrapped my arms around her. She was alive. She'd made it. I couldn't speak or move. I stood there frozen, holding her. Then all of a sudden the emotions I had been struggling to contain inside burst. I dropped my head onto Lauren's shoulder and began to cry. My wife just held me as I tried to gain some sense of control. I couldn't. I was completely overcome, and then there was that damn cop.

"Geeze. Come on. Be a man. You're embarrassing me."

Something snapped. Whatever it was, I was back in the real world. I slowly loosened my grip on Lauren and whispered into her ear.

"I'm...gonna...kill...that...fat...bastard."

She was smiling. "He's just having fun. He's right. The world can use a bit of levity about now. It's going to be okay. I missed you."

"God, I missed you, too." I held Lauren at arm's length. "You have no idea how good it is to see you. What a beautiful sight, but where's Aubrey?"

"She's back on the plane with the other kids."

"Plane, kids? What are you talking about? How come you didn't answer your phone?"

"I had a lot of calls to make. Then, of course, my battery died. Sorry."

"Calls. What calls?"

"When you told me we needed to get as far away from California as we could, I called Paul our pilot and told him to fly the Gulfstream to Vegas. I guess they just barely made it. He said something about using the taxiway as a runway. I could hardly be mad at Paul and the co-pilot for bringing their families. Their wives are watching Aubrey now."

"Why are they still in the plane?"

"Remember you told me the ash from the volcano was going to wreak havoc on the world for the next couple of years."

"Right, there's not much we can do about that."

"The news has been awful. There are so many people that need help." She cupped my face with her hands. "I should be scared to death, but as long as we're together that's all that matters." I kissed Lauren's palms and hugged her again. She whispered in my ear, "Chuck, will you ever forgive me for what I did? I wanted a baby so badly."

I tried to speak, but couldn't. Tears began to roll down my face again.

"It wasn't right, but when you asked me to marry you everything sounded so perfect. I had this vision of the family I've always dreamed of. I couldn't bring myself to tell you what I had done. I was afraid you'd hate me. And now...now..." It was Lauren's turn to cry and I had to hold her.

I slowly regained my composure as I made eye contact with this amazing woman. "The only thing that matters is that my family is safe. I know that trust is the foundation of any marriage. So trust me, we can work through this. I just don't know how, and to tell you the truth, right now I really don't care."

"Chuck, that was the only lie I've ever told you, and I promise I'll never do it again. Please believe me."

"What about when you hired me to work on that island?"

"Oh yeah." An embarrassed, but slightly evil grin filled Lauren's face. "That was business. It's different. Besides technically I never lied." She glanced at her watch. "Oh my. We have to hurry"

"Why?"

"We're flying to New York. I had my father's attorney draw up the documents so I can start a new foundation to help the survivors of the wave. I want to get them signed and then head back to California. There are going to be so many people that need assistance, not just single mothers, but orphans, the elderly. It's something I know I have to do." She straightened her shoulders. "This is how I plan on dealing with this tragedy."

"No, not you, us. We're going to be helping others together. In fact, from here on out everything we do we'll do together. Deal?"

"Deal." Lauren smiled once again. Some of the old enthusiasm was creeping back into her voice. She was starting to look like the woman I had met two years ago. That incredible woman that walked into the gym filled with confidence, poise, and a speck of guile. I kissed her on the cheeks, eyes, and mouth, the latter for a very long time. When we came up for air, she said, "I'm fine, now." Lauren continued to smile and then motioned to the Harley by the curb. "You want to drive?"

"I'm still a bit shaky, mind if I sit on the back."

"No problem. You would have been proud of me. Once we hit the

14 Freeway I was feeling pretty comfortable riding this baby."

Lauren swung her leg over the seat. I climbed on back and proceeded to wrap my arms around her waist. Before she had a chance to start the big V-twin, a cell phone rang. Lauren reached into her jacket pocket.

"I thought you said your battery died."

Lauren pointed at the instrument. "Co-pilot's... Hello... Hi Paul, what's up? We can't takeoff... How come? I see... That bad... I'm not sure what to say, we'll be there in a few minutes. Is Aubrey okay? Good." Lauren cautiously tucked the phone back in her jacket.

"What happened? We can't take off?"

"No, but that's not all." Lauren swiveled around in her seat so that she could look at me over her shoulder. All of the color had washed out of her face.

"Are you okay? You look terrible. What else did Paul say?"

"I've never heard him so scared. He could barely speak. The FAA said all aircraft are grounded indefinitely. Chuck, I can't believe what's happened."

"What?"

"He said the volcano in Hawaii is going to cause..." Lauren stopped to wipe her eyes. "He said there's going to be a mass extinction event like the asteroid that killed the dinosaurs. They're talking about hundreds of millions dying." She gripped the sides of her head, pulling on her silken hair. "How will we ever survive? Aubrey... Oh no... Aubrey. Our daughter, she may never grow up." Lauren began to tremble.

"Look at me." I reached up and drew her hands down and held them gently in mine. "Aubrey is going to grow up to be a beautiful young woman just like her mother. We're going to make it. We're going to survive as a couple and as a family. We'll get through this together. I promise."

"How can you be so sure?"

"I don't know exactly how, but I know we're going to get through this. We can do it."

Lauren and I sat there in silence, each trying to absorb the enormity of this disaster. She turned away to rub her eyes again. I put my arms gently around her, and I thought about how much the world had changed today. I thought back to the friends I had made and then lost in Hawaii. Friends like Dr. Grissom and Jimmy Jordan at the Volcano Observatory who had warned me that the world might be covered in ash. That we could be faced with a winter that lasts for years. At the time, I couldn't deal with it and left. Now, there wouldn't be any place to run.

I thought about the good people like Karl Klessig and Capt. Pixton, and even the not so good guys like Rat Face. Maybe Captain Sammy

was right, and Pele got her revenge. They were all gone, along with millions of others. People I never knew. People who's lives had been cut short for no apparent reason other than the fickle whims of nature. I'm sure some will say it was God's will. Well, if it was I hope he has a better place for them.

And then there was my good buddy Scott. The last time we spoke, he was racing to the highest point on Oahu. Something inside told me he had made it. I don't know why other than he's just to damn ornery to die. Besides, he's still got way too many lives left in him.

As I sat on the Harley soaking up my wife's warmth, I realized I didn't have a choice. This disaster had been thrust into my life and now I had to deal with it. I had to find a place where my family could survive. There was no way for me to know what we would face in the coming years, but I knew both Lauren and I were as tough as Scott. We were willful and smart enough to make it. But most important we had each other.

Lauren turned around one last time and smiled at me over her shoulder. She had stopped trembling and let out a slow breath. "I'll be fine. I know we'll make it," she said as if reading my mind. "Let's get Aubrey." I sat up straight with a nod. She started the Harley and put it into gear then waved to the fat cop. The smart-ass son-of-a-bitch waved back as she gunned the engine and sped away.

We roared out of the airport, past throngs of desperate refugees, around stranded cars and twisted traffic, flying over the road on a cushion of air. Even though I was half scared to death, the smile spreading across my face couldn't have been wider. I was with the person I loved and my family had survived. For the moment that's all I cared about. As we entered a short tunnel I looked around to make sure no one was watching as my hand slowly slid up just a few inches and cupped Lauren's breast. That's when I knew everything would be okay.

* * *

Compared to a beach house in Malibu, an abandoned mineshaft with twenty feet of snow outside might not seem like much, but we've managed to endure in this bizarre sanctuary. Aubrey has picked up one of my charcoal pencils and is drawing on the walls of the tunnel. Soon they'll be covered with her petroglyphs. I sit here wondering who might see her drawings of life after The Wave? Will anyone ever hear my story?